4/06

February House

February House

SHERILL TIPPINS

HOUGHTON MIFFLIN COMPANY
BOSTON · NEW YORK 2005

For information about permission to reproduce selections
from this book, write to Permissions, Houghton Mifflin Company,
215 Park Avenue South, New York, New York 10003.

Visit our Web site: www.houghtonmifflinbooks.com.

Library of Congress Cataloging-in-Publication data is available.
ISBN 0-618-41911-X

Printed in the United States of America

Book design by Robert Overholtzer

MP 10 9 8 7 6 5 4 3 2 1

For Bob and Dash

Contents

Illustrations

FOLLOWING PAGE 146

7 Middagh Street, Brooklyn
Courtesy NYC Municipal Archives

George Davis
With the permission of Peter A. Davis

Carson McCullers in Central Park
Carson McCullers, 1940, photograph by Louise Dahl-Wolfe, Center for Creative Photography, University of Arizona, © 1989 Center for Creative Photography, Arizona Board of Regents

Wystan Auden on moving day
With the permission of Peter A. Davis and courtesy of the Weill-Lenya Research Center, Kurt Weill Foundation for Music, New York

Wystan Auden and Chester Kallman
Henry W. and Albert A. Berg Collection of English and American Literature, The New York Public Library, Astor, Lenox and Tilden Foundations

The view from Brooklyn Heights
Courtesy of the Brooklyn Historical Society

Klaus Mann
Courtesy Munchner Stadtbibliothek, Monacensia Literature Archives, Collection Klaus Mann

Gypsy Rose Lee
Courtesy of Erik Lee Preminger

Louis MacNeice
Bodleian Library, University of Oxford, Stallworthy Dep. 30N, polyfoto

Wystan Auden and Erika Mann
Henry W. and Albert A. Berg Collection of English and American Literature, The New York Public Library, Astor, Lenox and Tilden Foundations

Wystan Auden and Benjamin Britten
W. H. Auden and Benjamin Britten, New York, c. 1941; photo: Courtesy of the Britten-Pears Library, Aldeburgh

Preface

So many try to say Not Now
So many have forgotten how
To say I Am, and would be
Lost if they could in history.

—W. H. Auden, "Another Time," 1939

New York is full of old people, struggling to occupy their allotted space despite the pressures of the younger generations pushing in. Elbowed by joggers, hedged in by cyclists, they make their daily odysseys to the supermarket and then retreat to the safety of their homes. As one of tens of thousands of college graduates moving to New York City in the 1970s, I was as oblivious as the next twenty-two-year-old to this segment of the population. A decade later, as a new mother in Brooklyn Heights, a neighborhood of brownstones facing Wall Street across the East River, I merely noted the number of people with aluminum walkers on the sidewalks as I maneuvered my child's stroller around them. A few years on, however, when I began volunteering to deliver meals to the housebound and got to know many of these people as individuals, I began to regret my past indifference.

Many liked to talk, and I found that I liked to listen. The octogenarian who had covered her walls with her own arresting paintings told me about the silent-film actress who had once lived at the nearby Bossert Hotel and ordered up a milk bath every day. The retired city councilman with the fierce gray eyebrows described the spectacular sunsets, enhanced by post-Depression factory fumes, that he had so enjoyed on his homeward walks over the Brooklyn Bridge. The chain-smoking former navy officer recalled the rich scent of chocolate that used to waft through the streets from a Fulton Street candy factory before World War II. I learned,

too, how the Brooklyn Dodgers got their name (Brooklyn residents were once called "trolley-dodgers" because of the many speeding trolley cars on the borough's streets); how a working-class girl could enjoy a free daily swim at the St. George Hotel's swank saltwater pool (all it took was a doctor's note); and what Irish-American children were told when they found an orange in their Christmas stocking ("Thank Mr. Tammany, not Santy Claus").

Most intriguing to me, however, were the references to a house that once stood at 7 Middagh Street (pronounced *mid*-daw), a short, narrow lane at the neighborhood's northeastern tip overlooking the former dockyards and, beyond, New York Harbor. The house had been rented, one neighbor told me, by a group of well-known young poets, novelists, composers, and artists the year before America entered World War II. Aware that enormous devastation lay ahead and determined to continue contributing to the culture as long as possible, they had created an environment for themselves to support and stimulate, inspire and protect — just a few blocks from where I lived.

When I learned that these residents included the poet W. H. Auden, the novelist Carson McCullers, the composer Benjamin Britten, Paul and Jane Bowles, and, of all people, the burlesque artist Gypsy Rose Lee — all under thirty-five but already near the apex of their careers — my interest was piqued even further. In a pictorial survey of Brooklyn's history, I found a photograph of the house — a small, shabby brick and brownstone structure with elaborate Tudor trim. The man who had signed the lease and organized this experiment in communal living turned out to have been George Davis, a fiction editor at *Harper's Bazaar* who had single-handedly revolutionized the role played by popular magazines in bringing serious literature and avant-garde ideas to the American masses. Davis was known for his attraction to the eccentric in culture, in entertainment, and in his choice of friends. With his encouragement, nights at the Middagh Street house became a fevered year-long party in which New York's artistic elite (Aaron Copland, George Balanchine, Louis Untermeyer, Janet Flanner, and Louise Dahl-Wolfe, among others) mingled with a flood of émigrés fleeing Nazi-occupied Europe, including the composer Kurt Weill and the singer Lotte Lenya, the artist Salvador Dalí and his wife, Gala, and the entire brilliant family of the Nobel Prize–winning novelist Thomas Mann. Days, however, were dedicated to their work — writing, composing, painting, and otherwise seeking new answers, new approaches to life in a collapsing world.

By the winter of 1940–41, 7 Middagh — called "February House" by the diarist Anaïs Nin because so many of its residents had been born in that month — had developed a reputation as the greatest artistic salon of the decade. Denis de Rougemont, the author of *Love in the Western World,* claimed that "all that was new in America in music, painting, or choreography emanated from that house, the only center of thought and art that I found in any large city in the country." Throughout the months of that suspenseful season, as Hitler's armies tightened their hold on Europe and killed or wounded thousands of British citizens in bombing raids, Thomas Mann's son Klaus labored in the Middagh Street dining room, assembling essays, poems, short stories, and reviews for *Decision,* a monthly "review of free culture," while upstairs in the parlor, the British émigrés Benjamin Britten and W. H. Auden worked together on an "American" opera that would express their hopes for and misgivings about their adopted country. On the third floor, McCullers agonized over the opening paragraphs of *The Member of the Wedding,* while in the room next door George Davis coached Gypsy on her own project, a comic burlesque mystery novel called *The G-String Murders.* Bowles, then a composer, wrote a ballet score in the cellar while his wife, Jane, did Auden's typing and wrote her own novel, *Two Serious Ladies.* Oliver Smith, destined to become one of Broadway's most prolific set designers and producers but then a destitute twenty-two-year-old, washed the dishes, tended the furnace, and, like many "youngest children," took on the role of family peacemaker. Auden, one of the greatest poets of his generation, served as housemaster to this lively household — which at one point included several circus performers and a chimpanzee — collecting the rent, dispensing romantic advice, playing word games with his housemates, and strictly enforcing nighttime curfews — all while laying the groundwork for some of the most courageous and original work of his career.

Perhaps inevitably, the intensity of life at 7 Middagh and the pressures created by the war in Europe led to physical and emotional breakdowns, domestic disputes, and creative crises. Even as the residents succumbed to the pressure of the times, so too did the United States. The attack on Pearl Harbor, on December 7, 1941, provoked America's entry into the fiercest and most destructive war in history — a six-year conflagration that killed fifty-five million people before it ended. As the artists of 7 Middagh Street had expected, they were scattered in all directions by these events. Some enlisted as soldiers. Others used their skills to create propaganda, conduct surveys, or entertain the troops. And, in the sweeping changes that took

place over the next half-decade, 7 Middagh Street itself disappeared, torn down to make way for the construction of the Brooklyn-Queens Expressway. Today, nothing remains but an unmarked stretch of sidewalk, a wire fence, and a precipitous drop to the lanes of traffic speeding from one borough to the next.

What does remain is the work these artists created. The final parts of Auden's book *The Double Man,* his poems "The Dark Years," "If I Could Tell You," "In Sickness and in Health," and the brilliant and innovative oratorio *For the Time Being,* were all completed during or inspired by the year at 7 Middagh. The twenty-seven-year-old Benjamin Britten gained both the artistic experience and the emotional growth necessary to create his first great opera, *Peter Grimes.* Carson McCullers's two final masterpieces, *The Member of the Wedding* and *The Ballad of the Sad Café,* were born in Brooklyn. Auden's support helped Jane Bowles take the first necessary steps toward completing her only serious novel, while Paul Bowles's jealousy over their relationship spurred him toward the writing of fiction for which he is now largely known. Even Gypsy's *G-String Murders,* written with the help of her admiring housemates, became a 1941 bestseller, establishing her reputation, not just as a stripper who could write, but as a writer who also knew how to keep an audience entranced.

Frequently, I go out of my way to pass the dead-end street where the house once stood just to remind myself that these extraordinary artists actually occupied the space I do now—living together, arguing, laughing, creating, and using their imaginations to increase others' awareness of the issues and choices laid bare in that horrible, horrifying time. *If we don't act now, when will we?* they asked themselves in choosing this shared creative life. *If we don't use our talents to find a new way to live, who will?*

How this houseful of geniuses answered those questions is the story my elderly neighbors wanted me to hear. But the questions themselves are what keep me coming back, dreaming of the house at 7 Middagh.

Part 1

The House on the Hill

All genuine poetry is in a sense the formation
of private spheres out of a public chaos.

— W. H. Auden

1

In the town there were two mutes, and they were
always together. Early every morning they would
come out from the house where they lived and
walk arm in arm down the street to work . . .

— Carson McCullers, *The Heart Is a Lonely Hunter,* 1940

Summer in New York City is never pleasant, as tempers rise with the
temperature and the noises, smells, and colors of Manhattan intensify in
the humid air. In June 1940, conditions were made worse by the alarming
state of world events. Hitler's troops had invaded Poland the previous
autumn, signaling the beginning of another European war. In April, fol-
lowing a tense seven months of promises and threats, the Nazis had in-
vaded Denmark and Norway, taking both countries in an astonishing
forty-eight hours. Holland fell in May, less than a week after its initial in-
vasion. Belgium and Luxembourg followed. As German troops moved
into parts of France, British forces scrambled to resist, but their efforts
proved too meager and far too late. By mid-June, after a disastrous rout
of ill-prepared British military forces at Dunkirk, the inconceivable oc-
curred. France fell, having resisted Hitler's onslaught for only ten days.
Paris, world symbol of democratic enlightenment, was now under Fascist
control. As the swastika was raised over the Arc de Triomphe, Churchill
stepped up the digging of bomb shelters in London.

The speed and efficiency with which the Nazis had extended their do-
main across Western Europe left the rest of the world stupefied. Every
day in New York that summer, new horrors appeared in the headlines:
Parisians were fleeing the city by the thousands, gunned down on the
roads by German planes. In some French villages, citizens disgusted by

their own corrupt government greeted Hitler's soldiers with flowers and applause. Newsreels provided images of German troops patrolling the muddy ghettos of Krakow. Radios screamed the news of the Soviet occupation of Lithuania, Estonia, and Latvia. And in the city, sailors and soldiers in uniform maneuvered for sidewalk space with hordes of Austrian, Czech, Polish, Danish, French, German, and Italian refugees.

Until that summer, it had been possible for Americans to tell themselves that the conflagration was just one more struggle in an endless succession among nations that would never get along, a struggle that had nothing to do with them. That conviction was less easy to maintain now that German U-boats were sinking ships in the Atlantic and Hitler had announced that Britain — the last country standing between Germany and the United States — was next in line for attack. Memories of the First World War, with its terrible cost in terms of human life and prosperity, were still fresh in most people's minds. Since then, the country had been preoccupied by the worst economic depression in its history. But a general desire to avoid further problems had begun to give way to a growing understanding that the evil force overtaking Europe could not be stopped through passive resistance, negotiation, economic sanctions, or any other nonviolent means.

As Europe appeared to be going up in flames that summer, heat flared from a different source in America. Sparked by innovations brought home from Paris in the 1920s, fueled by a decade of political foment and shattering economic hardship, American literature had achieved an astonishing new level of authority and power. In 1929, a year in which National Socialist Party members were assaulting Communists in the streets of Berlin, Thomas Wolfe's *Look Homeward, Angel* was published in the United States. In 1930, as the Reichstag elections increased the number of Nazi seats in the German government from twelve to one hundred seven, William Faulkner published *As I Lay Dying*. Erskine Caldwell's *God's Little Acre* appeared the same year in which Adolf Hitler became chancellor of Germany and the books of European authors were burned. When Poland fell to the German invaders, Americans were reading John Steinbeck's *Tortilla Flat* and *The Grapes of Wrath*. And in that terrible spring of 1940, as the great nations of Western Europe collapsed one after another, Richard Wright, the self-educated son of a black Mississippi sharecropper, published the saga of the black murderer Bigger Thomas in his first novel, *Native Son*.

Now, in June, as German troops breached the borders of France, the southern writer Carson McCullers's first novel, *The Heart Is a Lonely Hunter,* appeared — a work that would lead indirectly, through the relationship between the author and an editor in New York City, to the creation of a bridge between Europe's crumbling culture and the burgeoning artistic life in America. The novel told of four outcasts in a small southern town — Mick Kelly, a young girl who longed to compose music but lacked the education; Jake Blount, a frustrated political activist to whom no one would listen; Biff Brannon, a café owner who quietly pondered his patrons' lives; and Doctor Benedict Copeland, a Negro physician who railed against the system that victimized his patients. All four of these characters had been drawn into a friendship with a fifth misfit, a solitary deaf-mute named John Singer, who they believed understood them in profound ways that went beyond words. They failed to realize that Singer himself was grieving over the departure of his only friend, another mute who had been placed in an institution. This mutual misunderstanding — or spiritual deafness — would lead to a tragic end.

Within days of its publication, *The Heart Is a Lonely Hunter* became the literary sensation of the summer — not least due to the almost freakish youth of its gifted author. The literary critic Clifton Fadiman, writing for *The New Yorker,* called the novel a "sit-up-and-take-notice book for anyone to write, but that a round-faced, Dutch-bobbed girl of twenty-two should be its author simply makes hay of all literary rules and regulations." McCullers, he noted, "deals familiarly with matters no nice twenty-two-year-old girl is supposed to be an authority on, drunks, down-and-outers, poor Negroes, perverts, workingmen, and the wide, fearsome solitudes of the human heart." *The Heart Is a Lonely Hunter,* he concluded, was "a first novel that reads like a fifth . . . a story with an extraordinary obsessive quality, eerie and nightmarish, yet believable." Rose Feld added in the Sunday *New York Times* on June 16: "Maturity does not cover the quality of her work. It is something beyond that, something more akin to the vocation of pain to which a great poet is born."

It strained the imagination to believe that this tall, gawky, rail-thin southern girl, who had turned twenty-three in February but who looked no more than sixteen — a girl with little formal education who dressed in men's long-sleeved shirts with loose cuffs flapping, loose corduroy trousers, and chunky shoes — could have created what some were calling a work of genius. The novel's appearance sparked a buzz of curiosity. Who

was this girl and where did she come from? How did she write such an astonishing book? Who helped her? What else had she written, and was it for sale?

The young author herself, as self-conscious and shy as her photographs suggested, read the reviews of her novel in a dingy fifth-floor walk-up west of Greenwich Village, an apartment she and her husband, Reeves, had rented just days before. For Carson and Reeves McCullers, the spectacular success of *The Heart Is a Lonely Hunter* was as much of a shock as it was to everyone else. Until that month, they had been living in a miserable boardinghouse in Fayetteville, North Carolina, struggling to survive on Reeves's earnings as manager of the local branch of the Retail Credit Corporation so that Carson could write. "We had no other friends and were content to be alone," Carson would later write about that difficult period in their lives. Often, while awaiting the final $250 publication payment for her novel that would allow Reeves to quit his job and the couple to travel north, "we would just look at the parked cars with New York license plates and dream about the time when we, too, could go to the magic city." And yet now, only weeks later, when the two young Southerners walked hand in hand up Fifth Avenue in New York, it was photographs of Carson's own childlike face that gazed back at them from the bookshops' display windows, and it was Carson's name in the news.

Carson had lived in New York before. She had first arrived at age seventeen, pursuing her mother's dream for her to study piano at the Juilliard School. From before her birth in the small town of Columbus, Georgia, her mother had been convinced that her daughter was a genius, and for the first decade and a half of Carson's life it was assumed that her gifts would express themselves through music. Carson was a talented player, though perhaps not sufficiently gifted for the performance career her mother had planned. As it happened, after a bout of rheumatic fever, misdiagnosed and improperly treated, Carson no longer had the physical stamina for the professional life of a musician. It was fortunate that, at least as legend would have it, she lost her tuition money on the subway before she could enroll in her first music course. Instead, Carson settled for a series of day jobs in the city and night classes in creative writing at Columbia and New York universities. She worked hard and attracted the attention of the noted literary mentor Sylvia Chatfield Bates before ill health and lack of funds forced her to return to the South at age twenty. There, at her mother's house, she met and soon married twenty-

four-year-old James Reeves McCullers, an army clerk at nearby Fort Benning. "It was a shock, the shock of pure beauty, when I first saw him," she later recalled; "he was the best looking man I had ever seen." The bonds that truly united them, however, were a liberal political stance that distinguished them from most others in their southern milieu, a reverence for music and books, and a shared ambition to become great writers.

Those early years in New York had been very different from this summer of 1940. Back then, the gangly teenager with the faunlike gaze — known by her maiden name, Carson Smith — had been so terrified by the city that she spent entire days curled up with a book in a telephone booth at Macy's, the only place she felt safe. She made few friends aside from an occasional roommate and one or two girls in her college classes. Her part-time jobs left her feeling even more disoriented as she wandered lost through the outer boroughs, trying to deliver papers, or was reprimanded for reading Proust on the job. By the time she had found a congenial work situation — as a freelance dog walker, able to observe other New Yorkers without attracting notice herself — it was time to return home.

But now, all of that had changed. Carson had a new identity, having taken her husband's surname, and had gained new confidence through the completion of her novel. She had survived the rigors of the editorial process, despite what she considered "bizarre" changes (which she rejected for the most part) suggested by her highly respected editor, Robert Linscott. Perhaps most difficult of all, she had waited — a year longer than expected due to a misunderstanding of her contract — for the final publication payment so that she could return to New York. It was perhaps not surprising, therefore, that while Reeves could not stop exclaiming at the surreal quality of her sudden fame, Carson herself felt that certain private sense of inevitability and entitlement common to very young artists who achieve recognition with their first sustained effort.

All her life, after all, Carson had fled the monotony and narrow thinking of her southern childhood in favor of the grand landscapes of the world's great literature. Growing up, she was known for reading not just books but entire libraries. Other girls in bobby socks could hardly compete with Dostoevski, Tolstoy, Flaubert, Katherine Mansfield, and Thomas Wolfe. As a married woman, shunned by her neighbors for her aloof manner and her friendly relations with the local Negroes, it was these favorite authors to whom she turned in her imagination for solace

and advice. If now she felt, as years later Norman Mailer would also feel in his early twenties, "prominent and empty," with "a power over others not linked to anything [one] did, and a self not linked to anything [one] felt," this was only because she had not yet found the door through which to finally join her fellow writers, the people she felt she had always known. But the door existed — Carson was sure of that. And it existed somewhere in New York. Now that she had proven herself as an author, she would surely soon become a member of that illustrious inner circle.

And yet, for a brief period, not much happened. Her editor in Boston, with whom Carson had communicated only by mail, had not yet come to New York to meet her. Having returned to the city only recently herself, Carson was not particularly easy for interviewers, editors, or literary hostesses to find. In the southern tradition of calling on neighbors of similar social standing, Carson had naïvely written to a number of celebrities — including the actress Greta Garbo and the émigré activist Erika Mann, the eldest offspring of the author of *Buddenbrooks, The Magic Mountain,* and *Death in Venice,* Thomas Mann — requesting convenient times to visit. But it was too soon to expect a reply. Gradually, invitations would begin to filter in. But for a short time after the appearance of her novel, Carson and Reeves were suspended in a strange limbo between "before" and "after" the period when their lives were transformed — a stillness oddly similar to the pause in the nation at large that summer between its denial of the catastrophe taking place in Europe and its recognition of the need to take action.

While she waited, Carson went on the rambling walks in which she had indulged all her life, reacquainting herself with the city for which she had yearned so passionately in previous years, a city that was already changing in subtle ways that she did not yet understand. On the surface, daily life in Manhattan appeared much the same. As in previous summers, Carson wrote, the neighborhood children, "their faces shrill and delicate," raced through the narrow streets extending west toward the Hudson River, scrambling after balls and disappearing down flights of basement stairs. City trees still bloomed on the gray sidewalks, and the twilights in that season were "long and luminous and sweet." What changes there were were subtle, under the surface — changes "not of the waking mind, but of the myth." One noticed, for example, that after the fall of Paris, the loose cotton shirts and straw sandals of Mexico had become the new street fashion. Newspaper sales had grown more brisk, and the newsstands near the subway stations now collected crowds of readers.

Carson noted, walking through her own Italian neighborhood shortly after Italy had entered the war, that a small grocery store had hung a red, white, and blue sign reading I LOVE AMERICA across its screen door. "A woman stood behind the counter near the entrance," Carson observed. "Her hair, parted in the middle, was drawn back stiffly from her face, which was pale, angular, and rigid. She stood with her arms folded across her chest, the hands motionless and very white."

It was in the midst of this summer stillness, both private and public, that Carson received a message from George Davis, the fiction editor of the American fashion magazine *Harper's Bazaar*. Davis had read Carson's novel and was eager to discuss the publication of her work in his magazine. Might she be available to meet for a drink? He preferred to meet new authors at the Russian Tea Room in Midtown, but there was always the Village's Brevoort Hotel bar or even the White Horse Tavern near her home.

The invitation was disarmingly friendly from such a well-known editor at such an important magazine. Despite its focus on women's fashion, *Harper's Bazaar* had also developed a reputation as a publisher of important new literary fiction, and George Davis was considered one of the most innovative editors in the business. Carson had been disappointed when, as recently as the previous fall, Davis's office had rejected two of her stories, "Sucker" and "Court in the West Eighties" — as had the *Virginia Quarterly*, the *Ladies' Home Journal*, *Harper's*, the *Atlantic Monthly*, *The New Yorker*, *Redbook*, *Esquire*, *American Mercury*, the *North American Review*, the *Yale Review*, the *Southern Review*, and *Story*. It was gratifying to be wooed by this editor now that she was a success.

If Carson had expected George Davis to resemble in any way her respectable editor from Boston, he disabused her of that notion from the moment he entered the bar. The same height as Carson though significantly pudgier, thirty-four-year-old George liked to dress in his friends' castoffs or thrift shop bargains — eccentric ensembles often set off with a bright Parisian scarf that trailed behind as he slid, catlike, across a room. His green-eyed gaze, couched in the face of a matinee idol just beginning to go to seed, could size up a public space in an instant, focusing on his prey as his lips slid into a sardonic grin. Known throughout the literary set for his practical approach to writers' needs, George made a point of ordering the best food and drink that *Harper's Bazaar* could buy for himself and his author and then settled down to seduce.

It was to be a pleasurable process, because in fact George considered

The Heart Is a Lonely Hunter one of the best novels he had read in years
— one that had affected him on a profound emotional level even as he
admired its style. In his low-pitched, mellifluous voice, George told Car-
son how moved he had been by her depiction of a rural life that he, too,
had experienced growing up in the small, slow farming community of
Clinton, Michigan. Like her protagonist, the young Mick Kelly, George
had wandered among the back fields and mysterious alleys of his home-
town, and like the deaf-mute, John Singer, he had known what it was like
to feel different from the others, derided and misunderstood. Perhaps the
most affecting character for George, however, was Benedict Copeland,
the hard-working Negro doctor who deplored the tragedy of his patients'
lives as he improvised skin grafts on burn victims and treated syphilitic
children in crowded two-room shacks. George's father, too, had been a
country doctor, and so he had grown up hearing stories of babies deliv-
ered on kitchen tables, of the boy who fell into a vat of boiling oil, and of
the abandoned urchin who died from a kick in the stomach by a rich
man's horse.

At the end of the First World War, George's family had moved to De-
troit, where his father had helped treat many of the tens of thousands of
victims of the Great Influenza Epidemic — a scourge that left coffins
lined up along the streets for the gravediggers to collect, until the city ran
out of coffins. George had been left alone to haunt the libraries and
movie theaters and, as he grew older, to explore the back alleys of De-
troit's Greektown, a seedy district whose Prohibition "coffee houses" fea-
tured, in Davis's words, "a marvellous swamp in sinister frondescence"
with the sexually ambiguous Miss Elsie Ferguson on the piano, Miss
Dixie dancing to the Prayer of the Moon Virgin, and command perfor-
mances by Mother Fannie Starr, the Toledo Camp, the Awful Mrs. Eaton,
and an assortment of "mysterious apparitions, anonymous madams
from hell."

And that, naturally, George told Carson, had been only the beginning.
With the help of a lonely French sister-in-law brought back from the war,
he had learned to speak fluent French by the time he finished high
school. After a few odd jobs in the bookshops and steel mills of Detroit
and Chicago, he had fled to Paris in time to enjoy the final few years of
the 1920s' expatriate literary revelry. As luck would have it, George's up-
stairs neighbors at the Hôtel Saint-Germain-des-Prés were none other
than the thirty-five-year-old *New Yorker* columnist Janet Flanner (who
wrote her "Letter from Paris" column under the name "Genêt") and her

olive-skinned, exotic-looking lover, Solita Solano (née Sarah Wilkinson of Troy, New York). With these two black-suited, white-gloved, wildly eccentric American women in charge, George, at twenty-one, soon found himself in the center of literary Paris, sharing bottles of *vin ordinaire* with Ernest Hemingway, F. Scott Fitzgerald, Katherine Anne Porter, Djuna Barnes, the Irish writer James Stern, the British novelist Ford Madox Ford, the historian George Dangerfield, and the midwestern novelist Glenway Wescott. The shipping heiress Nancy Cunard, who owned the Hours Press, was also part of this circle, along with her lover, Louis Aragon, who was editing *La Revolution Surrealiste,* and Margaret Anderson, the editor of the *Little Review,* a "Magazine of the Arts" whose motto, printed on the cover of each issue, read: "MAKING NO COMPROMISE WITH THE PUBLIC TASTE."

With his excellent French, George soon gained entrée into Parisian groups as well — getting to know Jean Cocteau, who was then completing his novel *Les Infants Terribles* and an opera with Stravinsky, *Oedipus-Rex,* and the mischievous, cherub-faced artist Christian Bérard, whose neoromantic paintings of fashionable French women had inspired the designs of Elsa Schiaparelli and Christian Dior. For a while George became Bérard's closest friend, visiting his studio, where the pair pawed through old American movie magazines together, and roaming the city, where they could indulge their shared appreciation for "the whole comedy of the bar and the street." Both Bérard and Cocteau were addicted to opium, and George, in his provincialism, became fascinated by the "convoluted quiets, delicious fears of discovery, flatteringly harsh demands on the purse," associated with their habit. Though not attracted to the drug himself, George had often sat with Bérard as he smoked, "his pipes and lamp not fastidiously arranged but hauled from under the bed on a messy breakfast tray," or watched him sleep off the effects in his hotel room.

Of course, all of them — the Americans, at least — were as poor as it was possible to be, George assured Carson, who listened in amazement to this first of what she would soon learn was just another of George Davis's typically endless and captivating monologues. The rooms of their Parisian *pensions* were always freezing. Whoever had received an advance that month bought food and drinks for the rest. George recalled one night when, unable to afford a hotel room, he had stumbled through the narrow streets to a shop where another friend, the twenty-eight-year-old poet and freethinker Kay Boyle, sold hand-sewn Greek-inspired dance

tunics for Isadora Duncan's brother, Raymond. Boyle, who was writing a novel on the backs of envelopes when not tending customers, took George in, and the two spent the night side by side on the floor of the shop, with George wrapped in a Greek tunic to keep warm.

And, of course, like everyone else in Paris in the 1920s, George had written a novel. Originally calling it "Like Brown's Cows," later "Mere Oblivion," he intended for it to unmask, once and for all, the hypocrisy and tragedy of midwestern middle-class life. The completed novel, published by Harper Brothers as *The Opening of a Door*, was notable more for its exquisite style and use of language than for its strength of plot or even original content. Yet, to everyone's surprise — George Davis's most of all — it became one of the most critically acclaimed American novels of 1931. Clifton Fadiman, the same critic who had hailed Carson McCullers's novel in *The New Yorker*, had written that year in the *Nation*, "The most important fact about this first novel is that it was written by a young man of twenty-four. The smoothness of the prose, the unity of the tone, the author's calm refusal to pose any difficulties of whose solution he is not wholly confident: these are all the marks of a practiced craftsman. 'The Opening of a Door' is one of the most unfirstish first novels I have ever read. It is difficult to believe it the work of one so young."

And so George Davis understood precisely the situation in which Carson McCullers found herself that summer. Like Carson, he had seen his name trumpeted in *The New Yorker* and the *New York Times Book Review* as a great new voice in American literature. He had read reports of his novel's phenomenal sales across the country as one printing after another was consumed. He had been photographed by Man Ray, flattered in the gossip columns of the *New York Herald Tribune,* and eagerly discussed in the women's book clubs and discussion groups of the very midwestern society he had so effectively satirized in his book. To his astonishment, George had even been named in print as one of the ten people who "might bring back to life the cadaver of civilization" — along with Mrs. Franklin D. Roosevelt, General Electric's Owen D. Young, and the composer George Gershwin. George Davis understood, too, how ridiculous such honors were in the light of that one reward that a true writer longs for above all others — to be welcomed by the select group of authors and other creative artists whom one has admired anonymously for years. "They included me *in,* an in of healing, instructive enchantment," he later wrote of the fashionable Paris intelligentsia who soon became his friends — André Gide, André Maurois, Paul Eluard, André

Breton, Bertolt Brecht's collaborator Kurt Weill and his cabaret singer wife, the sultry Lotte Lenya, the choreographer George Balanchine, the neo-Romantic Russian painter Pavel Tchelitchew and the surrealist Salvador Dalí. Despite "the early hurts and repressions that made me so often feel a dullard, an impostor, in their company," these sublimely creative, intelligent human beings had accepted George Davis of Clinton, Michigan, and made him one of them.

It was a remarkable story for Carson McCullers to hear that summer as she experienced her own first success. As an adolescent, she had read *My Life,* Isadora Duncan's autobiography, and had begged her father to allow her to go to Paris to become a dancer. More recently, an adult acquaintance in Columbus had inspired her with accounts of a brief sojourn on Paris's Left Bank, and Carson had decided that someday she and Reeves would live and write in Paris. Now, at the very moment that Paris had fallen to the Fascists, here was someone with a background not unlike her own who had experienced precisely that form of communion.

Carson responded with such enthusiasm to George's stories that the two soon became constant companions, finding that they had much more in common than either might have suspected. Not only were they both American romantics, voracious readers steeped in the mysteries of their lonely rural childhoods, but they also shared a gothic sense of humor and a taste for the unconventional, even the bizarre. Like Carson, George had been fascinated by the ramshackle carnivals that had passed through his midwestern hometown — particularly by the sideshows featuring hermaphrodites, midgets, and Siamese twins, whose sad isolation symbolized, for both of them, the essential alienation they had always felt as sensitive observers in rough, unforgiving surroundings. In Europe, George told Carson, he had visited a number of family circuses traveling through the countryside and was fascinated to find giants and bearded ladies setting up housekeeping just like couples in the Midwest. He showed her his treasured collection of photographs of carnival performers and took her to the sideshow on Brooklyn's Coney Island, where he had befriended a pair of pinheads and a number of other performers. Carson stared in fear and awe at these outsiders, torn between a desire to join them and an urge to run away, but George made every effort to turn them into insiders — to invite them into his world and help them to feel at home.

Wherever George Davis went, he made friends. Forced to leave Paris at

twenty-seven, having squandered the advance on his never-completed second novel, he arrived in mid-Depression New York determined to maintain the Parisian philosophy that "all life is theatre, be it tragedy or comedy," and that it is a "magnificent kind of courtesy toward other people, to have one's personal life, one's thoughts and emotions, so under control that all of it can be transcended, interpreted, acted out." By then, George had become a master at the art of intimate conversation, engaging perfect strangers in long, intricate accounts of his latest sexual adventures until they felt compelled to confide their own secrets in return. Nothing that happened to George was ever too shocking, depressing, or silly not to be woven into a mesmerizing story, imbued with a mixture of perceptiveness and humor that was peculiarly his and recreated with the dramatic gestures and expressions of a born actor. By the end of his first year in New York, burlesque dancers and bartenders on the Bowery greeted him like royalty, according to one longtime friend. Socialites and fashion mavens adored him for his wit and sensitivity. His folksy, rocking chair manner and basic generosity disarmed the surliest shopkeepers and office assistants. Moving easily from the seedy environs of the Bucket of Blood, a bar in Brooklyn frequented by sailors and transvestites, to the parlors and dining rooms of Park Avenue heiresses, university professors, and Broadway stars, George soon began publishing humorous essays and short stories in *Vanity Fair* and similar magazines based on the people he befriended.

Meanwhile, George's own well-placed *bons mots* were making the rounds. There was the time at Drossie's, a cheap downtown cafeteria frequented by the Village's more outlandish characters, when George witnessed a spat between the Scottish poet Allan Ross MacDougal, then a secretary to the filmmaker Ben Hecht, and another diner who was also a writer. As the two exchanged insults across their separate tables, MacDougal taunted his competitor, "At least I have a job, which is more than you have." The other writer retorted, "Ass-kissing is not a job, it's an attitude," and abruptly yanked the cloth from MacDougal's table, sending his dinner splattering to the floor. A shocked silence ensued, broken only when George murmured pleasantly, "On the contrary, ass-kissing *is* a full-time job."

And then there was the time that the opulently feline artist Eugene MacCown, elegant in a leopard jacket and purring with newfound wealth, showed his friends around his renovated apartment, only to hear George remark as they entered the gleaming new bathroom, "Shouldn't

you have had a sandbox put in instead?" And some time later, when an unfriendly associate happened upon George and a dozen male friends dining in an uptown restaurant and remarked, "My word, it's the Last Supper." George retorted mildly, "Yes, now that Judas has arrived."

Such remarks had won George Davis an enviable reputation in literary circles. By 1936 the poet MacDougal's employer, Ben Hecht, had begun calling George "the funniest man in America" and fetching him by limousine to perform at his dinner parties. Another friend, the film star Marion Davies, thought at about that time to suggest to her lover William Randolph Hearst that a place be found for George on one of Hearst's magazines. George's novel was sent for review to Carmel Snow, the new editor in chief of Hearst's fashion magazine, *Harper's Bazaar*. Snow, a hard-nosed, hard-drinking veteran of *Vogue*, had already hired as art director Alexey Brodovitch, a former set designer for Diaghilev's Ballet Russe in Paris who had transformed the look of the dowdy magazine with bold, arresting cover illustrations by the art deco graphic designer A. M. Cassandre and interior art by Man Ray, Henri Cartier-Bresson, George Grosz, and Salvador Dalí. Next, Snow had discovered the socialite Diana Vreeland dancing at the St. Regis in a white lace Chanel dress and bolero with roses in her hair, and persuaded her to take on the job of fashion editor despite her protestations that she had never even visited an office before. George came next, his novel having met with Snow's approval. With his three dynamic colleagues, George had proceeded to make journalistic history as, out of sheer enthusiasm, they introduced Middle America to the best of European and American art, literature, fashion, and ideas.

While Brodovitch found ways to tie together the magazine's various departments in ways that had not been done before — creating, for example, a "Surrealism Issue" that featured surrealistic art, essays, and fashion photographs and covered the Surrealist Exhibition at the Museum of Modern Art — Vreeland introduced her "Why Don't You?" column, challenging American readers to inject some playful originality into their lives by wearing "violet velvet mittens with everything" or giving a friend "an enormous white handkerchief-linen tablecloth" with favorite sayings embroidered in "black, acid green, pink, scarlet and pale blue." While innovative photographers such as Louise Dahl-Wolfe abolished traditional studio portraits in favor of fashion shoots in exotic locales, George tossed out his predecessor's humdrum stories, addressing "the feelings and problems of America's young women," and began publishing truly

modern work by Jean Cocteau, Colette, John Cheever, Dawn Powell, Antoine de Saint-Exupéry, Gertrude Stein, Elizabeth Bishop, and many others.

Soon, *Harper's Bazaar* became known as an exciting if somewhat eccentric home for new fiction; it was more willing than *The New Yorker* to take risks with its content and able to pay top dollar for talent. And George, to his own surprise, had discovered that he liked editing. Not only did his job allow him to indulge his perfectionist tendencies toward language — and to lunch out on the company's tab — but he now was able to funnel both money and publicity to those of his artist friends most in need of a boost. In 1937, George talked Carmel Snow into sending him to London, where in the space of a few days he managed to sign up the British literary lions Virginia and Leonard Woolf and Edith and Osbert Sitwell, as well as the young and fashionable novelist Christopher Isherwood and the poets Stephen Spender and W. H. Auden. None of these writers would have considered selling their work to a fashion magazine in England, but they were so impressed by George's literary credentials, charmed by his personality and humor, and intrigued by the terms of the magazine's contracts that they agreed. Publication in the American magazine was "as pleasing as it was unexpected," Auden later wrote, "because though at first it seemed rather odd to find one's words wedged between advertisements for bras or deodorants (one of the latter, I remember, ran, 'It's always April underneath your arms'), we had never been paid so much in our lives."

Thanks to George, Isherwood's short story "Sally Bowles" — quite a scandalous tale in 1938 — shocked readers across America. It was part of Isherwood's new book, *Good-Bye to Berlin,* a lightly fictionalized record of his years in Weimar Germany, joined at times by his friends Wystan Auden and Stephen Spender — a book that would eventually become the play *I Am a Camera* and the film *Cabaret.* Davis had met Isherwood and Auden in London just weeks before their departure for China to write a kind of travel diary in prose and verse as they observed China's recently resumed conflict with Japan. After arranging to publish an excerpt from the book, to be called *Journey to a War,* Davis urged the two writers to stop by New York for a visit on their way back to England. Isherwood and Auden liked the idea, and in late June of 1938, having arrived in Vancouver from China, they took a cross-country train to New York.

"We ought to be wearing togas," Auden said, eyeing the marble columns and vast spaces of New York's Pennsylvania Station. But there was

no time for further comment because George Davis was approaching them on the platform. Greeting them with great enthusiasm and stuffing their pockets with what appeared to be enormous wads of cash as advance payment for their book excerpt, George proceeded to take the writers on a frantic, fantastic sightseeing tour of the city. "We shot up and down skyscrapers, in and out of parties and brothels, saw a fight in a Bowery dive, heard [the jazz singer] Maxine Sullivan sing in Harlem, went to Coney Island on July the Fourth," Isherwood wrote in his diary. George introduced them to the playwright Maxwell Anderson, to Lotte Lenya, who had by then come to America, to the dance impresario and arts patron Lincoln Kirstein, the literary hostess Muriel Draper, and the young filmmaker Orson Welles. George seemed determined to make the two writers feel that New York was a performance staged especially for them, Isherwood later wrote, and that everyone in the city had been yearning for their arrival. Determined to prove that New York was not only the most exciting city in the world but the most romantic, George offered to provide each writer with whatever partner he desired. "All right," Isherwood responded, half-joking, "I want to meet a beautiful blond boy, about eighteen, intelligent, with very sexy legs." Instantly, such a boy was produced, and Isherwood was sufficiently entranced to maintain contact with him after he returned to England.

As such a high level of activity would have proved impossible to sustain for the length of their nine-day visit under normal circumstances, Davis supplied Auden and Isherwood with Benzedrine tablets to get them going in the morning, Seconal at night to help them sleep, and alcohol to enhance their experience all day long. All three substances were legal at the time, and Auden was impressed by how efficiently they got him out of bed in the morning and to sleep at night. He listened with interest, as well, to George's enthusiastic accounts of how easy it was for a writer to live off the proceeds of his work in New York, as opposed to London, and his promise that if they moved to America he would help place their stories and poems in his own and other magazines. With his seemingly infinite capacity for entertainment and fun, George "was a marvelous companion and guide," Isherwood wrote. "It was very largely due to him that we both fell madly in love with America, and decided to return the first moment we could."

That was in 1938. Two years later, when George Davis met Carson McCullers, he was able to give his new friend an equally thrilling tour.

Though he still spent much of his free time on the Bowery, befriending such performers as Tugboat Ethel and Bilious Margaret, former Society Deb, he had also gathered around him the very members of New York's higher literary echelon whom Carson longed to join. By 1940, both Isherwood and Auden had achieved their goal of moving to America; while Isherwood had since gone on to Hollywood to work for the film studios, Auden lingered in New York. That summer, Carson was introduced to the English poet who, at thirty, had been awarded the Gold Medal for Poetry by King George VI. Now thirty-four, Auden was widely considered the best living poet writing in the English language, and he commanded an imitative cult following among the younger literary generation that was the despair of college professors everywhere. Meeting him, Carson felt buoyed by the same sense of unreality that had sustained her through the ecstatic response to her novel, so she was able to feel instantly at home in the presence of the tall, tow-haired, chain-smoking poet. Despite their mutually incomprehensible accents (Carson would forever mispronounce Auden's first name "Winston"), contrasting backgrounds, and opposing opinions on many literary works, the two quickly settled into a teacher-student relationship that both enjoyed.

Erika Mann had been kind enough to respond to Carson's request to talk with her about the émigré experience — material Carson claimed she needed for a new novel-in-progress — and had arranged to meet her. By this time, Carson had had a similar encounter with Greta Garbo, only to find that she and the actress had little to say to each other. But Carson discovered that Auden and George Davis knew Erika and her younger brother, Klaus, quite well. Klaus and George had met in Paris in the late 1920s, and Auden had met Erika through Isherwood, who had come to know her in the cabarets of 1930s Berlin. Since then the two siblings, now thirty-three and thirty-four, had been exiled from Germany and had drifted from Vienna to Paris to Prague to Amsterdam to New York along with thousands of other wandering émigrés, "wearing out our passports quicker than our shoes," in Brecht's memorable words. In 1935, when Erika was threatened with the loss of her German citizenship for having created *The Pepper Mill*, a popular cabaret revue satirizing the Nazi regime, she appealed to Isherwood to marry her so that she could obtain a British passport. Isherwood too strongly loathed bourgeois society to join it through even a sham marriage, but he referred Erika to Auden, who agreed to become her husband sight unseen. The couple met shortly before their wedding, and while they never lived together as man and

wife, each preferring partners of their own sex, they became friends during their time in New York.

When Carson sold her first story at the age of nineteen, she had spent part of the $25 payment on a copy of Thomas Mann's new *Stories of Three Decades*. Now, in 1940, it was a thrill to meet the Mann siblings and their friends, many of whom had recently fled the horrors of Europe and had urgent stories to tell. In Fayetteville, she and Reeves had listened to the news from Europe with growing alarm but had felt virtually alone in their anxiety, surrounded by ignorance and apathy. Here, however, Erika Mann, a strikingly handsome, charismatic actor and writer known for her political passion and intellectual confidence, was already making plans to rescue the hundreds of artists, political dissidents, and other enemies of the Reich who had fled Nazi-occupied northern France and were trapped in the unoccupied southern part of the country around Marseilles. The Nazis, Mann explained to Carson, had a list of enemies whom they intended to eliminate one by one. The Emergency Rescue Committee that she was helping to create must therefore compile its own list of all the European artists and intellectuals who required rescuing. The group would then send representatives to Europe to find the fugitives, secure passports and American visas for them, and smuggle them over the border into Spain.

Among those missing were Erika and Klaus's younger brother, the historian Angelus Gottfried ("Golo") Mann, who had served as an ambulance driver for the French forces until he was captured, and their uncle Heinrich, a popular writer and politician whose anti-Nazi stance had caused his books to be burned and banned. But the Mann siblings appeared as concerned about the intellectuals they did not know personally as they were about their own relatives. Even Klaus, ordinarily less passionate than his sister and something of a dilettante by nature, had been moved by Hitler's methodical campaign against free expression to organize resistance efforts, tour America to lecture on the situation in Europe, and write several books decrying the evils of fascism wherever it was found. Every artist *must* take a stand, he insisted to Carson in his heavily accented English. This was not simply a conflict between nations. The future of Western culture itself was at stake.

To that end, Klaus had recently embarked on a new project to complement Erika's rescue operation: the creation of a literary journal in New York committed to opening a dialogue between émigré artists, who could "warn an unaware and drowsy world" of the dangers spreading

across Europe, and Americans artists, who would respond with their own views. Such a periodical would serve as a bridge of communication between the two cultures.

Carson was as captivated by Klaus's plans as she was attracted to his air of moody, German romanticism. Klaus Mann had enjoyed a successful literary career in Berlin and was now attempting to write fiction in English in the United States, so he enjoyed talking about books with Carson. By the end of June, he had read *The Heart Is a Lonely Hunter,* describing it in his journal as "very arresting, in parts. An abysmal sadness, but remarkably devoid of sentimentality," and Carson herself as "a strange mixture of refinement and wildness, 'morbidezza' and 'naivete,'" and, in a way, herself a spiritual outsider, another kind of émigré.

Reeves McCullers sometimes accompanied Carson on her visits to this new circle of friends, all of whom appreciated his genial southern manners, good looks, and ability to tell a good story. Like Carson, he felt honored and excited to be included in their activities. But he was less than delighted when Carson developed an infatuation for Erika Mann's friend, the thirty-two-year-old Swiss novelist and photographer Annemarie Clarac-Schwarzenbach.

"She had a face that I knew would haunt me for the rest of my life," Carson later wrote about Annemarie. The daughter of a well-to-do Swiss silk merchant, with a slim build, short blond hair, and sad, sensitive expression, Annemarie was well known for her beauty. Dressed in couture ensembles supplied by her lover, the Baronessa Margot von Opel, the wife of the German automobile manufacturer, she inevitably appeared glamorous and sophisticated to Carson, but it was perhaps her highly androgynous appearance and personality that drew the young writer most strongly. Carson soon learned that, like herself, Annemarie had felt herself to be "like a boy" from early childhood, and she had dressed and been treated as a boy by her family. Both women had excelled at the piano as well, and both had enjoyed critical success with the publication of a novel at the age of twenty-three.

For Carson, these discoveries were not simply the happy coincidences of a new friendship but a means of connection, a signal that she had found a door into the desired larger world at last and, in Annemarie, a spiritual twin. In her confused excitement that summer, Carson found even Annemarie's addiction to morphine romantic, as well as her profound depression over the events in Europe and her unhappy relationship with the baronessa.

Annemarie did not return Carson's enthusiasm. She was accustomed to being pursued and, while she was fond of this American girl, she found Carson's obsession with her rather alarming. She did what she could to discourage Carson, refusing most of her frequent invitations and extended favors.

Reeves witnessed Carson's infatuation with increasing distress. He correctly perceived her yearning for Annemarie as an expression of her desire to leave her past behind. Carson's introduction into this circle had opened not only new intellectual vistas but new sexual and emotional possibilities as well, possibilities that threatened to exclude him.

Even back in Fayetteville, there had been increasing tensions in their marriage as Reeves worked at a job he disliked to support Carson while she wrote. When they first married, the couple agreed to alternate, year by year, the responsibility of supporting the two of them, with Reeves taking the first turn at a job. "It was going to be a marriage of love and writing for both of us," Carson recalled.

But by the end of the first year Carson had a publishing contract and was thereby obligated to keep writing, and at the end of the second year they agreed that it made more sense for her to continue with what was becoming a successful career. Now, with their fourth year of marriage approaching, Reeves sensed the passing of his own chance to become a successful novelist. He knew, too, that it was Carson's nature to discount whatever she already had in favor of the shining object just out of reach. As she wrote in an early short story, "Sucker," "There is one thing I have learned, but it makes me feel guilty and is hard to figure out. If a person admires you a lot you despise him and don't care — and it is the person who doesn't notice you that you are apt to admire."

Unemployed, at loose ends, and envious of the opportunities opening up for Carson, the twenty-seven-year-old drowned his bitterness in alcohol, leaving the house for the bars in the morning and stumbling back home to lie in bed and read. Meanwhile, Carson tried to concentrate on her writing. The success of her first novel had increased the pressure to write a second masterpiece. Yet, though she had dabbled with at least two ideas — the one she had discussed with Erika about a friendship between a Jewish refugee and a black man in the South, and another evoking the emotional life of an adolescent girl in Georgia — nothing much had emerged. And now it was July, and the apartment was hot, and Carson found the stagnant air and Reeves's drunken presence unbearable.

Carson had her own memories of her marriage to Reeves — memories

that now seemed to foretell their current situation. She remembered, for instance, that on their wedding night she and Reeves had lain in bed together, sharing a box of candy. Much later that night, Carson had awakened to find Reeves wolfing down the rest of the candy in secret, without sharing it with her. To Carson, his urge to consume the candy offered early evidence of the greed and laziness that now led to his desire for the fruits of her success without having done any creative work himself. It seemed to Carson that her husband would never be happy until he had stolen more than his share of her happiness. And as long as she felt that way about him, she couldn't focus on her work.

Carson began calling George Davis at home to confide her troubles. He listened sympathetically, but he also understood that part of Carson's emotional volatility had much to do with the sudden changes in her life. Looking for a solution, he suggested that she work on something else for a while, something easier to finish. When he had first contacted Carson, it was in hope of acquiring a short story or essay from her. Was there anything among her papers that they might work on together and publish in *Harper's Bazaar*? Carson invited George to climb the steps to her fifth-floor rooms and rummage through her trunk filled with papers. He soon came across an entire novella that she claimed to have completely forgotten. Called "Army Post," it was based on a story Reeves had told her about an enlisted man at the Fort Bragg Army Base, near Fayetteville, who had been arrested for voyeurism. The tale began with a deceptively simple line, "An army post in peacetime is a dull place. Things happen, but then they happen over and over again." It then proceeded, step by quiet step, to relate a gothic tale of repressed sexuality and madness played out in a complex series of relationships among a repressed homosexual army officer, his sensual wife, a philandering fellow officer and his own disturbed and introverted wife, and the driven young enlisted man who forces their private fantasies out into the open.

The novella, featuring as it did the birth of a deformed infant, the torture of a stallion, a murder, and an army wife's self-mutilation, in no way resembled the lyrical novel that had brought Carson fame. Its power was of another order altogether, classic and stark as a Greek tragedy. Yet Carson insisted that she had sketched it out quickly as a relaxing exercise after the hard work of completing her novel. George considered the results stunningly effective in a writer so young. Offering Carson a contract for $500 — the same amount she had been paid for the publication of her

novel — he arranged to work with her on the revisions at his office each morning to give her some time away from Reeves.

Only an editor brought up on the *Little Review*'s motto, "Making no compromise with the public taste," would dare to publish a story so bizarre in a women's fashion magazine in 1940, no matter how sophisticated the magazine claimed to be. But George had absorbed the basics of promotion at the feet of the French masters of spectacle, Christian Bérard and Jean Cocteau. Scandal and controversy, he had learned and still believed, not only sold magazines but, when it concerned literature, created new readers. It was the furor raised by stories like this one that kept the publishing industry's blood circulating and writers like Carson in the public eye.

Carson was surprised to find that despite his wild lifestyle and well-known eccentricities, George approached his work with complete seriousness. During their morning sessions, he proved to be at least as gifted an editor as he was a raconteur. It was a revelation to Carson to observe his sensitivity to the rhythm and structure of prose, his "unslakable love of words and their correct usage," and the patience with which he questioned her about a character's motivation or worked with her on a passage or a page over and over until she got it right. This demonstrated respect for the prime importance of literature, and the spiritual life it expressed was another part of the "inner circle" experience for which Carson had yearned.

Their morning sessions were satisfying for another reason as well. Carson loved spending time in the atmosphere of "slick nuttiness" that prevailed at *Harper's Bazaar*. Fashion mavens, photographers, designers, writers, and editors — all "indelibly entwined," as one staff member described them — constantly invaded one another's offices, exchanging jokes, weeping over romantic tragedies, and otherwise getting through the day together. While George was off overseeing the efforts of his assistant, a hard-working young woman Carson's age named Frankie Abbe, to whip up a few paragraphs on "How Young People Live Today," Carson might spot Diana Vreeland striding down the hall, trailing her minions and spouting such instant classics as, "We all need a splash of bad taste — it's hearty, it's healthy, it's physical. I think we could use *more* of it. *No* taste is what I'm against." If there was more hysteria in the atmosphere than usual that summer, it was understandable as the Paris couture shows had vanished, and no one knew what would fill September's Fall

Fashions issue. Meanwhile, the news from Europe was getting worse. In mid-July, Hitler launched an operation to land twenty German divisions on the southern coast of Britain. Rumors flew among the staff, a number of whom were émigrés, that this famous novelist or that well-known physicist had been captured by the Nazis, had escaped, or had been beheaded — no one knew which — and that the bombing of London would begin that week. The worse the news got, the more restless the atmosphere became at the magazine.

After their sessions, George and Carson frequently went out for lunch and drinks — the alcohol increasing in proportion to the food as the days grew steadily hotter. George was always eager to expand on the details of his great, tumultuous love affair, carried on mostly by post for the past nine years, with the French sailor Edouard, whom he had first met in Paris at the height of his writing success. Handsome but inconstant, Edouard showed a tendency to express his affection when he was most short of funds, then vanish once his pockets were replenished. The two had reunited twice during George's trips to Europe, only to argue furiously and part in anger — then to reconcile by mail. George had done his best to bring Edouard to America after the outbreak of the war in Poland, but the sailor had delayed, and now, as France succumbed, no more news arrived.

It was not, in fact, as much a tragedy as it seemed after a few drinks, since George was happy to console himself with the sailors, stevedores, and other strong young men loitering around the parks and dockyards of New York. It seemed as though George preferred telling the story of his romance — embellishing the facts as needed — to actually living it. Others might have found it off-putting to hear him tell, in his confidential purr, of the time he picked up a sailor in Montmartre, accompanied him to his lodgings, and was halfway through the act of lovemaking when he realized that they were performing before a one-way mirror, on the other side of which was gathered an appreciative audience. But Carson merely sipped her sherry and countered with a story of her own — not as shocking as George's perhaps, but a healthy start in the process of self-mythologizing in which both took such pleasure. George could soon picture almost as clearly as Carson the mahogany fixtures, French wallpaper, and polished antiques in her father's jewelry shop in Columbus, as well as the bleak slum near the river that had so frightened her as a child.

All through that summer they held hands across the table at restaurants, met for stingers in Greenwich Village, and relaxed in George's

apartment — crammed full of such prized examples of Victorian gothic as velvet settees framed with bulls' horns, pious porcelain vases in the shape of a woman's hands, and framed, hand-tinted nineteenth-century Valentines adorned with sentimental verse — talking for hours at a stretch with no subject or idea, however world-encompassing or embarrassingly personal, excluded. Occasionally, on stifling weekends, George took Carson along to his friends' country retreats. Lotte Lenya, George's old friend from Paris, enjoyed playing hostess at her cottage less than an hour from the city while her husband, Kurt Weill, was working with Ira Gershwin and Moss Hart on their new musical, *Lady in the Dark*.

It was always fun to gossip with George about the theater, to listen to his long, loopy conversations with Carson, in which the younger writer called him "honey" and "George, precious" in her slow southern drawl while he patted her on the arm. Lenya, who had grown up poor and largely self educated in Vienna, loved to read, though her tastes were eclectic, and she freely admitted that she most loved what she called trash. She felt a sympathy for Carson, so young but a fellow artist, and admired George's generosity in acting as her mentor and friend. The serious literary conversation, however, never withstood the heavy drinking for long. On more than one afternoon Lenya's two guests "sipped their way to either a giggling incoherence or a taciturn withdrawal that was practically a summer snooze." Lenya would then serve hot dogs and refill the glasses of iced tea, leaving plenty of room in Carson's glass for her customary sherry or gin.

The pair also visited Janet Flanner, who had fled from Paris and was now writing her *New Yorker* column at the ramshackle Tumble Inn in Croton-on-Hudson. Flanner, now in her late forties, had been struggling for some time with a difficult profile of Thomas Mann, and she was glad to vent her frustrations to someone new. She and Solita both fully enjoyed young Carson, so full of what Flanner termed the "energy of affection." They treated her with the same generosity they had shown George a decade earlier — entertaining her with stories of their life in Paris (while Solita wept with George over the city's demise), advising her on her career (both of them had published first novels, and neither had completed a second), and telling her in no uncertain terms to "face facts" and forget about Annemarie.

These outings failed to distract Carson from her worries, however, as a phenomenal heat wave descended, making life even more unbearable. The heat was so appalling that tens of thousands of New Yorkers fled to

Coney Island, turning its beach into a mass of human flesh. Carson's health, always delicate, began to falter. Her editor, who by then had met her in New York, arranged for her to retreat to the Bread Loaf Writers' Conference in Vermont for the final two weeks of August. Although Carson made sure that a spot was reserved for Annemarie as well, the Swiss writer departed instead for the baronessa's home on Nantucket. Disappointed — but satisfied, like George, that her romantic drama made a good story — Carson left New York determined to concentrate on her work.

Early in August, a new review of Carson's novel had appeared in the *New Republic* written by Richard Wright, the author of *Native Son,* whose first novel had preceded Carson's that year and whose short story "Almos' a Man" had recently been published by George. Wright heaped praise on *The Heart Is a Lonely Hunter,* remarking especially on the "astonishing humanity that enables a white writer, for the first time in Southern fiction, to handle Negro characters with as much ease and justice as those of her own race." He attributed this to "an attitude toward life which enables Miss McCullers to rise above the pressures of her environment and embrace white and black humanity in one sweep of apprehension and tenderness." It was an unusual statement for an African American writer to make in 1940, and Carson's fellow authors at Bread Loaf looked forward to meeting the child prodigy who had been thus praised.

Whereas two months earlier such attention would certainly have overwhelmed Carson, her experiences that summer had prepared her to turn the situation to her own advantage. Within days she was playing German *lieder* on the piano and drinking tumblers of gin with the fifty-four-year-old poet Louis Untermeyer, offering to sleep with him if he liked. (Untermeyer, though flattered, declined the offer.) She also had a chance to meet, if only in passing, Robert Frost, Wallace Stegner, John Marquand, and an even younger fellow Southerner, Eudora Welty. When Auden, just back from visiting Isherwood in California, arrived at Bread Loaf to give a reading, he and Carson swiped Stegner's only bottle of bourbon — on a Sunday, Stegner would later point out, when it was impossible to buy another one — and retreated to a corner, where they drank the bottle down while exchanging confidences.

By the time Carson left, not only were the corrections on the galley proofs for "Army Post," now retitled *Reflection in a Golden Eye,* nearly complete, but nearly everyone at Bread Loaf knew everything there was to know about Carson's good friends Erika, Klaus, Reeves, George,

Wystan, and Annemarie. If Carson had dreamed just three months before of joining the literary elite, she appeared to have made considerable progress in a very short time.

Carson McCullers's hard drinking and chain-smoking at Bread Loaf left her even weaker than when she arrived, and she returned to New York to find the overall situation unchanged. The news from Europe had only grown worse as the Battle of Britain began. More than a thousand civilians had already been killed by Hitler's bombing raids on British airfields and aircraft factories, and now, at the beginning of September, London itself was under attack. The American government responded to this new disaster with hardly more energy than it had mustered for Holland, Belgium, or France. Erika Mann, outraged by this show of apathy, departed for London to volunteer for the British Ministry of Information, broadcasting antiwar propaganda to the German people. She planned to proceed from there to Lisbon to help organize the exodus of refugees from Europe. Meanwhile, in New York, the war had become virtually the only topic of conversation. Tempers shortened at *Harper's Bazaar* as staff members sensed the end of an era. "Everything was weakening," Vreeland wrote. "I knew that we were heading toward *rien*."

George, who always tended to swing from "larky" to depressed as the hot months of summer took hold, grew especially irritable this year as he watched Paris sink beneath the waves. The friction that surfaced intermittently between himself and Carmel Snow had increased since May. A certain degree of conflict was inevitable between the editor in chief, with her fiscal responsibilities toward her publisher, and George, whose respect for money was minimal and whose cultural ambitions were high. Always before, such conflicts had led to an exchange of threats, ultimatums, and well-phrased insinuations until an unhappy compromise was reached.

This summer, the bad times had begun with the arrival on George's desk of "The Leaning Tower" by Katherine Anne Porter, another of his close friends and one of his favorite writers. The story — admittedly, long enough to classify as a novella — was set in Berlin in 1931; it followed the experience of a naïve young American tourist who witnesses a series of disturbing examples of postwar German economic misery, wounded pride, and bitterness. The deadpan tale laid out in Porter's brittle style the human truths underlying the political events that had subsequently taken place there. Certainly, George felt, American readers could do with

a simple explanation of how fascism had emerged in Germany and how it could take hold in any country, even this one. But Snow had refused to purchase "The Leaning Tower" unless Porter agreed to cut it by half.

What was there to cut? George wondered. The story was a masterpiece. In any case, he knew that Porter, who had gotten her start in "slick" magazines, thoroughly despised them for just this type of literary disrespect. As she wrote to their mutual friend, the novelist Glenway Wescott,

> Big Money magazines . . . I lived and worked in that Limbo once . . . and I washed its nasty smells off me carefully a great while ago . . . I made an exception of *Harper's Bazaar* on account of George Davis, but I have always been uncomfortable, more than a little apologetic in my mind, about stories of mine appearing there. Yet, if they would publish them as I wrote them, and I wrote them without regard to their tastes, and would pay me well . . . what was lost except perhaps a little shade of my vanity?

George argued passionately in defense of the story, but his senior editor refused to budge. In the end, George had no choice but to report Snow's decision to the author, with predictable results. Porter took her story back, presenting it later as part of a short story collection, and claimed she would never again allow Snow to publish her work.

That was in June. In July, Glenway Wescott's own long-awaited story had arrived. Wescott had been in a creative slump since the publication of his much-praised *The Grandmothers* more than a decade earlier. But George had attended the novelist's readings of his work-in-progress and couldn't wait to publish his new work. *The Pilgrim Hawk* was an exquisitely crafted tale of a single afternoon at the French country house of a young American heiress and her guests that recreated, as if preserved in amber, the careless, indolent world of 1920s Europe. George had no doubt that the story was another masterpiece, with special significance for everyone that summer. But once again the pronouncement came down from Carmel Snow — or "Mrs. Cold Caramel," as Wescott privately called her — that the story was too long. She would offer $300 for it on the condition that Wescott cut the manuscript significantly. That was out of the question, so another story addressing the tragedy overseas would not appear in *Harper's Bazaar*.

Disgusted, George put Carson's *Reflections in a Golden Eye* through its publication paces — dividing the text between two upcoming issues to avoid challenging his readers' attention span — and resolved to spend

even less time at the office. Frankie, his assistant, had resigned, and her replacement, a young writer named Dorothy Wheelock, was startled by Carmel Snow's instruction that her first duty each morning was to call George and ask whether he planned to come in that day. Instead of going to work, George spent more time with Carson, but she was able to talk only about her husband's continued bad behavior.

In the past weeks, Reeves had increased his drinking even more and had even slapped Carson once — the first time in her life anyone had struck her — when she arrived home late from an evening with Erika and Annemarie. He had also revealed to her, with great satisfaction, that while she was in Vermont, Annemarie had met with him to discuss ways in which he might patch up his differences with his wife. It was Annemarie's opinion that Carson lived in a bizarre imaginary world and was perhaps seriously ill.

This betrayal, as Carson saw it, was the last straw. The threads of jealousy and envy that had wrapped themselves around her husband and herself had made their life together intolerable. Even Reeves's fumbled attempts to make amends with surprise gifts and dinner parties irritated her. She wanted freedom — freedom to write without Reeves always present, freedom to find her way back into that intellectually exciting circle to which George had introduced her. But the wonderful prospect of life in New York seemed to have wilted almost as quickly as it had bloomed. Erika was in Europe now. Annemarie was on Nantucket. Klaus was in California, raising funds for his magazine. Wystan Auden seemed to spend all his time on Long Island, where his friend, the composer Benjamin Britten, was living. And, as the heat refused to break and let in that best of New York seasons, early autumn, George and Carson sank ever deeper into the doldrums.

To distract herself, Carson had begun reading Louis Untermeyer's new book of memoirs, *From Another World*. It recalled the poet's many adventures through decades of a life in letters with John Reed, Robert Frost, Laura Riding, and many other visionary poets, writers, and political activists. As a member of the editorial staff of the groundbreaking *Seven Arts* literary journal, Untermeyer wrote, he had helped create the magazine's manifesto: "It is our faith and the faith of many that we are living in the first days of a renascent period, a time which means for America the coming of that national self-consciousness which is the beginning of greatness. In all such epochs the arts cease to be private matters; they

become not only the expression of the national life, but a means to its enhancement." Wouldn't it be wonderful, Carson mused to George, to feel oneself at the beginning, rather than what appeared to be the futile culmination, of a great movement in literary history? Wouldn't it be wonderful to live, all the time, as part of a creative group?

Such words could only frustrate George further as he continued struggling against Carmel Snow's editorial strictures. He had never fully reconciled himself to the end of his writing career and the prospect of a permanent life as an editor. His iconoclastic approach, stubbornly maintained despite years of office work, was one of the reason his writers adored him, but it interfered with his ability to meet deadlines, keep expenses down, placate advertisers, and otherwise do his part to keep a popular magazine going. As a result, he had given Snow plenty of cause for complaint, and her irritation was exacerbated by George's erratic attendance. If he needed to think, or if it was raining, or if he couldn't dig up the bus fare, he preferred to stay home. When Snow objected to missed deadlines or engagements, he pointed out that he did his best work at night and that the theater openings and parties that kept him up until dawn were necessary to maintain the relationships necessary to the magazine's literary prestige.

But *Harper's Bazaar* was, in the end, a business. And finally the conflict between these two stubborn professionals came to a head. Called to task for the usual reasons, he insisted that his job was a creative one and that he intended to continue approaching it in his own creative way. If she was displeased by this attitude, he would be happy to resign. It was a dance that they had performed many times before. But to George's surprise, this time Snow changed the music by accepting his resignation.

The way George told the story later — having polished and revised it in his usual manner — thoughts of his past-due rent, utter lack of savings, and the marvelous, unedited stories on his desk caused him to regret his decision instantly. He asked Carmel Snow to reconsider. Surely she would take him back? "Only if you get down on your knees and beg me," the editor replied. So George got down on his knees and begged. And still "Mrs. Cold Caramel" said no.

It was September 1940, and George Davis, at thirty-four among the most dynamic, innovative, and beloved editors in New York, was out of a job. At a time in history when events were taking place that would transform

the world, his voice had been abruptly silenced. That month alone, George had published "Nuit Blanche" by Colette, "The Loved One" by H. E. Bates, John Cheever's "I'm Going to Asia," and a P. G. Wodehouse essay, along with a profile of the presidential candidate Wendell Willkie by Janet Flanner, an analysis of American Indian dance by his friend Lincoln Kirstein, and poems by Elizabeth Bishop and Stephen Spender. The short story writer Nancy Hale had contributed the second installment in a series, "American Failings" — the first being "our weakness for publicity" and the second, "our fear of being alone." But the cover of the special mid-September issue echoed the country's increasingly patriotic tone with the phrase "The Call to Color" superimposed on an image of a young woman saluting the American flag.

Left to his own devices, facing an empty wallet and the impending loss of his apartment, George found it difficult even to get out of bed and read the newspaper or turn on the radio. And who wanted to hear Edward R. Murrow broadcasting the sound of London's air raid sirens to America or describing how the searchlight beams swept the sky and invisible pedestrians' shoes clicked on the sidewalks of the blacked-out city "like ghosts shod with steel shoes"?

An era was coming to an end. Carson, trying to console George, suggested he try again to write a novel. But he had grown unaccustomed to solitary work. He would miss the camaraderie of his life at *Harper's Bazaar*. Perhaps, he suggested playfully, since Carson was so unhappy with Reeves, the two of them might live together. Carson hesitated. "Like brother and sister, of course," she said. George, laughing, promised it would be a platonic arrangement, and the pair did spend a day searching the area near Lotte Lenya's summer cottage for a bungalow they could afford. But nothing proved suitable, and George confessed he could never sleep well in the country, since a running brook sounded to him "like a train coming into a subway station." Besides, he would never be able to bear the isolation of country life. Carson agreed, musing that if only a family could be created like the one at *Harper's Bazaar* or like Untermeyer's group, which had produced the *Seven Arts*, perhaps it wouldn't be so lonely. It would be like living at Bread Loaf, except it would be year-round.

The dream seemed futile, particularly that summer, when the future had become so unpredictable, but George couldn't put Carson's vision out of his mind. What a relief it would be to leave Carmel Snow's anger

and Reeves McCullers's envy behind, to live with others like oneself and serve as mutual catalysts for one another's creative lives. Even if it meant being terribly poor, at least they would be poor together.

And what was the alternative? Carson herself had expressed it in *The Heart Is a Lonely Hunter:* "All of us here know what it is to suffer for real need. That is a great injustice. But there is one injustice bitterer even than that — to be denied the right to work according to one's ability. To labor a lifetime uselessly. To be denied the chance to serve. It is far better for the profits of our purse to be taken from us than to be robbed of the riches of our minds and souls."

This, to George, was the most frightening prospect: to find himself isolated, cut off from the world, and unable to contribute the fruit of his talents. But how, with no job and no money, could he serve?

That night, George had a dream.

2

Summer was worse than we expected:
now an Autumn cold comes on the water . . .

— W. H. Auden, "The Dark Years," 1940

George dreamed he was standing on a narrow city street, looking at an odd little four-story house in the middle of a residential block. It was typical of most Victorian townhouses, with dining room and kitchen on the ground floor, parlor above, and two floors of bedrooms at the top. But the details of its decoration — fanciful black stucco filigree, a peaked roof, a steep, narrow stoop with its own sharply inclined roof resting on carved wooden pillars — gave it the look of a Belgian shopkeeper's residence crossed perhaps with a witch's cottage from a German fairy tale. It looked nothing like the boxy, red brick houses on either side.

It was not the first time George had had this vision. It was a recurring dream that came to him in times of stress and that left him in a lighter, more optimistic mood in the morning. This time, however, the dream continued long enough for George to recognize the neighborhood. The shade trees, the air of quiet domesticity, and especially the view at one end of the street of the Manhattan skyline across the water — it had to be Brooklyn Heights, where Wystan Auden now lived. George looked back at the house, still in his dream, and was filled with a sense of its vast, empty interior. The house was large enough to accommodate George and all of his closest friends. Somehow, he knew it was for rent.

George woke the next morning determined to find the house in Brooklyn. It was a spectacular day for an outing. Autumn had arrived in New York, with its crisp breezes and sharp, brittle light. Taking the sub-

way from Manhattan's East Side to Brooklyn's Borough Hall station, he emerged to find the neighborhood's Victorian mansions and grand hotels gleaming at the top of the bluffs, superimposed against the sparkling water of New York Harbor and monitored by seagulls overhead. Tightly wedged between the water and the commercial and civic hub of Brooklyn, the small residential district provided a quiet retreat for shoppers and office workers as well as the children who raced along Pierrepont Street trailed by uniformed nannies.

Even slowing down to peer first at one brownstone, then another, it took less than thirty minutes for George to search the main streets, but without success. Gradually, he moved downhill toward the neighborhood's northern edge, where the streets named for Manhattan's great mercantile families gave way to simpler "fruit" streets — Pineapple, Orange, Cranberry — and respectable Brooklyn Heights threatened to give way to the unsavory dockyards below. Some of the single-family homes had already succumbed, divided up to make boardinghouses or abandoned. This evidence of decline only made the area more interesting to George. And the area's somewhat down-at-heel look — old men shambling home from the bars, sailors wandering about in restless packs, young mothers gossiping on the front stoops — corresponded precisely to what he had imagined. Yet he could not find the house in his dream.

Finally he reached tiny Middagh Street, a four-block lane clinging to the edge of the northernmost bluff overlooking the Fulton Ferry and the dockyards below. At this extreme end of the Heights, the houses looked even older and smaller than those nearby, some covered only by clapboards and hunched over ground-floor shops. Even the shadows were deeper as the sun's rays struggled to reach the narrow gap between the buildings. But George hardly noticed these deficiencies. Halfway down the last, dead-end block, nestled in a row of ordinary brick homes, stood the object of his search, resembling in every detail his nighttime vision. George let his gaze drop to the sign in the parlor window. It read, as he knew it would, HOUSE TO LET.

George telephoned Carson and insisted that she come to Brooklyn right away. She hesitated at first, uneasy at the thought of traveling to an outer borough and getting lost for hours in a tangle of subway lines. But contrary to her expectation, she found the neighborhood surprisingly easy to reach — a single stop past Manhattan's Wall Street, a five-cent ride from her Village home. She, too, was charmed, as George met her at the station and walked her to Middagh Street, by the serenity of

the old neighborhood. It was easy to understand why Auden had chosen to live here. The low buildings and waterfront location offered more light and fresh air than Manhattan, and the harbor served as an insulating barrier between the famous poet and the world of society hostesses he preferred to avoid.

After a summer in Carson's cramped rooms on West Eleventh Street, the house at 7 Middagh seemed enormous. Standing in the street, facing the house, the view to the left of the busy harbor stretching to the shore of downtown Manhattan was stunning, and the short, dead-end block itself afforded a sense of privacy and seclusion almost unheard-of in the city. The front steps led to a charming wooden porch with gingerbread trim. A person could have a rich life in a house like this — standing before the large wooden door, welcoming guests like the grand hostesses of Charleston and Atlanta. Peering through the windows at the high-ceilinged parlor with its marble fireplace, it was possible — for an imaginative twenty-three-year-old, at least — to picture sophisticated parties and brilliant conversation taking place inside. Still, an entire house — how could they possibly afford it?

George had the answer. While neither he nor Carson had enough money to rent the entire brownstone, each could afford a small piece of it. And if they invited friends to move in as well, together they could raise enough money for the rent and expenses. It would be the group life that Carson had been dreaming of, he explained excitedly, a sanctuary for themselves and others who were also, for financial, political, or any other reason, finding it difficult to focus on their work. He knew, for example, that Auden was looking for a cheaper place to live. If such a respected poet moved in, everyone else would follow. It would be an experiment, he told Carson — a test for himself and a test for each other. But surely it was worth trying.

Carson listened raptly as George outlined his plan. Like George, Carson's spirit of adventure was strong. Yet, also like George, she was essentially a family person who liked to keep loved ones close by. Renting a house like this would allow her to make the kind of dramatic gesture she enjoyed while creating the domestic order that best supported her work. Growing up, she had benefited from the social and intellectual ambitions of her mother, Marguerite Smith, who had created a modest *salon* of her own in which Columbus's interesting and eccentric had played Bach on the gramophone and discussed favorite works of literature. The idea of replicating this experience with the likes of Wystan Auden and George

Davis certainly appealed more strongly to Carson than remaining cooped up with Reeves or finding an apartment on her own.

Setting out immediately to talk with the rental agent, Carson and George soon learned that the house had previously been occupied by an elderly widow, then converted to a boardinghouse. The house had fallen into such neglect that the widow's son was willing to offer a long-term lease to anyone willing to keep it from deteriorating further. The rent would be low — $75 a month — with one month's security deposit due on signing.

Roughly the same price as a small apartment on the East Side in Manhattan, the four-story house was a bargain — particularly now that the prospect of war had led to more weddings and a housing squeeze in New York. It was also a wreck, as George and Carson realized when given a tour. But the size of the kitchen and dining room made up for the crumbling plaster, and the ornate parlor was perfectly suited to George's taste. The rear windows offered the same views of New York Harbor and the Brooklyn Bridge that had inspired the poets Walt Whitman and Hart Crane. And the building's reconfiguration as a boardinghouse made it appropriate for group life already. It was a risk, they agreed, but they would accept it.

There was still the problem of money. Neither of them had $150, but George knew someone who did. His friend Lincoln Kirstein, a wealthy department store heir, was devoting his life to supporting the arts. The hulking thirty-four-year-old whose grim, vulture-like demeanor masked a shyness that his artist friends found charming, had funded his first creative ventures as a student at Harvard, where he had cofounded the iconoclastic literary journal the *Hound and Horn* and published early works by Katherine Anne Porter and Stephen Spender. He had also cofounded the Harvard Society for Contemporary Art, which had exhibited — often for the first time in America — the works of Georgia O'Keeffe, Juan Gris, Giorgio de Chirico, Max Ernst, and Man Ray. This led to his supporting role in the creation of New York's Museum of Modern Art in 1929. In recent years, however, Kirstein had fallen in love with ballet and with the idea of bringing this European dance tradition to America, where an independent style could be developed. Having imported the choreographer George Balanchine to New York and raised the funds necessary to create the School of American Ballet and the American Ballet Company, he helped stage a series of stunning original productions every year.

George Davis happened to know — because he had introduced them and followed their friendship for years — that Kirstein idolized Auden and in his earnest devotion would do practically anything to make his life more secure. As far back as 1933, shortly after the publication of Auden's *Orators,* Kirstein had been scandalized when the composer and music critic Virgil Thomson had lazily insisted that Kirstein summarize the collection for him in "just one word."

Kirstein had sought an introduction to Auden and Isherwood when they first came to New York. Then, when Isherwood moved to Hollywood and Auden had to leave their shared apartment, Kirstein invited him to stay at his own home until he found a new place to live.

The arrangement had not worked particularly well, as Kirstein's sometimes clumsy efforts to ingratiate himself with Auden tended to go sour. Often abrupt and unintentionally rude — walking off in the middle of the conversation if bored — the young man whom Isherwood had described as a kind of tormented Gulliver surrounded by tiny, beautiful dancers, could be a difficult companion. Once, feeling playful, Kirstein stole up behind Auden and sprayed the back of his neck with perfume, causing him to leap into the air in surprise and slap at his neck, screeching, "*Fuck! Stop that!* What on *earth* are you doing? I positively *loathe* perfume!" Flushing purple, Kirstein left the house until he had recovered.

Yet, despite the misunderstandings and Auden's private opinion that ballet was a minor art, not really worthy of so much attention, he was fond of Kirstein in return. He had dedicated his poem "Herman Melville" to this friend who had taken such pains to introduce him to American history and literature, and he had spent much of the past summer at the home of Kirstein's sister, Mina Curtiss.

Kirstein knew that Auden was looking for cheaper housing, and he regretted George's departure from *Harper's Bazaar.* He could see how 7 Middagh Street could improve both of his friends' situations. Further, the idea of a creative group house headed by someone as well connected and beloved by artists as George appealed to him — as did the opportunity such a situation would provide for more material for George's spellbinding and often salacious stories, to which Kirstein was thoroughly addicted. And he could think of a dozen people or more who might comfortably live at 7 Middagh Street — dancers, choreographers, artists, and musicians, as well as writers. Eager to be involved, Kirstein wrote a check for the initial expenses — an amount laughably minuscule com-

pared to that demanded by his other arts projects. He looked forward to dropping by Middagh Street in a month or so, after George had got it up and running, to see how the experiment was developing.

With check in hand, George was able to sign the lease and pocket the keys. The official moving date was October 1, but as George explained to Carson, they would have access to the house before then so they could begin repairs. In the meantime, there was much to do. George needed to arrange for his furniture and other belongings to be moved to Brooklyn, while Carson would have to decide how to break the news of her departure to her husband. They would need to find painters, carpenters, and plumbers — something neither of them had ever done in New York. George was excited to have a new project, but much depended on Auden's involvement. George would not feel fully comfortable until he had brought his British friend on board.

This task was not likely to prove much of a challenge. Auden and Davis had discussed sharing an apartment with Isherwood once before, when the British writers had first arrived in New York. George's relationship with Auden had flourished during the previous year and a half, nourished by long lunches paid for by George's employer and an exchange of amusing notes, letters, and poems when one or the other was out of town. Auden often described George as the wittiest person he had ever known, and George worked hard to maintain that position. The poet also appreciated George's ongoing efforts to find him publication and lecture opportunities that helped pay his bills.

It was true, as George Davis and Lincoln Kirstein had heard, that Auden was in a bad financial state that autumn. Lacking a private income, he depended solely on his writing for support, along with a weekly teaching post in Manhattan and occasional lectures elsewhere. The previous year, attracted by the serene atmosphere and human scale of Brooklyn Heights, he had rented an apartment on the top floor of one of the grandest houses overlooking the harbor, at Columbia Terrace and Montague Street. The apartment was small, but the view was one of the best in the city, and the insulating distance from Manhattan's literary scene made the steep rent worth paying. Since then, however, events in Europe had led to a ban on the exportation of British money. Cut off from the profits on the sales of his books in England, Auden had instructed his parents to donate them instead to a fund for transporting children out of bomb-threatened London and had looked to America for other sources of income.

But they had proved hard to come by — certainly more difficult than George had led him to believe on their first visit in 1938. And while it was true that American publishers generally paid more than those in England for poems and book reviews and that Americans, always eager to improve themselves, compensated him well for lectures and readings, the cost of living in New York was also quite high. The fact was, Auden had overextended himself. If he did not find a solution soon, he did not see how he could continue the daily writing routine on which he utterly depended — and he was just now completing the commentary to a long poem, "New Year Letter," which would soon be published with a few shorter poems in a book to be called, in its American edition, *The Double Man.* For a while he had thought that his close friend Benjamin Britten might move in along with his lover, the singer Peter Pears. But there was really no room in the small apartment for Britten to work on his music while Auden wrote, and the composer had bridled at the high cost of even half the apartment's rent.

Auden was also losing patience with his intrusive landlady, who had admitted to spending entire nights parked in her car outside the house, keeping an eye on the comings and goings of tenants whose activities had caused complaints. For a man such as Auden, who lived openly as a homosexual despite its illegal status in 1940, such a remark was bound to cause discomfort. As he later wrote to a curious friend, his determination to live openly as he liked was "largely dictated by Worldly Prudence." He had found that most people responded to his behavior with the thought "'If there were *really* anything in this, he couldn't dare be so obvious,'" whereas, "If one is secretive, and then, discovered, one is lost." Nevertheless, there was always the danger of confrontation. At the price he was paying to live on Columbia Terrace, Auden hardly needed the aggravation of a stranger's excessive interest in his life.

George, visiting the poet in his untidy, paper-strewn apartment, suggested in his warm tones that a move to Middagh Street would provide the perfect solution to all of these problems. At $25 per resident, the rent must be a third of what Auden was paying now. Middagh had acres of rooms — they could each take half a floor — and nowhere in New York would Auden find a more congenial pair of housemates. As George painted and renovated each floor, more artists could move in, and the expenses could be divided among more people. And if together they could lower their cost of living and enjoy the stimulation of one another's presence as well, who knew what they might be able to produce? It was obvi-

ous that time was short. Whatever they had in mind to create, they had better do it now.

Auden hardly needed the reminder. One had only to look out the window at the harbor to know that the opportunity to focus on literary activity was about to end. By September 1940, the number of passenger liners docking at the Manhattan piers had diminished significantly as the European war escalated. News of the bombing raids on London filled the daily newspapers. America clearly could not stand passively by much longer before its engagement in the war became not only a moral issue but a matter of self-defense. A military draft had been introduced in the United States that month. And Auden, more than either of the other future residents of 7 Middagh Street, knew what sort of havoc war and politics would wreak on their individual lives.

Twelve years earlier, as a recent Oxford graduate who had, as he cheerfully admitted, hardly cracked a newspaper in his life, Auden had traveled to Berlin just as Germany's Weimar Republic was beginning to crumble and fascism rise in its stead. The city's heady cultural brew had already produced Dadaism, expressionism, Bauhaus architecture, and particle physics — and still appeared to be in a state of constant revolution. With its favorable exchange rate, Berlin served as the mecca for restless young British artists that Paris represented for Americans. Auden's arrival coincided with the premiere of Brecht and Weill's *Threepenny Opera,* the publication of *King, Queen and Knave* by Vladimir Nabokov writing as V. Sirin, Marlene Dietrich's latest film, and exhibits of the works of Otto Dix and Georg Grosz.

More significant, in the words of Christopher Isherwood, "Berlin meant Boys." The cabaret district around the Friedrichstrasse, with its small bars and trysting alleys, was, Isherwood wrote, a "promised libidoland," where male prostitutes would do anything with anyone for money. Berlin was "a city with no virgins. Not even the puppies and kittens are virgins," exulted Stephen Spender, who followed his two friends to Berlin. This atmosphere promised relief from the repressed environment of England — particularly, as Isherwood pointed out, for those well-brought-up young Englishmen who could relax sexually only with foreigners of the working class.

Conveniently, the recent university graduates had at that time fallen under the influence of the American psychologist Homer Lane, who defined God as the pure inner desires of an individual, unwarped by the

strictures of society. If this was true, then ignoring one's own nature in favor of others' rules was a sin, and the path toward spiritual and emotional health lay in "complete freedom of behavior." Auden, pushing back the heavy leather door curtain of his favorite boy-bar, the Cosy Corner, did his best to follow Lane's advice.

Of course, Auden and his friends were aware that their passionate but brief relations with Berlin's street prostitutes had everything to do with Germany's recent bout of rampant inflation and the current high rate of unemployment, and rarely if ever any real sexual attraction. Many if not most of the prostitutes haunting the cabarets were heterosexual, earning an income in the only way they could.

If this power imbalance occasionally threatened to touch the British writers' consciences, they were protected for a time by educated England's traditional conception of the working classes as "characters" placed on earth for their amusement. As the Irish poet Louis MacNeice later wrote, "You may throw darts with the yokels in the village pub but all the time the yokels are on the stage and you are in the stalls." In fact, Auden and his comrades initially found the prostitutes' very emotional aloofness exciting in contrast to their physical availability. "The attraction of buggery is partly its difficulty and torments," Auden would tell a friend. "Heterosexual love seems so tame and easy after it." Like Carson McCullers more than a decade later, he found that he was stimulated by unsatisfied desire and felt that "there is something in reciprocity that is despair."

Opting for male partners, while made easier by Berlin's political climate, was not a particularly difficult decision for Auden in any case, thanks to the open attitudes of his close circle of friends. At Oxford, he had had opportunities for homosexual play, though never in anything like the liberating context of Berlin. Gradually, along with Isherwood and Spender, he came to know some of the Berlin boys as individuals and to care for them as true lovers or at least friends. And if he liked to brag to his friends back home that he was taking part in the "white slave traffic," in the end he freely admitted that in Berlin he had been more "a middle-class rabbit" than a successful predator.

But already, the playground in which these writers had explored their sexuality and practiced their poetry had begun to shut down. The October 1929 American stock market crash had a devastating effect. Sexual and other forms of social tolerance began to evaporate in the face of economic disaster.

With terrifying speed, violence returned to the streets as Jews and other "troublemakers" were persecuted by political slanderers and thugs taking advantage of the public's need for scapegoats and for distraction from their acute distress. Every day saw new restrictions on the expression of individual opinion, the movements of certain individuals, the freedom to obtain a job or a visa or entry into certain organizations and clubs. Free speech gave way to propaganda, free passage through the streets to riots, vandalism, and physical attacks. Then the 1929 elections resulted in an enormous victory for the Nazi Party and a defeat for the Social Democrats and Communists. It was eye-opening for the Britons to see the real effects of economic hardship, class division, and political chaos on their working-class German friends. But by that time Auden had turned twenty-two and his parents had stopped his allowance. He had no choice but to return to England.

Back at home, Auden turned to a series of jobs as a private tutor, a boarding school teacher, and a writer for documentary films. But his life in Berlin persisted in his imagination — he had learned much about human nature as well as the power of politics to shape the destiny of individuals. In his free hours, he began to transform the raw material of his life in Berlin and England into a series of remarkable poems, produced in quick succession. Some conveyed the sense of boding darkness that he had experienced in Germany: "All this time was anxiety at night, / Shooting and barricade in street." Some alluded to the sexual openness that he and his friends had enjoyed there: "Before this loved one / Was that one and that one." Others expressed his impatience with Little England — a prim, self-censoring nation where "Whispering neighbours, left and right, / Pluck us from the real delight." And still others warned of bad times to come:

> It is time for the destruction of error.
> The chairs are being brought in from the garden,
> The summer talk stopped on that savage coast
> Before the storms, after the guests and birds:
> In sanatoriums they laugh less and less,
> Less certain of cure; and the loud madman
> Sinks now into a more terrible calm.

Auden's irreverent, aggressively modern verse, by turns boldly transparent and tantalizingly obscure, touched a nerve in menbers of Britain's disillusioned younger generation, who in the decades after the First

World War had come to feel that they were suffocating in what Auden called "this country of ours where nobody is well." His gift for language and nuance — "Lay your sleeping head, my love / Human on my faithless arm" — won the praise of his elders, including Eliot and Yeats. As one critic wrote years later, "The mortality, the guilt, the faithlessness, the beauty of human beings were [Auden's] themes. One of the great charms of his poetry was that he wrote as one of the guilty, one of the faithless, one of the moral." But as poem after blinding poem exploded onto the 1930s literary scene in newspapers, journals, and a series of collections (*Poems*, 1930; *The Orators*, 1932; *The Dance of Death*, 1933; *Look, Stranger!*, 1936), readers his own age most treasured the urgency of his writing and its implicit assumption that the examined life was worth the struggle:

> O plunge your hands in water,
> Plunge them in up to the wrist;
> Stare, stare in the basin
> And wonder what you've missed.

Still in his twenties, the son of a Yorkshire physician had become the most admired young poet in Britain. One unforeseen result of this success was that he soon found himself put in the uncomfortable position of "representing" the post–World War I generation at a time when, in MacNeice's words, "Young men were swallowing Marx with the same naïve enthusiasm that made Shelley swallow Rousseau" and fascism was becoming more widely recognized as a force to be reckoned with. Auden's artistic interests continued to be individual and moral rather than political; he freely admitted to being too bourgeois by nature ever to become a Communist. Nevertheless, he sympathized with leftist ideals. Swept up by what the already exiled Klaus Mann dryly referred to as the free world's "vague social conscience," he joined his fellow British artists in speaking out against fascism, signing petitions, and raising funds to aid the thousands of Germans now fleeing to Paris, Vienna, and Amsterdam.

The Spanish Civil War struck most members of the European and British intelligentsia as the first critical test of fascism's ability to expand to the rest of Europe. For this reason if no other, it was obvious that General Franco must be defeated. An International Brigade was created of writers, activists, and workers willing to fight the Fascists. Auden, caught up in the fervor, decided to join them — if not as a soldier, at least as an

ambulance driver or in some other noncombatant capacity. While considering himself a pacifist, he felt that his responsibilities as a writer required his direct involvement in the events in Spain. "I shall probably be a bloody bad soldier," he wrote to a friend, "but how can I speak to/for them without becoming one?"

The scene Auden encountered in Spain was far worse than he had imagined. In Germany he had been appalled by the patriotic hysteria, lust for violence, and fierce repression he witnessed, but in Spain these behaviors extended to all-out bloody mayhem and mass murder. And this hell on earth — the burnt-out landscape of plundered villages and weeping children that was now Spain — had been created not just by the Fascists but also by the Republican army supported by Auden and his friends. Shocked by the evidence of Fascist rape, pillage, and summary executions, he was also profoundly disturbed by the sight of churches gutted and burned to the ground by the Republican forces and reports of Catholic priests pulled out into village squares to be shot. Although he himself had rejected the Anglican Church of his childhood, this violence against a religious institution created in Auden an almost visceral revulsion, and as a political activist he felt partly responsible.

Auden returned home from Spain months ahead of schedule, unwilling for once to discuss his experience. Years later he wrote, "No one I know who went to Spain during the Civil War who was not a dyed-in-the-wool Stalinist came back with his illusions intact." He now viewed the slogan-tossing, speechifying, committee-joining fervor of the British intelligentsia — activity for which he had served as a beacon on some occasions — as potentially as damaging as fascism at worst and, at best, utterly ineffectual in changing the course of world events. The only evidence of improvement that he could see was in the social and professional standing of those who had made connections and garnered attention by supporting "the cause."

As a result, Auden lost what little taste he had ever had for politics. Yet he had become a bigger celebrity in England than ever before. He received the Gold Medal for Poetry and at around the same time was the focus of a special edition of the well-regarded poetry magazine *New Verse,* in which Christopher Isherwood, Stephen Spender, Cecil Day Lewis, Louis MacNeice, and others offered their praise. Such recognition, while gratifying, also carried with it an odd note of finality, reflected in Dylan Thomas's sardonic footnote to his own contribution to the special issue: "P.S. — Congratulations on Auden's seventieth birthday." There

was a sense that Auden, having been canonized by the age of thirty, had finished his great work and might as well now be dead.

In fact, Auden found this level of acclaim "extremely embarrassing because I knew that certain kinds of success one had, had nothing to do with what I really cared about, and of course one would have to pay for it later." His conscience bothered him for his past know-it-all approach to political issues, and after Europe, the entire insular, competitive, backbiting world of literary England felt stifling. Having been home for less than a year, Auden resolved to leave again.

But travel only took him to another war. In 1938, a few weeks after George Davis arrived in London and persuaded Auden and Isherwood to publish their work in *Harper's Bazaar,* the pair left for China to begin the adventure on which they would base their book *Journey to a War.* The Sino-Japanese War had ended with a truce in 1933, but it had recently resumed with a vengeance with the Nanking Massacre, in which 140,000 Chinese civilians were murdered. The two young writers, buffered by their British hosts' efforts to give them only "a tourist's acquaintance with China," took a lighthearted approach to their assignment at first. But they grew more sober as they encountered such sights as a dog feeding on the carcass of a dead spy and experienced what Isherwood described as the "dull, punching thud" of bombs falling on city streets, "the concussions that made you catch your breath; the watchers [exclaiming] softly, breathlessly: 'Look! Look! There!' . . . It was as tremendous as Beethoven, but *wrong."* It was the pointlessness of the carnage, perhaps, that shocked them the most. "War is bombing an already disused arsenal, missing it, and killing a few old women," Auden wrote. "War is a handful of lost and terrified men in the mountains, shooting at something moving in the undergrowth. War is waiting for days with nothing to do; shouting down a dead telephone; going without sleep, or sex, or a wash. War is untidy, inefficient, obscure, and largely a matter of chance."

The pair were still in China on March 12, 1938, interviewing Mrs. Chiang Kai-shek, when they heard that the Germans had invaded Austria. "The bottom seemed to drop out of the world," Isherwood wrote, as he and Auden endured the assurances of a German adviser to the Chinese government that "of course, it had to happen. And now I hope that England and Germany will be friends. That's what we Germans have always wanted. Austria was only causing trouble between us." The Fascist takeover of Spain, no matter how strongly encouraged by the German Nazis, had been an internal affair. But the invasion of Austria meant that

another all-out European war was imminent. Even more chilling were the reports of the enthusiastic welcome given by the Austrian public to the German tanks rolling across their borders and the crowd of eighty thousand celebrants who welcomed Hitler into Vienna. It was, in the words of one writer, "clearly no national rape but a marriage in which the groom found himself overwhelmed by his bride's enthusiasm." Still, the British, the French, and the Americans chose not to respond.

Auden and Isherwood continued through China, but both men were losing any hope that the political conditions in the world might improve in the near future. Violence was "successful like a new disease," Auden wrote in "Sonnets from China," his contribution to *Journey to a War*, "And Wrong a charmer everywhere invited." Fascism no longer appeared to be an evil force, visited on the public from above or below, but a sickness that lived within each individual and could be easily tapped, given the appropriate circumstances and timing:

> Behind each sociable home-loving eye,
> The private massacres are taking place;
> All Women, Jews, the Rich, the Human race.

The first poems from *Journey to a War* began to appear in British journals just as Auden and Isherwood returned to England by way of New York. While Auden's "Sonnets from China" caused him to be dropped by the *Daily Worker* crowd, the response by the rest of the British public was enthusiastic and strong. It was already clear that, despite his youth and an eccentric demeanor, the thirty-one-year-old's place in the British literary tradition was assured. His calendar was filled with engagements to speak about war, his telephone rang, and the newspapers and literary journals reported his every word and action. Once again, in spite of his own best intentions, his moral protest against political events only served to propel his own career forward while making no discernible change in the victims' lives.

From the age of fifteen, Auden had resolved to spend his life becoming a great poet — not necessarily famous but great. He had clear opinions on what this entailed: a great poet does not waste his days basking in the comfort of his own celebrity, monitoring his advancement within the literary community while spouting ill-informed political opinions for the BBC. A great poet arranges his life so that he can focus on his work — work that should consist of making himself and others "more aware of ourselves and the world around us," as he later wrote. "I do not know if

such increased awareness makes us more moral or more efficient; I hope not. I think it makes us more human, and I am quite certain it makes us more difficult to deceive." More than ever, England, with its Arts Council chairmanships, lectureships, and awards, struck Auden as intellectually incestuous and ultimately stifling. "That English life," he would remark, ". . . is for me a family life," a pleasant enough environment that nevertheless limited his development as an artist. "I love my family very dearly, but I don't want to live with them," he added. Life in England was preventing him from growing up.

It was now the late summer of 1938, and the international situation had continued to deteriorate. The Loyalist cause in Spain was clearly doomed, and the British Communists were distracted by the last of Stalin's trials. Hitler, having absorbed Austria, moved methodically forward, demanding the surrender of more than eleven thousand square miles of territory at the western end of Czechoslovakia. Surely, the British public assumed, this outrageous land grab would not be tolerated. Germany's neighbors would have to resist. As the threat of war that had hovered in the distance for the past six years became more of a reality, London was seized with what MacNeice described as the "dumb, chattering terror of beasts in a forest fire." The British intelligentsia, once so eager for political debate, now "sat in the Café Royal moaning about their careers," while in Piccadilly Circus at midnight, "hand after hand shot out as if from robots, grabbing the Extra Editions" to learn whether their own plans and dreams would now be put on hold.

Auden and Isherwood worried over the fate of their German friends. The prospect of an all-out war with Germany weighed heavily on their minds as they imagined former lovers lured or forced into Nazi uniforms, and they wondered how they could join a conflict against a people whose individual members they had known and loved. A few months later, Auden attempted to express the uneasy sensation of knowing of others' suffering while one is safe and sound:

> About suffering they were never wrong,
> The Old Masters: how well they understood
> Its human position; how it takes place
> While someone else is eating or opening a window
> or just walking dully along . . .

In fact, there seemed to be no clear-cut issues, no purely good side, anywhere in 1938, and they could anticipate years of moral floundering,

slogan-shouting, and the slow collapse of Europe's culture ahead. Under the circumstances, Auden's recent visit to New York with Isherwood took on a greater retrospective glow, and George Davis's sales pitch resounded ever more strongly. Europe, Auden and Isherwood suspected, was drowning in its own history. It was impossible to see clearly in a world trapped by centuries of tradition, whereas in America there was "no past. No tradition. No roots — that is in the European sense . . . It's the only country where you feel there's no ruling class. There's just a lot of people." The idea of living without such boundaries or restrictions was frightening, Auden admitted. But it was also an exciting prospect to rely solely on one's own conscience and experience.

While visiting his brother in Belgium that September, Auden impulsively visited a fortuneteller, who told him there would be no European war. Returning to London, he passed on the prediction to Isherwood, and the two agreed to emigrate to America together. Then they looked at the newsstands. The headlines told of the British prime minister's agreement with Daladier, Mussolini, and Hitler to fully yield to Hitler's demands for part of Czechoslovakia in exchange for his promise not to seek further territory. The Munich Accord, a final attempt to appease Hitler for the sake of peace, came to symbolize the culminating moment in Europe's humiliating and shortsighted attempts at containing the expansion of the German empire. Yet for now, the utter relief in Britain was palpable. War had been postponed.

In January 1939, Auden and Isherwood set sail on the *Champlain*, packed with European refugees, for America's vast, innocent, wide-open territory. They would reach New York, "penniless as before, but this time not friendless," Isherwood wrote to George Davis. "I do hope you'll be around when we arrive?"

George was unable to greet them on the freezing-cold day that the *Champlain* pulled into New York Harbor, but Erika and Klaus Mann arrived on the quarantine launch to welcome their friends with great excitement and a full supply of juicy gossip. Soon Isherwood and Auden were installed in the friendly and inexpensive George Washington Hotel in midtown Manhattan — a place Isherwood hated and Auden loved, as it could allow him to live as "a lonely," like everyone else in this country, he believed, and with "140 million lonelies around," he need not waste his time conforming to or rebelling against anyone else's expectations.

But loneliness was not an issue for the two writers. Not only was

Auden's poetry already well known on this side of the Atlantic, but both *Journey to a War* and Isherwood's *Good-bye to Berlin* were soon to be published in the United States. Parts of both books had already appeared in *Harper's Bazaar,* where the young authors had been flatteringly photographed by Louise Dahl-Wolfe and described as "the leaders of a highly gifted and rebellious group of young English writers who live and write with a fiery spirit English literature has not known since Byron and Shelley." As a result, the pair found themselves in the center of a literary and social whirlwind, dragged from editor's office to society gathering to theater opening to Harlem nightclub.

Auden and Isherwood did their best to cope with this unexpected onslaught of flattery and praise. Isherwood, with his affable manner and winning smile, found it relatively easy to satisfy his American hosts' image of a clever young British writer on his way to the top, but Auden, shyer by nature, struck some at first as arrogant or dogmatic. Recalling the impressive effects of the drug regimen introduced by George Davis the year before, Auden turned for relief to a dose of Benzedrine each morning and Seconal at night and found that this "chemical life" solved all his problems. Overnight, he felt, he became not only brilliantly talkative and entertaining at society dinners but a more productive writer as well. Having been advised of the possibility of being subsidized by one of their Park Avenue hostesses if they behaved appropriately, the pair jealously defended their best prospects against other aspiring artists and thanked God for the English accents that the Americans so obviously admired. When no patron materialized immediately — discouraged, perhaps, by Auden's nicotine-stained fingers, nearsighted squint, and remarkably stained and wrinkled clothes — the poet got to work writing articles and book reviews for the *New Republic, The New Yorker,* and the *Nation* and lecturing once a week at the New School for Social Research, a university for adult students whose faculty included a number of other accomplished exiles.

By February, not yet realizing that New York did not represent the country at large, Auden and Isherwood had developed strong opinions about their adopted home. "The Americans want everything canned," Isherwood wrote to his mother. "They want digests of books, selections of music, bits of plays. Their interest is hard to hold for long. No great reputation is safe. Everybody is constantly being reconsidered. This is partly good, of course. But there is a lot of cruelty in the public's attitude to has-beens."

Auden enjoyed his new home more, especially as he found opportunities for the anonymous life he craved. He found, for example, that it was possible to write for hours at a corner table at Schrafft's without being disturbed, and he began to do so almost daily. Still, he had to agree with Isherwood that the people in this country were, for the most part, shockingly oblivious to the danger posed by the Nazis' movements across the Atlantic. Even as a new wave of exiles washed ashore from Western Europe, the United States continued to do business with Germany and allowed Hitler's embassy to remain open. When, in March, Germany violated the Munich Accord by sending troops across the Czech border and proclaiming that Czechoslovakia as a nation no longer existed, Americans shook their heads, according to the British writers, and smugly pronounced the rest of Europe "a goner." It irritated Auden and Isherwood to witness, as they worried for their friends back home, the lack of understanding in America that Czechoslovakia's fate could become their own.

In that spring of 1939, everything changed for Wystan Auden. For the first time, he fell in love. The encounter took place at a talk sponsored by the left-wing League of American Writers, featuring Auden, Isherwood, MacNeice, who had come to America for a brief visit, and Auden's critic and admirer, the aspiring poet Frederic Prokosch. The event was well attended by hordes of earnest college students, despite a two-hour delay while the writers were fetched from another location to which they had been misdirected. Sitting in the front row was eighteen-year-old Chester Kallman, a fledgling poet at Brooklyn College, with his occasional lover and fellow poet Harold Norse.

By most accounts, Auden stole the show. His typically disheveled appearance ("Miss *Mess*," whispered Kallman, eyeing the poet's drooping socks and untied shoelaces) contrasted dramatically with the astounding power of his new poem, "Elegy to Yeats," evidence of another great creative leap forward since his arrival in the United States. But Isherwood was still the more attractive of the pair, and it was he whom Kallman and Norse tried to corner for an "interview" backstage. The novelist was more interested in another fan who had joined them, and he gave that boy a card with the address and phone number of the East Side apartment he now shared with Auden. Kallman appropriated the card from the better-looking student as soon as they left the building and a few days later appeared at Isherwood's front door.

"It's the wrong blond!" Auden complained when he opened the door to see Chester standing there. When Isherwood saw who it was, he returned immediately to his writing. Chester entered nevertheless and, in a brief, awkward conversation, finally captured Auden's interest by mentioning Thomas Rogers, one of his favorite Renaissance poets. With that, they were off. The two spent the rest of the afternoon discussing literature (Auden's specialty) and music (Chester's passion). By their next meeting, they were lovers.

Tall and slim, Chester Kallman had the androgynous face of an angel but blurred, as though God had tried to smudge it out with His thumb. The son of a Brooklyn dentist and a former actress in the Yiddish theater who had died when Chester was very young, the boy had developed a protective gloss of arrogance over the years, along with a caustic Brooklyn wit. Yet Auden was entranced by the fierce love of language and music that frequently surfaced in his conversation — a passion that Chester had nurtured largely on his own throughout his childhood. On the surface, the insouciant, sexually confident Jewish teenager appeared to have little in common with the thirty-two-year-old product of early-twentieth-century, anti-Semitic, middle-class England. Yet Auden may have glimpsed a reflection of what he himself might have become if he had been born and raised in this wild country rather than his own. As he wrote in his poem "Heavy Date" that year:

> I believed for years that
> Love was the conjunction
> Of two oppositions;
> That was all untrue;
> Every young man fears that
> He is not worth loving:
> Bless you, darling, I have
> Found myself in you.

"I am mad with happiness," Auden wrote to Benjamin Britten, who had himself recently arrived in the United States. At last, after years of grudgingly applauding Isherwood's frequent conquests, the chain-smoking, Benzedrine-popping poet had someone new to pine for, a love challenging enough to get his creative juices flowing. Chester Kallman, young, handsome, vain, intelligent, and unpredictable enough to hold his attention, seemed to have been sent by God.

<center>* * *</center>

Auden's infatuation was so all-encompassing that at first he hardly no-
ticed the successive waves of resentment beginning to reach America
from Britain as a result of his and Isherwood's lengthy absence. Much of
the initial outrage over their departure stemmed from utter disbelief that
two of Britain's greatest young literary figures would prefer uncultured
America to England. By the spring of 1939, however, as Hitler began to
move toward Poland and British military conscription was announced,
the cry for the writers' return grew shrill. Ignoring the fact that war had
seemed much less likely when they left England, pundits and politicians
began to accuse Auden and Isherwood of having deliberately abandoned
their country in a perilous time. Responding to the announcement of the
military draft, Auden presented himself to the British consul in New
York to offer his services, but he was told that only Britons with appro-
priate technical expertise were wanted at this time. Still, Auden knew that
the time to commit himself — to something, anything — was now. He
needed to arrive at some sort of position on the moral and intellectual
questions raised by the advent of war — not because of the hue and cry
in Britain but because it was his duty as a poet living in these times.

At the same time, Isherwood decided to leave New York for Holly-
wood. He "wanted to get away from New York and into the 'real' Amer-
ica," he later wrote. He hoped to find work in the movie industry, "but I
. . . was not sure of anything, even staying in America."

Auden knew he would deeply miss his friend, who had served as a
spiritual brother since their days at St. Edmund's preparatory school in
Surrey. He had come to depend on the constant presence of this com-
panion with his "squat spruce body and enormous head," as he had de-
scribed Isherwood in *Look, Stranger!* in 1936. Still, he had Chester. Auden
had been spending a great deal of time with Kallman's family in Brook-
lyn, scribbling poems on the subway as he traveled there and back each
day, fixed on the idea of settling down permanently with his young lover.
Once the idea occurred to him, he couldn't let it go. He began to analyze
— in his poetry and conversation — the personal responsibilities and
commitment that he was convinced should accompany true love. Auden
had always used his life as the ever-evolving medium from which to forge
his philosophical ideas, however much those ideas might change from
day to day. Now, having largely given up on political activism and having
been turned down for military service, he looked to his love affair for the
raw material from which to create his poems.

Auden began to consider himself married to Chester and wore a wed-

ding ring for a brief period — though the ring soon vanished. Once the college semester ended, he convinced Chester to accompany him on a cross-country "honeymoon" — traveling south by bus to New Orleans, west to New Mexico, on to California to visit Isherwood in Hollywood, and then back to New York by train. Like most honeymoons, the vacation had its sublime moments — a hilarious afternoon with the widowed Mrs. D. H. Lawrence in Taos, during which Auden accidentally walked off with the key to the chapel containing Lawrence's ashes — and its disappointing ones, as when Chester flirted with the various youths he met along the route. Auden was appalled by parts of the country he'd never seen before (later deploring the "unspeakable juke-boxes . . . the anonymous countryside littered with heterogeneous *dreck* and the synonymous cities besotted with electric signs") and objected to Chester's constant quoting of Hart Crane, whose work Auden disliked. He was also disappointed in the cultural environment around Taos, "dotted with the houses of second rate writers and painters. It's curious how beautiful scenery seems to attract the second rate. For me, I like it for a holiday, but I'd rather die than live permanently in a beauty spot, at least till I'm much older." But when he and Chester holed up in a borrowed mountain cabin by themselves, they had an unforgettable, pleasantly debauched time.

All that summer, Chester practiced writing poems in a notebook much like Auden's, which he had bought at a stationer's on Montague Street in Brooklyn; Auden was hard at work on a prose work called "The Prolific and the Devourer," influenced by Blake's *Marriage of Heaven and Hell* and the *Pensées* of Pascal. The discourse, written in the form of an interview or dialogue, was Auden's attempt to work out, in logical steps, the artist's duty in times of war. Was it to fight as a soldier like any other man, to put his particular gifts to use in the creation of propaganda or other material to support the war effort, or to remain outside the conflict and dedicate himself to the interpretation of human nature? By choosing this last option, perhaps artists could help lead men out of their trap of violence or at least give them something to live for afterward.

Isherwood, with whom the pair reunited when they arrived in Los Angeles, startled Auden with the announcement that he had chosen, along with his British colleagues Aldous Huxley and Gerald Heard, a pacifist stance toward the European conflict. He simply could not accept the possibility of killing any of the German boys he had known and cared for, he said — nor, for that matter, any German boy cared for by anyone else.

Since his arrival in Hollywood, he had taken steps to inform his pacifism by studying Vedanta philosophy and practicing yoga. These actions forced Auden to consider his own willingness to become a soldier. He had already stated, in "The Prolific and the Devourer," his belief that artists did not belong in the realm of politics — both because they were likely to prove ineffectual and because they had other, separate but equally important work to do. If this work concerned, as he had suggested, making us "more aware of ourselves and the world around us" so that we might become more difficult for politicians to deceive, then it was the artist's responsibility to seek out and communicate those truths that could help raise human consciousness toward greater understanding and better actions.

But did this belief lead directly to nonparticipation in any war? Auden now added a question-and-answer section to the end of his prose piece in which he served as his own interrogator to explore this issue, among others. Asking himself whether he had become a pacifist, he appeared to try on Isherwood's views when responding, "The trouble about violence is that most of the punishment falls on the innocent. That is why, even if you imagine you are fighting for the noblest of ends, the knowledge that it is more your children than yourself who will have to pay for your violence . . . should make you hesitate." But he also restated his belief that as a person who, like everyone else, had been quite willing to help create the current situation in Europe through thousands of small, thoughtless actions, he could hardly justify avoiding the consequences by refusing to don a uniform. Still, it was best to leave the conduct of wars "to those who believe in them" for as long as possible, he wrote. His abilities were put to better use in the classroom and on the page. The artist and the politician must accept their differences and instead focus in their separate realms on doing their jobs well.

Unsatisfied, Auden wrote in the role of interrogator, "You keep evading the real political issue." To some extent this was true. Despite pressure from England and the implicit pressure from Isherwood, Auden remained undecided about his place in the rapidly changing world situation. On the one hand, he glumly remarked that if he chose the path of pacifism, he would probably have to start studying yoga when he returned to New York. On the other, he wished he could simply forget about current events.

Work and love were both progressing well for him that summer. "For the first time I am leading a life which remotely approximates to the way

I think I ought to live," he wrote to a friend back home, adding, "I never wish to see England again. All I want is, when this is over, for all of you to come over here."

But political events continued apace. Traveling back to New York on the train with Chester, listening to the radio, Auden wrote to a friend that "every hour or so, one has a violent pain in one's stomach as the news comes on." Pain or not, the news kept coming, and every hour it was worse. Edward R. Murrow, the bane of British emigrants with his grim reports from London, broadcast the day's evacuation announcements: "If you live in one of the areas mentioned and have a child of school age, and wish to have him evacuated, send him to school tomorrow, Friday, with hand luggage containing the child's gas mask, a change of under-clothing, night clothes, house shoes, spare stockings or socks, a tooth-brush, a comb, a towel, soap, facecloth and if possible a warm coat or mackintosh, a packet of food for the day. Schoolchildren will be taken by their teachers to homes in safer districts . . ." Frequent news bulletins spoke of German troops massing on the Polish border. Finally, on September 1, 1939, as the two men arrived back in New York, they heard the words Auden had been dreading. Hitler's armies had invaded Poland. The war in Europe had begun.

If ever there was a time when the right words were needed, this was surely it. This war, as virtually everyone in Europe now understood, was not simply a question of national sovereignty but a battle over human freedom, over the human soul. If the evil set loose in the world were to be conquered, those who were its enemies would need all possible insight, understanding, and wisdom to achieve their goal. Having settled back into his room at the George Washington Hotel, Auden began writing "September 1, 1939," perhaps the first poem written in World War II and a work that not only defined the awful inevitability of this war for so many but felt uniquely prescient in America even decades later:

> I sit in one of the dives
> On Fifty-second Street
> Uncertain and afraid . . .

The "dive" was Dizzy's Club, a bar on the Midtown jazz strip fre-quented by Chester and Harold Norse. Dizzy's was "the sex addict's quick fix, packed to the rafters with college boys and working-class youths," Norse wrote. "Amid the laughter and screaming and ear-split-

ting jukebox music, it was like an orgy room for the fully clad." Chester Kallman had introduced Auden to the place on their return to New York. Returning alone one evening, Auden took a table in a corner of the room and began writing. Similar clubs that he had known in Berlin no longer existed — their denizens, owners, performers, and financiers now imprisoned, exiled, or dead. The same fate was likely to have befallen any poets writing at a corner table, any readers who enjoyed their poems when published, and whoever might have helped lead the poetry to fruition. Those who had escaped were now in Paris, or Amsterdam, or even London. But they had better move on soon. New York itself — and open environments like Dizzy's, places where individuals were free to love, to experiment, to live without punishment — might not be immune.

> I and the public know
> What all schoolchildren learn,
> Those to whom evil is done
> Do evil in return . . .

"I'm sure we are all in for a bad time during the next six months, perhaps for being killed," the novelist E. M. Forster wrote to Isherwood from London. "That's one of my reasons for not wanting you and Auden back here. Another is that you both must and can carry on civilization."

> All I have is a voice
> To undo the folded lie,
> The romantic lie in the brain
> Of the sensual man-in-the-street
> And the lie of Authority
> Whose buildings grope the sky . . .

With the horrors of Berlin, Spain, and China still vivid in his mind, along with his recent efforts to define his own responsibilities in time of war, Auden concluded:

> Defenseless under the night
> Our world in stupor lies;
> Yet, dotted everywhere,
> The little points of light
> Flash out wherever the Just
> Exchange their Messages:
> May I, composed like them

Of Eros and of dust,
Beleaguered by the same
Negation and despair,
Show an affirming flame.

Even before the poem appeared in the pages of the *New Republic* that October, Auden regretted what he considered the false emotion, the self-aggrandizement, of "September 1, 1939." Prior to its publication, he had tinkered with various lines. But no matter what he omitted or altered, the poem continued to strike him as "infected with an incurable dishonesty." As an ordinary man more interested in his love affair than in Europe, how could he claim any special ability to "show an affirming flame" or in any way affect matters in the future? Loved as the poem has been for generations, it was rejected by its author almost from the start.

Auden's faith in his ability to create positive change was again profoundly shaken when he attended a German cinema in Yorkville, a neighborhood of German immigrants near the apartment he and Isherwood had shared. To his surprise, it screened a Nazi propaganda film showing the recent invasion of Poland. Watching Hitler's soldiers marching through the streets lined with defeated men, women, and children, members of the audience began to yell, "Kill them!" and "Kill the Poles!" Appalled, Auden was filled with the sense, as he later described it, that "every value I had been brought up on, and assumed everybody held, was flatly denied." Instead, he witnessed "the brutal honesty of the assumption that might is right." Here in New York were the viciousness and hatred he thought he had left behind ten years earlier in Berlin. But now its perpetrators were panting at the prospect of victory. The moment was so ugly that Auden despaired of ever finding any remedy for such evil.

Throughout the following months, as Britain braced itself for a German attack that never came, as Norway fell, then Denmark, then Holland, Auden worked on his next major poem, "New Year Letter," and the Commentaries that would accompany it — another attempt to work through his sense of what the artist's role should be in relation to society, especially during wartime. The process proved difficult — he made many more deletions and corrections than usual. This was not surprising, as the news continued to be depressing and distracting throughout this period, when he was trying to create a new philosophy utterly different from any that he had held before.

But it was the useful kind of difficulty, precisely the type that, Auden believed, every artist was put on earth to face. "While those whom we love are dying or in terrible danger," he stated in a commencement address at Smith College on the day France fell to Germany, "the overwhelming desire to do something this minute to stop it makes it hard to sit still and think. Nevertheless that is our particular duty in this place at this hour. To try to understand what has come upon us and why." Quoting Rilke, whose *Letters to a Young Poet* he had recently read, Auden insisted that "we must always hold to what is difficult, then that which now still seems to us the most hostile will become what we most trust and find most faithful . . . perhaps all the dragons of our lives are princesses who are only waiting to see us once beautiful and brave. Perhaps everything terrible is in its deepest being something helpless that wants help from us."

By the time George Davis approached Auden with his proposition for 7 Middagh Street, the poet had already reached another turning point in his thinking. Much of his developing philosophy had to do with a growing conviction that, contrary to his earlier belief in the essential goodness of human nature, the type of evil overtly expressed by Hitler and others like him existed potentially in every human being. "Terrifying powers work within us, or are carrying out their work through us," Auden wrote that year, and these powers could never be fully eradicated — not through art, education, economics, politics, or any other means. This did not mean he believed that one should stand by and allow the individuals who chose to act on their evil impulses to continue. It did mean, however, that another approach must be taken in fighting them. No one could operate from the assumption that he was immune to infection or was not causing a form of the disease himself. The flip side to this belief was the idea that a higher consciousness — the truest and best of human thinking — was equally potentially present in every human soul. In his new writing, Auden hoped to increase his own and others' awareness of the "Hitler" in all of us as well as the divine.

By now, however, the actual Hitler was out in the world, initiating the bombing of Britain. When the RAF retaliated, he announced over the airwaves, "I have tried to spare the British. They have mistaken my humanity for weakness and have replied by murdering German women and children. If they attack our cities we will simply erase theirs." All British

men in America between twenty-one and thirty-five had been called back to England, though none had yet departed. Since Auden had registered his intention to acquire American citizenship, he was no longer wanted by the British military, though he was now eligible for the American draft. Nevertheless, reports continued to arrive from England of caustic remarks in newspapers and literary journals about the continued absence of Auden, Isherwood, Aldous Huxley, and other British artists.

Cyril Connolly, the editor of a new literary journal, *Horizon,* had referred to Auden and Isherwood the previous winter as "ambitious young men with a strong instinct of self-preservation, and an eye on the main chance, who have abandoned what they consider to be the sinking ship of European democracy." This was followed by an expression of concern by Auden's friend Harold Nicolson, in the *Spectator,* that the writers' presence in America might discourage Americans from supporting the fight against Hitler since "four of our most liberated intelligences refuse to identify themselves . . . with those who fight." Other comments seemed motivated more by panic over Britain's situation or by personal animosity than by the writers' absence. George Orwell was quoted as remarking that "Mr. Auden's brand of amoralism is only possible if you are the kind of person who is always somewhere else when the trigger is pulled." Verses were published in the newspapers, satirizing the "cowardly" writers' escape. In June 1940, Sir Jocelyn Lucas raised a Question in the House of Commons about whether the writers who, he claimed, had sought refuge abroad and stated that they would not fight should be stripped of their British citizenship. The suggestion was dropped in the general chaos that ensued when the minister to whom the question was posed confused W. H. Auden with H. W. "Bunny" Auden, a tennis player who was also out of the country.

Auden, like Isherwood, felt embarrassed by the attention, though he acknowledged that some resentment was understandable, given the situation. He even remarked that he considered Connolly's comment a fair one and insisted that he did not take offense. He did not intend to change his plans at anyone else's behest, but as George had implied, he did perhaps feel more pressure, as a result of this criticism, to use his presence in America to focus even more intently on his work. He could sense a crisis of some kind mounting in his work and in his personal life — and for Auden, the two were closely intertwined. Though not sure what it was, he was certain it would involve a change, so perhaps a change of domicile

was in order as well. It would be a relief, in any case, to share a home with others to whom he did not have to explain any aspect of his private life. He agreed to accompany George up to take a look at the house on Middagh.

By now, the neighbors were accustomed to the sight of the tall, shock-haired poet striding rapidly, cigarette in hand, through the tree-lined streets. George, shorter and softer but with a lively, expressive face that invited inquiry, struggled to keep up. The pink light of sunset reflected off the windows of the mansions facing the harbor, but George hardly noticed as he hastened to fill his friend in on the house's many advantages.

Finally, rounding the corner of Middagh Street, Auden caught his first glimpse of his future home. It was something of a disappointment. The house appeared rather small, actually, and more dilapidated than George had led him to believe. But when given a tour, Auden began to see how 7 Middagh could become precisely the creative incubator George had in mind. He could once again have the top-floor rooms, with a view of the harbor and the Brooklyn Bridge — a view almost as splendid as the one he enjoyed at his place up the hill. He could still enjoy the lonely sound of ships' whistles drifting through his rooms. The basement dining room was quite large, with space for a dozen guests or more, and the kitchen was spacious enough to accommodate them all.

And Auden liked George's idea of trying to stage such an unusual experiment in a house in Brooklyn. George's appreciation for the pleasantly ridiculous made him an enjoyable companion. Carson McCullers, with her difficult accent and her habit of calling him "Winston," was a little strange, but there was no denying that both of them believed in the importance of books and literature and would respect his dedication to his work. George happened to be "pro-frog," whereas Auden was "pro-kraut," which might cause friction, but at least, unlike most other Americans, George did not expect a "serious" poet to wear a long face all the time.

In fact, the waterfront at the foot of the hill behind the Middagh Street house was a favorite destination for George and many of his literary friends in pursuit of illicit adventure. Like Kirstein, Auden could only imagine the stories that might arise from the editor's twenty-four-hour proximity to such a place. In any case, a house such as this one, poised between bourgeois comfort and a district that boasted some of the city's

most unashamed debauchery, could not help but appeal to a poet's sense of metaphor.

Auden asked George whether Benjamin Britten and his partner, Peter Pears, might be welcome at 7 Middagh. George agreed that of course the musicians could have the first available rooms after Auden, Carson, and George himself had moved in. That simply, the agreement was made.

3

The house became a ship, slipped its moorings
... and after years and years I am again at sea.

— George Davis, 1940

Despite George and Carson's enthusiasm for the idea of creating a group home in Brooklyn, the house at 7 Middagh Street required a great deal of work. As the two writers realized on further inspection, the furnace was broken, the banisters wobbled, the floors needed sanding, the walls required plaster and paint, and there was something seriously wrong with the plumbing. Although the separate two-room suites on each floor did provide extra privacy, there were no locks on the doors, and the thin partitions promised to broadcast each housemate's every movement day and night.

Still, these were minor drawbacks, in their view. More important were the large windows framing views of the leafy neighborhood in front of the house and the distant city to the rear, the plaster rosettes on the parlor-floor ceilings, and the carved wooden moldings — plus the enticing promise of personal freedom and intellectual stimulation that came with the lease. George got busy asking around for the names of plasterers while Carson moved her few belongings into her third-floor rooms.

They had decided that, at least while major repairs were in progress, George would take the front half of the top floor, whose large sitting room and small bedroom faced quiet Middagh Street and the walled rear garden of another brownstone across the lane. Auden took the corresponding two rooms in the back, with their view of the Brooklyn Bridge and Manhattan's skyscrapers. It was a provocative vista, but there was no danger of its distracting the poet from his work, since the sensitivity of

his eyes required him to keep the curtains closed while he worked. As he had written years before in his poem "Letter to Lord Byron":

> For concentration I have always found
> A small room best, the curtains drawn, the light on;
> Then I can work from nine till tea-time, right on.

Carson, on the other hand, took great pleasure in placing her own writing table directly in front of the large windows of her suite directly below Auden's. She reveled in the sight of the East River sparkling in the sunlight as she arranged her typewriter, notebooks, pencils, ashtray, cigarette lighter, and china teacup within reach. Shabby as the house was, Carson's high-ceilinged rooms, soon to be painted Empire green and hung with velvet curtains, seemed like a palace to her. "At last, after all the years of apartment misery I was living in a comfortable, even luxurious house," she would write. Certainly, it was a far cry from the North Carolina boardinghouse in which she had lived with Reeves, with its plywood partitions so thin that the young couple could never escape the sounds of the sick, wailing baby next door or the arguments, slaps, and weeping of its parents.

It had not been easy to convince Reeves to agree to her decision to move. He resented her abandonment of him at this difficult time in their marriage and did not see why he was not invited to join the group. After all, he knew and liked both George and Wystan Auden, and they enjoyed his company as well. He, too, hoped to write a novel and could benefit from a household designed to facilitate such work. Besides, a group life like the one she described — particularly when run by George Davis — was likely to prove too stimulating for someone as physically frail as Carson. She needed quiet, Reeves insisted, and someone who understood her needs.

It was just the kind of suffocating talk that Carson could not bear, and it only bolstered her determination to begin a new life on Middagh Street. Pointing out how strained their relationship had become, she finally convinced him that a temporary separation would do them both good. On his own, Reeves could perhaps make better progress with his writing or, if he preferred, with finding a job, and Carson would be better able to resume her role as his partner once she had made some headway with her second novel. In the end, Reeves reluctantly helped Carson pack her bags and carry them to Brooklyn. It would not be a complete separa-

tion, they agreed. She would visit him in Manhattan, and he could come out to dinner as often as he liked.

Now, a salty breeze wafting in through the windows beckoned to Carson, and she set out to explore her new neighborhood. This was always her first action when moving to a new location. Not only were long daily walks a therapeutic part of her writing process, helping her to sort out her thoughts, but the sights she saw and the people she met never failed to provide new ideas for her writing.

She quickly familiarized herself with Middagh Street, which stretched west for several blocks past a tiny fire station, a red brick parochial school, and a modest candy factory emblazoned with the sign PEAK'S MASON MINTS. Maple trees overhung the sidewalks, their flaming red autumn leaves used by the neighborhood children to build bonfires in the gutters. Carson soon got to know the man living in the house to the left of 7 Middagh, who had agreed to deliver their coal, and the woman to the right, who shared her home with a dozen stray dogs and a pet monkey and who was rumored to be very rich and very stingy. Carson was intrigued to learn that, frail as this elderly woman appeared, she had once been jailed for smashing the windows of a saloon in a temperance riot.

Such local gossip was provided by Mr. Parker, the druggist in the small pharmacy on the first floor of the clapboard house on the corner. He was a shy man with a carefully groomed yellow mustache whom Carson got to know while weighing herself each morning on the pharmacy scale. She had noticed that as she balanced the weights, Mr. Parker would move noiselessly to her side to check the results. He "always gives me a quick little glance," she wrote, "but he has never made any comment, nor indicated in any way whether he thought I weighed too little or too much." Carson had already developed a special fondness for him after overhearing through the open windows of his shop his determined efforts to help his uninterested daughter with her schoolwork. Night after night, his patient voice floated down the quiet street — "The square of the hypotenuse of a right triangle is equal to . . ." — apparently to no avail.

Mr. Parker passed on to Carson many of the old legends of Brooklyn Heights, a number of which she recorded at her desk for later use. She learned about Love Lane, a narrow alley named for an attractive young woman who shared a house on its corner with her two bachelor uncles. The girl was so charming that suitors lingered longingly outside her window every night, writing poetry on the fence and crowding the sidewalks

so that the neighbors hardly had room to pass. The girl was long gone now, but the street name remained.

Middagh Street itself had quite a different history, having been dominated for decades by the legendary Miss Middagh, the last matriarch of the Dutch family that had established a mill on this site in the early eighteenth century. Late in life, Miss Middagh had decided that it was wrong for the streets to bear the names of the most prominent residents, so she began slipping out late at night and tearing down the street signs. Each time the signs were replaced, the opinionated Miss Middagh tore them down again until the city gave up and changed the street names to the fruits Carson saw now — Pineapple, Orange, Cranberry Street, and so on. By the time of her death, Miss Middagh's name was the only one remaining on the street signs of the North Heights. And so she left this earth a satisfied woman.

Carson appreciated the Middagh family's choice of a hilltop location for their business and home. Another advantage of the site was its proximity to the sea. Carson loved the sight of seagulls overhead and the sounds of shouting workmen that drifted up from the active wharves and warehouses of the waterfront. "Isn't it wonderful to live in a neighborhood with fresh salt air!" she would exclaim when she returned home from her wanderings. She was likely to be greeted by the sight of George Davis, still in his bathrobe, sleepily directing the work of a carpenter or painter in the parlor or the narrow front hall. A number of workmen had begun repairs on the house, but as their employers enjoyed sitting down with them for a drink or a chat, they made slow progress. One of them, an Italian-American carpenter whom Carson liked for his habit of whistling arias as he worked, brought a bottle of homemade wine to work one day to celebrate the birth of his first son. After they had finished the wine, the carpenter invited Carson to join the festivities at his house at the opposite end of Brooklyn, in Sheepshead Bay. Carson enjoyed meeting his many relatives and neighbors and sampling the local provolone and Italian pastries, along with more of the wine. She was especially taken by the electrician's grandfather, who "had the face of a charming old satyr," she wrote, and who said of the new baby, "He is very ugly, this little one. But it is clear that he will be smart. Smart and very ugly."

Surely, such an experience was worth the delay in getting the stairs fixed. And even if the repairs were taking longer than expected, the house had begun to come together in other exciting ways. George's former col-

leagues at *Harper's Bazaar* had been thrilled to hear about his new experiment and were quick to show their support. A flood of housewarming gifts arrived from Manhattan in what Carson described as a kind of "multiple bridal party." The cover illustrator Marcel Vertès sent George watercolors for the walls, Diana Vreeland donated a grand piano for musical evenings in the parlor, and other friends contributed piles of curtains, dishes, and kitchen appliances. A new gramophone arrived as well, allowing George to play selections from his prized collection of French music hall records and Carson her recordings of Schubert and Bach. Meanwhile, George's own furniture was delivered, and several unused rooms were soon stuffed with mahogany bookcases, glass-fronted cabinets, S-shaped loveseats, oil lamps, gilt-framed mirrors, and an apparently infinite array of unusual American *objets d'art* for the house once the repairs had been made.

This accomplished, George could devote himself to what he considered the most enjoyable part of moving into a new home: hunting down additional necessities at the Curio Shoppe on Manhattan's Third Avenue, Miss Kate's junk shop on Brooklyn's trolley-rattled Fulton Street, and other such mysterious emporiums where he preferred to spend his time. Carson, too, became enchanted by this world, seemingly frozen in time, when she accompanied George on his expeditions. Miss Kate, the Brooklyn junk store proprietor, was a "lean, dark, and haggard" woman, Carson wrote, who slept in her shop most nights "wrapped in a Persian rug and lying on a green velvet Victorian couch." She had one of the handsomest faces Carson had ever seen, but also one of the dirtiest. A neighboring merchant remarked admiringly that Miss Kate was a good woman, but "she dislikes washing herself. So she only bathes once a year, when it is summer. I expect she's just about the dirtiest woman in Brooklyn."

By the time Auden arrived on the first of October, Carson and George felt they had made a great deal of progress toward rendering the place habitable. A number of George's motley collection of companions, including eighteen-year-old Victor Guarneri, who worked part-time as a stevedore on the Brooklyn waterfront, and Frankie Abbe, George's former secretary, who had recently separated from her husband and now spent much of her time at the house, had helped move furniture, hire repairmen, stock the kitchen, and otherwise get the house working. Still,

Auden was alarmed to see the chaotic state of his new home. While it was true that George had carefully arranged the piano and other furniture in the parlor, for example, the repairmen were still working there, and the room was filled with construction debris and plaster dust. Half-eaten meals were abandoned on the piano or wherever else they had been wolfed down, and dirty dishes piled up not only in the kitchen sink but in the ground-floor bathtub as well. George's knickknacks seemed to cover every flat surface, chairs and tables were stacked everywhere, and aside from the hasty placement of a table and chairs near the kitchen door, the rear garden had been left overgrown with ivy and weeds. Worse still, since the furnace had not yet been repaired, the house had no heat or hot water, nor did the toilets always work.

Perhaps it was simply how Americans lived. Auden and his fellow expatriates had already learned to adjust to life with people who manipulated their eating utensils in strange ways and dined on remarkably odd combinations of food ("insane salads," Auden would comment), who said "a quarter of five" instead of "a quarter to five," and in general behaved in uncivilized ways. Auden himself did not object to a high level of physical disorder in his domestic life. He was well known for living in dimly lit rooms littered with books and papers, overflowing ashtrays, and dirty martini glasses, all lightly dusted with cigarette ash and half-hidden by the cloud of smoke that generally surrounded him.

But now, when he hoped to focus on his work with special intensity, the poet urgently required a quiet space and a predictable routine. In his apartment on Columbia Terrace, he had been able to adhere to his preferred schedule of several daily writing sessions interrupted only by meals, afternoon cocktails, and bedtime at ten o'clock. At 7 Middagh, he found that at ten o'clock George was just beginning to gather energy for his favorite part of the day. Heading into Manhattan to gather friends from the theater and Midtown restaurants, George spent the night touring New York's nightclubs, bars, and brothels, and then stumbled home with friends in tow for several alcohol-soaked hours of soul-searching before dawn. After his guests left or passed out in their chairs, he would turn to his clacking typewriter, writing the long, confessional, self-dramatizing letters so familiar to his friends. On many occasions, when Auden came downstairs in the morning, he would find George Davis passed out on the sofa, fully dressed. There he would remain through breakfast and much of the morning until nearly noon, when one was

likely to glimpse him stepping naked over the plumber, murmuring sleepily, "Vex not his ghost: O let him pass!" from *King Lear* on his way to the bath.

The daytime work hours were not much better, with the kitchen often full of chattering photographers, actors, artists, and other curious visitors. Throughout the afternoon, George could be heard talking on the telephone with his many friends in Manhattan, opening each conversation with "What's going on?" in his warm, teasing tone. Then he would go on to report the day's gossip, honing with every call his descriptions of the "ruin" he had rented and the adventures he had been having as a result. Carson, too, seemed to find it hard to concentrate; she clattered down to the kitchen several times a day to refill her thermos with a mixture of hot tea and sherry she had affectionately nicknamed "sonnie boy." Most alarming to Auden, meals turned out to be equally casual. Carson enjoyed playing chef, but her menus were limited to such dishes as meat patties, canned green pea soup with wienies, and a concoction she called "Spuds Carson" — mashed potatoes mixed with onions, cheese, or whatever she found in the larder. Even these were often burnt to the consistency of charcoal, since Carson tended to wander off and forget that she was cooking. George, while capable of throwing together a delicious dinner, preferred to dine out at one of the sailors' hangouts in the neighborhood, such as Lottie and Jack's on Pineapple Street, when not with friends in Manhattan.

It was ironic that Auden should find himself in such a situation, since he had been considering at length, in both his recent essays and in the long poem "New Year Letter," the ideal conditions necessary for creating good works of art. If it was the artist's job to perceive and tell the truth, and if this duty appeared to have become especially important in light of recent events, how could it be best facilitated? Long before arriving at Middagh Street, he had discarded the romantic idea that unbridled bohemianism was likely to lead to the creation of anything worth reading, looking at, or listening to. The fundamental premise on which bohemianism was based — the idea that "'good' equals what the bourgeoisie do not do" — was self-evidently false. Regular meals and quiet work hours were required for efficiency in every realm, and just because factory owners relied on them should not prevent artists from doing so as well.

On the other hand, naturally, it was also possible to go too far in the direction of the aesthetically sublime. Auden had conveyed the appeal of the orderly environment in a brief but memorable portrait in "New Year

Letter." Written in the form of a thank-you letter to a friend after a visit to her home, he had recalled their experience of listening to music together during the week that the war in Europe began — enjoying the benefits of a civilized life even as it was threatened. He had then added:

> To set in order — that's the task
> Both Eros and Apollo ask;
> For Art and Life agree in this
> That each intends a synthesis,
> That order which must be the end
> That all self-loving things intend
> Who struggle for their liberty,
> Who use, that is, their will to be.

The hostess to whom the poem was addressed was Elizabeth Mayer, the wife of an émigré Jewish psychiatrist and mother of two adult and two adolescent children, at whose home Benjamin Britten and Peter Pears had been living intermittently for more than a year. The Mayers had come to America from Munich, where Elizabeth, who had been trained as a pianist, had held one of the city's most successful *salons*, attended by many of Europe's most talented writers, artists, and musicians. Now living in a small cottage on the grounds of a sanatorium in Amityville, Long Island, where her husband served as medical director, Elizabeth continued to invite dozens of artist friends to spontaneous large dinner parties and for overnight stays, despite her small quarters.

Britten had described Elizabeth in a letter as "one of those grand people who have been essential through the ages for the production of art; really sympathetic & enthusiastic, with instinctive good taste." Indeed, the formidable Elizabeth seemed to devote more attention to her guests than to her children, whom she would send to an empty patient's cottage if necessary (to their wry amusement) to make room for another musician. When Auden came to visit, Elizabeth set up a writing table for him at the end of the living room, opposite Britten's place at her Bechstein piano. She would then move between the two all afternoon, supplying Britten with food — she considered him too thin — and Auden, in his cloud of cigarette smoke, with cups of tea. After dinner, they would listen to recordings on the gramophone or, even better, Britten would play the piano for them and Pears would sing.

Britten and Pears, whom the Mayers playfully referred to as "the geniuses," considered the house in Amityville a kind of paradise. Auden,

too, as his poem demonstrated, found great pleasure in the reliability and comfort of the life there. But in his poem he had explored the idea that such highly nurturing environments could also harm the artist because they were essentially closed. By limiting the possibility of change and access to the unknown, they prevented the artist from encountering the ambiguous or difficult elements that would spur him toward true creativity and expression. Without the random interloper that interferes with his perfect vision, Auden suggested, an artist becomes stagnant and only repeats himself in a cosseted, self-reflecting cycle. One could even say that at times the Devil himself served God's purpose, then, by luring the artist toward inauthentic paths and thus revealing to him, by contrast, what his true path had always been.

At 7 Middagh Street, Auden saw an opportunity to create a viable balance between the closed domestic perfection of a home like Elizabeth Mayer's and the romantic, bohemian chaos that he had discovered on moving in. Rather than living apart as separate individuals in "a crowd of lost beings," they could create a true community — a rational society united by their common values and passions that left room for the unexpected.

Granted, even by mid-October they were far from having achieved that goal. Auden's friend, the writer James Stern, and his wife, Tania, were surprised to find, when they dropped in one afternoon, "George naked at the piano with a cigarette in his mouth, Carson on the floor with half a gallon of sherry, and Wystan bursting in like a headmaster, announcing: 'Now then, dinner!'" Even Britten and Pears had been unable to hide their shock and disappointment when they had visited their future home at around the same time, only to discover the workmen still at their task and the house itself squalid almost beyond belief. "They're incredibly slow! Don't you believe that this country is so marvelously efficient!" Britten wrote of the workmen after he and Pears had hastened back to Elizabeth Mayer's house with the promise to return for another inspection in about a month's time. But despite this evidence, Auden believed that a healthy group life was possible. All they needed were some rules.

It was clear now, and should have been clear from the beginning, that George Davis was not the one to provide them. As brilliantly as the editor acquitted himself at both the high and low extremes of New York life, he was also, of all the people Auden knew in the city, perhaps the least able to manage the conventions and requirements of everyday living. Everyone knew, for example, that the editor's odd apparel, borrowed from

friends or rescued from thrift shops, resulted from a horror of the ordinary so pronounced that he would do almost anything rather than enter a department store. Banks so discomfited him that he preferred to beg the assistants at *Harper's Bazaar* to cash his paychecks for him. And, as Auden now discovered, the furnace remained broken because George had run out of funds but could not force himself to bring up the subject of money with his housemates. He believed that as writers, Carson and Wystan should not have to think of such things.

Finally comprehending the situation, Auden approached it with characteristic good humor. A group house like this one required a firm guiding hand, he told George, and for this job he nominated himself. He was thoroughly familiar with the requirements of communal living; he had attended boarding schools for years and served as an English public school teacher with sufficient skill and enthusiasm to have been nicknamed by his students "Uncle Wiz." Now, taking his place at the head of the table, he announced with relish that several goals must be attained before 7 Middagh Street could become the catalyst for creative productivity that they all desired. First, they must agree on a schedule of regular hours for work and for socializing, and during work, silence must be maintained. Second, a list of chores must be created and divided among the residents as best suited their talents and needs, and these tasks must be completed. Third, they must find a way to raise money to pay for necessary repairs and then invite others to move in as quickly as possible to facilitate the payment of rent. Auden himself would be responsible for collecting the rent, paying bills, and scheduling repairs. It would be excellent if they could afford a cook as well, eventually. He and Isherwood had had a cook named Elizabeth at their apartment in Manhattan, and he still recalled with great pleasure her pleasant company and "civilized meals."

Carson and George responded enthusiastically to Auden's efforts to take charge. Carson volunteered to wash dishes and provide wine for dinner when she could afford it, and George got on the telephone to solicit magazine work for all three of them. In the meantime, Auden improvised for himself a schedule of early-morning work sessions in his room (before any workmen arrived) and a second session, beginning at 10:30 A.M., at a corner table at a nearby cafeteria. Sending one of his poems to Harry Brown, a fellow poet and admirer who worked at *The New Yorker,* he added a note: "Dear Harry, PLEASE sell this to the New Yorker as I am VERY VERY VERY poor . . . I STILL HAVE NO HOT WATER I STILL HAVE NO HOT WATER. I shall go crazy."

It was thrilling to George and Carson to watch this intelligent, inquisitive, critical poet — whose focused energy was so different from their own — bring their domestic lives into order. Clearly, Auden enjoyed organizing other people's lives and could be depended on in every way, in MacNeice's words, to be "getting on with the job." By the end of the month, they began to see results. George's networking efforts garnered commissions for both Carson and Auden for work to be published in *Harper's Bazaar* and *Vogue* as well as an offer from his friend Louise Dahl-Wolfe to photograph Carson in Central Park, where she had taken pictures of Auden and Isherwood two years before. Auden would supplement his own income through a number of essays and book reviews for *Common Sense,* the *Nation,* and other journals in the coming weeks, while George, who had not yet gotten around to beginning his novel, considered writing some *New Yorker* profiles instead. Until the checks started to arrive, they would have to make do with the money they had. But at least Auden and Carson were enjoying regular work hours again, and George had enlisted Victor's help in throwing together occasional evening meals.

Often, a dinner prepared for four or five would have to be stretched to serve six, seven, or more, when friends stopped by to spend the evening: Reeves McCullers, Chester Kallman, Frankie Abbe, James and Tania Stern, Lincoln Kirstein, Klaus Mann, back from California, Annemarie Clarac-Schwarzenbach occasionally, and even Carson's friend from Bread Loaf, the Brooklyn native Louis Untermeyer, on one or two occasions. These feasts, while still held in primitive circumstances with an understocked kitchen and amateur cooks, proved lively as Auden's housemates discovered that the poet was not as conventional as he liked to pretend. Wolfing down his food, taking big swallows of cheap Chianti ("I have the digestion of a horse as you know," he later admitted), he tossed out opinions almost faster than his listeners could take them in. He did not particularly like teaching college students, he might remark, because he felt that by their age they should be teaching themselves. Or he might begin the dinner conversation with, "There are two things I don't like — to see women drinking hard liquor and to see them standing at bars without escorts." If he could come up with a more provocative or outrageous opener, he would make it. And if George or Reeves or Louis Untermeyer ventured an insufficiently interesting response, Auden was likely to fix him with a look that the poet Joseph Brodsky later described as that of "a physician who is interested in your story though he knows

you are ill." He would then veer into a lively discourse on Rilke, a word game such as Purgatory, in which one chose two people who would least like to be stuck with each other in that realm for eternity, such as Tolstoy and Oscar Wilde, or the loud recitation of his own or another's poetry.

Carson listened in fascination to Wystan's pronouncement that detective stories were virtually the only type of novel that he cared to read. Most other kinds, particularly American novels, lacked interest in his opinion. He disliked Steinbeck's work, for example, since he did not believe that novels could successfully deal "with inarticulates or with failures." Moreover, he was struck by the utter loneliness of American literature. Emerson, Hawthorne, Melville, James — American literature was "one extraordinary literature of lonely people." That was not necessarily a criticism. It was the destiny of all Western nations, as the machine age developed, to lose their traditions, their connections, their allegiances. America was just ahead of the rest of the world in highlighting man's aloneness, his real condition.

Auden spoke so rapidly that his tumbling river of words became incomprehensible at times, particularly as the wine thickened his tongue. The Americans were interested to note that he seemed especially attracted to theories that involved organizing concepts into categories, especially if they applied to human behavior. Jung's typology approach to personality, for example, delighted him, with its neat classifications of individuals into Introvert or Extrovert and those who operated primarily through Sensation, Thinking, Feeling, or Intuition. Auden, for instance, was a Thinking and Intuition type, weaker in the areas of Feeling and Sensation. This meant that he apprehended his life experiences through his intellect rather than his emotions, and only after a considerable delay did his feelings come into play. As a result, contrary to what others often assumed, he learned from such experiences with more difficulty than most, and grew more slowly as a result. Nineteen-year-old Chester, on the other hand, was a Thinking-Sensation type, which enhanced his understanding of music and certain other arts but implied a tendency toward narcissism. What was needed, Auden advised with all the prescriptive self-confidence of a physician's son, was to learn one's missing skills from others who had them. Chester could develop his emotional side through his college friend Elsie, for example, who had once been in love with him, and intuition from Auden himself.

Chester Kallman hardly needed Jung to illuminate either Auden's personality or his own. Now in his final year at Brooklyn College and living

at his father's apartment in Manhattan, he visited Auden nearly every afternoon after classes, occasionally staying the night. As his partner of more than a year, Chester was familiar enough with Wystan's theories to slough them off without comment. Still influenced, perhaps, by his early flirtation with the psychologist Homer Lane, for example, Auden was always insisting that virtually all illness was psychosomatic, the result of the suppression of natural impulses or other unnatural psychic or emotional activity. Rheumatism and arthritis sprang from a stubborn personality. Physical deformity was the product of a struggle between instinct and will. Frustration in love led to boils, and one could get cancer by stifling the creative urge. Auden's own chain-smoking, he liked to point out, was the result of insufficient weaning, while those with bad breath wanted to be left alone. One took a risk arriving at the table with any mild malady, such as a cold, for Auden was likely to pounce with a diagnosis and not let up until the victim agreed with him.

As for the much-vaunted Jungian personality types, Chester had known even before he met Auden that the poet's weakness lay in the realm of feelings or emotions by analyzing his poetry and discussing it with Harold Norse. When confronted, Auden admitted that his poems lacked feeling (though many of his readers would have disagreed) and added that the only way he could evoke emotion in his writing was by first processing it through his intellect, by putting it on the table and analyzing it.

Like most college poets, Chester placed a high value on the convincing expression of emotion and found this form of dry analysis deplorable. He believed, too, that it led to stunning errors in perception. Chester had once described to Norse a time when he and Auden were riding the subway to Chester's grandmother's home and began to argue over which psychological roles they played with each other. As the other passengers looked on in disbelief, Auden shouted over the roar of the train, "I am *not* your father, I'm your *mother!*" and Chester yelled back, "You're *not* my mother! I'm *your* mother! . . . You're my *father!*" "But you've *got* a father!" Auden countered. "I'm your bloody mother and that's that, darling! You've been looking for a mother since the age of four!"

He was referring, of course, to the fact that Chester's mother had died when he was that age. And it was true that Chester liked to tell the story of how he fell in love with his aunt Sadie after his mother's death. His passion for Sadie became so strong that he begged her to marry him when he grew up, and the young woman playfully assured him that she

would. The result was that when she prepared for her real wedding a year later, young Chester felt utterly betrayed. He pitched such a fit that his befuddled family finally told him that he could marry Sadie, too. Thus, Chester stood with Sadie and her groom beneath the wedding canopy and danced with them at the wedding reception until, exhausted, he fell asleep. When he woke, he found the couple gone and himself again unforgivably abandoned. Not long afterward, his father married a woman who would torment him for the rest of his childhood.

This incident proved, as far as Auden was concerned, that Chester still longed for a mother, and he was more than willing to play the part. But Chester just liked to tell the story of Aunt Sadie because it was a good story. In actuality, he was significantly more preoccupied by a longing for the father who, while physically present, had emotionally abandoned him to a sadistic stepmother. Chester chalked it up to emotional blindness when Auden failed to realize that his sexual preferences leaned decidedly toward the punitively paternal.

It amused the Americans to observe how Chester played the untamable foil to Auden's demanding schoolmistress. The teenager's willingness to goad his partner into flights of pique, or to taunt him from across the table with invented bits of verse, kept the conversation raucous and entertaining. Auden himself, stirring an after-dinner martini with his pinky, laughed along with the others when Chester recited such lines as:

> Wystan is like the fire
> That licks along the wood
> Wystan is the desire
> Of mankind for the good
> Wystan is the poet
> That makes the trees to grow
> The trees don't know it
> But Wystan thinks so.

Tania Stern was glad to see Chester win the approval of the table — particularly of Auden, who continued to advise the boy not to try to publish his poetry yet and critiqued his work only on technical grounds, showing little of the outright enthusiasm that young writers crave. Auden acted this way with the best of intentions; he himself regretted having to live with his own published juvenilia and hoped for better for Chester. When critiquing he did not consider the topic of a poem his business as much as its execution, but his limited support inevitably irri-

tated and worried Chester. Auden seemed oblivious, too, Tania noted, to the look on Chester's face when he insisted that it was "not your place" to relate an anecdote about one of his friends or when he abruptly turned his back, shutting Chester out of the conversation. For a boy whom Auden himself had fondly called a "portrait of pure pride," such insensitive treatment boded ill.

In general, however, it hardly mattered whether or not one agreed with Auden. Either way, MacNeice would write, one "came away from his presence always encouraged; here at least was someone to whom ideas were friendly — they came and ate out of his hand — who would always have an interest in the world and always have something to say." Carson, far from being offended by his lack of interest in novels, drank in his remarks about American literature and thought a great deal about them, both at the dinner table and later in her room. By now she had given up on trying to write about the émigré and his friendship with a black man in the South and had returned to *The Bride and Her Brother,* the novel about the adolescent girl with which she had been struggling for nearly a year. Its twelve-year-old, tomboyish protagonist, whom Carson had named Frankie Addams (a nod, it would seem, to her new friend, Frankie Abbe), could be considered precisely the type of "inarticulate" whom Auden claimed could not be represented in fiction. Half-formed and drifting, Frankie dreamed of faraway places, longing in her southern environment to experience snow. She was, in many ways, the embodiment of the loneliness to which Auden referred when he talked of Emerson and Hawthorne. And it was precisely the nature of this inchoate yearning on which she wanted to focus in this novel even more intensely than she had in her previous one.

Carson's own such experience had reached its apogee in the grief she felt as a teenager when Mary Tucker, her piano teacher and first adult friend, moved away. In *The Bride and Her Brother,* Frankie would suffer a similar sense of abandonment when she learned that her brother planned to marry and leave town. Contrary to Auden's opinion, Carson felt that, in a sense, inarticulates and failures may be the only people worth writing novels about. But she also knew that their inability to formulate their feelings made it difficult to portray them. She had to find a way to put Frankie's undefined yearning into a form that could be grasped by the reader and fully understood.

Despite Auden's tendency to dominate the conversation, others managed to have their say as well. Carson, a consummate storyteller, de-

lighted her housemates with her descriptions of life in Georgia. She might recount, her slow drawl growing more pronounced the more she drank, the kinds of nicknames that Southerners give their family members — Brother Man, Little Bob, sister, baby-child, honeybunch, and her favorite, "King the Beauty," still used for her young cousin, now grown. She could list the descending social categories of the South, from "plain" to "common" to "common as pigs' tracks," or describe the hot summer nights she used to spend with her five cousins on the wide sleeping porches back home and the homemade ice cream they used to make and eat every Sunday. Her new friends especially liked the southern phrases she recalled from her childhood, such as her father's remark that "if I hadn't sold that Coca Cola stock I could just sit and pat my foot."

Klaus Mann, too, captured the others' attention with a description of the rescue from France of his younger brother, Golo, and his uncle Heinrich Mann — both now safely recovering at Thomas Mann's house in Princeton. Lincoln Kirstein added a certain gravity to the group that could even charm when lightened by the presence of one or more of his dancers. And George Davis, as always, was able to recount the most tragic news or bit of theater gossip in a manner so studied and mock-sincere as to leave the others weak with laughter. As November drew near, these intimate dinners at 7 Middagh became an almost nightly festival of "gobble and gossip," providing precisely the balancing element of intellectual stimulus that Auden had hoped for.

With the parlor still a shambles, the group frequently went out for their after-dinner drinks — often downhill to the decadent Sands Street district bordering the Brooklyn waterfront. "Hell's Half Acre" was the nickname Sands Street had been given by the local population. Hell or not, the brawling bars, tattoo parlors, and male and female brothels adjoining the piers were known around the world as the place any right-thinking sailor would want to go when he died. Naval officers in uniform tended to congregate uphill at the St. George Hotel, where elegant dining, dancing, and more discreet assignations were available, but George was convinced that this seedy district's cruising sailors, cheap liquor, and barroom imbroglios made for better entertainment.

That autumn of 1940, the Brooklyn waterfront had become an increasingly exciting destination. While the war had virtually ended the luxury liner traffic between Europe and New York, emptying many of Manhattan's piers, Brooklyn's docks served primarily cargo and were now

benefiting from a frantic rerouting of world trade. African and South American freighters brought their aromatic spices, coffee, and other goods to Brooklyn instead of Britain or France, picking up American automobiles and manufactured goods for the journey home. By October, sixteen steamship lines serving South America were docking in Brooklyn, while six New York companies provided weekly sailings to Capetown and other African ports. The few British and Dutch ships that arrived slipped into the docks with their guns and camouflage paint like harbingers of doom — the British freighters fetching food for their beleaguered homeland while the struggling Dutch maintained a single route between Brooklyn and the East Indies.

The new ships brought an exotic flavor to the run-down district, whose only other income came from the thousands of blue-collar workers at the nearby Brooklyn Navy Yard. The mix of immigrant laborers, their numbers expanding weekly to fill new orders for the coming war's fleet, with thousands of footloose sailors and the kind of drifters who gravitate to waterfront life, created a rough-and-ready, Wild West atmosphere that the Middagh Street crowd found irresistible.

The writers soon became regulars at such places as Tony's Square Bar, known as the toughest sailors' bar in the world. "All the bars exploded into fisticuffs. It seemed to be a navy tradition," recalled one enthusiastic patron, but Tony's had the reputation for maximum excitement at a minimal price. In other taverns down the block, Carson wrote, one could observe the "vivid old dowagers of the block who have such names as The Duchess or Submarine Mary. Every tooth in Submarine Mary's head is made of solid gold — and her smile is rich-looking and satisfied." These two older prostitutes had a stable list of sailor clients "and are known from Buenos Aires to Zanzibar. They are conscious of their fame and don't bother to dance or flirt like the younger girls, but sit comfortably in the center of the room with their knitting, keeping a sharp eye on all that goes on."

The area no doubt stimulated Carson's memories of the riverfront shantytowns she had explored in her childhood and reminded George of Detroit's Greektown and Auden of the alleys of Shanghai. But George most enjoyed bringing along guests who were either the least likely to come across the district on their own — Columbia professors, editors from *Vogue* — or who could by their presence step up the intensity of the show. Among the latter was one of his closest friends and America's best-known burlesque star, Gypsy Rose Lee. The sight of this bejeweled, er-

mine-cloaked stripper descending on Sands Street after a Broadway show always created a gratifying stir among the sailors.

Carson, too, thrilled to meet a star like Gypsy, and it was a good time for the burlesque star to be out celebrating. Although only twenty-six (or perhaps twenty-nine — due to her mother's habit of forging her children's birth certificates, Gypsy could never be sure of her age), she was enjoying the highest peak yet in an extraordinary career. That summer she had starred in *The Streets of Paris,* a wildly popular revue at the New York World's Fair, where the producer Mike Todd had not only paid her $4,000 a week but had posted her image forty feet high — "larger than Stalin's" — on the front of the Hall of Music. With that success behind her, Gypsy was now appearing on Broadway opposite Bert Lahr in the Cole Porter musical *Du Barry Was a Lady* when not posing for photographs for *Harper's Bazaar,* attending parties on Park Avenue, or otherwise getting her name mentioned in New York's gossip columns. Over the past decade, such activities had helped expand Gypsy's fame as a performer from the tawdry, post-vaudeville strip club circuit of the Depression to the classier burlesque "opera houses" of New York, Chicago, and other large cities and finally to the more legitimate stages of Broadway, Hollywood, and the World's Fair.

One sign of her success was the extraordinary number of Gypsy imitators who populated New York's bars and nightclubs in the early 1940s — from the "sepia Gypsy" in a Harlem cabaret, to "Gypsy Voga Lee" in a traveling "Cavalcade of Girls," to "Our Very Own Gypsy Rose Lee," who provided entertainment for a program put on by the Young Communist League. The female impersonator Billy Herrero, wearing a brassiere filled with birdseed for that natural look, billed himself as the "Brazilian Gypsy Rose Lee," while Hubert's Museum on Forty-second Street featured a "Gypsy Rose Flea."

Gypsy maintained a game attitude toward most of this activity. "Money in the bank" was her attitude. Not only was imitation the highest form of flattery, she would remark while tossing back a gin and tonic (not so easy to get these days) and lighting one of the 150 Turkish cigarettes she smoked each day, but it meant free publicity for her. Anyway, she could thank God she wasn't one of the carbon copies.

Certainly, Gypsy was an original. Long-legged, radiantly healthy, and remarkably self-possessed, she lacked the blond-bombshell looks that were popular in Hollywood but had a powerful, statuesque beauty all her own. Small-breasted and large-hipped, she designed and often sewed her

own costumes to emphasize the long neck, elegant profile, and creamy, glowing skin that her public had grown to love. Her auburn hair, too flyaway to be worn loose, was usually arranged in an elaborate coiffure, and her signature six-inch heels added glamour to her five-foot-nine-inch frame. But her greatest charm lay, George felt, in the athletic, almost tomboyish stride that belied these ladylike accoutrements — a holdover, perhaps, from a childhood spent playing the male parts opposite her prettier younger sister in vaudeville. In every way — from her sophisticated manner of handling the ogling crowds to her half-joking, almost British-sounding contralto with carefully pronounced French phrases (punctuated occasionally with an American curse word or two) — Gypsy gave the impression of a smart, ambitious, self-made young woman with a well-developed sense of humor. This persona had been born more than a decade earlier, at about the time Gypsy and George had met.

Crammed around a Sands Street table, the residents of 7 Middagh listened, entranced and amused, as Gypsy told the story of the day she first set eyes on George Davis. It was just after Gigolo, her pet monkey, strangled to death in Omaha in a coat she'd sewn for him from the scraps of some old hotel blankets, she told them. Gypsy, known then as Louise Hovick, was thirteen years old at the time — an awkward, overweight adolescent resentfully touring with her sister, June, in the care of her mother, Rose, and Rose's manager-boyfriend, Gordon. Louise had left Gigolo in his coat overnight to keep him warm, but he had twisted the cloth around his neck until he couldn't get free. It was the first real tragedy of her life, but they had to move on. They disposed of the monkey and traveled to Detroit, where the miserable teenager's nights were spent onstage and her days cooped up in the Dixieland Hotel, listening to the grownups argue.

But Louise had a secret. Next door to the hotel she had discovered a magical place — her own special retreat — the Seven Arts bookstore. Even June didn't know about it or the hours that Louise spent there. Gypsy described it as "a strange, wonderful place with batik scarves on the walls and small tables and chairs placed in the dimly lighted corners of the room. Candles, stuck in bottles, threw flickering lights on the bookshelves."

Louise had always loved books, but she was even more attracted to the people sitting at the bookstore tables, so unlike anyone in her daily life. During the late afternoons they would crowd into the shop, looking "almost alike with their shaggy haircuts and low flat shoes," talking eagerly

about F. Scott Fitzgerald, James Joyce, and Ernest Hemingway. Eavesdropping on their conversations, Louise browsed through the bookshelves, pondering what to buy with the allowance she had saved. She had to be careful about the books she chose. Not only were her funds limited, but she was allowed just one trunk for all her books and her sister's toys. Whenever she bought a new book, she had to let an old one go. Already she had replaced *A Child's Garden of Verse* with Boccaccio's *Decameron* and *The Wizard of Oz* with *The Rubáiyát of Omar Khayyám.* "In the candle-lighted bookshop I hesitated between a copy of Firbank's *Flower Beneath the Foot,* which had a lovely picture on the faded gray cover, and *Marius the Epicurean,*" Gypsy wrote years later. "I knew if I bought either one I would have to make room for it in the trunk. I was wondering more about which of my old books would have to go, when the manager of the store spoke to me. 'Have you read Shakespeare's sonnets?' he asked, offering me a slender cloth-covered book."

The manager, of course, was George Davis, then a teenager working to earn enough money to get out of Detroit. Gypsy could still picture how he looked that day, she claimed. He handled the books gently, and his voice was gentle, too. He didn't seem to mind that she hadn't yet bought anything, though she had been in the shop every day for a week. No one else seemed to be buying books either, she noted, at least not often. All they were doing was talking about them.

Young Louise didn't particularly want a book by Shakespeare, but she did want to be a part of that world. In her most sophisticated voice, she told George that since she worked in the theater she didn't care much about reading plays. "These are poems," George explained kindly.

Louise bought the sonnets and never forgot George's generosity — or his apparent instant understanding that her search had been not just for a book but for a different way to live, a different person to be. A decade later, the two met again in New York and soon became close friends. By then, Louise had weathered her initiation into burlesque at the age of sixteen, earning $75 a week to strip for men with newspapers in their laps. Desperate to escape this show business ghetto of red-lit clubs and noting that girls with a gimmick got paid a lot more than ordinary strippers, she had developed a burlesque act of her own based on a piece of advice from her mentor, Tessie the Tassel Twirler: "You don't dump the whole roast on the platter. Always leave them hungry for more."

The point was, Louise realized, that men didn't really want to see another naked woman — they'd rather imagine what was under her clothes.

This concept appealed to her innate modesty as well as to her love of a good show. Pursuing the idea, she changed her stage name to "Miss Gypsy Rose Lee," a name that prepared the audience with just the right bump-and-grind rhythm each time it was announced. Then she designed, as costumes, a number of comically modest, ankle-length dresses with shirtwaists, broad belts, and mutton sleeves, all held together by black-tipped dressmaker's pins. Slipping demurely onstage, looking freshly scrubbed and blooming, she recited lighthearted song lyrics filled with double-entendres, accompanied by a few musicians in the orchestra pit. As she recited, she smiled primly at the audience, slowly removing the pins, one by one, and dropping them insouciantly into the tuba player's horn as the drummer emphasized its landing with an exaggerated thump. Making a great play out of discovering yet another pin, Gypsy would allow the larger pieces of clothing to gradually fall away.

As she pretended to greet the loss of part of her clothing with shock and dismay, her audience responded with laughter and calls to remove the rest. "Darlings, please don't ask me to take off any more, I'll catch cold!" she would plead, ducking behind the curtain and peeking out in mock terror. "No, please, I'm embarrassed! . . . No, honestly, I can't. I'm shivering now." Then would come more toying with the dress, another exit, and another teasing entrance until the dress was completely off and the patrons were sure that they would finally catch a glimpse of Gypsy's entire frame. But no. At the last moment, with the sleight of hand of a practiced magician, she managed to drape the remaining bits becomingly over one hip or pull a bit of the curtain in front of her — either way, offering just a glimpse of a G-string but otherwise preserving her modesty. By 1935, when she turned twenty-one, Gypsy had refined her motto to a frank, funny, "Make 'em beg for more — and then don't give it to them!"

It was her good luck to make her debut on New York's burlesque stages just as it was becoming fashionable for the city's intelligentsia to attend the shows. Gypsy had never lost her desire to count herself among this crowd — a group she might have joined had fate handed her a different childhood and some education. Once she spotted the artists and writers in the back rows of the clubs, she began tailoring her performances just for them. Whatever made them laugh stayed in her act, and she took advantage of every opportunity to invite them backstage. Through Eddy Braun, her socially prominent but married paramour, Gypsy had been

introduced to the sophisticated lyrics of Dwight Fiske, a piano player at the Savoy-Plaza. Back downtown, at her own Irving Place Theater — "America's oldest home of refined burlesque" — Gypsy presented the same sly double-entendres ("Like Eve I carry round this apple every night / Looking for an Adam with an appetite") to an audience oblivious to its high-camp intentions but more than appreciative of her girlish charm. "Come on, Gyps, take it off, we know ya!" they would yell — always in vain, however, always in vain.

Soon after her reunion with George, to whom Gypsy still looked up with a reverence typical of the hard-working autodidact, he wrote an elaborate tribute that appeared in *Vanity Fair* and helped establish Gypsy's name and image in the consciousness of mainstream America. A burlesque star like Gypsy "need not know how to sing, she need not know how to dance," wrote George, "though, if she wishes, she may take a stab at both." What she needed was attitude, and Gypsy had plenty of that.

Davis described her efforts to take part in the city's Intellectual Life by filling her Gramercy Park apartment with modernist paintings and Empire sofas, devouring books by Proust, Kafka, and Marx, and cocking her head self-consciously mid-conversation to ask, "Whither the New Negro?" If she erred occasionally — calling a new book "skintillating" or falling into overly enthusiastic shop talk with her chorus girl friends — no one could accuse her of not trying her best. She was a whirlwind of energy, nearly all of it aimed at self-improvement.

"The great thing about Gypsy Rose Lee is her gayety. It is a force with her," George wrote. Gypsy possessed a rare "sparkle, an honest-to-God *joie de vivre*." But he felt obliged to warn readers about her irresistible attraction to men with bald heads. "I don't know what it is about baldheads," she was quoted as saying thoughtfully, "but they have been a lifetime habit of mine. I have been chasing them ever since I first started in vaudeville, when I was six." And chasing them she still was, George added. "'Darling! Sweetheart!' she screams, ecstatically, when she spies one in a box or in the front row of the orchestra. 'Where have you been all my life!' Everything stops until Gypsy has ornamented his few remaining locks with a bright ribbon, or at the least left the imprint of a kiss on his gleaming pate. If he fights her off, Gypsy's ardor is only doubled." No doubt, George concluded, Gypsy's talent and intellectual bent would soon lead to an affiliation with the highbrow Theatre Guild, the

producers of *Porgy and Bess* and dozens of other groundbreaking shows. "Only, one word of warning to their box-office," he wrote. "*Don't sell any first row seat in the orchestra to a baldheaded man.*"

Since that time, Gypsy had demonstrated her show business acumen in more ways than were possible to count. She had appeared at the opera in a cape made entirely of orchids; had protested after a police raid, "I wasn't naked. I was completely covered by a blue spotlight"; had headed the grand march at Columbia University's senior dance; had encouraged journalists to call her "the bohemian stripper" — a phrase later transmogrified into "the naked genius"; and had had herself photographed half-submerged in a bubble bath while chatting with a reporter about the portrait she planned to commission from Max Ernst. After landing a starring role in Ziegfeld's *Follies* along with her friend, the comedienne Fannie Brice, Gypsy left the show without a backward glance when offered a Hollywood contract for $2,000 a week and pretended to ignore the ad — "Experience not necessary" — that an angry Ziegfeld ran for her replacement.

Hollywood turned out to be Gypsy's biggest mistake. She had no talent for acting — and even if she had, the mothers' clubs, church groups, and Legion of Decency would never have allowed "the undisputed queen of the New York strippers" to become an American movie star. The first blow came when the Hays office forbade her employer, Twentieth Century–Fox, from using Gypsy's stage name in her films. The second came when the studio head, Daryl Zanuck, lost his nerve after receiving four thousand letters of protest and asked her to play down her burlesque background. In a regrettable effort to pacify "the virgins," as twenty-three-year-old Gypsy called her outspoken opponents, she very publicly married Bob Mizzy, a dental equipment salesman. It was a stillborn marriage, however, and Gypsy's mother, Rose, hammered a final nail into the Hollywood coffin when she appeared in Zanuck's office in an old coat she'd once worn for milking cows, complaining that her daughter had left her to starve and begging for a bowl of warm soup. Accustomed as he was to stage mothers' shenanigans, Zanuck had no problem ignoring Rose, but there was no way to save Gypsy's film career. Without her famous name, she was useless to the studio. He assigned her to a series of five forgettable movies and declined to renew her contract at the end of the year. "I'm a Hollywood floppo, that's what I am," Gypsy told her sister when she returned to New York sans husband in 1939.

Fortunately, Gypsy was the kind of trouper who could easily start over.

She rented a small, ground-floor apartment on East Fifty-seventh Street and accepted George Davis's offer to help fill it with Victorian lamps, carnival memorabilia, antique music boxes, porcelain cherubs, and other collectibles with which they were both obsessed. Having made a new home, she signed up for classes at the New School for Social Research and renewed contact with a widening circle of New York artists and intellectuals. Gypsy's original blend of earthiness and intellect, which still drew plenty of admirers, inspired more than one of her friends to suggest she try her hand at theatrical social satire or even serious drama. Gypsy knew her limitations, however, and passed these opportunities on to her sister. In return, June introduced Gypsy to the nightclub impresario Mike Todd.

As June wryly remarked later, Gypsy's meeting with Todd was "money at first sight." Well known in New York's show business circles as one of the country's most promising new producers — basing his formula for success on the idea that a great show for a cheap price would always sell out — the tough-talking theater tycoon was putting together four shows for the New York World's Fair's second summer season in 1940, and he still needed a knockout star for one of them. What he was looking for, he had told June, was a flamboyant female crowd-pleaser — a Sally Rand type who could light up the New York fair the way Rand had Chicago. When June suggested Gypsy, Todd laughed and remarked, "That's a no-talent broad worth a million bucks on any midway."

While "no-talent" rankled, "a million bucks" caught Gypsy's attention. Sick as she was of doing midways, the failure of her Hollywood adventure had scared her. She wanted money — in fact, after the childhood she had survived, it was quite possible that she could never have enough. For $4,000 a week, double what she'd made in Hollywood, Gypsy agreed to star in Mike Todd's extravaganza *The Streets of Paris*. Six times a day, all summer long, she stalked down a runway in a black Schiaparelli sheath with a padded fishtail for a train (donated by Diana Vreeland) singing "Robert the Roué from Reading, P.A." Not surprisingly, *The Streets of Paris* quickly became the fair's most popular show.

Mike Todd made Gypsy an enormous amount of money that year and took her to new heights of success, but his tough-guy, cigar-smoking persona — he called women "dames" and sometimes regretted his inability to "make with the words" — proved almost as exciting to Gypsy as a bald head. "I like my men on the monster side," she wrote the following year, only half in jest, to a friend in New York. "A snarling mouth, evil eye, bro-

ken nose — if he should happen to have thick ears, good! And I like a little muscle, hair on the chest, none on the head. A nervous tic excites me and if with all these things he wore green suits — BANK NIGHT!"

Todd and Gypsy came from the same world — two smart, ambitious, self-educated survivors of a devastating Depression. But Todd was not only married, he had a girlfriend as well. Gypsy wanted to play it smart this time around. That year at the fair, Todd had produced or managed not only *The Streets of Paris* and a number of other full-length shows, but also a ten-acre replica of the New Orleans French Quarter, a Dancing Campus where twelve thousand people danced to the music of Harry James and Les Brown, and some smaller, quarter-a-ticket attractions. For the moment, at least, Gypsy preferred a piece of this action to a place in Todd's bed.

It was impossible, as Carson, George, and their friends lingered in the smoky bars of Sands Street, listening to Gypsy's stories and laughing at her jokes, not to remark on what a wonderful writer she could have been. They were as amused as anyone else by the half-condescending references to Gypsy in the press as "a classic paradox: an intellectual stripteaser," but Gypsy clearly did possess both a lively imagination and a wonderful sense of narrative. No one could deny the remarkable mental acuity with which she ran her one-woman industry, juggling stage appearances, licensing agreements, film cameos, modeling sessions, and a host of lawsuits and countersuits in which she was always involved. With the money she had earned, she now owned a farmhouse in the country, where her mother tended an assortment of ducks, chickens, goats, pigs, and Gypsy's pet monkeys; paid the rent on her Manhattan apartment; collected modern art and Victorian antiques; contributed to numerous left-wing arts organizations; and supported her indigent relatives in Seattle, her hometown. How hard could it be for someone like Gypsy to write a novel, too?

As her friends soon learned, Gypsy had already been working on this question, and as usual George Davis had helped her. It had all started several months earlier, when a nervy public relations associate of Walter Winchell's had the bright idea of writing a guest column while Winchell was on vacation and signing it with Gypsy's name. Gypsy retaliated by writing her own guest column the next time Winchell left town — and found that despite the difficulty of typing with three-inch fingernails, she enjoyed the experience. A few weeks later, she followed up with a fifteen-page description of a funny incident that had happened backstage. It was

just a bit of burlesque atmosphere, but it gave her a taste for writing sto-
ries, and she decided she wanted more.

As a show business veteran, she already had an idea of what kind of
story she could sell, as well as a title that would be sure to capture atten-
tion. She'd write a murder mystery set in the world of burlesque, she had
told George. The murder weapon would be a chorus girl's G-string. She
would call the book *The G-String Murders*. She was sure it would make a
fortune and enhance her reputation as an "intellectual stripper" — if she
could only get it written.

This was in August, when George was preoccupied by his struggle with
Carmel Snow at *Harper's Bazaar*, but the idea amused him. The trouble
was, Gypsy didn't know how to write a novel, and George didn't have
time to teach her. Instead, he suggested she hire his new secretary, Doro-
thy Wheelock, to write a first draft. Though only in her early twenties,
Wheelock had already published one paperback mystery and written an-
other. A short story of hers would appear in the magazine's October is-
sue. Following her boss's orders — and being too new to the magazine
business to know whether it was part of the job — she began churning
out chapters for Gypsy Rose Lee.

But Gypsy found that no matter how hard Dorothy worked, the mate-
rial failed to satisfy her. Each time the young secretary arrived at her
apartment clutching another sheaf of papers, Gypsy could hardly finish
reading them before racing to her typewriter to rewrite the entire section
from the start. Dorothy didn't know anything about burlesque — she
did! And who knew better how to build up suspense before the final rev-
elation? It was obvious to the younger writer — and finally clear to Gypsy
as well — that calling herself an author wasn't enough. She wanted to
write the book as well.

When Gypsy heard about the household George was creating at 7
Middagh Street, she was intrigued. As in her adolescence in Detroit, she
continued to find herself drawn to those "strange, wonderful places" in
the world where people talked passionately about books. Serious artists
like Auden and McCullers impressed her deeply, despite her own consid-
erable fame. That year, she could afford to take time off to satisfy a desire
she had had all her life. Why not join the group at Middagh Street and
write a book? George needed money. She could pay him to teach her.
And she could rent one of the two-room suites as her Brooklyn atelier.

Lighting a cigarette, she placed the proposition before the others. They
responded precisely as she wished. If her idea for a detective novel was

brilliant, the idea of writing it at 7 Middagh Street was even more so. Carson in particular had already become wholly addicted to Gypsy's stories, and the idea of sharing a house with this warm and lively entertainer was a more exciting development than she could have dreamed up.

Before they shook hands, however, Gypsy imposed one more condition. She could not tolerate the chaotic conditions of life at 7 Middagh Street, she told the others. If she was going to spend time there, her cook, Eva, would have to come, too. She recommended that they hire a maid as well. In fact, they were all so short of money, she would give them a loan. Two hundred dollars should get the parlor finished and the furnace repaired.

It was a perfect arrangement for everyone. George would have a job and enough money on which to live. Carson would have Gypsy sharing the third floor. Auden would be most grateful for the services of a professional cook. And Gypsy would finally write her novel. Civilization had come to Middagh Street; now the real work could begin.

4

I wrote it three times, with a Thesaurus.

— Gypsy Rose Lee, 1941

"That's admirable," Janet Flanner remarked when George described the experiment at 7 Middagh over the telephone. The *New Yorker* columnist had long considered Brooklyn's brownstone neighborhoods among the city's hidden treasures. "And what is [the house] like, George?"

"Well, it's an old house, quite a handsome old house, a boardinghouse, really," he replied.

But the connection wasn't clear, and Flanner thought he said it was a "bawdy" house. "Why, George, how did you find one? That's just priceless for the pack of you."

Flanner's comment made sense, given her familiarity with the young group, but by early November the bawdy life at 7 Middagh had begun to give way to a more structured existence. Thanks to Gypsy's contribution, the furnace now produced heat and hot water and the cellar was supplied with coal. As the carpenters finished their work in the parlor, George was able to finish decorating. Gypsy persuaded him to replace his spindly parlor settee and straight-backed chairs with sturdier pieces from her farmhouse, but the knickknacks on the mantelpiece, the framed pictures by Bérard, de Chirico, and Vertès, the oil lamps and antique trunks, still gave the parlor a genteel charm that suited the entire household.

George himself moved from the top floor to the high-ceilinged rear room adjoining the parlor, with its romantic view of the rear garden's untended apple trees and rampant ivy. The parlor had benefited from Gypsy's steadying influence, but George was able to have his own way with his bedroom. He soon transformed it into a fantasy of framed Valentines, magazine covers, and movie-star chromos, with an enormous

bookcase displaying his prized complete set of Balzac, a cherry secretary near the window for writing letters, and a rocking chair for reading near the antique brass bed.

As the most disruptive repairs were completed, Auden's insistence on regular mealtimes and work periods helped the group settle into a routine. No longer was it necessary for the poet to escape to a restaurant to write, and even George and Carson seemed temporarily chastened by his early-to-bed, early-to-rise approach. The greatest improvement in their quality of life, however, had to do with the arrival of Eva Morcur, Gypsy's cook.

Eva had started working for Gypsy in 1932 as part of a publicity stunt cooked up when Gypsy was still just a bit performer in Flo Ziegfeld's *Hot-cha!* on Broadway. Gypsy had been looking for a way to distinguish herself from the four other dancers with whom she shared a dressing room. Eddy, her society boyfriend, suggested engaging a backstage maid to give herself the aura of a leading lady. Such a luxury was unheard-of for a chorus girl, but Gypsy followed his advice. The sight of the magisterial black woman wrapping Gypsy in a robe after a striptease had precisely the desired impact on the Broadway producers and journalists visiting backstage. A few years later, after Gypsy's star had risen, she and Eva transferred their partnership to Gypsy's glamorous Gramercy Park penthouse, where Eva served as chef and majordomo for the elaborate soirées they staged for New York's cultural, social, and show business elite. "You got your track shoes on? We're moving fast up here today!" Eva was likely to shout to Gypsy's sister, June Havoc, when she arrived on a party day. Gypsy's envious mother may have complained about Eva's penchant for fancy flambé dishes, but the chef, who had enjoyed an earlier career as a singer at the Cotton Club in Harlem, displayed a dramatic flair that suited Gypsy's guests.

Auden was delighted by Eva's culinary talents, particularly her willingness to satisfy his longing for traditional, haute bourgeois meals with several courses. Under his direction, the large table in the ground-floor dining room was loaded nightly with platters of roast beef covered in gravy, boiled potatoes, freshly cooked vegetables, and chocolate desserts. Susie, the daily maid whom Gypsy had engaged for $10 a week, helped serve the meals when not facing the Sisyphean task of tidying up after this active group.

With the addition of these domestic servants, the assemblage at 7 Middagh did, in fact, begin to resemble — if in a distorted fashion — the

middle-class families up and down the block. George Davis, as pater-familias, exuded an aura of contentment as he perused the newspapers at the dining table, waiting for the others to assemble. ("Now, Victor," he would murmur without looking up as his stevedore friend dropped a grappling hook beside the back door. "Don't scare Chester. He's very delicate.") Facing him across the table, housemother Wystan Auden popped Benzedrine tablets and grumbled about the bills. Carson McCullers, the family ingénue, took her place midway between these two nodes of domestic authority, passing the eggs and paying respectful attention to Auden's lectures on Kierkegaard, while Gypsy played the sensible older sister, pouring herself a fresh cup of oolong tea and discussing a trip into town to buy provisions. Sophie and Boy, a pair of cats contributed by George, added to the aura of domesticity. Auden, who had hoped but failed to persuade Chester Kallman to live with him in the house, was flattered by Sophie's choosing to sleep on his bed.

This bourgeois life must have come naturally to Auden, George, and Carson, who had all been brought up in more or less middle-class surroundings. Still, Louis MacNeice, who came to stay at 7 Middagh that autumn, was amused by the sight of his old friend Wystan laying down the law to a "family" consisting of a New York flâneur, a burlesque stripper, and a wide-eyed southern wunderkind who sipped sherry from a china cup. Breakfast would be ready at nine o'clock sharp, Auden announced, and those who were late would not be served. Residents must reserve places at dinner for themselves and their guests; missed meals would be charged to their accounts. Auden clearly welcomed the challenge of dividing food costs with minute accuracy among all the housemates and reminded everyone over breakfast that one square of toilet paper should be sufficient for each bathroom visit — whereas *someone* had been expending paper by the handful.

If Auden thought he was approaching the rock-steady environment of such artistic sanctuaries as Bread Loaf or Yaddo, he would no doubt soon learn differently. But then, MacNeice mused, why should one try? The thirty-three-year-old Irishman, who was awaiting passage back to Britain to report for military duty, had already begun to feel a kind of advance nostalgia for this artistic life. He still recalled the inferior works that had resulted when the leftist artists of the 1930s tried to imitate the lifestyle of the hypothetical Working-Class Man. Far better to simply relax into one's natural state, even if it was "ever so Bohemian, raiding the icebox at midnight and eating the catfood by mistake."

It didn't take long for Janet Flanner, with her reporter's nose for a good story, to look in on George Davis's new home. She, too, was amused to find the residents grouped around the dinner table arguing passionately about the sex lives of the great composers or listening to Gypsy's spine-tingling tales of how Waxy Gordon, the famous gangster, once forced a dentist to fix her teeth. Flanner and her partner, Solita Solano, were also pleased to find a number of old friends from Paris lounging about the parlor, kitchen, and dining room — Glenway Wescott and Charles Henri Ford, the Russian painter Pavel Tchelitchew, the fashion photographer George Platt Lynes and his lover, Monroe Wheeler, a curator at the Museum of Modern Art. And, now that Klaus and Erika Mann had returned to New York, both the artistic and political conversation at 7 Middagh began to heat up.

The atmosphere was especially giddy that November in the wake of Franklin Roosevelt's reelection to a third term in office, defeating the isolationists' favorite, Wendell Willkie. It had been a bitter contest, with America's role in the European conflict at the center of the debate.

In September, the draft had been instituted; in October, the first American draft number — 158 — had been called. The first draftees would be shipped south for military training by the end of November. That same month, the president sent fifty World War I destroyers to Britain in exchange for the use of a string of British military bases in the Atlantic — bypassing Congress to do so. Outraged isolationists denounced these acts as a "conspiracy against our peace, tranquility and honor as a nation." On election day Roosevelt garnered less than a third of the number of popular votes he had won in the previous election, but they added up to victory. It was seen as a clear indication that the United States would enter the war in a matter of months if not weeks.

Klaus Mann joined the enormous throngs gathering in midtown Manhattan. When Roosevelt's victory was announced, "the uproar and clamor in Times Square were overwhelming — half bedlam, half carnival," he wrote. Among the celebrants he spotted were the writer Vincent Sheean's wife, Diana, who had dedicated herself to the cause of transporting British children to the United States. "Aren't we happy?" she shouted to Klaus through the crowd. Now, at last, the British population could hope for American aid.

Both Klaus and Erika Mann, eager to move forward now that America had taken another step toward engagement, traveled out to Brooklyn to talk over their plans with their friends. Erika had only recently returned

from her trip to Britain and Portugal and was eager to report what she had seen. She described to Flanner and others in the Brooklyn parlor the sound of the air raid sirens in London, the experience of sharing a bomb shelter at four A.M. with dozens of half-dressed strangers, and the strong sense of optimism and determination that seemed to have taken over Britain now that it was in the midst of the conflict.

In Europe, the Emergency Rescue Committee was now smuggling hundreds of artists and intellectuals over the Pyrenees to safety. The story of her brother Golo and their uncle Heinrich's escape from France had already made New York's newspapers. The pair had made the harrowing mountain crossing by foot accompanied by Heinrich's wife, Nelly, a former nightclub singer, and the famous Austrian novelist Franz Werfel. Werfel's imperious wife, Alma Mahler Werfel — the widow of Gustav Mahler, who was known throughout Europe for marrying only geniuses — had joined the group in a billowing white dress, "like a great flag of surrender," visible for miles. She insisted on bringing a heavy suitcase stuffed with Mahler's music scores, Bruckner's Third Symphony, and Werfel's manuscript-in-progress. Despite these complications, the unlikely group had managed to conquer the Pyrenees' sheer, windswept cliffs and slippery terrain, and were all now in the United States.

Americans were captivated by such dramatic stories, Erika pointed out, but their interest in these intellectuals and artists, about whom they knew little, was not likely to last. Most of the people here would begin to support engagement only if they began to comprehend what *they* stood to lose if Hitler won. The Third Reich, with its motto of unity at all costs, stood poised to crush centuries of European intellectual development and free thought beneath its boots. Somehow, people here held on to the illusion that such reactionary forces could never come to power in the United States. It would take the collective voice of the émigrés — those who had witnessed the gradual descent from public apathy to stunned disbelief to morbid fascination to despair as freedoms were curtailed, friends arrested, books burned — to demonstrate to Americans that it could indeed "happen here."

Erika's passion was palpable, but of course she had been fighting the Nazis for more than a decade. As early as 1930, when only twenty-four, she had been denounced in the Nazi press as a "flat-footed peace hyena" and described as looking not quite human. Erika had responded then, "If they want a fight — they can have a good one. I may be a peace hyena, but certainly I am no sissy." Fighting fascism had become her life's purpose,

and now, as she made plans to return to Europe to resume work actively with the rescue mission, she hoped her friends would help to spread the story of Europe's collapse.

Flanner, who considered Erika "the prince of the Manns," agreed with alacrity to interview some of the new refugees for a piece in *The New Yorker*. She was still responsible for European coverage, even though she had been shut out of France, and she depended on the émigrés to provide her with up-to-date anecdotes and information. But Klaus Mann had also moved forward with his own project — the literary and political journal in which refugees would be able to express their views directly and read a full range of informed American responses. For months he had traveled cross-country soliciting funds for his magazine and had dispatched countless letters to well-known writers requesting essays, stories, and poems. Now, in November, he had amassed enough of both to be able to launch his first issue at the beginning of the new year. Some of the contributions were no doubt motivated by respect for his famous father, but Klaus Mann also brought with him the credibility gained from having founded a similar journal, *Die Sammlung* (*The Collection*), among the exiled artists in Amsterdam in the mid-1930s — which had cost him his German citizenship in 1934. Whatever the reason for the strong show of support, Klaus was ready to begin. At Wescott's prompting, he had named the journal *Decision: A Review of Free Culture,* to highlight its emphasis on the need to take action.

The residents of 7 Middagh Street were impressed by the extraordinary degree to which this melancholic writer had been energized by his new project. In normal times, Klaus emerged so rarely from the shadow of his older sister that his peers in America jokingly referred to him as "the invisible Mann." (Chester Kallman would eventually top this with, "No, he's the subordinate Klaus.") But even Klaus's father, who disapproved of his openly homosexual lifestyle and his intermittent addiction to morphine, had to admit that *Decision* had given his son a new sense of purpose in this foreign country. Klaus himself had been impressed by the generosity with which wealthy donors had financed his risky project. "Curiously, I can't help feeling surprised when any proposition of mine is taken seriously by 'the grown-ups,'" he wrote in his diary. "But, amazingly, [*Decision*] materializes: people believe in it. There is something called 'Decision Inc.,' with officers, office and a bank account. The secretary looks exactly the way a real secretary should look — in fact, she is very pretty — and apparently fails to notice that I don't look like a boss."

Klaus Mann looked to Brooklyn for moral support and new ideas for his venture. And there he found them as Carson McCullers offered her services as editorial assistant, George Davis provided editorial, layout, and marketing advice, and Wystan Auden joined *Decision's* board of editorial advisers, which already included Sherwood Anderson, Somerset Maugham, Vincent Sheean, Robert E. Sherwood, Ernest Boyd, Horace Gregory, and Thomas Mann. For the first issue, to be published in January, Janet Flanner had agreed to contribute "Paradise Lost," a meditation on the death of the republic of France; Jean Cocteau, a surrealist tale called "The Ruins of Paris"; and Aldous Huxley, "Dust," an essay in which he argued that small philosophically oriented communities were the only solution to, on the one hand, the mental dissipation of modern life in America, and on the other, the fascism of Europe. Franz Werfel submitted an essay of thanks to America for offering him sanctuary. Isherwood, whom Klaus had visited in Los Angeles in August, wrote an admiring review of *For Whom the Bell Tolls*, while Klaus critiqued Anne Morrow Lindbergh's *Wave of the Future* for its disturbing message that "after all, the [Fascist] dictators can't be so bad since they are so successful."

In his editorial for the premier issue, Klaus wrote of the need for the world's artists and intellectuals to join the fight to rescue their culture. A group of writers may begin to accomplish this mission by "stimulating each other to find the right attitude, the right approach and the right ideas." It was his hope that *Decision* would provide this kind of forum in America, "last bulwark of liberty, focus of our hopes." "We want to make an independent magazine but not an impartial one," he added. "Nobody interested in culture can afford to be impartial now. Culture must take sides and turn militant, or it is bound to perish."

To emphasize this point, he planned to include in this first issue a symposium in which several well-known writers would respond to the questions: "Do you think intellectuals can or should have an influence in political affairs?" "What should be the role of a cultural review in this connection?" The responses varied widely. But one of the contributors, Auden, objected to any identification of artists as "intellectuals" separate from the rest of humanity. If the word "intellectual" meant a capacity for abstract thinking, as contrasted with manual skill or the organizing skills of the politician, he argued, then airplane designers, code decipherers, and campaign strategists were as much intellectuals as were poets. And if this was the case, then one could not really speak generally of the intel-

lectual's role in wartime but only the roles of particular intellectuals. And "as far as writers are concerned," he added, "their problem is not *What should I do as a writer?* — the answer to that is the same under all circumstances. *Write as well and truthfully as you can* — but only *Have I any other capacities, e.g. physical strength, which are of direct military value and which I ought therefore to offer to the state?*"

He added, "The value of a magazine like *Decision* seems to me to be independent of peace or war in their political sense. The struggle of culture with ignorance and barbarism is continuous and never-ending. War, as such, is only a sharp reminder that civilized life is always in greater danger than we realize, and that we have never done as much to maintain it as we could."

This rather equivocal response lacked the fighting spirit that Klaus and Erika were hoping for from the creator of "September 1, 1939." As Klaus had complained to Isherwood in California, Auden was being "very cagey" about his position on the responsibility of writers regarding the war. Like Isherwood, Auden had avoided making the kinds of definite public statements that the Manns hoped could serve as propaganda against Hitler.

The Manns' passion was rooted in their own experience of what happened when intellectuals failed to act. But Auden, Isherwood, and MacNeice lived with vivid memories as well — recollections of the damage done in England in the 1930s when left-wing writers, artists, and thinkers heedlessly subverted their talents to a political cause. What they had learned from that experience was that the truth of any social structure or political event was more complex than petitions could express; that neither side of such issues was wholly right or wrong; and that by "turning militant," the artist risked extending the kinds of lies that had caused the problem in the first place and thus betrayed his duty to the truth.

Now, in 1940, it was easy to point to similar forces at play among the right-thinking American intellectuals who jostled for position even as Europe's condition turned critical. As stories began to appear about the dramatic rescue operations accomplished by the Emergency Rescue Committee (ERC), for which the Mann siblings had worked, the left-wing League of American Writers formed its own Exiled Writers Committee (EWC) to perform similar rescues, and a competition developed for press coverage and donations. High-profile émigrés including Heinrich Mann and Franz Werfel were persuaded to boycott one organiza-

tion's fund-raising event in favor of the other's, and when complaints were made, each committee accused the other of "alarmist jealousy" and political opportunism. These were precisely the kinds of ridiculous tussles that Auden, Isherwood, and MacNeice were determined to avoid.

At Cornell the previous summer, MacNeice had been confronted by a fellow instructor, a high-strung Frenchman whose anxiety over the events in Europe had prompted him to demand repeatedly, "*Poète*, why are you doing nothing? You must show us a course, it is your business." But who was to say that a MacNeice or Auden knew the best course of action to take in this situation? The poet's job was not, in their view, to take sides as a political activist, as Klaus Mann urged, but, on the contrary, to continue for as long as possible to illuminate the truths of the moment in the hope of making the right course more apparent for each individual reader. It was essential that these truths be presented in all their myriad contradictions and ambiguity — including, for example, the uncomfortable fact of the Allies' own imperialist past, the fact that this war would wreak horrible destruction on both sides of the front lines, that democracy harbors its own social evils that would not be cured by the Nazis' defeat, and the human truth that few individuals want to risk their lives for a political cause, no matter how just.

"Nobody interested in culture can afford to be impartial now. Culture must take sides and turn militant, or it is bound to perish," Klaus Mann had written. Auden believed, on the contrary, that the act of taking sides and turning militant — while quite likely to become necessary soon enough — spelled the death of free culture and the triumph, at least temporarily, of its enemies.

Serious as these disagreements could become, they failed to spoil the atmosphere at 7 Middagh Street, nor did they interfere with the writers' friendship. Klaus still hoped to persuade Auden and his friends to take a stand ("Just a little statement; once or twice would be enough"), while Auden considered all debate and discussion grist for his creative mill. He saw it as one of the great advantages of 7 Middagh Street, that everyone present understood and shared this process of grinding up the dross of daily life to create art. At Chester Kallman's urging, Auden had lately reread a number of works by Henry James, including *The Aspern Papers,* a collection of four short stories that explored the nature of the writing life and the conflicts between the artist's private and public selves. In one story in particular, James describes a writer who, it is discovered, has a

mysterious twin. While the author appears to be blandly socializing downstairs at dinner, telling mildly amusing jokes and flirting with the women, his spectral double is busy creating great works of literature in the darkened study upstairs.

At 7 Middagh Street, there was no need to explain to his housemates that the "real" Auden was always upstairs, working, even when he appeared to be dogmatically lecturing at the dinner table, arguing with Klaus, or demanding that the rent be paid. Beyond the closed door of his study, dark activities were in progress. This was what was required of them all — this relentless effort, which he would later describe in what he would consider his best work, *The Sea and the Mirror,* as throwing oneself against the "black stone on which the bones are cracked." Half of Auden's attention was always in his study, and soon he would feel the need to physically join his specter. Those around the dinner table grew accustomed to the sight of the thirty-four-year-old poet shuffling up the stairs in his slippers — worn out of respect for his painful corns — to disappear for hours in the darkened den. "Unless I am in love with them," Auden wrote, "I am delighted to see my friends for an hour, and then I want to be alone like Greta Garbo."

Downstairs, however, one would find the materials necessary for this work. Downstairs were the ideas, the arguments, the images, and the passions that served as "the extraneous and discardable medium for the writing of poems." Doing the crossword puzzle in the morning, discussing detective novels with Gypsy, debating opera with Chester, and otherwise "rummaging into his living" for "the images that hurt and connect," Auden unearthed rich creative ore for later analysis. Earlier that year, a book reviewer for *Time* magazine had written, "Traditionally, poems are composed as soliloquies in some quarter of a poet's mind: Auden's most characteristic poems are composed as colloquies between various quarters of his mind. Oxonian Auden's up-to-the-minute mind has, roughly speaking, as many, and as sketchily correlated, quarters as a university has classrooms or a newspaper has columns."

The results lay throughout the house — on random bits of paper stuck in books and on tables and especially in the lined notebooks that he bought at Stevenson & Marsters, on Fulton Street. Line after line of verse, hastily sketched but with astonishingly few changes, demonstrated this transformation of the flotsam of daily life into art. "Across East River in the night / Manhattan is ablaze with light," he had written in Brooklyn. And, in October, having moved into the chaotic Middagh Street house:

Where am I? Metaphysics says
No question can be asked unless
It has an answer, so I can
Assume this maze has got a plan.

Even the phone book provided material: a series of business listings copied down on a page of Auden's notebook ("Airconditioning . . . Beauticians, Beer pumps, Bookkeepers . . . Caterer, Cleaner, Janitors") was incorporated, a few pages further on, into the lines for a radio play, "What's freedom anyway? Ask the boys and girls in the city, ask any of them, ask the typists and the teletypists, ask the chiropractors or the airconditioning contractors, ask the brokers and the bell-hops and the beerpump makers and the baby carriage makers." And after this came more lines for "St. Cecilia Day Ode," "Lady Weeping at the Crossroads," and other brilliant works.

The process of turning words into poems had also become financially easier by mid-November. Earlier that fall, Auden's equilibrium had been further threatened when Chester Kallman's father decided to transfer responsibility for his son's expenses over to the poet. Dr. Edward Kallman had resisted the fact of his son's homosexuality for years, having learned of it only when the boy's first great admirer, a wealthy, middle-aged man named Charlie, had offered to pay Chester's way through Harvard if his father would allow him to adopt him. The shock of that encounter finally wore off, but the dentist — who, though short and rotund, was himself quite a ladies' man — clung to the hope that his son would eventually outgrow what he considered a homosexual phase. Despite his feelings, he was fond of Auden and considered him a better partner for his son than the toughened sailors or students he might otherwise choose. If Auden wanted to pretend to be married to his son, however, then Dr. Kallman felt he should make a financial commitment as well.

A solution to this new difficulty had arrived in the form of a letter from Caroline Newton, whom Auden had met through Glenway Wescott the previous winter. The middle-aged daughter of a wealthy New York bibliophile, herself a trained psychologist, Newton greatly admired Auden's work and had become romantically attracted to him despite knowing about Kallman's role in his life. For months she had courted him with theater tickets and dinners. Now she made an outright offer to partially subsidize his writing. It was the kind of half-embarrassing, half-welcome patronage that Auden and Isherwood had jokingly sought out on their

arrival in New York, but that could be something of a burden when it actually occurred. Were it not for Kallman's expenses, Auden might not have accepted the offer. As it was, though, he gave in, extending an open invitation to Newton to join the table at Middagh Street, where she could talk literature with Klaus and Erika Mann, Wescott, Davis, and others whom she already knew well.

Auden was now free to focus on some of the ideas that had been coalescing in his mind over the past difficult months. And the issue that most concerned him was the very question Klaus Mann had posed: what to do — what "decision" one should make, as a writer but more fundamentally as an individual human being — when confronted with an undeniable evil. When he said, "Write as well and truthfully as you can," Auden did not, of course, mean that the writer should ignore world events any more than other incidents within his sphere. But one must find a means of judging whether one's response was a correct and effective one. In an open society like this one, art was potentially a powerful tool for directing unfocused human passion, but such a tool must be used wisely. And, as Auden had learned in the 1930s, no one — certainly no writer — was infallible. The dictator one helped to depose could turn out to have been a better choice than his replacement. New philosophies, no matter how benign, could lead to evil actions unimagined by their creators. Given the limits of our human understanding, all that could be expected, as Auden had written the month before, was that

> Time will say nothing but I told you so,
> Time only knows the price we have to pay;
> If I could tell you I would let you know.

This confusion — this inability to judge whether one's own actions were ultimately right or wrong — was the dead end to which Auden had been led the previous summer. But he did not want to remain there. There had to be a way, philosophically, to recognize such an extreme evil as that posed by Hitler, judge it wrong objectively, and therefore act against it without doubt and without reserve. The previous spring, Auden had been intrigued by a reference in Kierkegaard's *Journal* to "three stages of experience" through which most men typically pass. He recognized the first, aesthetic stage, in which the individual lives for the joys of each passing moment, as comparable to his own life in Weimar Berlin. The second, ethical stage, in which the individual becomes aware of social inequities and involves himself in public issues and politics, corre-

sponded to Auden's own efforts in 1930s Britain and in Spain. In the third stage, Kierkegaard suggested, the individual understands that the inherent good of mankind is a false concept, that no matter what actions one takes, good may not come as a result.

This was the stage that Auden had reached in the months before moving to Middagh Street. And he had read Kierkegaard's solution: the individual must either "abandon himself to despair, or must throw himself entirely on the mercy of God." This, then, he believed, was the "decision" he now faced. As he had no wish to simply despair, could he look to God — or, at least, to the Christian doctrine with which he was most familiar — for the objective vision, the metaphysical absolutes, where rational thought had failed? Could the principles of Christianity serve as the touchstone for correct moral action?

For several weeks now, Auden had been slipping away from 7 Middagh Street to attend early communion at an Episcopal church in the neighborhood. He chose it because it resembled the one he had attended growing up in England, and he found it comforting as he struggled with this new idea. By dropping in early, he missed the dull sermons and curious churchgoers he would have had to endure later in the day. And he did find — to his own surprise, since he had turned his back on religion more than a decade before — that these mornings seemed to help. When he returned home, his housemates and their guests, stumbling downstairs for breakfast, noticed an oddly beatific expression on his face, but no one thought to ask him where he'd been.

Much as Auden had looked forward to being "alone" with himself in America, relying only on his own judgments and experience, it was a relief during these difficult months to look to an outside source for answers. It was true that accepting God's judgment brought with it new moral responsibilities. In *The Double Man*, Auden quoted the theologian Paul Tillich: "at a special time special tasks are demanded, and one aspect of the Kingdom of God appears as a demand and expectation." But these unquestioned, unquestionable moral demands and expectations were just the kind of responsibility Auden longed for.

All that was necessary, it seemed, was to have faith in God. But he was not quite ready, in November 1940, to take that leap.

While Auden worked in his top-floor study, Gypsy Rose Lee paced the floor of her third-floor sitting room, describing to George Davis the kind of G-string they should use to kill the burlesque performer Lolita La

Verne. It should be a fancy one, of course, with fake emeralds on the front and "silver flitter" behind. They could have Siggy, the G-string man, sell it to her before the murderer got hold of it and used it against her.

Siggy, who sold G-strings out of a suitcase to chorus girls backstage, was one of the many burlesque characters Gypsy and George had assembled for her murder mystery. After much discussion, they decided to approach the book like a jigsaw puzzle: first write down all of Gypsy's anecdotes, character descriptions, and entertaining burlesque details, then arrange them into a rough story line.

George suggested that Gypsy begin by simply dictating some of her favorite stories to him. As she talked, he typed her words on the old typewriter she had installed in the larger of her two rooms above the parlor. This way, Gypsy could preserve the liveliness and timing that, as a comic performer, she had honed to perfection. It also eased her into the writing process, neatly evading the blank-page experience that caused so many beginners to panic. Seeing her words on the page afterward, Gypsy would make the connection between how she spoke and how she wrote. Then, once they had laid out the plot, she could incorporate these anecdotes into each chapter as she wrote.

So far, the system had worked well. George and Gypsy had agreed that her popular police raid story, which had occurred in real life during the premiere of a new act called "Illusion," could serve as the opening scene of the novel, to establish the burlesque setting and grab the reader's attention. Gypsy could model the burlesque hall where the murders would take place on the Irving Place Theater, where she had performed so successfully in the mid-1930s. Her former boyfriend, the womanizing burlesque comic Rags Ragland, might provide inspiration for the novel's love interest, Biff Brannigan, who would play Dr. Watson to Gypsy's Sherlock Holmes. And the burlesque prima donna Lolita La Verne was only the first in a list of murder victims that would include Dolly Baxter, a baby-faced blonde whose boyfriend Lolita had stolen, Princess Nirvena, based on the snootiest stripper Gypsy had ever known, the gangster owner of a neighborhood bar, and assorted stagehands and hangers-on. If the action threatened to slow down, Gypsy could always sprinkle a few professional terms into the dialogue, such as "pickle persuader," "grouch bag," and "gazeeka box."

Having already spent several months on this project and having cleared much of her busy schedule, Gypsy was eager to proceed. She dedicated herself to her first chapter with the energy of a dancer learning a

new routine. Like Auden, Gypsy was an early riser, so her writing schedule came to strongly resemble his. Getting up at six o'clock, she threw on an old cotton housecoat, made herself some hot tea, and began pounding the typewriter keys in her sitting room. If she was finding it difficult to decide where to dump the corpse or how to misdirect suspicion from the actual murderer to a suspect, she might join the "brains" for breakfast at nine so she could ask for advice and swap a few jokes to let off steam. If the work was going well, though, she kept at it straight through the morning until George arrived in the afternoon to review her progress.

While George was marking up her pages, Gypsy deflected her nervousness into useful activities, such as going over her calendar, making phone calls, painting her nails, or doing some embroidery. If she suspected that she had added an inch or two to her waistline, she might summon her masseuse to Brooklyn and "get her ass pounded" while she and George debated her descriptions of dressing room catfights and strip routines. If her extreme restlessness sometimes annoyed George, he didn't let it distract him. Now that Gypsy was living in his house, he was determined to teach her to write.

Going over a scene line by line, George assumed the same air of authority, otherwise absent, that Carson had noticed the previous summer. Asking softly but relentlessly, "But would Biff really do that? Would the Princess really care what was going on in the dressing room? What if, underneath your name on the marquis, we add 'Boxing Tuesday Nights'?" Gypsy absorbed his suggestions like the professional she was and understood that, even if her novel was lighter in tone than Carson's or Auden's work, this was an extraordinary learning opportunity.

When Gypsy did not have to attend a business meeting or appear at a Broadway opening or charity event, these afternoon work sessions were likely to drift into cocktails, dinner with guests, and late evenings in the parlor. Gypsy's suite had become another favorite place to assemble for most of the household. An experienced trouper, she had efficiently made her space as personal as a backstage dressing room, with furniture borrowed from George, homemade curtains in the windows, and scattered baskets of knitting and needlepoint. The typewriter rested on a small table in the corner, next to a tea tray and stacks of books, and George had reached into his supply of old clocks and porcelain figurines to add other details. Aside from a six-foot-tall cardboard cutout of Gypsy herself, brought to Brooklyn from a Broadway theater lobby, the large sitting

room exuded a cozy, feminine aura, perfect for long conversations on increasingly chilly nights.

Close as George and Gypsy had been before she came to 7 Middagh, their relationship intensified that November. George had never before spent so much time in her presence and was struck anew by her nervous energy. Funny and charming as he found her unselfconscious pacing, smoking, tea-drinking, skirt-adjusting, chattering activity, he also came to understand its roots in a lifelong fear that poverty, failure, and disgrace were right behind her and gaining ground. At twenty-six, Gypsy had already been hospitalized more than once with stomach ulcers. Her doctors had ordered her — unsuccessfully, for the most part — to cut down on coffee, alcohol, and cigarettes. After their editing sessions, Gypsy would confess to George her fear of what would happen when she was too old to perform burlesque. But George, who also saw the strength and resourcefulness with which his friend attacked each new project in her life, considered her stage persona among her least important assets. He loved, for example, to watch Gypsy's face light up when she talked about her ramshackle farmhouse in the country. "For all your Norwegian ancestry, you travel by land; and you are in a true sense earthy," he wrote to her later that year. "You are never quite so beautiful as when you are standing out on your own land and telling of the improvements you are going to make on it."

Only a true friend would have been able to look past the "Illusion" of Gypsy's beauty to the survivor underneath. She responded by trying to be as good a friend to George. It wasn't easy, for Gypsy was, as Janet Flanner fondly described her, *"la femme de l'action,"* and George seemed to revel in formless nostalgia and unfocused longing. His expressions of sadness over never having written a second novel after his first success — and his lack of progress since his arrival in Brooklyn — were likely to be greeted by Gypsy with a spirited "Fiddle fiddle" and a contemptuous snort. George's problem, Gypsy insisted, was that he was too much of a perfectionist. Besides, he couldn't possibly write a serious novel here with all of the distractions the house provided. He should move out to her farmhouse and write his novel there. They could live together as writers, leaving New York behind. George declined the offer. But he acknowledged, as Flanner remarked years later, that Gypsy's brilliance lay in her ability "to regard as common sense what others regard as outright lunacy." Her sense of invention for life was her greatest gift.

Gypsy was glad to see that George made a special attempt to make

Chester Kallman feel at home at Middagh Street. George could often be found with Chester in the kitchen in the afternoons, rendering the Brooklyn boy helpless with laughter at his southern belle impersonations of a character he called "Miss *Bazaaar!*" Gypsy saw something of herself in the ambitious student whose Depression upbringing, touched briefly by his mother's theatrical career, had done little to prepare him for a literary adulthood. Certainly, she knew how it felt to be judged on one's sex appeal rather than intelligence or talent.

It was clear to Gypsy that, as Auden's favorite, Kallman initially felt isolated at 7 Middagh. When he arrived before Auden had finished his work, he knew better than to interrupt. From the beginning, their routine had been ordered around Auden's work. Waiting for him to finish, Kallman sometimes went out to the garden to do some writing of his own. But time dragged, and his imagination easily wandered. He idly doodled sketches of castle walls and girls' faces in the margins of his notebook, worked on the penciled stanzas of his "Ode to Winter," made a list of rhyming words ("malice, callous, palace"), and another list of favorite authors' names ("Dante, Rilke, Rimbaud, Meredith"). Once, his impatience surfaced on the page:

> Upon the porch my inspiration ceases
> But upstairs Wystan paces
> Like a horse before it races
> Intoning one by one his quickie masterpieces.

Not that Kallman disliked his situation with Auden, but he was ambivalent about a relationship in which he would always take second place. At nineteen, he was nearly the age that Auden had been when he experienced the life in Berlin that had since been immortalized in poetry and prose. Kallman, too, was considered a promising intellect in his own milieu, entering college two years ahead of his peers and surrounded by an admiring crowd of literary classmates. But these young poets and writers had, for the most part, drifted away, intimidated by the peering, impatient, domineering presence of the older, famous poet.

Kallman wanted to begin his own adventure, his own quest. If writing consisted of rummaging through one's life, as Auden had said, and dredging up the images that hurt and connect, he needed to have a life from which to dredge. Yet Auden's lukewarm response to his work and the assumption of others that it was not his brain that had attracted the older poet had undermined Kallman's confidence. The two men still

experienced a palpable joy when debating literature, philosophy, and music. Lately, though, Kallman had begun to complain about having a relationship with someone who "is always right." A number of people at 7 Middagh noted with interest how Gypsy seemed to try to make up for Auden's tactlessness by focusing her glamorous attention on Kallman, soliciting his advice and opinions.

But the Middagh Street resident who benefited most from Gypsy's presence was undoubtedly Carson. The young writer seemed to draw pure energy from her housemate down the hall, who was as warm and welcoming as Annemarie was distanced and cool. Gypsy delighted Carson with her stories of playing the back half of a cow in vaudeville, of touring with Ziegfeld's *Follies* with a menagerie of cats, turtles, guinea pigs, and a goldfish that she'd won at Coney Island. Carson was happy to listen again and again to descriptions of the strip routines of Nudina, whose specialty act involved a six-foot boa constrictor she stored under the sink in the women's dressing room, and Flossie, who covered her breasts with a Harvard pennant and wriggled her bottom at the audience, yelling, "Oh, Daddy!"

It was a relief, too, to have the company of another woman in the house. Auden and George were used to the bachelor life, sometimes shocking Carson with the kinds of places they were willing to visit. One night, she was so appalled by the sight of the derelicts who haunted the alleys and doorways of the Bowery bars they patronized that she ran all the way to Chinatown to catch a taxi back to Brooklyn. There she sat, cold and miserable on the steps of the house, waiting for her friends to come home and let her in.

George's adventurous nature had exposed Carson in another way as well. Her novella *Reflections in a Golden Eye,* which had appeared in two fall issues of *Harper's Bazaar,* had created quite a scandal. The magazine's mid-American readers saw the story of homoerotic longing on an army base as shockingly inappropriate in these highly patriotic times, with their sons and husbands facing enlistment. George's friends at the magazine reported that a number of readers, including Mrs. George Patton, had canceled their subscriptions in protest. Such a violent response could not help but jar a young writer who just six months earlier had reached the pinnacle of literary success.

George, unperturbed, maintained that the outrage was excellent publicity, for it turned her fiction into news. But this further complication

added to Carson's emotional strain. Hard as she had tried for the past month — working at her desk for hours each day — she had still not managed to reach deeply enough into "the poetry of [her] own childhood" to find the center of *The Bride and Her Brother,* her developing novel. It was at times like this that Carson feared that her period of creativity was over and that she would never be able to write again. Unlike Auden, Carson could not simply make art happen by methodically processing the ideas and emotions of the day. For her, the development of a story was a mysterious, mystical process, like a "flowering dream." It depended on faith and patience and could not be hurried or forced. It could be maddening, however, to wait day after day for her magic elixir of hot tea, sherry, and cigarette smoke to take effect, only to come up with nothing. It was also true, as her husband had predicted, that the pace of life in Brooklyn was straining her health. At times, Carson experienced a kind of aching homesickness or nostalgia, not necessarily for her childhood home in Georgia, but for the time when she could write easily without the pressure of having to build a career or even of knowing that her work would be read.

It was a relief, then, to curl up with a whiskey in the warmth and safety of Gypsy's room, admiring her friend's healthy frame in its sheer nightgown — worn, if the night was chilly, over baggy-kneed long underwear — as she moved about the room. Gypsy's face was likely to look a little smudged late at night, since she rarely bothered removing her makeup; she kept her fine hair out of her face with a single huge hairpin. Carson was interested to discover that despite her practical intelligence, Gypsy was quite superstitious. Hats on the bed, whistling in a dressing room, and the color green backstage were all considered unlucky. For good luck, one must eat twelve grapes, one on each of the twelve strokes of midnight, every New Year's Eve.

Carson felt that she could tell Gypsy anything, so of course she did. Night after night, her voice drifted from behind Gypsy's door, bemoaning the emotional absence of Annemarie, who seemed to be succumbing to her own difficulties with romance, politics, and drugs. Reeves, too, had been causing problems as, still unemployed, he hung about the house in Brooklyn. He was like a piece of driftwood, always floating along, unable to find a place for himself. It grieved Carson, who could recall happy evenings not so long before in Fayetteville, when they would sit together by the stove for a last glass of sherry before bedtime. But when he was invited to spend an evening with the Middagh Street group, his resentment

began to boil over after a few drinks and a long, painful night of arguments and accusations would ensue.

Gypsy, like so many of the other women writers who frequented the house — Janet Flanner, Solita Solano, and others still to come — responded to Carson's emotional vulnerability by trying to take care of her. As Carson later remarked, the perfect antidote to exhausting emotional or mental activity at 7 Middagh was a visit with Gypsy, who would respond to the discovery of some lovely apples in the garden with, "I will make a strudel tonight." When their talks went far beyond midnight, she sometimes allowed Carson to fall asleep in her bed. Having grown up sleeping with her siblings, her cousins, and her "first love" — her grandmother, whose lemon verbena scent Carson never forgot — the southern writer was comforted by physical contact with her friends. She admitted later that homesickness caused her to cling "somewhat limpet-like" to Gypsy and the others at 7 Middagh. "There was a family feeling that was dear to me," she wrote.

George's tales of life at the house soon spread through the studios, theaters, and editorial offices of New York. It became common knowledge that the poet Wystan Auden was living and working in a ruin of a house in Brooklyn; that the ingénue-writer Carson McCullers lived with him, dutifully corresponding with her mother every day; that George Davis, who had rented the house, believed it to be haunted — or so it seemed, he murmured suggestively, what with all of the creaking stairs, squeaking doors, and ghostly whisperings that could be heard through the night.

Interest ratcheted up considerably when word got out that Gypsy Rose Lee had joined the group. The telephone on the table near the entryway began to ring constantly. Was it true that Gypsy had moved to Brooklyn? the callers wanted to know. Was it true she was writing a detective novel? Yes, it was all true, George assured each person. Not only that, but he and Gypsy were engaged.

Suddenly, the trip across the bridge to Brooklyn Heights seemed a small price to pay to visit 7 Middagh Street. An increasing number of friends, and friends of friends, began angling for invitations. So far, George and his housemates had felt constrained in their socializing by the ongoing repairs and general confusion in the house. But the miraculous had finally occurred: all the workmen had gone. Everyone agreed that it justified a celebration.

It seemed appropriate, however, to first hold a private dinner of their own before opening their doors to the outside world. As it happened, Thanksgiving Day was approaching. Benjamin Britten, whose top-floor room was now ready and who was preparing to move in with Peter Pears, would be turning twenty-seven that week. The group agreed to hold a combination housewarming, birthday celebration, and Thanksgiving feast, inviting everyone who had made their life together possible. Carson helped George compile a guest list that included Lincoln Kirstein and any friends he cared to bring, Klaus and Erika Mann and their brother Golo, Annemarie Clarac-Schwarzenbach, Reeves McCullers, Chester Kallman and his father, several friends from *Vogue, Mademoiselle,* and *Harper's Bazaar,* the composer Aaron Copland, a favorite of Britten's, and Beata and Michael Mayer, the grown children of Britten's Long Island hostess, Elizabeth Mayer. At Carson's urging, George also invited the author Richard Wright, who had so favorably reviewed her novel the previous summer. "My friend Carson McCullers was so deeply touched by your review of her book and is most anxious to meet you," George obligingly wrote. "I am sharing a house with McCullers and W. H. Auden in Brooklyn. It is now terribly torn up but we hope soon to have a housewarming and would be delighted if you could come."

Having agreed that it didn't seem right to expect Eva to prepare the meal, since she was one of the people they wanted to thank, Carson volunteered to do the cooking. She approached her assignment with enthusiasm, buying a case of champagne along with the ingredients for a roasted turkey with chestnut dressing and all the trimmings. However, she got off to a poor start on Thanksgiving Day. "I had bought a small turkey and the guest list was about twenty people," she admitted years later. "After some dirty looks at me George just picked up the turkey, took it out of the house, and exchanged it for an enormous bird more suitable for the occasion."

Somehow, a feast was successfully prepared. Wright was unable to attend, but most of the other guests appeared. The long dining table nearly disappeared beneath the quantity of food. The champagne flowed, along with the red wine, and the conversation grew lively as the guests discovered how much more they had in common than they had realized. Auden enjoyed practicing his German with Golo Mann, who was now staying with his family in Princeton and working for the Emergency Rescue Committee. The earnest, dark-eyed young German was pleased to

have this opportunity to talk with the poet, whom he had met in Switzerland years before and considered perhaps the most intelligent man he had ever met. Auden "thought truths out for himself," Golo would observe later, and many of the ideas he expressed in passing "could have been expanded into whole books."

Up and down the table, shouts and laughter prevailed as Kallman called to "Miss Master" to pass the potatoes, George described to Kirstein the *gorgeous* hunk of seafood he'd sampled on Sands Street the night before, Gypsy brushed tantalizingly past Dr. Kallman on her way to refill the teapot, or McCullers chattered over the wine about the curious fact that all of her favorite books as a young child had had something to eat in them.

For Britten and Pears, after their long stay with the Mayers on Long Island, 7 Middagh felt a little like another planet. The tall, slim, neatly dressed composer and his handsome, wide-shouldered partner smiled politely as they held out their wineglasses to be refilled. The Mayers had frequently held large dinner parties attended by artists, but none of them had included a nationally known stripper, a child author who seemed well on her way toward alcohol poisoning, or anyone like George Davis, and none had ever reached this level of hilarity. It was ironic that it was the Mayers, and not this group, who were living in an asylum on Long Island. Still, Britten and Pears harbored high hopes of making themselves at home here. New York City was the place to be to find commissions and arrange performances, both of which they desperately needed. And everyone was very friendly, generous, and terribly enthusiastic about one's work, even if they were not familiar with it. Besides, there was no denying that the rooms were cheap.

The Thanksgiving feast lasted long into the night, long past the point of inebriation. When all the food was consumed and the champagne and wine done away with, the group moved upstairs for coffee and cognac before a roaring fire in the parlor. There, they entertained one another by singing songs, accompanying one another on the piano, and playing a variety of games. Those who did not know Britten learned that he was a consummate pianist, as good as a concert performer, and Pears thrilled the group with his brilliant tone and strong, expressive delivery. As more logs were added to the fire and the conversation grew even livelier, a game of charades was proposed. Michael Mayer, already dazed from the experience-of-a-lifetime of having Gypsy Rose Lee sit on his lap with a

gin bottle in her hand, drew the play title "You Can't Take It with You" and tried to act it out by "failing" to carry McCullers across the threshold. (This proved difficult to pull off, since Carson weighed nothing and was easy to carry.) A game of Murder soon followed, as the celebrants turned out all the lights and slipped silently up and down the creaking stairs and through the half-furnished rooms, shrieking with delight as they hunted one another down. "The evening or rather morning ended with Peter and George Davis doing a ballet to Petrushka, up the curtains and the hot water pipes," Britten later wrote to his friend, the violinist Anthony Brosa, "an impressive if destructive sight."

It was nearly dawn when the group heard sirens coming from the small fire station down the block. Gypsy loved fires, as did Carson. The two women jumped up impulsively and ran out of the house. "We ran for several blocks chasing the fire engines," McCullers recalled. "It was exhilarating to be out in the chilly air after the close heat of the parlor." For the first time in months, she felt free of the anxiety of her work. She could hardly believe that she, Carson, was running through a street in Brooklyn hand in hand with Gypsy Rose Lee. It had been an amazing two months in the house on Middagh Street, despite the crises and setbacks, enriched by friendships such as she had never known before. Out of the despair of the summer had come this life. She was no longer alone. She had much to be thankful for.

And now — running after the fire engine, laughing, and shivering in the night air — Carson experienced the moment of illumination for which she had been praying. The key to her novel, the image that would allow her to continue, had emerged at last. "I caught Gypsy's arm," she would recall, "and out of breath said, 'Frankie is in love with her brother and his bride and wants to become a member of the wedding!'

"Gypsy looked at me as though I had gone insane," she added. For Carson, however, months of confusion had ended in an instant. She burst into tears, leaning on the taller Gypsy in the near-freezing air. It all made sense now. Like Chester Kallman and his aunt Sadie, Frankie wanted to marry her brother and his bride — to become a member of their wedding and thereby, in a larger sense, an accepted and fully loved member of the world. The twelve-year-old girl, so unhappy and vulnerable in Carson's developing story, longed only for the same kind of connection with others that Carson herself was trying to achieve, a connection with people who saw her as she really was rather than as who she

was assumed to be. A world of people like those who occupied the parlor inside.

By midmorning, a thin dusting of snow covered New York. Winter was coming. It was November 29, the day that MacNeice was to depart for England, and he had already packed his bag and put on the wolf collar coat that Auden had given him. MacNeice had little desire to join the war in Britain — no more than Auden did, in fact. After months of soul-searching in America, however, he had decided that returning to England was, for him, the lesser evil. Nevertheless, he grumbled, "it is hard to risk your life for a Lesser Evil on the off-chance of some entirely problematical betterment for most likely a mere minority in a dubious and dirty future." He was returning, he wrote, "to a past which is not there . . . somewhere without tenses," a place that was changing so fast that if he stayed away for even one more year, he felt, he would have to stay away for good. Still, he had loved his time in America and did not judge those who chose to stay.

At 7 Middagh Street the residents slept in, lulled by the low moan of the ships' horns in the harbor and the plaintive call of seagulls. The house was full to bursting with exhausted revelers, oblivious to the early movement up and down the block. In the top-floor room facing the Manhattan skyline, a new poem lay among the litter of manuscripts and books on Auden's desk. "In Sickness and in Health" was an ode in praise of married love, a meditation on the sacred quality of a committed relationship between two people — evidence of a new direction in Auden's thinking. But the poem could have been addressed, too, to all who had laughed and talked and danced and celebrated the night before:

> Beloved, we are always in the wrong,
> Handling so clumsily our stupid lives,
> Suffering too little or too long,
> Too careful even in our selfish loves:
> The decorative manias we obey
> Die in grimaces round us every day,
> Yet through their tohu-bohu comes a voice
> Which utters an absurd command — Rejoice.

Part II

The Bawdy House

DECEMBER 1940—FEBRUARY 1941

Here, I'm afraid, one is inclined
to speak of Europe in the past tense.

— Benjamin Britten

5

Every day America's destroyed and re-created
America is what you do,
America is I and you
America is what we choose to make it.

— W. H. Auden, *Paul Bunyan*, 1939–41

By December 1940, 7 Middagh Street had been opened to guests and the house filled with them almost instantly. Poets and publishers shared taxis to Brooklyn to spend time with Auden, McCullers, and Davis; composers and conductors arrived to exchange news with Britten; and everyone from the theatrical, film, literary, and art worlds wanted to share a cocktail with Gypsy Rose Lee. It became fashionable in Manhattan to mention that one had been out to Davis's house to partake of one of Eva's hearty meals or to spend an evening in the parlor with Kirstein and Balanchine, George Dangerfield and Flanner. Entertaining, too, was Davis's assortment of colorful new friends from Sands Street, including Snaggle-Tooth, a pimp who handed over all his ill-gained profits to his old Italian mother, and Ginger-Ale, a piano player so called "because he sparkles, but it's not champagne."

Louis Untermeyer, Carson's guest, was bemused by her attempt to construct a life based on the artistic values he had celebrated in his recent book. Carson clearly relished the role of cohost of the city's newest *salon,* even if George's guest lists and decorating scheme gave it a rather bizarre slant. She appeared euphoric in this setting — more energized and voluble than at Bread Loaf, sufficiently confident to join conversations with such heavy hitters as the playwright William Saroyan and the producer Cheryl Crawford, a cofounder of the left-wing Group Theatre.

It was always a pleasure to share a meal with Auden, who frequently recited his poetry-in-progress at the table, soliciting comments and suggestions from his companions, many of which would be incorporated into his work the next day. George, too, was clearly in his element as he picked and chose from his seemingly infinite number of contacts to spice up an evening *en famille*. But it was Gypsy who provided the greatest heat at the center of those early winter nights, dropping in for meals "like a whirlwind of laughter and sex" and working the parlor with professional skill, perching on the arms of chairs, leaning close to whisper a confidential word into tweedy professors' ears, and letting loose a rich, throaty laugh that thrilled everyone. Guests who had heard that she was sharing an atelier with the likes of Auden may have come to laugh, but they were often surprised to find her remarks on books, theater, and art not only well informed but original and perceptive. Gone were the painful days of mispronouncing the names of famous authors and blurting out mid-party, "You son-of-a-bitch!" Thanks in large part to George, who had been tutoring her for years before she ever set foot on Middagh Street, Gypsy was becoming a legitimate "brain."

Still, it was her frank enthusiasm that most attracted her fellow artists. Writers and composers warmed to her interest and found, as they shared their triumphs and frustrations with her, that no one understood better than she the vicissitudes of the creative life. The visual artists, too, fell hard for the tall writer in her provocative red silk gowns. Pavel Tchelitchew made himself a permanent member of Gypsy's inner circle. Marcel Vertès was devastated when Gypsy took offense at his attempted clever comment that she was intelligent as only ugly girls are as a rule. Blaming his poor English for the blunder, he swore that he would learn the language solely to speak to Gypsy.

Britten attended these parties with great anticipation, for they allowed him to mix with important music and theater people whom he might not otherwise see. Some of the musical guests were already friends of his — including Copland, and whose American style of composition Britten much admired, and Colin McPhee, whose years spent transcribing gamelan music on the island of Bali had informed his own original work in fascinating ways. But Britten also had the opportunity to meet the young composer Leonard Bernstein, who had spent the summer working with the new Tanglewood Festival in Massachusetts, Bernstein's mentor, Marc Blitzstein, who wrote the wildly successful and groundbreaking political opera *The Cradle Will Rock,* and the acid-tongued but highly influential

Virgil Thomson. Knowing that Lotte Lenya was a close friend of Davis's, there was always a chance that her husband, Kurt Weill, might drop in after the out-of-town tryouts of *Lady in the Dark*. Britten had met Weill the previous summer, on vacation in Maine, and had enjoyed a long talk with the émigré composer about American musical theater, a genre with which Britten hoped to experiment.

Britten was especially gratified to strengthen these connections because he had experienced a rash of professional misfortunes recently. His first symphony had been rejected (for political reasons, most likely; it had been commissioned by the now-hostile government of Japan), the premiere of his *Violin Concerto* at Carnegie Hall had received mixed reviews, a winter season of performances in Britain had been canceled because of the war, and a major Chicago performance had been canceled as well when his frozen British bank account left him unable to travel to the Midwest. The former wunderkind, who had been considered by many the most promising British composer of his generation, was so short of funds that he had accepted a job as conductor for the Suffolk Friends of Music Orchestra, a small amateur group on Long Island, for $10 per rehearsal. It was not the kind of work he had expected to find in America. As he wrote to his friend the violinist Antonio Brosa, "We would not think of playing anything as high-brow as the Brandenburg Concertos. We only play Slav music which seems to suit the enthusiasm of the Long Islanders; so much so that last Tuesday I strained my back and I am now groaning whenever I move."

Aside from the potential for professional contacts, the evenings at 7 Middagh Street were intriguing in other ways. It was astonishing for Britten to witness the carelessness with which everyone in the house exhibited his or her own particular brand of sexuality. His relationship with Pears had begun only the previous year, after the two had come to America together. It was the first serious, open love affair of Britten's life, and while he and Pears were much more discreet by nature than Wystan Auden and Chester Kallman, they had already inadvertently caused a scandal at their former home in Amityville. A Mr. Titley, the sanatorium's superintendent and their host's employer, had noticed how crowded the Mayers were with their guests and had offered to put Britten and Pears up at his larger home on the grounds. Not wanting to impose on the Mayers more than necessary, the composer and singer had agreed to the plan. But Mr. Titley and his wife had not expected the two to share a single bedroom when two were available. The discomfort that resulted had

led to increasing friction, and the embarrassed musicians eventually re-
turned to the Mayers', dragging a trail of muted but persistent gossip
behind them. One could not help but wonder what the Titleys would
make of a house such as 7 Middagh, where Chester performed expert im-
personations of his favorite opera divas, Klaus Mann inhaled delicately
on a cigarette while his sister, Erika, harangued the guests, George Davis
worked his charms on a Sands Street sailor in the corner, and, as Louis
Untermeyer remarked, "Gypsy did not strip, but Auden did plenty of
teasing."

Britten was long accustomed to Auden's goading tendencies when it
came to his own sexual behavior — and he didn't always mind. Since the
two had met in 1935, when creating the music and narration for a series
of British documentary films, their friendship had been grounded in two
basic tenets: a shared high regard for each other's artistic abilities and the
understanding that Auden knew best. At twenty-one, Britten had lived a
tightly controlled existence, still very close to his mother, and was per-
haps constitutionally unable to act on his secret attraction to adolescent
boys. As a result, Auden, a physician's son, and Isherwood, a former med-
ical student, had greatly amused themselves through the latter half of the
1930s by diagnosing Britten's condition and recommending therapeutic
action.

In a poem written for Britten in 1936, Auden spelled out their general
philosophy when it came to their friend, whom they affectionately called
Benjy:

> Underneath an abject willow,
> Lover, sulk no more:
> Act from thought should quickly follow.
> What is thinking for?

In 1938 Auden made a more specific suggestion in a letter from Eu-
rope: "I've got something waiting here for you that will make you crazy.
16. . . . mother dead. Father drinks. Shall I get a photo? Such eyes. O la,
la." And when the young composer ventured a move on a boy he liked,
only to be rebuffed, Auden briskly advised, "Dear Benjamin, Nothing to
worry about really. As I haven't seen him, I can only guess at what hap-
pened, but human nature runs along certain lines.

> I. You oughtn't to have given him the chance of going to the Corner
> House.
> II. Did you play the piano. Most important.

III. I'm afraid like many people he enjoys a feminine love of power.
The correct line is
A. To appear comparatively indifferent emotionally
B. To take not the slightest notice of a refusal.

Remember he WANTS to be mastered."

Such playful provocation was typical of Auden, but it contained a serious element as well. Auden wholeheartedly admired Britten's work — over time the composer had, in addition to his own considerable oeuvre, set many of Auden's poems to music, created accompaniments for plays on which Auden and Isherwood had collaborated, and periodically worked with Auden to create cabaret songs for their friend, the singer Hedli Anderson. However, as the years passed, music critics had grown increasingly impatient with Britten's seemingly limitless adaptability at the expense of a unique musical personality of his own. His compositions were called technically brilliant but creatively unfocused, indicative of great promise but still immature. By 1938, Britten seemed to have stalled creatively, and Auden was certain that the source of the problem lay in his reluctance to come to terms with his sexuality. If it was in his power to further the cause of British music by prodding Britten, Auden considered it his duty to do so as both a friend and fellow artist.

Britten was willing enough to go along with Auden's bullying. Considering himself intellectually inferior, he was grateful for the attention and flattered by the famous poet's passionate belief in his work. And some of Auden's efforts had been quite successful. It was Auden who introduced Britten to the work of the teenaged poet and street urchin Rimbaud — poems that had inspired the composer to begin a cycle of settings he called *Les Illuminations*. It was Auden who, after his own arrival in America, had urged Britten to follow in the hopes that the new environment would not only provide new musical influences and contacts, but would also jolt him into the freer behavior that might push him to another creative level.

Aaron Copland, who had met Britten in England at about that time, also urged him to make the trip. American audiences, he said, were less critical of young composers and more accepting of new work. With so many American communities beginning to build concert halls, it was easier there than in Britain for a composer to find work. Britten acknowledged that there was much about American music that he loved — Broadway tunes and film soundtracks especially — and that it would be

fun to try to involve himself in those arenas. "I am now definitely into my 'American' period, & nothing can stop me," he wrote to friends near the end of 1938. "I hum the tunes & mutter the words all day, & all my ideas now seem to be that way too." As a result, after the death of his mother, Britten boarded a ship to America in 1939 with Peter Pears.

Again, the effect was roughly what Auden had hoped for. While Britten did not initiate an affair with a teenaged boy, he unexpectedly found himself in a relationship with Pears, who was three years older. It was a love affair that deepened daily, based on friendship and great affection, and the passion and joy that it inspired in Britten led to the completion of the *Illuminations* song cycle, with its glorious repeated, attention-grabbing phrase, *"J'ai seul la clef de cette parade sauvage"* ("I alone have the key to this savage parade"). Next had come the moving *Violin Concerto,* a musical contemporary of Auden's "September 1, 1939," as it too was written in response to the beginning of the war, and *Sinfonia da Requiem,* dedicated to Britten's deceased parents — all evidence of a great step forward in his work.

Now, in Brooklyn, Britten looked forward to a new collaboration with Auden, whom he considered his closest friend aside from Pears. The year before, at the suggestion of his American music publisher, he and Auden began work on an operetta for performance by high school choruses. Britten was told that such a work would help get his name known beyond the eastern cities to the rest of America and could potentially provide him with income. Having been shocked by the poor quality of music instruction in the Midwest during a visit there, and loving amateur productions of all kinds, he was eager to proceed. Besides, Britten had never before attempted an opera, and a children's operetta seemed a good way to experiment with the form. Auden saw it as an opportunity not only for another enjoyable collaboration but as a new means through which to express his evolving ideas about America.

Their first challenge was to select an appropriate story. The royal dramas and ancient myths that served as the basis for most European operas struck Auden as inappropriate for a modern nation such as this one. However, America had its own myths, which Auden believed were as profoundly connected to the collective American experience as the classic legends were to Europe. Americans, too, had had a common "enemy" to conquer — not an invading nation or dynasty but nature itself. The essential story of America was that of taming the wilderness and building a civilization from scratch. Searching among America's folk tales for inspi-

ration, Auden came across the legend of Paul Bunyan, the giant lumber-jack who, with the magical blue ox, Babe, at his side, chopped down the trees used to build America's towns and cities. This, he decided, was a story that would appeal to high school performers and could also serve as a vehicle for the ideas about America that he wanted to explore — ideas about what choices are necessary to develop and maintain a modern society. These issues would become more urgent once the ashes had settled on the war in Europe, and so were especially important for adolescents to consider.

Racing forward with the work, as was his tendency, Auden had finished most of the libretto by January 1940. Britten had made a good start on the music as well, and when Lincoln Kirstein heard him perform some of the tunes, he was struck both by their vitality and charm and by their uniquely American style. It seemed to him that Auden's and Britten's efforts in opera were similar to his own in ballet — to create a uniquely American tradition in what was currently a European art form. He suggested that his and Balanchine's Ballet Caravan produce *Paul Bunyan* on Broadway. Excited by the idea of working on Broadway, Britten began to discuss with Auden the changes that such a production would require. But just then Britten succumbed to a serious streptococcal infection (which Auden diagnosed as a psychosomatic expression of homesickness for England), and both production and operetta were abandoned.

Recently, Auden had received a more modest offer from a representative of the Columbia Theater Associates, a group of actors at Columbia with a mission to broaden the audience for new theater. If *Paul Bunyan* could be completed immediately, the group would consider staging it at the university's Brander Matthews Hall in late spring, 1941. It was hardly a glamorous debut, but Auden hoped — and Britten agreed — that it might lead to greater things. The collaboration was one of the reasons that Britten had moved to the house at 7 Middagh Street. Meanwhile Pears, who had toured America years before with a choral group, the New English Singers, hoped to organize a new group to perform English madrigals and some of Britten's compositions.

But even with the promise of these new ventures, the house at Middagh Street still took getting used to. Their two front rooms on the top floor were charming, with a practically English view of the narrow street and the well-tended garden across the lane. But the absence of carpets meant that Gypsy's warm laughter drifted up through the floorboards,

mixing with the sound of Auden's and Kallman's voices down the hall and, on many occasions, with McCullers's arguments with her husband downstairs. During the day, the doorbell rang every other minute, and someone was always working on a project in the dining room, playing records in the parlor, or holding parties in his or her room. The house remained untidy, too; Susie, the maid, did her best, but with residents like these, her task was impossible.

And the constant talk of the war made it difficult to concentrate. Britten still had two sisters in England — one of them in London and constantly threatened by bombs. With overseas mail agonizingly slow, it was impossible to know from day to day whether she was safe. Britten didn't like to think about England much these days, anyway, because — like Auden, Isherwood, and the other British artists in America — he was being loudly censured for his absence. In September, an essay he had written for the *New York Times* before the bombing of London began, "An English Composer Sees America," had resurfaced in England. His countrymen took strong exception to its praise of the working conditions for composers in the United States as compared to Britain. "Truth is always impalatable, especially when one is in the middle of an air-raid," Britten wrote to a friend. "I feel sick it was issued there just at this moment."

Later that month, he received a letter from his British publisher, describing the rising resentment over his decision to remain in America. There was no doubt, the publisher wrote, that it would be difficult to get Britten's works performed in this hostile climate. He declined to advise Britten on whether he should return — but the composer learned from another source that for months a rumor had been circulating that the entire trio of British artists — Britten, Auden, and Isherwood — might never be allowed back in England.

This news shocked Britten. He told his publisher that he understood the hostility and asked him not to go out of his way to promote his works. "If people want to play them over there, they will, but I don't want you to embarrass yourself in any way," he wrote. "I have been desperately worried, not really about what people are saying (I feel that one's real friends in England will be unselfishly pleased that one is being spared . . . that is in fact what every letter says so far), but about the fact that one is doing nothing to alleviate any of the suffering."

Like Auden, Britten had reported to British officials in the United States and was told he was not yet wanted back, since he possessed no military skills. The situation was complicated for Britten because both he

and Pears were pacifists and could conceivably be imprisoned in Britain if they refused to enlist. Even if they won conscientious objector status, they would be banned from employment by such government-run institutions as the BBC. And, of course, homosexuality was illegal in the British military (as in the United States). Underlying Britten's anxiety must have been the fear that his sexual life would be laid open to public examination. For the time being, at least, Britten and Pears elected to stay where they were.

Still, it was painful to look into the eyes of the refugee writers, artists, professors, journalists, political dissidents, and other intellectuals who began to appear in increasing numbers at the parties in the house in Brooklyn. By 1940, the flood of wealthy dukes and princesses fleeing Europe had largely abated. The members of this new wave, most of whom had already been drifting across Europe for four years or more, arrived half-starved, with haunted expressions, dressed in ragged clothes and holding tight to the hands of their remaining children. Many of the more than three hundred individuals who had been brought to America by the European Rescue Committee remained in shock from recent events — their escape from concentration camps and French prisons, their crossing over the mountains, their fight for passage across the ocean, and their arrival in New York.

Years later, Isherwood would describe the feelings that filled the newcomer as his ship pulled into the harbor:

> God, what a terrifying place this suddenly seemed! You could feel it vibrating with the tension of the nervous New World, aggressively flaunting its rude steel nudity. We're Americans here — and we keep at it, twenty-four hours a day, *being* Americans. We scream, we grab, we jostle. We've no time for what's slow, what's gracious, what's nice, quiet, modest. Don't you come snooting us with your European traditions — we know the mess they've got you into. Do things our way or take the next boat back — back to your Europe that's falling apart at the seams. Well, make up your mind. Are you quitting or staying? It's no skin off *our* nose. We promise nothing. Here, you'll be on your own.

Dazed by all the people in the street chattering in foreign tongues, by the shops miraculously stuffed full of goods — a dozen varieties, it seemed, of every item — and clutching their well-worn scrapbooks full of performance notices in Vienna and literary prizes won in Prague, these creative intellectuals drifted through the city in search of others like

themselves, who could give them information, point them toward cheap housing, and, God willing, get them work. Nearly all of them, it seemed, had heard of Klaus and Erika Mann. The siblings had become such prominent activists that a joke now circulated within the community that one must first pay them a visit in America before being accepted as an official refugee. Frequently, the pair could be found at 7 Middagh Street. To the artists who sought them out there — any one of whom may have been, a decade earlier, a respected European cultural leader accustomed to life's abundance — the music, conversation, and hospitality that greeted them were like a surreal dream.

To Klaus Mann, now in exile for seven years, it was a familiar pattern. In every city that had welcomed these intellectual refugees — Prague, Amsterdam, Paris, Brussels — centers of activity and discussion had sprung up out of nowhere. Wherever they appeared, he wrote, such meeting places became the center of "a diffuse but lusty literary life" — a living embodiment of the literary forum that Mann had created with *Die Sammlung* and now with *Decision.* Such meeting places — both actual and on paper — were the most powerful means available, he believed, to "focus the scattered energies of our exiled intelligentsia" and thus amplify the voice defying Hitler.

Golo Mann, who had been feeling alienated by his prominent parents' cozy, upper-middle-class existence in Princeton, had recently accepted an invitation to move into 7 Middagh's unfinished attic. Now, Klaus enlisted Golo's help in turning the Brooklyn house into a kind of refugee center for artists. Here, the new arrivals met or were reunited with such European eminences as Franz and Alma Werfel, Pavel Tchelitchew, George Balanchine, the Austrian novelist Lion Feuchtwanger, the Italian journalist Max Ascoli, William and Elizabeth Mayer, and the Manns themselves — all alive, thriving, and willing to help them integrate into American life. At the same time, the Americans could learn from these survivors what life was now like across the ocean in Hitler's Europe.

Already, Janet Flanner had interviewed Golo Mann and a number of other recent émigrés for her stunning article "Paris, Germany," which appeared in the December 7, 1940, issue of *The New Yorker.* Instead of outlining the political moves of the past few months or focusing on Europe's political leaders, Flanner wisely evoked, in her crisp, sardonic tone, the chilling details of daily life in the occupied country. "Paris is now the capital of limbo," she began. "It is a beautiful French city on the banks of

the Seine which only Berlin, the capital of Germany, knows all about." Stating flatly that the French would have to become a race of liars and cheats in order to survive, she described housewives faking pregnancy by stuffing pillows under their apron fronts in order to obtain milk. Along the roads leading out of the city, taken by the refugees in June, the bodies of French soldiers had remained exposed through the summer while dead Germans were efficiently buried in gardens and flower beds. And meanwhile, she wrote, "the German soldiers, with money in their pockets for the first time in twenty-two years . . . have steadily advanced through the Paris shops, absorbing, munching, consuming lingerie, perfume, bonbons, leather goods, sweet silly novelties" — methodically ingesting all the wealth of Paris that they so coveted.

The visitors to 7 Middagh Street had other stories to tell — of narrow escapes from Nazi searches, of navigating port cities packed with refugees, and of saying good-bye to their rescuer, Varian Fry, who bestowed on each departing person a supply of cigarettes for bribing soldiers, a handshake, and the magic words "Have a good journey and I'll see you in New York."

But recalling the wreckage of Europe was the last thing they wished to do now — even if it were possible to fully communicate the experience of witnessing the arrest, the murder, or the deportation of a friend or loved one. Instead, they wanted to talk about America — to begin their new lives and, most of all, to work. Their years of wandering had taught them how quickly, despite the welcoming speeches at charity dinners and government functions, popular opinion could turn against them. Already, complaints had begun to surface in the press of the "intellectual blitzkrieg of America," of America's "becoming saturated with European thought." A number of American academics demanded to know how, when there were thousands of American Ph.D.'s still out of work because of the Depression, the nation could justify inviting hundreds more. New regulations were already being instituted to make it more difficult or almost impossible for émigré physicians and other professionals to obtain licenses in the United States. "I like them, these Americans, and they behave magnificently toward us," one émigré remarked, "but fundamentally — they don't realize it themselves yet — we are not wanted *even here*."

Soon, many of the refugees, having realized that jobs with the New York Philharmonic or at Columbia University were scarce, would begin fanning out across the country to take positions with the new amateur

symphonies, theaters, and art institutions that were springing up in midsized cities everywhere, each in need of the experience and education that the Europeans had to offer. Until then, Klaus Mann could provide a few with immediate publication in *Decision* — a morale boost that might help them restart their writing careers in the United States. Others could at least receive directions to the nearest German-language newspaper kiosk, public library, or museum while they mulled over the significance of their presence in this new world and considered what mistakes they might, as society's thinkers, try to help this country avoid.

The first issue of *Decision* was sent out for review on December 18, and the response was hugely positive. Klaus was invited to read from the journal on the radio, along with the Pulitzer Prize–winning poet Stephen Vincent Benét, and requests for copies began pouring in. "The list of our sponsors and contributors becomes almost unduly glamorous," he wrote in his diary. Encouraged, he threw himself ever more feverishly into his activities. Like his friends from overseas, he found it a great relief to turn away from the devastation in Europe with the second issue of *Decision* and focus instead on the question of what kind of society should be created next, here in America. "When this war began the democracies found themselves shockingly unprepared for it," Klaus wrote in his editorial column; "what they lacked as much as planes and guns, were ideas and aims." Even today, the democratic countries had no constructive program with which to refute the Nazis' propaganda, nor any clear postwar policy. "It is, therefore, the task and natural function of the intellectuals, of independent writers, scholars and thinkers, to visualize and outline the structure of a new society. We must not forget that almost all the great revolutionary changes in history were anticipated and prepared by the intellectual vanguard."

In this issue, Klaus added, he would provide a survey of various groups in the United States and Britain now working to create some form of "new order," so that readers could consider the implications of each one for themselves. He singled out for particular praise the manifesto *The City of Man: A Declaration on World Democracy*, published that winter by Viking Press and signed by seventeen distinguished thinkers — including the theologian Reinhold Niebuhr, a professor at New York's Union Theological Seminary, the chairman of the American Friends of German Freedom, and an active fund-raiser for refugee aid. Klaus explained that Niebuhr and his fellow authors strove to define the moral, legal, and economic foundations of a new form of democracy that could

begin to correct the kinds of problems that, they believed, had led to the current crisis. These tenets, designed literally to change the world, rested on the belief in certain absolute, objective moral values that must be considered before any economic, social, or other policy could be put into place. The authors advocated, too, a personal activism that must naturally emerge as the result of these objective values — and that they claimed was required by their religious beliefs.

As it happened, Auden had also been reading Niebuhr's views in his book *Christianity and Power Politics*, which he reviewed for the *Nation*. He summarized Niebuhr's argument that Western democracies, having developed from the Renaissance tradition, saw human history as a realm of infinite positive potential — and ignored to their peril the truth that the potential for evil exists permanently within this realm as well. The progressive democratic conviction that an individual could extricate himself from a state of sin — that is, eradicate his potential for evil through either mysticism or rational action — was false. The practice of pacifism, for example, would never achieve its goal of world peace in the face of political devastation because it was based on the idea that perfection could be achieved simply through progressive thinking. Evil, whether active or latent, would always remain, and it was blasphemous, as well as tragic, to ignore this truth when choosing one's actions.

Niebuhr's argument succinctly expressed many of the ideas that Auden had been mulling over since his visit with Isherwood the previous summer. He, too, had come to believe, particularly since the awful experience in the German cinema in Yorkville, that turning to pacifism and yoga would be a tragic misdirection of his energies. Still, Niebuhr's choice to rely solely on orthodox religion for guidance in choosing how to act left him a little uneasy, considering religious history. Furthermore, he thought it was actually possible for certain individuals to lead such a saintly existence that they changed the world for the better. He wondered, in his review, whether Niebuhr had simply "seen the bogus so often" that he had lost his ability to believe.

Auden's discomfort may have been partly the result of his own recent rediscovery of religious worship — and its associated saints and mystics. It also sprang from the fact that two of his closest friends — Isherwood and Britten — claimed to be pacifists. And even if his views increasingly conflicted with theirs, Auden's loyalty forced him to seek a way to excuse them from the rules he was striving to create for himself and everyone else.

Isherwood, who with Aldous Huxley had in fact submitted two pleas for pacifism to *Decision,* had written to Auden, asking whether he felt abandoned by Isherwood's having opted for the practice of yoga and official status as a conscientious objector. Auden did his best to provide Isherwood with an out, responding:

> I shan't feel you have walked out on me, whatever happens. The only really difficult question to *decide* — all the other difficulties are difficulties of execution — is; what is one's vocation? As you know, I regard the contemplative life as the highest and most difficult of all vocations, and therefore the one to which very few people are called — fewer even than are called to be creative artists, among whom rightly or wrongly, I believe my place to be: for the other I am not good enough. If you are *certain* you are called, then of course you must obey, but you *must* be certain, otherwise it is just presumption. The ethical problem depends on where on the spiral one is. At my level, I must fight if asked to, and believe that America should enter the war. At the level you are aiming for, such questions have no meaning.

Isherwood, Auden decided, was excused from action against Hitler because he felt called to a kind of sainthood. And Auden considered the creation of music itself a sacred act, so Britten was excused from fighting on similar grounds. As long ago as 1938 he had evoked his sense of music as the most sacred of arts in his poem "The Composer":

> Only your notes are pure contraption . . .
> Only your song is an absolute gift.
> You alone, alone, imaginary song,
> Are unable to say an existence is wrong,
> And pour out your forgiveness like wine.

These assertions were difficult to justify for someone as rational as Auden, however, and he wrestled throughout the winter with the implications of his own statements and their many exceptions. In "Christmas 1940," "At the Grave of Henry James," and "Kairos and Logos," he praised the religious mystics and tried on for size a variety of Christian attitudes, but he himself deplored the pompous and awkward tone of much of this work and rejected most of it almost immediately.

The difficulty for Auden came down, for the most part, to the act of placing his faith in an impersonal Absolute. As he had written to Isherwood, he was not cut out for the "contemplative life." His focus lay in the realm of everyday reality — of finding the universal in the personal. Besides, he was not willing to take this journey of faith, to learn to

rely on the objective moral tenets of Christianity, on his own. If faith was, as Kierkegaard wrote, a matter of "always being out alone over seventy thousand fathoms," Auden — the poet who had come to America to become one anonymous "lonely" among thousands — now resisted embarking on a spiritual journey without his lover by his side. That December, he wrote to Chester Kallman in a command that was also, perhaps, a plea:

> A solitude ten thousand fathoms deep
> Sustains the bed on which we lie, my dear:
> Although I love you, you will have to leap;
> Our dream of safety has to disappear.

Carson had responded with great excitement to the addition of the two British musicians to the household, the opening of the house to visitors, and the arrival of the émigrés from Europe. Her dream of playing host to New York's cultural elite had not only become real, but the house at 7 Middagh Street was turning into an international forum such as she could never have imagined. The situation brought to mind, for Carson, a convent near her childhood home where the gates had always been shut. One day, when she was about four, she and her nanny were walking past the convent and Carson noticed that the gates were open. Inside, in a courtyard, she could see children joyfully eating ice cream and playing on swings. She begged to join them, but her nanny refused because Carson wasn't Catholic. The next day, the gate was shut. For years Carson fantasized about the marvelous party that must be going on inside, she wrote, but she could never get in.

Now Carson was in, and her excitement led to a frenetic level of activity at her desk as well as downstairs. Having finally experienced the moment of illumination that she had needed to move forward with *The Bride and Her Brother* (later renamed *The Member of the Wedding*), she set to work transforming her insight into words on a page. "It happened that green and crazy summer when Frankie was twelve years old," the novel began. "This was the summer when for a long time she had not been a member. She belonged to no club and was a member of nothing in the world. Frankie had become an unjoined person who hung around in doorways, and she was afraid."

Carson went on to describe the summer heat of the town where Frankie lived and the girl's desultory days spent playing bridge with her

six-year-old cousin, Henry, and Berenice, the Negro maid. "The world seemed to die each afternoon and nothing moved any longer," she wrote. "At last the summer was like a green sick dream, or like a silent crazy jungle under glass."

She well remembered that dead, abandoned feeling of childhood. And she knew that Frankie would look to her departing brother and his bride as her means of escape. But the way to that solution remained unclear. As hard as she tried that winter, she was unable to proceed beyond her first evocation of Frankie's loneliness — to choose the correct path, from the infinite number of possibilities that presented themselves, to the wedding at the center of the story. Determined to break through her year-long resistance, she adjusted the elements of her traditional routine, increasing the number of hours spent at her desk, stepping up her consumption of alcohol, and staying up late with George, Gypsy, and their friends in search of further inspiration. She took time off only to work on the remunerative magazine articles George had procured for her and to help Klaus Mann with *Decision*.

Soon, this intense activity began to take its toll on Carson's emotional state as well as her health. In late November, the news had arrived that Annemarie Clarac-Schwarzenbach had been hospitalized in a psychiatric clinic after attempting suicide. Carson, stricken, learned that it was not her first attempt; like her morphine addiction, Annemarie's self-destructive behavior had begun years before. Now, despair over her difficult love affair with the Baronessa von Opel and her guilt over not having returned to Switzerland, where her father had just died, had overwhelmed the young woman. Hospital visits were prohibited, Carson was told, and though she wrote to Annemarie, she had no idea whether her friend received her letters.

The thought of Annemarie — the beautiful "pensive page," as Klaus Mann had described her — locked up in an institution and suffering the withdrawal symptoms associated with morphine, was too much for Carson to bear. She became weepy and emotional, lashing out at Reeves when he suggested that life at 7 Middagh might be too much for her at this time. Over the past several months, Reeves had grown increasingly disapproving of the group life in Brooklyn — not only of the high level of activity, but also of the open homosexuality accepted by both residents and guests. Carson insisted that the sex of two lovers had nothing to do with their feelings for each other. But Reeves felt threatened by the free

life that was fostered on Middagh Street. He, too, began drinking even more than before and succumbed to deep depression. By now he had entered into a number of sexual affairs in Manhattan, but none of them had developed into an emotional relationship that could compensate for the rupture with his wife.

No matter how much Carson and Reeves talked, drank, and wept together, their relationship failed to improve, and Carson saw her marriage as having ended. But she did not know how to convince Reeves to move on. It was not even clear, either to Reeves or herself, that she wanted him to leave permanently. In many ways, despite her talent and fame, Carson remained a child who could not loosen her hold on any person once an attachment had been created.

As the relationship grew worse and the weather grew colder, Carson's emotional distress increased. Unable to sleep, she drank with her friends downstairs or on Sands Street until the early hours of the morning. The others began to worry about her hacking cough and strange behavior. One night, at the ballet in Manhattan, Carson convinced herself that she had fallen in love with one of the female dancers onstage. Although she had never met the ballerina face-to-face, she took to lurking for hours night after night outside the stage door, hoping to begin a friendship. These sessions in the freezing weather caused her health to deteriorate so badly that George finally had to tell her in no uncertain terms that there was no future in the infatuation. "You're not to go down and moon outside her door any longer — do you understand?" he demanded. Chastened, Carson finally agreed.

By then, Carson had developed several serious respiratory ailments and lost so much weight that she was forced to remain in bed. There, she tossed and turned, worrying about her novel, about her relationship with Reeves, and especially about Annemarie. She would later describe this period as one of such intense suffering that she thought she might actually die. Everyone was relieved when her mother, Marguerite Smith, traveled up from Georgia to care for her. Marguerite, a voluble woman with a charming, deep-fried southern drawl, was accustomed to creative people's eccentricities after many years of running her own artistic *salon*, so she fit right in at 7 Middagh. She enjoyed chatting with Auden and George in the kitchen while concocting nourishing soups for Carson. Because she and Auden had a hard time understanding each other's competing accents, Marguerite tended to shout at the poet as though he were

hard of hearing. Auden kindly overlooked this habit, however, in the interest of learning the best way to make such southern dishes as Country Captain — sliced roast chicken with curried tomatoes and almonds, served with "rattling rice" — and Tipsy Squire — a rich dessert topped with whipped cream flavored with bourbon or brandy. Marguerite also described to Auden and George the southern tradition of turning out dozens of Christmas fruitcakes, covering the counters with pans full of sweet, sticky bricks soaking in brandy under clean white cloths. Mixing up a new batch of "sonnie boy" for Carson, she carried it upstairs, singing out, "Here, precious, a little toddy for the body." Soon, all the others at 7 Middagh had picked up the phrase.

For Carson, it was perhaps a relief to be cared for by her mother again after such a long period away from home. Her frequent childhood illnesses had made her unusually dependent on her mother into adulthood, and the two women fell back quickly into the familiar pattern of nurse and invalid. On nights when it snowed heavily, Marguerite helped Carson downstairs to sit before the fire. Gypsy, a favorite of Marguerite's, often joined them to cheer Carson up and make her mother laugh. Gypsy, who had a stage mother of her own, didn't mind listening to Marguerite's endless accounts of her daughter's brilliance. Carson, listening to the pair of them from her comfortable chair, may have already been formulating Frankie's remark in "The Bride and Her Brother": "The trouble with me is that for a long time I have just been an *I* person. All people belong to a *We* except me. Not to belong to a *We* makes you too lonesome."

Another reason Carson enjoyed her sessions in the parlor was that it had become the room where music was made. Since his arrival, Britten had begun working hard to complete the music for *Paul Bunyan*. Carson, who looked to music's structure to help build her novels, hoped to talk at length about music with Britten. Her fascination with the philosophical turmoil experienced by the British members of the household, and her sympathy for them as they worried for loved ones back home, informed the essay "Night Watch over Freedom," which she had written that autumn. In the article, to be published in *Vogue*'s January 1941 issue, she described Big Ben's ringing in the New Year in London, even though she had never been there. "On this night, London may be grey with fog, or the clean moonlight may make of the Clock Tower a silhouette against the winter sky," she wrote. "But when the bells sound it will be the heartbeat of warring Britain — somber, resonant, and deeply sure. Yes, Big

Ben will ring again this New Year, and over all the earth there will be listeners."

Like the refugees from France and Portugal, however, Britten, Pears, and Auden preferred to focus as much as possible on what they could accomplish in America. By now, Britten and Pears had presented a run-through of *Paul Bunyan* for the producer of the Columbia theater group, Milton Smith. It was a wildly improvised performance; Britten had not completed many of the songs and Pears, as the only singer, was forced to perform all the parts — quartets, choruses, duets, and so on. Nevertheless, Smith was so impressed by Pears's "magnificent, incredible" performance and Britten's "tremendous" music that he agreed at once to produce the work.

Auden and Britten, encouraged, stepped up the pace. In his libretto completed the previous winter, Auden had already constructed the operetta's general story line, in which Paul Bunyan appears in the mythically untouched American forest and, with godlike procreative skills, initiates its development toward industrial modernism.

The story begins with a virginal America awaiting the civilizing hand of man. Auden wrote:

> It is a spring morning without benefit of young persons.
> It is a sky that has never registered weeping or rebellion.
> It is a forest full of innocent beasts. There are none who blush at the memory of an ancient folly, none who hide beneath dyed fabrics a malicious heart.
> It is America but not yet.

Then Paul Bunyan appears, calling forth lumberjacks from Sweden to cut down the trees and build houses and welcoming farmers to clear fields, raise families, and in time make room for educated people to conceive the dreams necessary to create a full-fledged culture. Under Bunyan's guidance, America has become a modern, self-sufficient society, no longer dependent on the whims of Nature or limited by the Old World traditions that had produced its citizens.

But *Paul Bunyan* does not end triumphantly with the creation of this new social order. Auden made it clear in the final scenes that with the creation of modern industrial life, America's greatest challenge was just beginning. Now that the citizens of America were no longer bound by their former strictures, each was faced with the moral challenge of un-

limited free choice. Other countries, including those in Europe, would soon find themselves in the same position. "Now that, in a material sense, we can do anything almost that we like, how are we to know what is the right thing to do and what is the wrong thing to avoid . . . ?" Auden wrote in an essay describing this musical project. "Of what happens when men refuse to accept this necessity of choosing, and are terrified of or careless about their freedom, we have now only too clear a proof."

It was clear that, even in the simple story of *Paul Bunyan*, Auden had found a way to work through his ideas about the need for each individual to consciously identify and rely on a set of unconditional values. At the end, the frontier citizens, who have by now freely chosen their life's paths — as chefs, hotel owners, bureaucrats, and so on — gather for a Christmas feast to celebrate their evolution. It is at that moment that Paul Bunyan, the catalyst, announces that it is time for him to move on.

What's to become of America now? the bewildered citizens ask. Bunyan replies, as he prepares to depart for other worlds, that America is ever-changing, depending from day to day on the decisions of its people. "America is what you do," he reminds them (in Auden words). "America is what we choose to make it."

This opportunity for free choice — the aspect of life in America that most attracted Auden but that he also considered mankind's greatest challenge for the future — was the central theme of *Paul Bunyan* that he had wanted to convey to the cast of high school performers he had pictured as his readers. But as an experienced teacher, he knew he must first connect with his adolescent audience if he wanted them to attend to his earnest speeches. He had therefore filled the libretto with jokes likely to appeal to teenagers — giving the lumberjacks the ridiculous names Jen Jenson, Cross Crosshaulson, Pete Peterson, and Andy Anderson, highlighting the monotony of the lumber camp's meals (heavy on the beans), and lampooning the crass commercialism of the American radio advertisements that begin to appear as, in the libretto, modern America develops.

Britten had already set many of these scenes to equally playful music — giving a Donizetti-type accompaniment to the "Cooks' Duet" in praise of soup and beans and creating convincingly dopey music for the lumberjacks. When Auden assigned the role of ironic commentators to three pets — a dog, Fido, and two cats, Moppet and Poppet — Britten oblig-

ingly produced soprano solos. Most impressively, he created for "The Blues: Quartet of the Defeated" a recitation of the tragedies that accompanied America's growth (the bust at the end of a gold rush, a gunfight in the West, a drowning in the South, a stock market crash), a brilliant blues number sung in deep, rich *Porgy and Bess*–style bass. And perhaps because he was still, after all these years, somewhat intellectually intimidated by Auden, Britten even agreed to the poet's spontaneous decision that, since a giant as tall as Paul Bunyan couldn't fit on an ordinary stage, the main character would appear only as an enormous pair of boots while his songs were sung by an actor offstage.

Now, however, the collaborators anticipated a more sophisticated audience. They needed to flesh out the story and add new characters with showstopping solos. One of Auden's more recent additions was Inkslinger, a character who represented the Thinking Man, "the man of speculative and critical intelligence" who so often found himself isolated and undervalued in America. Auden's years in the United States, and particularly his months on Middagh Street, had given him ample opportunity to observe this American type. Many of his Brooklyn friends, including George Davis, Carson McCullers, Chester Kallman, and even Gypsy Rose Lee, could have identified with Inkslinger's resignation as he talks himself into taking a job as an accountant for Bunyan's lumber camp:

> It was out in the sticks that the fire
> Of my existence began
> Where no one had heard the Messiah
> And no one had seen a Cézanne . . .
> And I dreamed of writing a novel
> With which Tolstoi couldn't compete
> And of how the critics would grovel
> But I guess that a guy gotta eat.

It may even have been their collective vision for 7 Middagh Street that inspired the transcendent new ending that Auden now gave the song:

> It isn't because I don't love them
> That this camp is a prison to me,
> Nor do I think I'm above them
> In loathing the sight of a tree.

O but where are those beautiful places
 Where what you begin you complete
Where the joy shines out of men's faces,
 And all get sufficient to eat?

Auden would continue to shape the libretto and add sections as nec-
essary — but there was an even more urgent need for Britten's contri-
butions. Not only did he need to compose the music for "Inkslinger's
Song," but Milton Smith had pointed out that neither of the two roman-
tic leads — Tiny, Paul Bunyan's daughter, and Slim, the man she would
marry — had yet been given solos. Britten also needed to write a duet for
the pair and create a grand musical prologue that would bring up the
curtain.

It would be hard work, but Britten looked forward to experimenting
with a variety of American musical styles. His conversations with other
musicians were inspiring, as reports came in that season of the successful
previews of such shows as *Lady in the Dark* and the new Rodgers and
Hart musical, *Pal Joey,* with Gene Kelly in the lead. It was impossible not
to hope that if he, too, could come up with enough popular melodies,
Broadway or even Hollywood might call.

Gypsy Rose Lee had already traveled to Philadelphia to see the out-of-
town premiere of *Pal Joey* for herself — and not just because it featured
yet another takeoff on her own signature act, called "Zip." Gypsy had to
work hard not to take offense at a song built around the act of repeatedly
unzipping zippers when she herself considered zippers vulgar and never
wore them. The real reason she went to see the musical was that her
younger sister and former vaudeville partner, the struggling actress June
Havoc, had landed a featured part as Gladys Bumps — a one-number
role that she had managed to build into five. The musical was such a suc-
cess — and June, in particular, the fantastic new discovery, stopping the
show twice — that Gypsy wept with joy as well as, perhaps, just a touch of
competitive ire. Congratulating her sister and shrugging off the "Zip"
number with, "Anyway, now I'm a writer, to hell with acting," she re-
turned to New York to reassess her situation and plan her next move.

For weeks Gypsy had been receiving telegrams from Mike Todd, now
in Chicago, wooing her with Runyonesque endearments and alluding to
a possible job. Gypsy's attraction to the producer had not waned since
their partnership at the World's Fair. In fact, as the process of writing her

novel settled into a routine, Todd's plans in Chicago became even more alluring. As usual, Todd was thinking big, and, also as usual, his new project incorporated elements that had created the biggest successes in the last one.

Todd's Theatre Café in Chicago, scheduled to open on Christmas Day 1940, was billed as the largest nightclub in the world, with eight thousand seats. Todd had based its design on the quarter-a-ticket *Streets of Paris* philosophy: you can squeeze a lot more profit out of thousands of "working-class Joes" than from a few dozen "rich snobs." There would be no cover or minimum at the Theatre Café, dinner would cost seventy-five cents and champagne cocktails a quarter each, and the first show would begin at five in the afternoon. Inside, Todd's blue-collar clientele would encounter a sight they would never forget: a sixty-foot stage with a dance floor suspended above it, two dance bands working in shifts, a four-hundred-foot bar, and a spectacular show, *The Gay New Orleans Review*, "straight from 2500 performances at the New York World's Fair." It would include a *Ben Hur*–style chariot race and feature the comedy team of Willy, West and McGinty — and, if she were willing, it would star Gypsy Rose Lee.

It was a tempting offer. No one knew better than Gypsy how talented Todd was at making money, and his new project had all the earmarks of a huge success. No matter how much money Gypsy had accrued over the summer, she got very nervous very quickly when the stream of income began to dry up. "Everything's going out and nothing's coming in!" was one of her favorite phrases, and it wasn't a happy one.

Much as she enjoyed spending time at 7 Middagh Street and working with George, the writing business had turned out to have a serious downside — the necessity for a beginning novelist to finish her book before getting paid. Gypsy loved the process of churning out the chapters with George, but writing had turned out to be hard work — and not having a contract with a publisher was "like being all made up, ready to go on . . . and not knowing what theatre you're playing." Despite George's assurances, it was hard to tell whether her writing was any good. When the tea was just right during her morning work sessions and her business interests were going well, she found that she could write just fine. But "if I have night lunch with a smarty pants like Saroyan," she wrote, "I want to spit on the whole damned manuscript."

In short, Gypsy was fed up with the full-time literary life. The continued chaos — increased considerably now that the house was open to visi-

tors — and the squalor of a home shared by so many got on her nerves. Nor did she approve of all the drinking that went on at 7 Middagh. Now, with the refugees arriving by the shipload and Britten playing the piano all day, the house seemed to be turning into a Noah's Ark, with two of every species, making it impossible to concentrate. Gypsy began to think she'd be better off writing backstage. The sight of her sister having the time of her life in *Pal Joey* helped make up her mind. She missed the spotlight and she needed more money. And she didn't want to write any more — or much more — unless she got paid.

A little before Christmas, Gypsy broke the news to George that she had decided to join Todd in Chicago. George, stunned that Gypsy would leave before the book was done, tried to talk her into staying, at least until they had completed a few more chapters. But Gypsy had already packed her bags. In the previous month, she had completed two chapters to George's satisfaction. She agreed to write a third in Chicago and send it back for editing if he would find a publisher and try to get her an advance.

Despite her abrupt departure and George's sharp disappointment, there was no denying that each had profited considerably from their brief partnership. Gypsy's presence had lent a unique twist to the household and attracted the most sought-after names in cultural New York — names that George was certain would continue to travel out to Brooklyn. And Gypsy herself was leaving not only with the completed chapters and the material for others but with an address book full of impressive new names. During the weeks she spent among the Brooklyn literati, Gypsy had formed warm and lasting friendships with Janet Flanner, Carson McCullers, Louis Untermeyer, Pavel Tchelitchew, Cheryl Crawford, the poet Muriel Rukeyser, and the noted biographer Carl Van Doren. Marcel Vertès was now peppering her with charming cartoon letters that transcended his limitations in English. Gypsy, recognizing an opportunity when she saw one, sweetly requested the rights to a sketch he had made of her: she was sitting at a dressing table in a pink negligee and high heels, typing madly on her Underwood with a cigarette between her lips. Vertès gallantly agreed to the gift, and Gypsy used the image as her personal logo for the rest of her life. "Dammit, I love furriners!" she wrote jokingly to a friend. "Aside from the hand kissing they really make like gents."

Gypsy's departure in December left not only an empty suite on the third floor of 7 Middagh but an equally empty hole in George's life. Over

the winter, George had grown as dependent as Carson on Gypsy's sympathetic ear and bracing, no-nonsense attitude. He dutifully wrote to her a number of times as he carried on with his duties as nominal landlord — providing all the juicy details on the holiday party: their cook, Eva, "got plastered, but not objectionably," and both Chester Kallman and Susie the maid became very friendly with a group of visiting British sailors. But George felt let down by Gypsy's refusal to stick it out at 7 Middagh until she fully understood the writer's craft. By deciding that she had learned what she needed to know and moving on, he felt, she was giving up her best chance to escape the destiny her mother had handed her. "You have learned that there are other things in life worth acquiring — and for the time being it seems to you that they can be bought with the same coin, pushed once across the counter," he wrote. "It isn't so, but you won't discover that until the mask is forever off, and you will no longer be Illusion."

With Gypsy's departure, George gave up on his own novel as well. Called "The Victim," the novel had intended to tell the story of a woman who has always expected a terrible tragedy to befall her — and then one day it does. But, as George admitted to Gypsy in a letter, his progress on the book had been negligible and he saw no point in trying to continue. "There's no use making a tragedy of it," he wrote. "I simply am not one of those people who *must* write. Carson is, Wystan is, I'm not. I should have thought of that when I made my high handed decision to leave the Bazaar. Week by week since then I have bogged deeper in despair; I'm all but paralyzed by it now."

Like Gypsy, George was tired, too, of "everything going out and nothing coming in." "That talk about being bohemian and that God will provide was just a little tune that I was whistling in the dark," he wrote. By Christmas week — having received a generous year-end bonus from Carmel Snow, who despite their differences had followed his experiment with great sympathy and interest — he was negotiating to return to work on a freelance basis for *Harper's Bazaar*. That, along with his work on *Decision* and the responsibilities of the Brooklyn house, would keep him busy for the time being.

In the days before Christmas, Carson agreed to return home with her mother for a recuperating stay. It would be a temporary absence, Carson assured George, just long enough to get her strength back. Within days, Marguerite had packed Carson's bags and taken her home. Their train

was filled with "Dixie Darlings," soldiers from the eastern seaboard shipped south for basic training. Carson knew what a shock it would be for some of these Yankees to experience the South for the first time, with its routine treatment of Negroes as animals, and the periodic lynchings matter-of-factly reported in the newspapers. It was an odd situation, to say the least, for young men preparing to fight fascism overseas. Carson, who detested and denounced bigotry wherever she saw it, found for this reason especially that on most occasions, the moment she stepped off the train and was greeted by her father was the same moment that she began longing to return north.

"Being home again has been rather like a strange and broken dream," Carson wrote to Muriel Rukeyser, who had lately been spending a great deal of time helping Klaus Mann with *Decision*. Perhaps her retreat had been a good thing; maybe now she would make some progress on her novel. She wouldn't be gone long, she assured her friend — just a few weeks, a month at the most. In the meantime, her rooms at 7 Middagh were available. Muriel was welcome to use them if she liked.

For Christmas, Carson sent George an antique clock, along with a fruit-cake baked by her mother. When she learned that George would be alone for Christmas, she offered to send the train fare for him to join her in Georgia, but he declined. He liked knocking about the "fantastic old house," he wrote, with the cats, Sophie and Boy, their eyes blazing as they roamed from room to room, and the ghosts that he still insisted roamed the halls.

Ben and Peter were spending Christmas at the Mayers' house on Long Island. Auden was also absent, visiting friends. Golo Mann had decided he could suffer being reunited with his clan for the duration. Gypsy remained in Chicago, preparing for her opening on December 27 as she sent pages to George along with grumbles about the cost of postage. Bending to her will, George had met with Lee Wright, the editor of the Inner Sanctum Mystery Series at Simon and Schuster, on Janet Flanner's recommendation. Using all his talents as a literary impresario, he created a glorious picture of the kinds of promotion a performer like Gypsy could contribute — and left behind the novel's first two chapters. All they could do now was wait for a response.

The week between Christmas and New Year's Day, George sat up late, writing letters at the secretary near his bedroom window, listening to the news on the parlor radio, and growing increasingly depressed. "Never

before since Jamestown and Plymouth Rock has our American civiliza-
tion been in such danger as now," warned President Roosevelt in his first
Fireside Chat since his reelection. "The United States has no right or
reason to encourage talk of peace on the part of the aggressor nations."
That same week in London, Trinity Church and eight Christopher Wren
churches had been destroyed or severely damaged by the Luftwaffe. And
nearly buried in the war news was the report that, a few days earlier,
Francis Scott Fitzgerald had died of a heart attack. Another light in
George's constellation, forged in the heat of 1920s Paris, had burned out.

"I'm sitting here in the parlor alone," George wrote to Gypsy in the
hours before dawn.

> There is a wonderful deep, wet fog outside, and the house creaks like a ship
> under way . . . At sea, Gypsy! That little phrase makes my heart leap high;
> why should I have ever been fool enough to want to be anywhere else? My
> happiest memories are of the sea, and so are my cruelest . . . I was lonely, I
> loved, I was lonely, I loved; the alternation is familiar, God knows, and often
> I think it is a sort of shabby arrogance on my part to believe that I brought
> to that alternation a unique talent, my own compound of courage and gen-
> erosity and tenderness. But as I sit here now, in this ramshackle ship's parlor,
> I dare believe just that . . . I am, oh believe me, these few days before the New
> Year, where I belong: at sea in Brooklyn.

Seven Middagh had been a nurturing home for George and Carson,
a literary incubator for Gypsy, a working studio for the three British
émigrés, and the first stop in a new life for countless European refugees.
After only three months, it had become a new world, a free zone, for so
many. In a sense, the ramshackle Brooklyn house was developing into a
miniature culture in its own right. It was America — but not yet.

6

Ideas vibrate, pulsing against each other . . . and
there are a thousand illuminations coming day by
day as the work progresses.

— Carson McCullers

In the wake of Roosevelt's December 1940 Fireside Chat, Americans
were faced with the need to make their own decisions, their own "correct
choices," and they began passionately debating the issue of the country's
involvement in the European conflict. The split in opinion fell largely
along class lines as socialites in Seattle held bingo parties for Britain and
the First Families of Virginia threw a Relief Ball at the Hotel Jefferson
while ordinary families saw their drafted sons off to basic training camps
for "peacetime military service." In December, two hundred "prominent
Americans" dispatched a telegram to the president, beseeching him to
join the war. On New Year's Day, the No-Foreign-Wars Committee urged
the "common people [who] provide the cannon fodder and pay for the
wars" to dispatch their own telegrams against engagement; more than
thirty thousand messages were sent.

It was becoming increasingly clear, however, that Roosevelt had al-
ready made his decision. Stymied by isolationist legislation that forbade
U.S. banks to lend money to "belligerents" — a means of assistance that
the nation had given Britain in World War I — Roosevelt made a detour
around the law by introducing the Lend-Lease Bill into Congress. This
legislation would allow the government to "lend" enormous amounts of
arms and other supplies to Britain in exchange for its promise to repay
the United States after the end of the war. "We must be the great arsenal
of democracy," Roosevelt insisted. "We must apply ourselves to our task

with the same resolution, the same urgency . . . as we should show were we at war."

Roosevelt continued to claim that he wanted to implement this aid as a way to avoid actual engagement, but most Americans rightly saw his actions as leading the country ever closer to the conflict, and this affected the national mood. The *New York Times* reported an increase in the New Year's revelry as a result of the "war gloom" overtaking the United States. The city's hotel occupancy increased fifty percent, and Times Square overflowed with Americans indulging in what many guessed might be their final holiday fling. "This year is going to be one of the most decisive periods of the twentieth century," Isherwood, in California, wrote in his diary on New Year's Day. "Nearly everybody is now convinced that we shall be 'in it' very soon."

In journals, magazines, and books across the country, the 7 Middagh Street residents had begun to contribute to the debate. Carson had regained her health sufficiently to return briefly to Brooklyn. She arrived for a two-week visit in early January, pleased to find "Night Watch over Freedom," her meditation on the Battle of Britain, in that month's issue of *Vogue.* Meanwhile, Auden's poem "New Year Letter," which had appeared that month in the *Atlantic* under the title "Letter to Elizabeth Mayer," focused on the American perspective:

> All our reflections turn about
> A common meditative norm,
> Retrenchment, Sacrifice, Reform.

Even Gypsy's political views were expressed in a photograph in the January 6 issue of *Life* magazine, in which she performed a striptease for the Star Spangled Ball, a white-tie war relief banquet at New York's Astor Hotel. The photograph provoked a wave of outrage, due not only to Gypsy's state of undress, but also to *Life*'s friendly coverage of high society's increasingly visible support for the war. The mayor of Youngstown, Ohio, barred that issue of *Life* from the newsstands of his city; *Life*'s readers fired off letters expressing their approval.

Increased emotional involvement in the war had its effect on *Decision*'s mailbox, too. Putting together the March 1941 issue, Klaus Mann included one letter to the editor praising the courage and faith of the refugee contributors and applauding his own efforts to mobilize the nation's intellectuals to speak out about the war. Another letter, which had

been scrawled in the margins of a *Decision* publicity brochure, began: "One glance at the prize collection of Anglophiles, Union-with-Great Britainites, Warmongers and Refugees which head this letter should convince any thinking American not to support what will so obviously be a propaganda sheet to involve uninformed Americans in another European War." The author-playwright William Saroyan sent in his comment that "all culture up to August 31, 1939, is now finished, and that, within the chaos, another culture is coming into being. Good or bad, one thing is sure; a new world and a new inhabitant of the world is getting ready to be born. Now is the pregnancy."

As George liked to point out, controversy was good. *Decision* continued to enjoy a generally positive reception, with "subscriptions and flattering comments pour[ing] in," Klaus wrote. Yet he himself was not yet satisfied. The big names he had enlisted to attract public attention now threatened to suffocate the journal, he felt, under the weight of their ponderous arguments and predictable views. To keep the debate alive, he needed to involve the younger generation, who would soon be required to defend democracy with their own lives. Klaus had been impressed by Erika's reports of the constructive passion that had overtaken the young British intellectuals she had met in London, many of whom had taken an apathetic approach to the conflict until it reached their shores. If *Decision* could be used to promote communication between these committed young British fighters and the undecided young Americans, he felt, a true, effective forum could be achieved.

Raising money for the creation of *Decision,* Klaus Mann had been much encouraged by the founding in London of a similar magazine, *Horizon,* by the poets Cyril Connolly and Stephen Spender. They were prime examples of the new activists Erika had described, having moved from a studied avoidance of politics during the Chamberlain era toward an acknowledgment, after the shock of Dunkirk and the fall of Paris, that the war was their concern. It had been easy, and quite gratifying, for Klaus to follow in the journal the writers' increasing determination to take action. Now, in its January 1941 issue, the *Horizon* editors wrote that the first issue of *Decision* seemed — "oddly enough, to English eyes" — dated, as it continued to quibble over philosophical issues that the British considered moot. Americans — and even British expatriates whom they knew well — struck the British as disengaged. Connolly complained that "no American letters get written" by Auden, Isherwood, and Aldous Huxley, and "to ask for them is like dropping pebbles down a well."

The editorial continued angrily,

This is regrettable, for *Horizon* has suspended judgment on the expatriates, holding that the wisdom of their departure can only be eventually judged by comparing their work in America with their potentialities, and with the work which is being done here. It is the personal opinion of this editor, however, that . . . they have missed their creative opportunity by not coming back . . . We are where we are because we believe what we believe . . . and we would not change places with them for the world.

Klaus, in *Decision*, pled neutrality in what he called "a row among old pals," but he pointed to the pride and pugnaciousness with which the British salvo had been released. "For it must be a tough job," he observed admiringly, "to produce a literary monthly under the constant shower of bombs and without encouraging mail from Beverly Hills or Brooklyn."

If Klaus sounded apologetic for Auden and the other British expatriates, it reflected his own frustration over Auden's continuing focus on the moral experience of the individual rather than on political issues. Klaus understood his friend's position — that it is not the poet's duty to tell people what to do but to present them with ideas that enable them to make their own rational and moral choices. This attitude was all well and good in peacetime. Yet even Louis MacNeice, who held similar views, had decided that the moment had come to stop writing about "choice" and finally make one.

Klaus's attitude toward Auden's perceived inaction was mild compared to his sister's. Erika was fed up with the British artists who pled pacifism in California or holed up in Brooklyn for the duration. It was too late for Isherwood, who would turn thirty-six in February and was thus ineligible for that year's American draft — and who in any case had declared himself a conscientious objector. But other well-known artists had set aside their work to commit themselves more fully to the fight against Hitler. Why couldn't Auden?

Auden might have pointed out that he had helped raise money for refugee aid organizations, contributing his own money to evacuation programs for British children and his talents in speaking at Aid for Britain functions — in addition to his own written condemnation of the events in Europe and his work with *Decision*. But he was not in the habit of defending his actions to his friends. He had his own opinion of Erika's approach to politics: he had long felt that a less hectoring tone in her speeches would prompt a better response from American audiences. But

he understood that, unlike himself, Erika was one of the breed of "politicians" or public people, as Auden had described them in "The Prolific and the Devourer." It so happened that she expressed herself through action in the world rather than creatively, on the page. Erika had "no use for mercy and compassion: she was incapable of forgiving sinners." Her judgment of Auden was irreconcilable and unbending.

Golo Mann, now living in the attic at Middagh Street and often hanging about the kitchen with his siblings, believed Erika's anger to be at least as much personal as political. Since their marriage in 1935 to secure Erika's British citizenship, she and Auden had developed a kind of courtly friendship sprinkled with jokes about their status as man and wife and punctuated by "family" visits to the senior Manns' Princeton home. The pair "liked each other decidedly," Golo later recalled, and by now their relationship had developed into a "serious friendship with even — believe it or not — a slight erotical touch." And just as Erika had not hesitated to use emotional blackmail with her famous father — threatening in the early 1930s to end their relationship if he did not speak out publicly against the Nazis — so she was willing to use her relationship with Auden to try to influence him politically.

On any other issue she might have succeeded, but Auden's resistance to the straitened intellectual life associated with political commitment outranked his fondness for Erika. Isherwood wrote in his diary that month: "If I fear anything, I fear the atmosphere of the war, the power which it gives to all the things I hate — the newspapers, the politicians, the puritans, the scoutmasters, the middle-aged merciless spinsters . . . I am afraid I should be reduced to a chattering enraged monkey, screaming back hate at their hate." Auden couldn't have agreed more.

Besides, he had begun to feel that he was beginning to make progress in developing a new approach, a new way of thinking that might function effectively even in the changed circumstances of this rapidly evolving world, and that it might give these terrible current events some meaning and significance. Golo, not a particularly popular member of the household because of his tendency to lurk, ghostlike, in the halls (he had been accused, too, of drinking all the cream off the milk bottles), was nevertheless among the most observant residents of 7 Middagh Street. It was he who finally asked Auden where he went early each Sunday morning. Auden confessed that he had been attending communion, but he preferred that no one else know. He was still working out the precepts

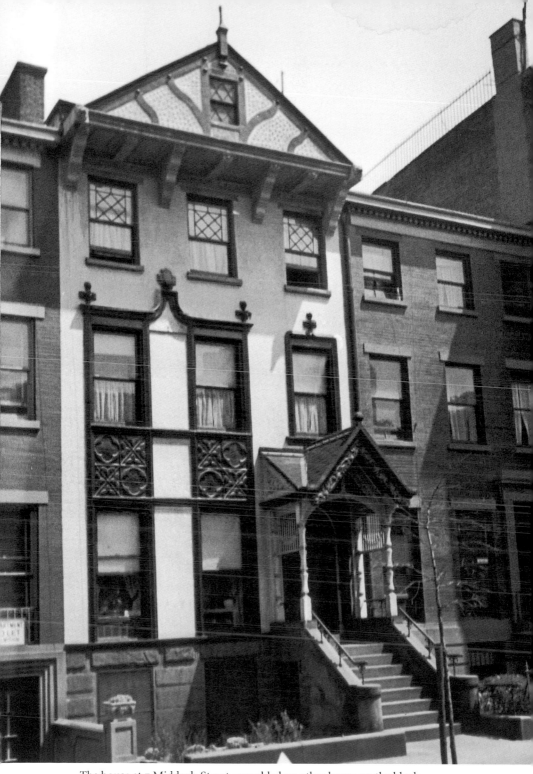
The house at 7 Middagh Street resembled no other house on the block.

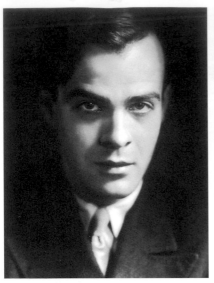

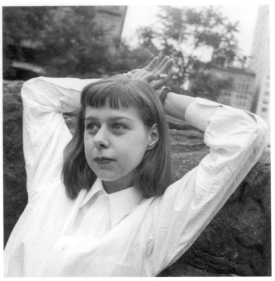

George Davis was "the one editor asso-
ciated with the stratosphere of litera-
ture," according to Gore Vidal. "If he'd
worked for the *Reader's Digest*, we
would have all aimed for there too."

During her first month at Middagh Street,
Carson McCullers posed for Louise
Dahl-Wolfe in New York's Central Park.

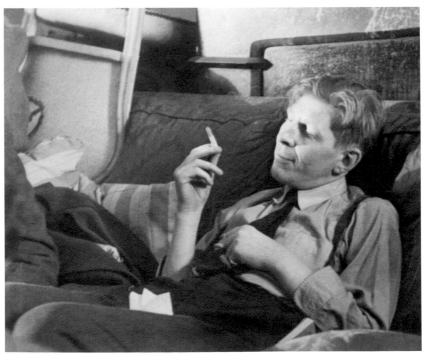

"I am at the moment in all the . . . discomforts of housemoving,"
Wystan Auden wrote to a friend.

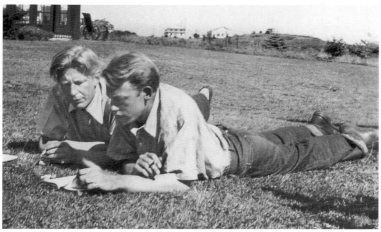

Auden wrote after meeting Chester Kallman, "I am mad with happiness."

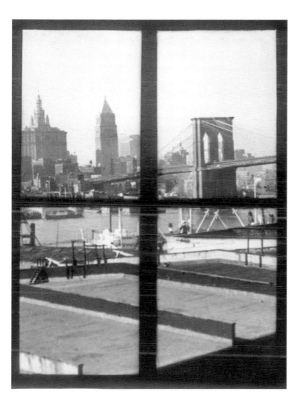

This view of New York Harbor and lower Manhattan had already inspired literary works by Walt Whitman, Hart Crane, and Thomas Wolfe.

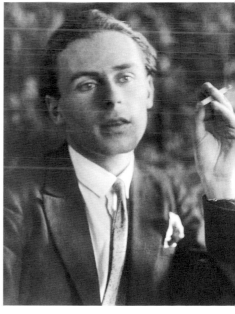

Klaus Mann hoped to turn 7 Middagh Street into an international center for political activism and "a diffuse but lusty literary life."

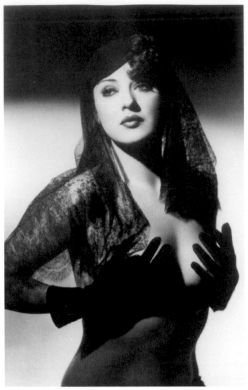

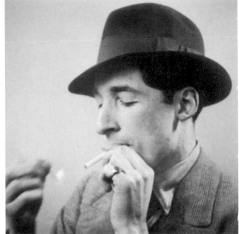

Louis MacNeice described the house full of artists as "ever so Bohemian, raiding the icebox at midnight and eating the catfood by mistake."

Gypsy Rose Lee dreamed of becoming a writer, but show business was in her blood.

Wystan Auden and Erika Mann met just before their wedding in 1935 and soon became friends.

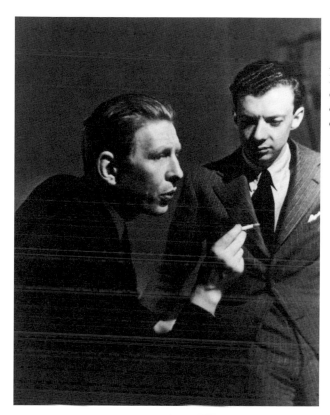

Auden and Benjamin Britten hoped to express their own idea of America in their opera, *Paul Bunyan.*

"Living is quite pleasant here when it is not too exciting," wrote Britten shortly after his arrival at 7 Middagh Street with the tenor Peter Pears.

George Davis wrote, "The house in Brooklyn is a symbol for me . . . it's a risk, it's a gamble with myself and others."

Gypsy's novel, *The G-String Murders*, made copious use of such professional burlesque terms as "pickle persuader," "grouch bag," and "gazeeka box."

The house became a destination for many sailors whose ships were docked at the bottom of the hill.

Oliver Smith, the future Broadway set designer and producer, tended the furnace, washed the dishes, and soothed the tempers of both residents and visitors.

"He wrote music and was mysterious and sinister," Jane Bowles said of her first meeting with her husband. "I said to a friend, 'He's my enemy.'"

Paul Bowles shared his room with a larger-than-life cardboard cutout of Gypsy Rose Lee.

Gala Dalí guarded her husband, Salvador, with what he called "the petrifying saliva of her fanatical devotion."

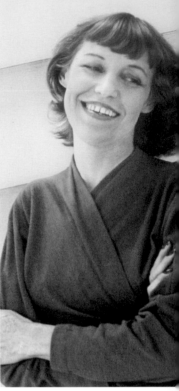

Richard Wright, an admirer of McCullers's work, moved to Middagh Street with his wife, Ellen, and their daughter in 1942.

Following the death of her first husband, the composer Kurt Weill, Lotte Lenya married George Davis and, with his help, built an illustrious singing career.

For years after the house at 7 Middagh Street was destroyed, the lives of George Davis and Carson McCullers remained intimately entwined.

and implications of Christianity in his mind and wasn't ready to discuss them with others.

He was more than willing, however, to talk over his ideas with Reinhold Niebuhr, the theologian whose book he had reviewed. Niebuhr had liked the review enough to contact Auden, and the two quickly became friends — along with Niebuhr's wife, Ursula, who was British. The three could now occasionally be found in the Middagh Street parlor, listening to British gramophone records and exchanging jokes about England.

It was Niebuhr who, through his own interpretation of Christian dogma, seemed to offer Auden a way out of his difficulty in placing his faith in God. Like Auden, Niebuhr was more interested in the personal experience of Christianity than in an abstract understanding of its philosophy. The politically active theologian helped convince Auden that Christianity's essential precepts, as opposed to the unwieldy structure of centuries of dogma, might provide the basis he sought for moral action.

In June 1933, when Auden was teaching at a boarding school in England, he had experienced what he considered a fleeting vision of true *agape*, or Christian love. He and several colleagues — none of them lovers, some not even particularly close — had been sitting out on the lawn at night, chatting casually, when "quite suddenly and unexpectedly, something happened. I felt myself invaded by a power which, though I consented to it, was irresistible and certainly not mine." For the first time in his life, Auden felt that he knew what it meant to love one's neighbor as oneself because that was the feeling that had overwhelmed him. He believed that his three companions were having this experience, too.

"I recalled with shame the many occasions on which I had been spiteful, snobbish, selfish," he later wrote, "but the immediate joy was greater than the shame, for I knew that, so long as I was possessed by this spirit, it would be literally impossible for me deliberately to injure another human being." He knew, too, that this feeling would eventually fade — and it did, gradually, after a couple of hours, although vivid memories of it continued to linger for several days.

This pure, redemptive love — an experience that instantly revealed all in clear, objective, moral perspective — was one form of faith that Auden believed he could embrace. Pledging allegiance to an unembodied force was against his nature, but seeking the sacred through the love of another individual made absolute sense. The choice of the individual was random — any single human being could represent, in all his foibles and

faults, the universal. But Auden, of course, chose Chester Kallman. Theirs could become a sacred marriage in which each would seek the God in the other. Through this Christian love, correct action in all aspects of life would become apparent, and that knowledge would be incorporated into his work.

"To be saved is to have Faith, and to have Faith means to recognize something as the Necessary. Whether or not the faith of an individual is misplaced does not matter: indeed, in an absolute sense, it always is," Auden wrote in a review of Kafka's works for February publication in the *New Republic*. He added, as Niebuhr no doubt agreed, "There are many places of refuge, but only one place of salvation, yet the possibilities of salvation are as many as all the places of refuge."

On January 7, Chester Kallman turned twenty; he was one year closer to manhood and would soon, presumably, begin an independent adult life. Despite Auden's advice not to publish anywhere but in students' journals until he was thirty, he had sold a poem to *Decision* for $10. Appearing in the March issue, it would make him a professional poet — his only other publications to date being essays for Columbia's literary journal and a short piece on American music for *Harper's Bazaar*.

Auden decided to organize a birthday feast followed by a party. He sent out the invitations and made lists of the necessary supplies; Chester's father and grandmother, "Bobby," cooked the dinner at Bobby's Brooklyn apartment and took it to Middagh Street. By now, Auden had spent so many evenings at Bobby's apartment, gossiping in her kitchen and petting her cat, that she considered him part of the family. Having been raised in the anti-Semitic environment of 1920s England, Auden valued this acceptance by Chester's Jewish family — despite Dr. Kallman's warning never to let Bobby know the true nature of his relationship with Chester.

Several of Auden's friends had also gotten to know various members of Chester's family. Lincoln Kirstein, who attended the party, was much drawn to Dr. Kallman's cheerful, urbane manner and his ability to tell a good bawdy story. As the dentist mixed sidecars for everyone after dinner, he kept Kirstein and Marc Blitzstein howling with laughter. Later, Pears serenaded Chester with "Make Believe," from *Show Boat,* and Kirstein cornered Britten to discuss the possibility of his composing the music for a short ballet. As the party grew raucous, Auden recited a poem that he had composed especially for the occasion:

There's wine on the table, and friends and relations
 From all over the city collected here;
So, Chester, let's open our gay celebrations
 By wishing you luck in your twentieth year.

What is the first thing I'd get for a poet
 If I could importune the gods, which I can't?
A technical gift? But you have that, and know it.
 The first thing I ask is an adequate *rente*...

Stalin and Ford are strangely united
 In a common scorn of the *rentier;*
Yet could I become one, I should be delighted;
 So hurrah for the small private income, I say...

He concluded:

And a message to all in the States where they're apt to
 Believe in the Tough and The Real — I say NERTS:
Considering the world that we have to adapt to
 We can thank our stars if we're introverts.

The birthday feast was a success, with Kallman more voluble and amusingly sarcastic than ever and Auden beaming with pride for his star pupil. A number of housemates and friends at 7 Middagh Street had noticed the new recklessness with which Kallman reached for a laugh, even if it meant cruelly mimicking his partner. Auden was rarely "Wystan" now — more often referred to, depending on the situation, as "Miss Mess" or "Miss Master." But then, he made fun of everyone — even his father.

Kallman's position as Auden's chosen one was not the only reason for his flushed cheeks and bright eyes that evening, however. He could hardly contain the secret he was concealing: he had fallen in love.

It had happened the month before, at a party that George had given that was attended by a number of officers from a British merchant ship docked in Brooklyn that week. One of the officers, an almond-eyed, fit young Oxford graduate named Jack Barker, had hiked up the hill the day of their arrival to present a letter of introduction to Auden, and as a result he and his friends were invited to the festivities.

Barker later compared the experience of arriving in New York City — having crossed the Atlantic, filled with U-boats, on a camouflaged mer-

chant ship from blacked-out Britain — as being shot out of a cannon into a circus of light and noise. It was no less exciting to enter the crowded house at 7 Middagh Street to discover Pavel Tchelitchew laughing with the painter Paul Cadmus, Klaus Mann arguing earnestly with the writer George Dangerfield, Marc Blitzstein with Benjamin Britten, and Cheryl Crawford with George Balanchine. To Barker it was like opening a door to find an entire generation of Western culture hidden away in this rickety old Brooklyn parlor. He was especially thrilled by the chance to interact with Auden, whom he idolized, and was relieved to find that the poet was quite approachable and pleased to talk with a fellow Englishman. He even invited him to stay at the house while he was in Brooklyn. Soon, Auden would give Barker an introduction to Malcolm Cowley, who would hire him to write an article for the *New Republic.*

If Jack Barker was fascinated by Wystan Auden, Chester Kallman was even more interested in Jack. By now, he had a decided preference for an English accent, and Barker's Oxford tones, excellent physique, and perfect manners inevitably attracted the Brooklyn boy. Jack admired Chester's sharp, witty conversation, and Chester basked in Jack's admiration. Once the seaman had moved into the house, it didn't take long for Chester to lure him into bed. He didn't realize that Kallman and Auden had a relationship, and Kallman was careful not to tell him. The affair had been brief — Barker had already shipped out by Chester's birthday — but he was expected back in about a month, and the glow from their encounter remained.

It was not by any means the first time during his relationship with Auden that Kallman had been attracted to another man. For years, Kallman and his friend Harold Norse had regularly cruised Central Park. "We rarely, if ever, went home alone," wrote Norse. "There was an endless parade of youth in the city, some as young as fourteen and fifteen . . . refugees from the Depression or from Nazi oppression. They were castaways, throwaways, runaways. Auden used to say, 'Sex is no problem. There are boys on every street corner.' This was true."

Auden meant to say that sex was no problem for those who wanted it, but he did not seem to fully acknowledge that Chester Kallman wanted it as frequently as possible with an endless succession of partners. It was perhaps the real reason that he insisted on living in his father's Manhattan apartment rather than with Auden: he had the opportunity to spend his evenings elsewhere when he was in the mood. And he often was, as Auden's sexual style bored him. The previous summer, after sev-

eral weeks with Auden and his friends at the home of Lincoln Kirstein's sister, Mina, Kallman wrote to Norse in desperation, "When I do get back to the city I expect to spend ¾ of my time flat on my stomach biting into pillows, listening to the music . . . of the bedsprings." Auden was not the partner he had in mind.

A number of Auden's friends were astonished that he seemed unaware of Kallman's betrayals. Kirstein joked with Kallman about Manhattan's subway tearooms — the toilets where men congregated for sex — and George often talked about the boys who could be found under the bridges and along the waterfront in Brooklyn. Whether Auden knew of Kallman's behavior and preferred to look the other way or he truly failed to see what was before his eyes, no one but he and Kallman knew. Of course, Auden was in no position to criticize, considering his own youthful adventures, and may have felt that Kallman was only quite naturally experiencing that first, self-indulgent, "aesthetic" stage of experience Kierkegaard described, as was appropriate for his age.

In the end, as Auden had implied in his remark about the boys in Central Park, casual sex, if painful to the betrayed partner, was really not so important, so Kallman's trysts had not damaged their relationship in any serious way. The affair with Jack Barker, however, promised to be different. Kallman was entranced by the handsome Englishman who dreamed of becoming a writer — who was, in a way, with his English manners and Oxford accent, a physically idealized if intellectually inferior version of Auden himself. With Barker, however, Kallman perceived the opportunity for one significant difference: for the first time in years, he held all the cards and would direct all the plays. He was drunk with love for Jack Barker — or at least he believed he was — but he was also drunk with the sense of being completely in command.

After only two weeks' absence, Carson found the house at 7 Middagh even livelier than when she had left it. Not only was George's pile of magazines in the parlor full of the writings of the Brooklyn group, but walking through the house, from bottom to top, she could glance past the open doors and see someone writing, composing, debating, or singing in nearly every room. Auden continued to preside over the breakfast table with "malicious dignity," as one visitor remarked, as the conversation veered from Jung to the ballet to pre-Columbian sculpture. But there seemed to be a new sense of excitement now, a feeling of artistic quickening. Certainly, everyone was working hard.

Much as Carson depended on her childhood surroundings to heal her when necessary, she had grown homesick for Brooklyn. Here, she was able to take up her adult life again — visiting with Janet Flanner, who dropped in occasionally with a new lover, the glamorous Italian radio announcer Natalia Murray — who soon became as maternally fond of Carson as Solita Solano had been. The three of them might debate Auden's assertion that Kafka was the primary representative of their age, or compare with George their funniest, most outrageous fan mail, or flinch as Lincoln Kirstein, known for his testiness, lashed out at a friend who had interrupted his conversation and then forgot all about the incident moments later.

Carson and Janet Flanner were especially eager for George's news of Gypsy. Rumor had it that Mike Todd was making money hand over fist with his Theatre Café and that Gypsy stole the show, stripping for more than three thousand people every night. To gain more laughs, she planted a woman in the audience who screamed just as she pulled the last dressmaker's pin from her dress while a waiter dropped a tray of dishes, and in the midst of the audience's laughter, Gypsy pretended to black out. Sex was only good for laughs, anyway, she told reporters. "I never try to stir up the animal in 'em." And she added, "Did you ever hold a piece of candy or a toy in front of a baby — just out of his reach? Notice how he laughs? That's your strip audience."

While she was in Chicago, Gypsy continued to type pages of her mystery in her dressing room — making corrections in the bathtub, she claimed, during the hour and a half it took to soak off her body paint after a show. George's efforts to help her find a publisher had given her a new burst of energy, especially after the editor Lee Wright offered her a contract. It was for shockingly little money, in her opinion — but George advised her to accept it and then work hard to make the book a bestseller. "If you kid [the publishers] along, and become their glamour girl, there isn't anything that can be thought up that won't be at your service," he told her. But if there was one thing that Gypsy knew about, it was public relations, and she hardly needed George's advice. "I'll do my specialty in Macy's window to sell a book," she wrote to Simon and Schuster's publicity director that week. "If you would prefer something a little more dignified, make it Wanamaker's window. There has been so much publicity about it already that I'm a little embarrassed. (The book I mean — not the specialty.)" She read the stack of murder mysteries that Wright recommended, met with Craig Rice, a Chicago beat reporter and best-sell-

ing female mystery writer who soon became a close friend, and bought herself a new typewriter ("I thought the blue ribbon was sexy"). Then she got back to work.

Meanwhile, magazine writers and gossip columnists drummed up talk about a growing competition between Gypsy and her sister. June Havoc had become one of the year's Broadway discoveries, and Gypsy's writing ambitions had by now become common knowledge. "Gypsy thinks June wastes her time on dull people, doing dull things. June thinks Gypsy wastes her time being a literary butterfly," reported *Life* magazine, whose reporters had always enjoyed promoting the burlesque star. While the constant ribbing became wearisome to Gypsy, she believed, along with George, that any publicity was good publicity. So the creation of a "literary Gypsy" spurred her to finish her book more quickly, before the public grew tired of the idea.

George didn't always cooperate as fully as Gypsy would have liked, however. Frequently, he responded to her batch of pages with a meandering letter filled with detailed descriptions of the goings-on at Middagh Street, vague evocations of his current mood, and such veiled remarks as "I'm delighted to hear that Todd wants you to stay on and make more money." Informing her that he had agreed to take over the cultural beat for *Harper's Bazaar* and was considering returning to work there full-time, he added such comments as, "I am aware that you will read these lines with a kind of fury, minor but genuine. Instead of brooding and getting nowhere, why haven't I been tackling the nine pages of your book? Don't worry I shall, immediately. These are thoughts that you haven't paid for, and they are using up time that having been bought isn't mine to waste. Will you try to forgive me? It just can't be otherwise tonight." Gypsy could perhaps now sympathize with the position in which Carmel Snow, George's employer, had found herself for so many years.

Through conversation and work, Carson fell easily back into the routine of life in Brooklyn. Her recovery in Georgia had been more than just physical — she felt emotionally renewed as well. In her short period at home, she had begun making real progress on her novel. Perhaps Auden was right when he insisted that illness was the body's way of forcing a creative catharsis. As she worked on "Brooklyn Is My Neighbourhood," a new article for *Vogue*, she felt stronger and happier than she had in nearly a year.

Benjamin Britten, on the other hand, had to fend off feelings of panic as he worked frantically to complete the music for *Paul Bunyan*, which

was set to open in less than four months. Having completed "Inkslinger's Song," he had started on the leads' solos. The love duet would come next, and then, since Auden had added a singing Narrator to fill in missing parts of the *Paul Bunyan* story between scenes, it was necessary to create a melody for him to sing. The Prologue had to be completed as well, and for this, the opening number, Britten hoped for something truly spectacular.

It would not have been such a difficult challenge if there hadn't been other projects that required attention. But he had to prepare for a performance of his *Introduction and Rondo alla Burlesca* for two pianos by his friends, the married British pianists Ethel Bartlett and Rae Robertson. He had agreed to arrange Chopin's *Les Sylphides* for a February performance by Kirstein's ballet company. Auden had asked him to provide the incidental music for "The Rocking Horse Winner," a radio adaptation of a D. H. Lawrence story that the poet was writing with James Stern. Britten's neglected first symphony, *Sinfonia da Requiem*, had been scheduled for its Carnegie Hall debut at the end of March, and he was still required to travel to Long Island once a week for a three-hour rehearsal with his amateur orchestra.

Having accepted the necessity of the Long Island job, however, Britten found he enjoyed the chance to closely study the music they were rehearsing and to get to know the musicians. Often, he stayed overnight at the home of David Rothman, the hardware store owner and music enthusiast who had recommended him for the position. The Mayers usually joined them for an evening of musical games — putting on a record and seeing who could identify it first — or of listening to Britten explain why a composer had created a certain motif or built a particular movement. Rothman so admired Britten's talent that he had introduced him the previous summer to Albert Einstein, who lived nearby and had befriended Rothman when he stopped by his shop for a pair of sandals. They arranged for a musical session together — Elizabeth Mayer and Britten on piano, Einstein on violin, and Pears singing. Afterward, Einstein said of the young musicians, "They are very talented and will go far."

These brief visits provided a welcome respite for Britten and Pears, but the pressure to produce returned as they entered the house in Brooklyn. Just as record-breaking crowds of revelers had filled Times Square for the holidays, the Broadway theaters themselves appeared determined to outperform one another in the quantity and quality of their offerings that year. *Pal Joey* and *Lady in the Dark* had enjoyed particularly successful

debuts. George had heard from Lotte Lenya that her husband stood to make enough money from the latter production to buy a house in the country near some of their friends. The show's surprise hit had been "Tchaikovsky," a fast-talking, audience-pleasing number consisting solely of the names of Russian composers; it was performed by an unknown young comedian named Danny Kaye, who could reportedly sing the entire song in thirty-nine seconds flat.

Britten and Auden hoped to come up with something similar. In fact, Britten was willing to throw just about everything into his American opera — from Stravinsky to Cole Porter to Kurt Weill to Gilbert and Sullivan to the folk melodies of Appalachia. Such a mix might come close to reflecting musically the American character that Auden was attempting to express in words — the invigorating brew of contrasting influences, ideas, and styles. Colin McPhee, the composer and Balinese music enthusiast whom Britten had met at the Mayers' and who visited Middagh Street regularly, continued to press Britten to consider how he might use the delicate, ethereal sounds of the Balinese gamelan and was able to educate him about American jazz as well.

Now they had begun work on the Prologue, a kind of advent scene in which a trio of wild geese announce the coming of the mythical Paul Bunyan. The section required a grand, Broadway opening, and Auden worked with Britten and Pears to make it as exciting as possible. The curtain opened on a Chorus of Old Trees singing, in ascending keys, the story of the cycle of life in the ancient forest. In staccato cries, the Young Trees objected to the status quo, voicing their desire "to see things and go places," to transform themselves into something new. They were goaded by the Wild Geese, who urged them forward in their rebellion, then announced the coming of the great agent of change, Paul Bunyan.

The problems began at this point. Nothing that Auden and Britten came up with seemed to be sufficiently grand. How could they convey the enormity of the change that was about to take place, yet maintain the operetta's playful style? Day after day — as their production deadline approached — they worked and reworked the piece but failed to find the key to unlock the story. Pears, singing the parts for Britten and Auden as they substituted words and rearranged bits of the melody, had already contributed one of his favorite phrases to the libretto. Auden had picked up on his habitual, whimsical remark that a given event was likely to take place "once in a blue moon," assigning that phrase to the Wild Geese as they warned of Bunyan's arrival:

Young Tree.	When are we to see him?
1st Goose.	He will be born at the next Blue Moon.
Chorus of Old Trees.	She's lying. It isn't true.
	O I'm so frightened.
	Don't worry
	There won't be a Blue Moon in our lifetime.
	Don't say that. It's unlucky.
	[The moon begins to turn Blue.]

Now, Britten began to consider the phrase as the key to the grand ending they desired. They emphasized the blue moon's arrival by doubling the line:

Young Tree.	Look at the moon! It's turning blue.
Chorus of Old Trees.	Look at the moon! It's turning blue.

As the piece continued with a frantic resistance from the Old Trees, then a reluctant giving in, Britten saw an opportunity for a spectacular full chorus, its crescendo laced with just a hint of Colin McPhee's glass-like, Bali-inspired tones:

But once in a while the odd thing happens,
 Once in a while the dream comes true,
And the whole pattern of life is altered,
 Once in a while the Moon turns Blue.

It was the kind of melody you could hum or whistle, and it must have been impossible not to as Carson walked down the hill to Sands Street for a night of drinking and talking with George Davis and Auden. As they entered one of the ramshackle bars and sat down at a rickety table, Carson noticed that the establishment was run by a tall, hulking Amazon of a woman who worked beside a hunchbacked midget. The midget strutted proudly about the place as though he owned it, Carson noted, and wherever he went he was "petted by everyone, given free drinks, and treated as a sort of mascot by the proprietor."

While not particularly unusual in that environment, the angular woman and her companion piqued Carson's interest. There was something about the connection between them — the choreographed movements of lifelong partners — that put into sharper relief their differences in physique and manner. Throughout the evening, as she talked and

drank with Auden and George, her eyes lingered on the proprietor's capable hands as she mixed the drinks and on the alert way in which the midget moved from table to table, always provoking roars of laughter.

This time, Carson's moment of "illumination" did not happen instantly. Instead, the night on Sands Street lingered like a colorful backdrop in the back of her mind for days as she said good-bye to her friends. She would stay at home for a month or so this time, she thought, long enough to make serious progress with *The Bride and Her Brother* so that she would be less easily distracted when she came back. But on the long trip south, the rhythm of the train and the sips from her flask lulling her into a pleasant reverie, Carson's impressions of the Sands Street bar must have mixed with thoughts of Gypsy and George Davis, Auden and Kallman, Reeves, and especially Annemarie, more irrevocably separated from Carson now than she had been before. Carson was greatly bothered by her inability to obtain news of her friend. Yet her stay at Middagh Street had been productive in other ways, as she would soon realize. Shortly after settling into her mother's house, Carson was struck with a vision so overpowering that she set aside *The Bride and Her Brother* so that she could record the essential elements of this new story. It would be set in one of the cotton mill towns that dotted the South, Carson decided, the kind with a main street just a few hundred yards long. The largest building, in the center of town, leaned so far to one side, Carson imagined, that it seemed about to collapse.

It was in this isolated, dreary house that Carson placed the Amazon from Brooklyn, whom she named Miss Amelia, and her small, hunchbacked companion. Miss Amelia was "a dark, tall woman with bones and muscles like a man. Her hair was cut short and brushed back from the forehead, and there was about her sunburned face a tense, haggard quality." At the table, "Miss Amelia ate slowly and with the relish of a farm hand. She sat with both elbows on the table, bent over the plate, her knees spread wide apart and her feet braced on the rungs of the chair." Her greatest talents were for building things and caring for people. And the liquor she brewed in a still out back had a special quality of its own. "It is clean and sharp on the tongue," Carson wrote,

> but once down a man it glows inside him for a long time afterward. And that is not all. It is known that if a message is written with lemon juice on a clean sheet of paper there will be no sign of it. But if the paper is held for a

moment to the fire then the letters turn brown and the meaning becomes clear. Imagine that the whisky is the fire and that the message is that which is known only in the soul of man — then the worth of Miss Amelia's liquor can be understood. Things that have gone unnoticed, thoughts that have been harbored far back in the dark mind, are suddenly recognized and comprehended.

Miss Amelia lived for one thing only: the little hunchback Cousin Lyman Willis had appeared on her doorstep one day and now strutted about her store in tight knee-length breeches, black stockings, and queerly shaped shoes laced up over the ankles. She spoiled him shamelessly, taking him for walks into the swamplands and letting him ride on her back, and rubbing him with pot liquor morning and night to give him strength. She even turned her store into a café so that he could enjoy the company of others.

Her love went unrequited. Cousin Lyman would soon fall in love with Amelia's former husband, "a terrible character who . . . caused ruin, and then went on his way again," and who would treat the midget as badly as Cousin Lyman treated Amelia. But in the end, who was hurt and who did the hurting were beside the point.

"There are the lover and the beloved," Carson wrote, "but these two come from different countries. Often the beloved is only a stimulus for all the stored-up love which has lain quiet within the lover for a long time hitherto. And somehow every lover knows this . . . It is for this reason that most of us would rather love than be loved." She concluded, "Almost everyone wants to be the lover."

With *The Ballad of the Sad Café*, Carson found a way to express the longing she experienced — more or less continually, no matter what the object — for true communion with a lover. Within the confines of this strange story of a triangular affair, a story that oddly echoed Auden's developing relationship with Kallman as well, she began to come to terms with the understanding that it was the act of loving, not the object of that love, that gave her energy and direction. *The Ballad of the Sad Café*, born in a bar on Sands Street, eventually became, in the opinion of many readers, Carson McCullers's greatest work.

7

Living is quite pleasant here when it is not
too exciting.

— Benjamin Britten

Carson McCullers loved snow, and winter remained her favorite sea-
son in New York, although she would never spend a winter in the city
without falling seriously ill. "These Northern skies in winter time," she
wrote to Reeves several years later, "somehow they are lovelier than the
skies of the South." The snow after a blizzard dazzled in the sunlight like
spun sugar, and there was a "sort of Bruegel heartiness" in the sight of
scarlet-cheeked children in their snowsuits racing out into the streets to
play. For adults in midcentury New York, winter was "the season," and by
this time the social life at 7 Middagh Street had become legendary.

George Davis, his novel discarded and Gypsy gone, had turned the full
force of his considerable talents to giving parties at his Brooklyn house.
Frankie Abbe, his former secretary who was now conveniently living next
door, stopped by with her toddler son to help with the lists of guests and
make phone calls — just as in their earlier days, though they were now
creating evening spectaculars rather than magazine text.

Years later, another of George's assistants described the structure of his
parties as a series of Chinese boxes. At the center were the guests of
honor — Auden, Britten, Diana Vreeland, Maxwell Anderson, Moss Hart,
Marc Blitzstein, Julien Green, and any other established artists who hap-
pened to bustle in from the cold. Radiating from this hot center of self-
conscious laughter and conversation were the editors, agents, recent
émigrés, and young hopefuls, all exchanging telephone numbers and ar-
ranging to meet again. In the outer ring, stevedores and shopkeepers
whom George had befriended, "working" friends such as Frankie and

Victor, who served as bouncer, Brooklyn neighbors, and friends and relatives from the Midwest observed the astonishing scene, remarking, "Well, it takes all kinds."

A more bizarre fourth ring was added when, with Gypsy's permission, George sublet her third-floor rooms to a family of circus performers: an organ grinder, his wife and two children, and the chimpanzee and assortment of trained dogs that made up their act. No announcement was made of their arrival, so several guests were surprised when, as they chatted in the kitchen, the chimp raced past into the adjoining bathroom, shut the door, used the facilities, pulled the chain, and raced out again. Such guests may have inspired a rash of gossip in Manhattan the next day, but to George they were simply friends hoping to make a few beneficial connections. Joe the chimp found work at *Harper's Bazaar* almost immediately, as it turned out, modeling piqué hats for spring.

That winter, as many as a hundred or more artists gathered on Middagh Street in a single night, many of them dazzlingly famous and all eager to reap as much excitement, fun, and professional advancement as possible from the evening. The Swiss author Denis de Rougemont, in town for the publication of his new book, *Love in the Western World,* visited 7 Middagh Street at the suggestion of his friend Golo Mann; he later remarked that "all that was new in America in music, painting, or choreography emanated from that house, the only center of thought and art that I found in any large city in the country." And with the addition of Klaus Mann's international set, the house was, perhaps more than any private home in America at that critical moment in history, "open to the world."

Among the composers who visited the house that winter was the thirty-year-old Paul Bowles, then known more for his musical than his literary talents. A handsome, slender, taciturn blond, often appearing in tailored suits with pocket handkerchiefs, Bowles was well connected to many of the residents and guests at Middagh Street. For the past year he had maintained a small, unheated studio not far from Auden's former apartment in Brooklyn Heights and had dropped in for afternoon cocktails there a number of times. Auden accepted Bowles at once because of his connection to Isherwood; the novelist had met Bowles in Berlin in 1931 and been so charmed that he had named his best-known fictional character, Sally Bowles, after him. Paul had, in fact, gotten to know the "real" Sally Bowles, aka Jean Ross, when he fell into the habit of meeting

her for lunch at the Café des Westens each afternoon with Isherwood, Stephen Spender, and Aaron Copland.

Bowles, who was only twenty while in Berlin — slightly younger than the others — chafed at what he considered the Englishmen's cliquish, condescending behavior toward him. But it seemed to be something that happened only when two or more Englishmen got together, he observed, because Isherwood was perfectly forthright and friendly when they were alone. As for Auden in Brooklyn, "I was considerably in awe of him," Bowles wrote years later. "His learning and the strange way in which he expressed himself when he spoke combined to make me always unsure of the meaning of his words. But that in itself was a pleasant, if losing, game."

In February 1940, Bowles found himself in something of a fix. Having gone to Mexico the previous summer to enjoy the cheap and leisurely ex-patriate life in one of the few places where such a life remained possible, he had been abruptly called back in September to compose the incidental music for a new Theatre Guild production of Shakespeare's *Twelfth Night.* Composing a score "meant to sound like antique and intricate chamber music," Bowles earned such excellent reviews — including an entire column by his friend Virgil Thomson in the *New York Herald Tri-bune* — that he was immediately given the job of scoring Philip Barry's *Liberty Jones* for Broadway. Next followed Lillian Hellman's *Watch on the Rhine,* again for the Theatre Guild, after which he had agreed to compose music for *Pastorela,* a ballet based on the traditional Christmas *posadas* of Mexico, for the American Ballet Caravan that Kirstein was creating to tour South America the next summer.

Bowles welcomed both the praise and the commissions — but as the work continued and his wife, Jane, came up from Mexico to join him, he needed a place to live. Currently, they were staying at the Chelsea Hotel in Manhattan, but Jane's constant partying there made it impossible for Paul to work or sleep. When Kirstein heard of their predicament, he sug-gested that they move to Middagh Street. At a monthly rent of only $25, it sounded like an excellent idea. While Bowles was unfamiliar with George Davis, Carson McCullers, Benjamin Britten, and Peter Pears, he did know and like Auden and had been a friend of Klaus and Erika Mann's since his time in Berlin. It was Erika, in fact, who had introduced Paul to Jane three years earlier.

Ordinarily, the Bowleses wouldn't have stood a chance of getting a

room in the house, for there was now a long waiting list, with many places held by needy refugees, but Kirstein used his influence as house benefactor to lobby on their behalf. Although George preferred writers to musicians as residents, he had little choice but to give the Bowleses Gypsy's rooms if she decided to give them up. Since Christmas, she had continued to waffle between the worldly temptations of Chicago and the aesthetic life of her Brooklyn studio, but George was under no illusion that she would choose Middagh Street in the end. It was just a matter of waiting for her to decide. At least Gypsy's subtenants, the circus family, had moved on, and their replacement — a diminutive actor known by everyone in the house as Tallulah's midget because he had appeared in a Bankhead play — would presumably create less wear and tear.

If Paul and Jane could not yet have a room, at least they could visit, so they soon began attending the almost nightly gatherings, large and small, at the house. Jane, an impish twenty-three-year-old, loved parties and was known for flitting from one man's lap to another, saying the first thing that popped into her head and then joining in the others' laughter at how silly it was. And what she said was often laughable, for Jane Bowles had quite a surreal view of life. Having experienced a bout of tuberculosis of the knee as a teenager, she now walked with a limp and had to sit with that leg straight out in front of her. She kept a small strip of adhesive on the knee at all times, as though hoping to convince others that the affliction was temporary. She became quite upset if anyone mentioned her leg, but at the same time she was convinced that it was all anyone thought of when they were with her — and these thoughts preoccupied her a great deal of the time. Still, Jane could be very funny and she was usually the life of any party she joined. Paul preferred lounging against a wall at the back of the room, coolly observing the goings-on, but his good looks and professional reputation drew others to him.

There was much to observe at Middagh Street that winter, aside from the parties. A crisis erupted in early February when the residents learned that Annemarie Clarac-Schwarzenbach had escaped from the institution where she had been confined. After wandering in the freezing Connecticut woods all night, she had managed to find refuge in a friend's apartment in Manhattan but was said to be very ill.

When word reached Carson in Columbus, she dropped her work and took the train north immediately. Concern for Annemarie's welfare mixed with a wild eagerness simply to see her friend again. But Annemarie, in her distress, called out instead for the Baronessa von Opel

and even Gypsy Rose Lee. Another suicide attempt soon led to Anne-marie's commitment to a different institution in the suburban town of White Plains.

Carson remained at 7 Middagh Street for several days, unable to see Annemarie but unable, too, to leave without knowing what would happen to her. It was agonizing for the young writer to imagine her friend isolated among uncaring strangers who knew little about the reasons for her despair. Fortunately, Annemarie was adept at seeing to her own interests when necessary, and soon convinced her doctors to allow her to return to Switzerland, accompanied by a nurse. There, she hoped to join Erika Mann, who had already returned to Europe to work with the refugee rescue mission. It was only through actively fighting the Nazi invasion, Annemarie had decided, that she could avoid the debilitating depression that had overtaken her since she arrived in New York. She left by ship for Lisbon. Carson never saw her again.

These events devastated Carson, but less so than they might have several months before. Now, after nearly a month's hard work in Georgia on both *The Bride and Her Brother* and *The Ballad of the Sad Café*, she knew for the first time since the publication of *The Heart Is a Lonely Hunter* that she was making real progress and that the work was good. It was an interesting time to be in Brooklyn, if only for a few days. Auden now openly attended church and continued to spend time with Niebuhr. Still working through his feelings about this new relationship with God, he had even begun referring to "Her" familiar ways, as though God were a stern but loving mother whom they must all try to please. Carson, her mind on *The Ballad of the Sad Café*, must have listened carefully to his talk of achieving salvation through love for another individual. Much later, she wrote of that work, "the love of God . . . the love of Agape — the Greek god of the feast, the God of brotherly love — and of man. This is what I tried to show in *The Ballad of the Sad Café* in the strange love of Miss Amelia for the little hunchback, Cousin Lyman."

Shortly after Carson's return to Georgia that month, *Reflections in a Golden Eye* was published by Houghton Mifflin. Again, many were shocked by the novel's depiction of sexual deviance and insanity in a military setting. Carson's father threw the book across the room after reading it. The family even received a telephone threat from the Ku Klux Klan; the voice warned Carson's father that she had better get out of town or they would come and "get her" before morning: "We know from your first book that you're a nigger-lover, and we know from this one

that you're queer. We don't want queers and nigger-lovers in this town." Carson's father spent the night on the front porch with a shotgun, ready to fend off the vigilantes, but no one appeared.

Such responses to the book's "morality" hardly bothered Carson; on the contrary, to some extent she enjoyed the scandal. Yet even many critics panned the book — apparently out of shock, for the most part, that a young woman would admit to knowing about, much less feature in her work, such "marginal" characters as homosexuals, self-abusive wives, and peeping Toms. Rose Feld, who had praised Carson's first book so highly, admitted that this novel was "a more tightly bound tale, more confidently constructed than the first," but described her final impression as that of "waking up from a nightmare, of relief in knowing that what has passed was neither real nor probable."

Carson could console herself that Louis Untermeyer had provided a quotation for the book jacket, calling *Reflections in a Golden Eye* one of the "most compelling, one of the most uncanny stories ever written in America." And a *Kansas City Star* reviewer pointed out that this statement was not an unusual phrase to find on the jacket of a novel. The unusual thing was that "it is perfectly true." The reviewer for *Time* magazine stated simply: "In its sphere, the novel is a masterpiece. It is as mature and finished as Henry James's *The Turn of the Screw.*"

The object of their discussion, however, was all a part of Carson's past. She had completed the novella six months earlier, and now it arrived like a relic from her childhood, bound between hard covers and dedicated to Annemarie. Six months earlier, her Swiss friend had symbolized all the glamour and sophistication of European culture — the world that Carson had longed to join. Now, Carson herself was helping to create a new, American culture that, with its psychologically complex, indigenous themes, both built on and defied the old. Though she grieved for Annemarie, Carson knew now — with two novels published and two more in progress — that no matter what happened, she would continue to produce her work.

February was a month of birthdays at 7 Middagh Street — so many that Anaïs Nin would later call it "February house." George had celebrated his thirty-fifth birthday on the fourth. By Carson's on February nineteenth, she was back at her mother's house in Georgia — rising and dressing before eight o'clock, as was her annual custom, to await the arrival of telegrams, flowers, and, most important, presents. On the twenty-first in

Brooklyn, Auden turned thirty-four, and Jane Bowles, who had finally inherited the entire third floor with her husband, celebrated her twenty-fourth birthday the following day.

Everyone at Middagh Street enjoyed birthday parties. But in 1941, the reminder of time passing highlighted what an unnerving time in history it was to be young and trying to create art that would survive the present turmoil. On February 7, the day before the House of Representatives was to vote on Roosevelt's Lend-Lease Bill, Churchill willed a positive result by announcing to his people, "We have broken the back of the winter. The daylight grows. A mighty tide of sympathy, of good will and of effective aid has begun to flow across the Atlantic in support of the world cause which is at stake." He assured the Americans overseas: "We do not need the gallant armies which are forming throughout the American Union. We do not need them this year, nor next year, nor any year that I can foresee. But we do need most urgently an immense and continuous supply of war materials and technical apparatus of all kinds . . . Our message to the United States: Give us the tools and we will finish the job."

The Lend-Lease Bill was passed by the lower house the next day, resulting in a national outcry both for and against. At 7 Middagh Street, this next step toward engagement served to increase the rising tide of giddy tension. The evening revelries began to take on an almost surreal quality — literally at times, as on the night Pavel Tchelitchew decided that the parlor needed more color and, grabbing his paints, decorated one long wall with a surrealist mural. (The image was so overwhelmingly grotesque that a number of people begged George to have it painted out. But it was not in his nature to discourage experimentation.)

The presence of Paul and Jane Bowles did little to mitigate this uneasy mood. Their marriage was unconventional: Paul was bisexual, and before their marriage Jane had slept only with women. They had married for the sake of convenience when Jane's mother refused to marry her own fiancé until after Jane was seen to. Paul had complied partly because marriage was something that one did and partly to shock his parents, since Jane was Jewish. Nevertheless, as husband and wife the two quickly became extremely close as they realized that no one else in the world was likely to so thoroughly comprehend, much less match, their shared proclivities and neuroses.

The couple divided the third floor equally. Paul moved into Gypsy's rooms, which still contained, to his amusement, the six-foot cutout of her in burlesque garb. Jane took Carson's rooms, with their green walls

and velvet drapes. Their housemates had already noted the decorous and almost Victorian manner in which they carried on their relationship in public — using pet names and treating each other with exquisite politeness and concern. It was therefore a surprise to learn that in private they carried on an intricate, extensive, and occasionally violent fantasy life. Recently, on tour with *Liberty Jones,* the couple had indulged in one of their favorite games in their hotel room. In this "seduction game," which involved a good deal of shouting and chasing each other around the room, Jane yelled at one point, "I'll get you for this. You've ruined my uterus." Then she fell silent, having noticed the open transom above the door. Similar remarks and noises threatened to spill out of their bedrooms and up and down the stairs of 7 Middagh Street.

Meanwhile, the couple introduced a new strain of artists to the house. They counted among their friends such luminaries as John Latouche, the creator of the recent, wildly popular *Ballad for Americans* and the lyricist for the hit Broadway musical *Cabin in the Sky;* the Theatre Guild members Bill Saroyan and Cheryl Crawford; and the ballet crowd surrounding Kirstein and Balanchine. They were also well acquanted with many of the artists associated with the expanding Museum of Modern Art, including Tchelitchew and his fellow neo-Romantic Eugène Berman, Philip Johnson, and Alfred Barr. Perhaps their most idiosyncratic friend, however, was Salvador Dalí, who visited the house a number of times that winter with his intimidating wife, Gala.

George, too, had known the Dalís for years, having met Salvador in Paris and translated his article "Surrealism in Hollywood" for *Harper's Bazaar.* He was typically delighted by the showmanship with which the slender Spaniard shamelessly promoted his work. Most amusing had been "Dalí's Dream of Venus," the combination surrealist art exhibition, girlie show, and funhouse that Dalí and his wife had created for the New York World's Fair. The craggy edifice of pink and white stucco, adorned with an enormous image of Botticelli's nude Venus, supported a pair of living female sirens in bathing suits who waved seductively at passersby and invited them to enter. The pavilion's entrance was wedged between two enormous stucco female legs in pink-and-blue-striped stockings. A sharp-toothed stucco fish guarded the crotch. To enter, one dropped a quarter into the eye of the fish and moved into Venus's inner chambers — past an oversized aquarium containing bathing beauties in topless swimsuits ("Dalí's Living Liquid Ladies"), a piano with a rubber keyboard in the shape of a woman's body, telephone receivers drifting like jellyfish at

the ends of their cords, and a cow wrapped in bandages that sweetly returned the viewer's gaze. Moving into the next chamber, visitors discovered an equally large dry tank in which a half-clothed Venus lay dreaming in a bed thirty-six feet long surrounded by mirrors and half-naked attendants. Scattered across the crimson sheets were bottles of champagne and lobsters broiling on beds of hot coals, while dozens of black umbrellas hung from the ceiling like bats. Visitors then moved through a surrealist art gallery containing artifacts based on the works of Magritte, Oscar Domínguez, and other friends of Dalí's, then a classic Dalí landscape of Catalan desert and melted clocks, and finally past a half-nude female taxi driver chauffeuring Christopher Columbus back to Europe in a New York cab while more "Surrealist babes" preened on the car's roof.

André Breton, the "pope of Surrealism," was so offended by the pavilion's much-touted commercial success that he officially banished "Avida Dollars," as he anagrammatically renamed Dalí, from the group's roster. But Breton was always banishing other artists, and Dalí hardly noticed in the glare of the publicity that he so thoroughly enjoyed: a cover story in *Vogue* and extensive coverage in *Harper's Bazaar* and *The New Yorker*, among other popular magazines. Hoping for even more attention, Dalí concocted a noisy feud with the pavilion's financial sponsor, a rubber manufacturer from Pittsburgh, claiming that the company insisted for aesthetic reasons on providing rubber mermaid tails when Dalí wanted his mermaids to have rubber fish heads instead. In "protest," Dalí hired an airplane and flew over Manhattan, dropping copies of a manifesto against rubber manufacturers titled "Declaration of the Independence of the Imagination and the Rights of Man to his own Madness."

"It is man's right to love women with ecstatic fish heads," Dalí wrote. "Man has the right to demand the trappings of a queen for the 'objects of his desire': costumes for his furniture! For his teeth! And even for his gardenias!" Having lambasted commercial culture for several pages, the document ended, illogically, with a paean to America: "Christopher Columbus, discovered American [sic]," it read, "and another Catalan, Salvador Dalí, has just rediscovered Christopher Columbus. New York! You who are as mad as the moon . . . I go and I arrive, I love you with all my heart. Dalí."

Gypsy Rose Lee had been asked to appear in Dalí's surrealist pavilion ("Come and See Gypsy Rose Lee's Bottom of the Sea"), but she had wisely declined in favor of Mike Todd's venture. George Davis was most

likely disappointed by her decision, as he could never have passed up such a show. Now, however, he was more interested in the autobiography the artist was writing, *The Secret Life of Salvador Dalí.* It was to be published by the owner of the Dial Press, Caresse Crosby, at whose Virginia mansion the Dalís had been staying since the previous summer. Rather than describing the actual events in the artist's life, *The Secret Life* contained a hodgepodge of funny stories, dramatic poses, and whatever else Dalí thought of tossing in. "At the age of six I wanted to be a cook," he began. "At seven I wanted to be Napoleon. And my ambition has been growing steadily ever since." He went on to state his opinion on social interactions: "Very rich people have always impressed me; very poor people, like the fishermen of Port Lligat, have likewise impressed me; average people, not at all." And he concluded with an affirmation of conjugal love that perhaps even Auden would be interested to discuss:

> As a child I was wicked, I grew up under the shadow of evil, and I still continue to cause suffering. But since a year ago I know that I have begun to love the being who has been married to me for seven years; and I am beginning to love her as the Catholic, Apostolic and Roman Church demands, according to its conception of love. Catholic love, said Unamuno, is, "If your wife has a pain in her left leg, you shall feel that same pain in your left leg."
> Gala, you are reality!
> And what is heaven? Where is it to be found? "Heaven is to be found, neither above nor below, neither to the right nor to the left, heaven is to be found exactly in the center of the bosom of the man who has faith!"

In fact, however, Dalí's show of religious fervor was less evidence of a conversion than a cynical attempt to ease his eventual acceptance into Franco's Spain — as well as an early move to position Gala as the embodiment of the artist's muse in a publicity ploy for his upcoming exhibition at the Julien Levy Gallery in New York in late April. With most of the other surrealists trapped in Europe, unable to obtain the necessary visas to come to America, Dalí pronounced the movement dead and himself prepared to take the tradition toward "a new classicism," thus saving modern art. "A desire for forms and limits possesses us," he claimed, thinking again, perhaps, of Fascist Spain. But all of this activity was aimed mainly at keeping his name in the news. As he would soon recall in his autobiography-in-progress, "Fame was as intoxicating to me as a spring morning."

George laughed at Dalí's posturing — accomplished all in French at

Middagh Street, since the artist spoke hardly any English. Bowles, too, was amused by the show. He had been introduced to Dalí two years earlier at the home of the art patrons Kirk and Constance Askew. At that dinner party, Dalí had gazed into the salad bowl and told a grim story of a child's death while Gala informed Bowles that he must buy a large aviary and shut her into it, then come and scatter food and whistle at her. *"Je veux être votre perroquet,"* she kept repeating, fixing Bowles in her shrewd gaze.

It was amusing, but Bowles also found himself deeply drawn to Dalí's and the other surrealists' focus on the power of the primitive subconscious, as well as their dedication to undermining all forms of authority. The son of an emotionally cold and abusive father, Bowles actively loathed any form of authority, so the surrealists' brand of creative anarchy appealed to him enormously. He welcomed the Dalís' presence at Middagh Street — although Jane, who already found it difficult to separate fantasy from reality and preferred to evade rather than confront authority, felt uncomfortable in their presence.

Certainly, Gala Dalí could make anyone feel uncomfortable. At forty-six a decade or more older than her hosts, the Russian surrealist rarely smiled, and when she did it was to express derision. The Middagh Street residents soon learned to fear her for her ability to freeze a dinner partner in her snakelike gaze and eviscerate him or her with one icy word. This she willingly did, guarding her husband with what he called "the petrifying saliva of her fanatical devotion" while he prattled on about his exhibition. Gala complained constantly and was unpleasant to everyone, Anaïs Nin had written after staying with them at Caresse Crosby's the previous summer. But she was utterly devoted to Salvador's advancement.

The Dalís' presence created some lively evenings in Brooklyn. But Britten and Pears were beginning to lose patience with the intensely bohemian flavor of their new home. The brownstone was becoming absolutely filthy with so many people tramping through at all hours, to say nothing of the cats. The furnace, now in operation, worked *too* well, turning the top floor into a sauna. Parties took place constantly, with George staying up until dawn with his sailor friends. The recent addition of the Bowleses directly beneath their room, their voices drifting up from the third floor to the fourth, hadn't helped. Britten found himself resorting occasionally to Seconal to get to sleep at night. And now Paul Bowles intended to move an upright piano into his room to work on the music for *Pastorela*.

Britten suspected that the resulting noise during his own parlor work sessions would drive him mad.

Britten didn't know how long he could withstand such a live-and-let-live atmosphere, even though he understood that much of his unhappiness sprang from circumstances over which no one in the house had any control. More bad news had arrived from England: the London apartment of his sister, Barbara, had been destroyed by a bomb, though she had survived. And Britten's musical mentor and former teacher, Frank Bridge, had died at his home in Sussex. It was not only a personal blow to Britten, who had already lost both parents, but also seemed a bad omen: Bridge's successful tour of America in the 1920s had been a major factor in Britten's decision to give this country a try. Meanwhile, life in Brooklyn was "just one hectic rush," with four complete numbers still to be written for *Paul Bunyan* before a final playthrough in less than a week. It was all just too much. Britten wrote to Elizabeth Mayer's daughter, Beata, that he was "just staggering out of an acute depression — probably into another one."

Auden sensed Britten's unhappiness and, still feeling intensely responsible for Britten's presence in the United States, tried to step in and correct matters. When Britten complained about the residents' habit of entering people's rooms unannounced, Auden ordered a buzzer installed by his friend's bedroom door. He placed strict limits on the use of the radio, since its constant war news upset Britten even more.

Britten didn't mention his irritation over another matter — the continued presence of Chester Kallman, who seemed to consider himself an expert on the opera, reenacting every scene of *Der Rosenkavalier*. It was, frankly, mystifying to him to observe Auden's unthinking acceptance of Kallman's musical taste and expertise. The year before, Auden and Kallman had taken to attending the opera together — Auden wearing a stained tuxedo left over from his Oxford days, along with sneakers or house slippers to accommodate his corns. Afterward, if they had the money, they would dine at an expensive restaurant while Kallman "instructed" Auden on Bellini, Rossini, and Monteverdi. "I am so anxious for you to meet Chester, though a little frightened as he is extremely musical, and you do play so fast," Auden had written to Britten then. Now, living at 7 Middagh, the composer was still waiting for evidence that Auden could learn much at all of value about music from this boy. It was a little sickening to see how Auden drank in his partner's words — and

then wandered about the house talking opera as though *he* were an expert, too.

Unwilling to hurt Auden's feelings, however, Britten turned instead to the matter of Paul Bowles. It was impossible for two composers to work in such proximity. No doubt Bowles found the situation just as untenable. Was there any way to separate them sufficiently so that they would not hear each other at work?

Auden, too, was glad to focus on Bowles rather than on any of the founding members of what he now called "our menagerie." And there was something about Bowles that irritated Auden as well. Whereas, for example, the other residents tended to dress quite casually, Bowles was an impeccable dresser, brandishing his silver cigarette holder in a way that Auden particularly disliked. At the dinner table, Paul picked neurotically at his food, and Jane fretted over him like a worried mother, murmuring such comments as, "Oh, Bubbles, if you'd just stick to cornflakes and fresh fruit!" An entertaining storyteller with a dry sense of humor and popular with the crowd that frequented 7 Middagh, Bowles nevertheless held others at a certain cool distance. Worst of all, he seemed to have little if any respect for the rules of the house. When Auden distributed the weekly bill for rent and expenses, Bowles routinely questioned his share. And it seemed that no matter what philosophical or literary proposition the poet put forth for discussion, the composer was prepared to shoot it down with a sardonic remark.

Nor was Auden fond of Bowles's surrealist friends. Part of it had to do with his "anti-frog" and "pro-kraut" bias, as he himself had described it — Auden disliked having to conduct dinners in French. And Auden had admitted years before in England that "I have never met a surrealist, so my ideas of the movement may be completely misconceived." But even if he had had any interest in or understanding of the visual arts, surrealism's society-bashing, logic-smashing dogma could hold little appeal for a poet so fully invested in a life of routine and in rational thought. The surrealists hated modern society, while Auden had embraced it as his subject. And Dalí, who had blurted out when first introduced to Auden, "Do you speak English?" stood poised to cause particular offense.

Still, no one could argue that the Bowleses were inappropriate additions to the household. Not only was Paul quite a successful composer, but Jane had been working sporadically for more than a year on a novel. She had begun reading excerpts to her friends, but her quaint delivery

had provoked such hilarity that it was difficult for her listeners to judge the writing. Lately, she and Auden had begun talking about literature and had found that they shared an interest in the novels of Kafka. In fact, the two had become so friendly during these discussions that Auden had asked Jane to do his secretarial work for him. To Paul's astonishment, the two now met in the dining room at six o'clock each morning so that Jane could type Auden's dictation for several hours before breakfast. They were delightful sessions for Auden; Jane, warm and attentive, willingly played pupil to his schoolteacher and also mothered him with treats from the kitchen and other forms of attention. And Auden's interest in debating ideas seemed to have sparked a period of increased productivity in Jane — a development that irritated her husband no end.

Recently, another member of the Bowles family had moved into the house — Paul's cousin Oliver Smith, who had turned twenty-two that February. Smith, too, was an artist, producing pleasant, realistic water-color scenes. He had been living for months in a run-down hotel on Water Street, tucked beneath the Brooklyn Bridge, painting scenes of the Sands Street district, but his room's lack of heat had become unbearable, and the Middagh Street residents had invited him in from the cold. Smith was as handsome and elegantly dressed as Bowles himself — though on a more modest scale — but somehow, with his affable personality, this affectation came off well for him. Having turned down his acceptance to the Yale School of Drama in favor of life in New York, the young man shared Auden's love for the city's teeming streets, skyscrapers, and dramatic vistas.

Oliver's dream was to become a Broadway set designer, but he was virtually unknown in the field. Still, the other residents were charmed by his leading-man looks, excellent literary taste, and air of languid sophistication, and he quickly won a place as the much-loved baby of the family. Joining the Bowleses on the third floor, he willingly assumed the chores of washing dishes and tending the furnace. Although he later described that period of his life as "slightly Dickensian," it did not take long for him to settle in among the clutter and junk as though he had always lived there.

So it was not Paul Bowles's relations who posed a problem for Auden but Bowles himself. Hunting Paul down while he was at work one day, Auden presented him with the problem: two pianos so close together were bound to create interference for both composers. As Britten had al-

ready claimed the grand piano in the parlor, Bowles would have to find another place to put his upright.

Bowles had to admit that the basement seemed the only possible place under those conditions. But he was outraged by this sign of favoritism toward Britten. Bowles was a close friend of two of Britten's American cohorts, Aaron Copland and Colin McPhee; he had, in fact, first met Britten at Copland's studio some months before. "At that time he was not talkative," Bowles later wrote; "he struck me as obsessed by his work." Even now, although the two composers ate at the same table each day, they had little to say to each other.

This coolness reminded Bowles of the benign exclusion he had experienced with Isherwood and his other British friends in Berlin in the 1930s. He had resented it then, and he resented it now. "One might say that the household was segregated rather than integrated," he later wrote; "there were British and there were Americans, and the members of each group appeared to find its own nationals more sympathetic, thus easier to converse with, than the others."

No matter that Bowles himself was known for having been "less than friendly" toward a different group of expatriate artists as a member of the raucous Young Composers' Group, which he had joined with Virgil Thomson some years before. "There was not a lot of brotherly and sisterly love," one observer dryly remarked of the winner-take-all atmosphere of that group of eager debaters. Regardless, no matter who was right, as junior resident at Middagh Street, Paul had to move.

The upright piano was installed in the house's dank subbasement, next to the boiler room and as far as Bowles could get from Britten's piano. "It might have been satisfactory had there been any heat," he wrote, "but New York is cold in the winter and there was nothing but a kerosene heater which smoked excessively." Still, working night and day with his customary earplugs, he made good progress on *Pastorela*. He would not allow the British contingent to interfere with his work.

Britten had not yet completed the score for *Paul Bunyan*, but more important now were the two solos for the romantic leads, Slim and Tiny. The operetta (or opera, as Britten also referred to it) had been scheduled to debut on May 5, with a preview the day before for the League of Composers, a few critics, and friends. The production had been fully cast, but the lead actors were still waiting for their most important numbers.

Setting aside his other commitments, Britten set to work on "Slim's Song" — the solo that would establish *Paul Bunyan*'s romantic hero as an American wanderer seeking a more settled life:

O ride till woods or houses
 Provide the narrow place
Where you can force your fate to turn
 And meet you face to face.

Influenced, perhaps, by Copland's American style — or possibly by a Western-style musical on which Kurt Weill had been working when the two composers first met — Britten created a happy-go-lucky Western melody to evoke the wide-open spaces of Slim's home. The song seemed less derivative of the earlier works of American composers, however, than predictive of later Broadway productions. Today, "Slim's Song" sounds like something straight out of *Oklahoma*, which did not appear on Broadway until 1943.

As Britten was completing this solo, Pears brought him the happy news that Helen Marshall, the actress cast as Tiny, happened to have joined Pears's madrigal group that month. In other words, Tiny could sing — a fortunate coincidence in this opera performed primarily by actors, not trained singers. Pears introduced Marshall to Britten, and while they were chatting, Britten casually asked the singer to give him her musical range. By the next night he had completed her solo — Tiny's homage to her recently deceased mother, a soaring soprano showpiece clearly intended to become the opera's most memorable tune.

With Britten working productively, Auden should have been able to return to his own work routine. But a development in his relationship with Chester Kallman was causing him distress. Chester had announced that, after his graduation from Brooklyn College in the spring, he planned to attend graduate school at the University of Michigan at Ann Arbor. And he planned to go there alone.

Auden was devastated by this announcement — particularly coming, as it did, so quickly after he had chosen his love for Kallman as his new religious and philosophical path. He knew that it was normal and even necessary for Kallman, at twenty, to strike out on a life of his own. But he was also cognizant of Kallman's roving eye. He wrote to Isherwood, who coincidentally had separated from his own lover that month, "Chester . . . should I think be there by himself, as he has never been

away from home or me. I shall try, I think, to get a job in some college. Being a real Victorian wife, I don't relish the prospect of being parted at all."

It was natural for Auden to tell himself that it must be a test. If he had faith in his marriage to Kallman, surely it should be strong enough to withstand a temporary separation. He did his best to meet this challenge to his new philosophy of Christian love. In early March he was scheduled to speak at a Yale University dinner, and he took the opportunity to describe the average undergraduate in what amounted to a loving, forgiving portrait of Kallman, and perhaps also himself:

> For the youth who is neither an aesthete nor a scholar, the years between eighteen and twenty-one are, perhaps inevitably, years of melancholy, uneasiness and self-distrust. Conscious for the first time of all the possibilities of the intellectual life, and in some cases of latent powers of his own, he rushes forward without plan or patience to storm the fortress of wisdom and knowledge, only to be repulsed time after time with nothing gained but bruises and the knowledge that he has made a fool of himself. Conscious for the first time of the importance of personal relationships, he must suffer many humiliations before he learns that, unlike his relation to his parents, love and friendship have to be worked for, carefully nourished, and above all, deserved. As I speak to you this evening, therefore, it is of that young man, outwardly arrogant but inwardly timid, gauche, careless, intolerant but eager to learn and be liked that I think of and to whom my remarks are primarily addressed.

At home, Auden adjusted his medications to try to accommodate his mental state, increasing his dose of Benzedrine and Seconal and placing a tumbler of vodka by the bed in case he awoke at night. While absorbing the shock of Kallman's announcement, he made practical plans for its implementation. Caroline Newton, his friend and patron, volunteered to finance Kallman's graduate school education and, once again, Auden accepted. Meanwhile, pondering what the boy's absence would mean to him, he began as always to order his thoughts within the restrictive but satisfying guidelines of poetry. Moving away from the celebration of marriage of "In Sickness and In Health," away from the instructional tone of "Leap Before You Look," he experimented tentatively with how a geographical separation from Kallman might feel. In "Atlantis," he offered advice to a young traveler as he departs on his quest. In "Alone," he acknowledged that being close to one's lover could be painful, too:

Each lover has a theory of his own
About the difference between the ache
Of being with his love, and being alone . . .

Auden still had no idea that Chester had already found a new lover in Brooklyn — and Kallman found himself unable to confess and possibly end what was likely to be the most beneficial relationship of his life. Still, his secret was too powerful to keep to himself. Instead of telling Auden about Jack Barker, then, he chose to tell Jack about Auden.

The young British Merchant Navy officer had returned to New York near the end of February. After two months of separation, he and Chester could hardly wait to reunite. When they did, it was clear that their mutual attraction was as strong as ever. This time, Chester made it clear to Jack that another man was involved and that they needed to be discreet, though he didn't yet reveal the identity of his other lover.

Jack went along with the clandestine arrangements that Chester obviously relished — making appointments with Chester's father, then arriving early to meet Chester in the office while Dr. Kallman was out to lunch. On one occasion, the dentist returned to find his office door locked and a patient waiting in the reception room. From inside the office he could hear Jack and Chester, engaged in a loud argument. Dr. Kallman banged on the door and insisted they leave, but they ignored him for nearly an hour before departing.

Dr. Kallman was furious with his son, not only for trespassing but especially for having betrayed Wystan. Jack might be younger and more attractive, he insisted, but Chester would never find another friend like Auden. The dentist may have had in mind the convenience of Auden's financial support and the prestige of his name, but it was also clear to him that few men were likely to have Chester's best interests at heart to the extent that Auden did.

Edward Kallman's efforts were fruitless; at twenty, Chester wasn't looking for a friend. He wanted passion of the sort he no longer felt for Auden. Craving drama, he also found himself attracted to the idea of being fought over by the two men who loved him. Once he was won, he wanted to be punished for having made the winner suffer. Love, pain, and punishment were frequently linked in the poetry carefully printed in his lined notebooks: "O my love and punishment, where are you?" and "Speak louder. I can't hear you. Don't be afraid / You'll hurt me; nobody's home . . ." He had, a friend later wrote, a longing to be mastered.

Kallman waited to make his move until the day Jack's ship was to depart. The two young men had arranged to meet at a nearby bar before Jack had to go aboard. There Kallman finally confessed the identity of his other lover. Barker reacted with shock and anger. Auden — the famous poet who had generously welcomed him to New York, whose poetry he had admired, whom he hoped to impress and perhaps even befriend — was the last person he wished to harm. In an instant, Kallman was transformed in Jack Barker's imagination from a passionate, seductive angel to a trickster into whose trap he had fallen. Struggling with the news, Barker declared that Kallman must tell Auden the truth or he would never see him again.

Barker's ship departed for Glasgow, leaving Kallman behind on the Brooklyn docks. Never before, perhaps, had the young man felt so abandoned and isolated. But it was also likely that he had never before felt so alive.

Part III

The House of Genius

MARCH–DECEMBER 1941

Once we could have made the docks,
Now it is too late to fly;
Once too often you and I
Did what we should not have done;
Round the rampant rugged rocks
Rude and ragged rascals run.

— W. H. Auden, "Domesday Song"

8

Can we make wounds beautiful?
The tiger at the window smiles.

— Paul Bowles, "Scene VIII," 1940

Wᵉ've got a roast and two veg, salad and savory, and there will be no political discussion," Auden announced to the Middagh Street residents as they took their places at the dining room table. The news had become too awful to contemplate, much less discuss. In the wake of Roosevelt's signing the Lend-Lease Bill in mid-March, London had endured one of its most punishing night raids since the beginning of the war. Already that year, nearly thirty thousand civilians had been killed. London had become a city of wailing sirens, drifting smoke, dead buried beneath piles of rubble. As the RAF struck back against its enemies, Berlin would come to look much the same. In Poland, the deadline had arrived for Jews to enter Krakow's walled ghetto. Yugoslavia, surrounded on all sides by Axis powers, would soon be carved up and parceled out among its enemies.

Europe was caught in a nightmare of its own making, suffering the consequences of decisions made in thousands of forgotten instances in thousands of individual hearts and minds. The hellish conditions that resulted were beyond the ability of anyone at 7 Middagh to control. Better, Auden felt, to focus on how best to build a new civilization from the detritus washed up on America's shores.

But focus became increasingly difficult to maintain as the fear and anxiety infecting the outside world seeped into the house during those last muddy weeks of winter. Britten in particular found it impossible to ignore the broadcasts of air attacks on London as he prepared for the Carnegie Hall debut of his *Sinfonia da Requiem*. The symphony, influ-

enced by Mahler, had been his most ambitious and most intimate expression to date of his grief and revulsion over the war. Proud as he was of his artistic accomplishment, the act of reviewing its three movements — a "slow marching lament," a frenzied "Dance of Death," and a concluding expression of final peace, as he described them — could only heighten his intense uneasiness over the welfare of his loved ones in England. It was discomfiting, too, to know that most of the American audience would listen in complacent ignorance of the emotional state that had inspired the composition. The performance, scheduled to be broadcast to nine million listeners on Carnegie Hall's weekly radio program, felt, Britten wrote to a friend, "rather like those awful dreams where one parades about the place naked."

Nor did the work on *Paul Bunyan* provide much relief. Rehearsals had begun and were quite exciting for the most part, as Britten and Auden met the cast and watched their ideas take shape onstage. But even now, the opera remained very much a work-in-progress: Auden continued to make changes that required new music, even though Britten was already working night and day to complete the score. It had become clear, too, that not only had some of the leads had no musical training, at least one was completely tone-deaf. While Britten scrambled to cut the nonsinger's solos and create new numbers for those who could sing, the director, Milton Smith, confronted Auden over the issue of the opera's tone.

Smith understood that Auden's interest in the opera was a way of conveying his view of America as civilization's newest experiment, in which its human population, free to do almost anything it likes, must devise a reliable new rationale to guide its actions. This idea was expressed clearly and entertainingly through the story of Paul Bunyan's transformation of virgin forest into urban centers with hotels, schools, movie studios, and government bureaucracies. The trouble was, in Smith's opinion, that these "Ideas" of Auden's had begun to outweigh the plot. The opera had begun to resemble more a strung-together series of *tableaux vivants,* each illustrating a separate theme, than a convincing and captivating story. What the work needed was more drama, more action, Smith insisted. Bunyan did, after all, according to legend, have an exciting life.

Auden objected that most of the elements of the Paul Bunyan tale, such as his growing six inches a day as a child, fighting the Indians, and battling and killing something called a whirling whimpus, would be im-

possible to stage. He had already agreed to solve this problem by writing several Ballad Interludes in which a guitar-strumming narrator would sing of Bunyan's exploits between scenes. He refused to compromise, however, when it came to the conclusion. There, following the grand, upbeat Christmas Feast number, in which each lead character announced his decision regarding the direction of his life, Auden had added a prolonged Litany — Paul Bunyan's solemn prayer for America as he prepared to move on with Babe, his blue ox, to other worlds. The festive atmosphere dissipated as Bunyan acknowledged sympathetically that "All but heroes are unnerved / When life and love must be deserved," but he expressed the hope that his American friends would somehow be saved from the "Pressure Group that says I am the Constitution, / From those who say Patriotism and mean Persecution," from "entertainments neither true nor beautiful nor witty . . . / From the dirty-mindedness of a Watch Committee," and from other pitfalls likely to befall any modern democracy.

Finally, following this Prayer, Inkslinger, the opera's intellectual, asked: "Paul, who are you?"

Paul Bunyan replied:

> Where the night becomes the day,
> Where the dream becomes the fact,
> I am the Eternal Guest,
> I am Way,
> I am Act.

And so the opera ended, in silence. Britten, adaptable as always, had composed a moving accompaniment that conveyed the sincerity of Auden's message. But Smith was disappointed by such a somber conclusion. He pleaded with Auden for a more upbeat, patriotic finale. "I don't want to sound like John Latouche," Auden snapped, and Bunyan's final speech remained in place.

Auden's gruff attitude toward Latouche and his thirteen-minute tribute to Democracy, *Ballad for Americans,* may have derived from the continued presence of the handsome, urbane lyricist as part of the group that had coalesced around Jane and Paul Bowles. It seemed at times that the group of dynamic theatrical writers and composers, which included Marc Blitzstein, Aaron Copland, Virgil Thomson, and Leonard Bern-

stein, had taken over the parlor, filling the house with American-accented conversation and laughter and making Auden, Britten, and even Pears appear the odd men out.

While Britten's talent allowed him to socialize with the Americans and even maintain a friendship with the amiable Copland, their collective presence increased the sense of alienation that always threatened to overtake him in the United States. Not only were these other musicians united in their nationality, but most were also former acolytes of the famed teacher Nadia Boulanger in Paris — a powerful musical mentor of whose overwhelming influence Britten privately disapproved. Auden, apparently responding to the group's insularity, had been heard to grumble that forty-three-year-old Virgil Thomson, who played the middle-aged guru to the group, reminded him of "one of those intimidating English butlers." Britten confided to his sister later that spring his belief that "I am definitely disliked (a) because I am English (no music ever came out of England) (b) because I'm not American (everything is nationalistic) (c) because I get quite a lot of performances (d) because I wasn't educated in Paris — etc. etc."

Other developments in the house added to the strain. The noise of renovations had resumed when Golo Mann departed to begin a lectureship at Olivet College in Michigan and Oliver Smith took over the attic. Smith had set to work at once transforming it into a fully functional studio in which to live and work, so there was no telling when the hammering above Britten's bedroom would stop. Noise continued to filter up from the floor below as well, as the Bowleses indulged in their extended games. One of their favorites centered on Paul's portrayal of Bupple Hergesheimer, a man-sized parrot, "monstrous in his behavior," who responded to Jane's efforts to put him back into his cage with weird, spontaneous eruptions of "Bupple" or "Rop."

As spring approached, a host of biological life forms had begun to assert their presence in the squalid house. Recently, Pears had seen a doctor about a foot infection, only to learn that its cause was most likely bedbugs hiding in the bed they had bought in the junkshop on Fulton Street. Fleas and other parasites easily entered the house on the backs of the cats, dogs, chimpanzees, and other animals that passed through.

The surreal quality of life in the house intensified, too, in the weeks leading up to Dalí's exhibition. If one could slice the building vertically in half and open it like a dollhouse, one might find Pears fighting off the itch of bedbugs on the top floor while practicing Britten's *Illumina-*

tions in his sharp, clear tenor (*"J'ai seul la clef de cette parade sauvage"*); Jane lining up an imaginary class of French schoolgirls on the third-floor stairs ("Adelaide, *tenez-vous droit!"*); and Gala Dalí in the parlor, fixing an uneasy Britten in her predatory gaze as she described her previous life as the Greek goddess Hera to Salvador's Zeus. Next door, George Davis could be seen peeling Dalí's portrait of Harpo Marx off the windowsill, crying to the maid, "It's rained on the picture, Susie. How could you? It's ruined! Ruined!" To which Susie replied sympathetically, "Yes, Mr. Davis, you're right. It sure is too bad, and it was such a beautiful picture of your mother, too."

Downstairs, in the dining room, Auden was likely to be entertaining Eva with excerpts from his *Harper's Bazaar* piece on the greatest last words ever spoken. His favorite was the remark made by the female impersonator Bert Savoy, who, noting an approaching thunderstorm on Long Beach, quipped, "There's Miss God at it again" — and was instantly struck by lightning. Next door, in the kitchen, Dalí rummaged for coffee until he spotted a stray cat near the stove that had been hit by a car and was nursing a bloody gash in its side. *"Je déteste les chats,"* he shrieked, recoiling in horror, *"et surtout avec des plaies!"* ("I detest cats, especially with wounds!"), before fleeing from the room.

Then there was the psychopath who tried to burn down the house by scattering feathers up and down the stairways, the increasing number of complaints that sailors were stealing items from the residents' rooms, and the suitcase that had been opened and pillaged — not to mention the frequent long nights of drinking in the parlor followed by dreary mornings cluttered with overflowing ashtrays and empty martini glasses.

There was no peace anywhere — not out in the world and not even in this temporary sanctuary that the artists had tried to create. By the end of March, the emotional strain had begun to affect the lodgers' health. Britten succumbed to "one of the plagues of Egypt," as he called the relapse of his streptococcal infection from the previous spring — the infection that Auden claimed was caused by homesickness. Paul Bowles contracted a case of measles and retreated to his room to be fed soup and fussed over by Jane. The most serious casualty, however, befell the one founding household member who wasn't there. The residents — George Davis in particular — had been horrified to learn that in late February, shortly after her return to her mother's house in Georgia, Carson had succumbed to a series of headaches so violent and excruciating that they had led to partial paralysis and an almost complete loss of vision. By

mid-March, her vision had returned to the extent that she was able to read, but she could still barely walk from her bed to the living room sofa, and her doctors were unable to determine the cause of her collapse. It would be years before this mysterious malady would be correctly diagnosed as the first of the severe strokes that would destroy Carson's health in the decades to come and lead to her death at the age of fifty.

Despite her affliction, Carson was determined to return to New York as soon as possible. But this time her husband, who had traveled south to help care for her, and her mother insisted that the house on Middagh Street was too stimulating for someone in her condition. If she were to go to New York, it must be in Reeves's care — and she must stay with him in their apartment on West Eleventh Street. In a sense, Carson's acceptance of these conditions served as a final judgment of the depths to which the experiment at 7 Middagh Street had fallen.

George, having lost Gypsy to Chicago, his friend Victor to the army, and now Carson to her illness and to Reeves, began to ask himself how long this group life could continue. The waiting list for rooms had grown so long that there was no hope of reaching its end; more names were added each week as anxiety about the future increased in New York's artistic community. The house in Brooklyn had become, it appeared, a lifeboat for a fortunate few, and as new residents replaced the original members, George sensed an unpleasant atmosphere of exclusivity beginning to permeate the drafty old house. Lincoln Kirstein replied, when Auden asked why he insisted on writing such scathing dance reviews for *Decision,* that the point wasn't so much the reviews themselves as the friends one made by writing them. And when Jane Bowles's friend, the former *New Yorker* employee Robert "Boo" Faulkner, expressed a wish to join the Brooklyn group, Jane coolly retorted, "You're not important enough."

This form of corruption, as George saw it, was anathema to his original intention for the house as an open forum to promote important work. In both structure and style, the vessel that was 7 Middagh Street appeared to have gone hopelessly adrift. Auden, too, seemed to have sensed the growing malaise and understood its significance. In a review of Theodore Roethke's new collection of poetry, *Open House,* Auden wrote in March that "a work of art, like a life, can fail in two different ways: either, in terror of admitting that there is any chaos, it takes refuge in some arbitrary conscious order it has acquired ready-made from others or thought up itself on the spur of the moment . . . or, lacking the

courage and the faith to believe that it is possible and a duty to bring the chaos to order, it contents itself with a purely passive idolization of the flux." It was necessary to create "both in Life and Art," he wrote, a "necessary order out of an arbitrary chaos" — not *any* order, but an order "already latent in the chaos, so that successful creation is a process of discovery . . . and the more consciously one directs this process the more one becomes both conscious of and true to one's fate."

An artist, Auden concluded, was someone who conducted this deliberate process of discovery — this conscious form of human development — in a public manner, to be shared by others. Such activity carried with it a responsibility to try not to allow the always-threatening opposing forces of arbitrariness and chaos to interfere. Auden was trying to maintain his own focus despite the arbitrary pressures of patriotism and nationalism created by the war and the forces of chaos working against him in the house on Middagh Street.

In March, Auden's new book, *A Double Man,* had appeared with his long poem "New Year Letter" at its center. Its publication coincided well with the current state of thinking in the United States, as much of the population observed with dismay a European culture now "on all fours to greet / A butch and criminal *elite*" and struggled with the question of "where to serve and when and how?" As a result, the book was well received in America — with a few significant detractors, including the poet Delmore Schwartz — but Auden had already moved beyond his poem's philosophical vacillation toward a full embrace of the "objective" moral dictates of religious faith.

No longer was Auden concerned, either, with the objections to his current direction that had been raised by a number of his closest friends. He made this clear in a debate with Klaus Mann, broadcast in mid-March, titled "The Function of the Writer in the Political Crisis." In the conversation, Mann asserted his view that creative writers are equipped by their professions to see farther and more clearly than the average man, and so they are morally obliged to galvanize the public politically when they see danger ahead. Auden insisted, more confidently and succinctly now than in previous months, that intellectuals do not by definition possess superior political insight — and may, in fact, be as easily tempted as the next man to use politics to their own advantage — but that by focusing on the timeless moral issues they may be able to help move the population toward a better future. In any case, the political present was no longer a matter for poets and writers, Auden claimed, but was in the hands of

"professionals," who would tell the population what it must do. Writers, meanwhile, should stick to what they do best and define the truths on which society could create new and better conventions.

Auden was aware of the exasperation with which Klaus Mann greeted his position — echoing that of Erika, now rumored to be with Anne-marie Clarac-Schwarzenbach in Switzerland, helping displaced people escape into that neutral country. But by that spring of 1941, Auden had lost interest in his friends' objections. Nor did he show any remaining patience with the debate, reportedly still "raging everywhere" in England, over his and other English writers' presence in America. The month before, when Golo Mann had urged him to defend himself against such criticism in a British newspaper, Auden had replied curtly that there was no point in responding to people whose minds were made up. But the continuing remarks in the British journal *Horizon* by Cyril Connolly, and particularly by Auden's friend Stephen Spender, struck him as especially gratuitous, given the circumstances, and he resented their power to distract and upset his fellow expatriates Isherwood and Britten.

Spender, who had written of his "regret" that Auden was not in England, as he was, to write poems about its great ordeal, had long been known in their circle of friends for his tendency to analyze his disagreements with them publicly, in print, instead of directly with those involved. He periodically suffered bouts of envy aimed at Auden — at Oxford, he had once written a novel in which Auden was portrayed as a kind of Lord of Death — and his addiction to publicity was such that he himself once wrote that it disgusted him to read a newspaper in which there was no mention of his name. Now, his and Connolly's stirring of the ashes of resentment against Auden had prompted Louis MacNeice, now in London writing for the BBC, to respond in the February issue of *Horizon* that "for the expatriate there is no Categorical Imperative bidding him return — or stay," and that while it might be right for an artist who was getting nowhere to return to England, "Auden, for example, working eight hours a day in New York, is getting somewhere; it might well be 'wrong' for him to return."

What Spender was pretending not to see in comparing the writers' situation in Britain to that of Auden was that, by 1941, no one in Britain had a choice about how to act. Their immediate destinies had been dictated when the bombs started to fall. Auden, Isherwood, Britten, and the other expatriates, on the other hand, were still able to decide freely how best to serve. And they were deciding — a much more difficult pros-

pect than automatically responding in the only possible way, by fighting back.

As the furor continued on both sides of the Atlantic, Auden decided he had had enough. He tried to stanch the flow of commentary by writing privately to Spender, the way he wished his friend had communicated with him:

Dearest Stephen:

People ring me up from time to time to ask me if I am going to answer what they describe as an attack by you in Horizon . . . Your passion for public criticism of your friends has always seemed to me a little odd; it is not that you don't say acute things — you do — but the assumption of the role of the blue-eyed Candid Incorruptible is questionable. God knows it is hard enough to be objective about strangers; it is quite impossible with those whom one knows well and, I hope, loves . . . As to your review of me, what you say is probably accurate enough, but the tone alarms me. 'One is worried about Auden's poetic future'. Really, Stephen dear, whose voice is this but that of Harold Spender M.P. [Stephen's father] . . .

But what really alarms me is that in a crisis of this time, you should be so bothered about what other contemporary writers are up to. What has to be done to defend Civilisation? In order of immediate importance: (1) To kill Germans and destroy German Property. (2) to prevent as many English lives and as much English property as possible from being killed and destroyed. (3) to create things from houses to poems that are worth preserving. (4) to educate people to understand what civilisation really means and involves . . . Literary criticism is a very small and negative part of the last. With your gifts for creation and education there is more than enough for you to do . . .

I don't see how my own attitude about the war can be of any interest except to myself, but here it is. If I thought I should be a competent soldier or air-warden I should come back to-morrow . . . As a writer and a pedagogue the problem is different for the intellectual warfare goes on always and everywhere, and no one has a right to say that this place or that time is where all intellectuals ought to be. I believe that for me personally America is the best, but of course the only proof lies in what one produces.

With the arbitrary judgments from England addressed, Auden next turned to the chaos in the house. In order to restore the household to a reasonable balance, it would be necessary to enforce new rules. First, social activities would have to end at a reasonable hour so that the artists in residence could get some sleep. To this end, Auden began adding a handwritten message to each of the party invitations sent out by George: "The carriage will depart sharply at 1:00 A.M." If guests attempted to stay be-

yond that time, the poet would descend in slippers and robe to insist that they leave, to their wide-awake host's disappointment.

Auden grew stricter regarding financial matters as well. Payment of rent had grown lax over recent months; now he announced that the rent would be paid each Tuesday at breakfast, and that anyone who failed to appear at that time could expect to find him knocking at their door by noon. Each resident's share of the household expenses ("George: 21.06 . . . Benjy Peter: 20") was scribbled into Auden's notebooks beside such lines as "A thousand vases — / Life's certainly spilt / From a thousand — roses." Britten and Pears, presented with a list of the week's costs, always paid immediately without objection, but those who tried to question their bills faced his immediate loss of temper.

It was at the dinner table, however, that Auden proved most domineering. Having already excluded politics as an acceptable topic of conversation, he now forbade personal arguments and bickering as well. His own monologues on literary topics grew louder and more difficult to interrupt, as he developed the habit of muttering a continuous "uh . . . uh . . . uh" between sentences to keep anyone else from breaking in. Some of his fellow diners were content to ignore him and carry on their own conversations, while others listened to Auden in fascination. Among the latter was Jane Bowles, now utterly under Auden's spell and avidly incorporating his ideas and opinions into her novel.

Two Serious Ladies was an autobiographical work — autobiographical as interpreted through Jane's refracted sensibility. Rather than create a single alter ego whose thoughts and experiences resembled her own, Jane split her ideas and concerns between two contrasting female protagonists, allowing each to play the "serious" game of making or refusing to make certain life choices and then examining the results. The novel begins with one of the two protagonists, Christina Goering, at the age of thirteen, playing a game with a neighbor girl called "I Forgive You for All Your Sins." In the game, Christina wraps the girl in burlap, covers her with mud, and then submerges her in a stream to wash away her sins. She does not play this game for fun, the character explains, but because it is necessary. And indeed, for the remainder of the novel, Goering conducts a single-minded if circuitous quest for spiritual redemption — selling her beautiful home to live in a rural shack and sacrificing her body through affairs with strange and possibly dangerous men. Meanwhile, her friend and fellow protagonist, Mrs. Copperfield, chooses a life of pleasure in the belief that God is dead and so cannot forgive her sins. Traveling passively

with her husband to Panama, despite her fear and dislike of exotic climes, she then drifts out of his sphere and into a kind of masochistic half-life with a female prostitute named Pacifica.

At the end of the novel, the two serious ladies reunite in a city restaurant to assess the effects of each journey on themselves and on each other. Goering judges herself "nearer to becoming a saint," but wonders anxiously whether a hidden part of her continues "piling sin upon sin." Mrs. Copperfield acknowledges that she has "gone to pieces, which is a thing I've wanted to do for years. I know I am as guilty as I can be," she adds, "but I have my happiness, which I guard like a wolf."

Jane Bowles freely adorned *Two Serious Ladies* with personalities, settings, and miscellaneous details plucked directly from her own life. The rural shack, the hotel in Panama, the grim urban apartments, and Miss Goering's inherited house — all could be easily recognized as homes Jane had occupied or visited while working on her book. Many of her daily experiences, too, became part of her fiction. Early in the story, for example, Goering asks a new acquaintance, Miss Gamelon, what she does for a living. "Not very much, I'm afraid. I've been typing manuscripts for famous authors all my life," responds the character — in words provided by an author who spent her mornings typing W. H. Auden's dictation — "but there doesn't seem to be much demand for authors any more unless maybe they are doing their own typing."

The name Gamelon intriguingly evoked the musical obsession of the Bowleses' good friend and Middagh Street habitué, Colin McPhee, and John Latouche served as the physical model, at least, for a character whom Goering would befriend at a party. "Goering" had been plucked from the newspapers. Mrs. Copperfield's husband, playfully referred to by the initials J.C., resembled Paul Bowles, with his lust for all things exotic and his cool acceptance of his wife's strange behavior. By placing Paul in her fiction, Jane was able to express without inhibition both her strong attraction and her underlying fear of her husband.

In her novel as in her life, Jane Bowles used a charming quirkiness — a feminine pretense that the ideas she presented were not of any real gravity but only a pretty and amusing game — to conceal a powerful and wholly original moral sensibility that corresponded in many ways to Auden's overt approach to similar issues. The thirty-four-year-old Protestant poet and the twenty-four-year-old Jewish writer had continued their discussions of Kafka's novels. Both agreed that his heroes dramatized the difficulty of maintaining religious faith in modern times, even

while seeking salvation. Men today could no longer hide from themselves the arbitrariness of the god they chose to worship, Auden claimed, and yet to lose faith in that object was to be damned. This was precisely the idea that Jane had tried to evoke in her story of Mrs. Copperfield and Christina Goering. Klaus Mann, who had written the introduction to the new edition of *Amerika* that Auden had reviewed, later described Kafka as "hypnotized by the problem of Original Sin," searching "all hiding places and dingy corners of the Ghetto for the name of the crime that he committed. What is my guilt? Who is my Judge? Where will the Trial take place? . . . My God, why has thou forsaken me?" The heroines of *Two Serious Ladies* ask the same questions, though not in so many words.

Paul Bowles, listening to Auden and his wife talk at the dinner table, disagreed with their approach to Kafka's work as a religious quest. "But that's nonsense," he objected. "Why can't they just be marvelous inventions, great novels?" The interruption annoyed Jane, who felt gratified to have found someone — and someone so important — who took her writing seriously rather than laughing as had her other friends. Already, during their typing sessions, she and Auden had discussed a wide variety of related issues and found that they held common views toward marriage as a spiritual and even religious commitment. Auden even seemed to approve of, or at least enjoy, all the little fears, anxieties, and other neuroses that had plagued Jane all her life and that Paul found simply puzzling.

"A neurosis is a guardian angel," Auden had written in his review of Kafka; "to become ill is to take vows." To Jane, such a statement must have felt like a benediction. It was little wonder then that, on hearing her husband object to a religious interpretation of the author she so strongly resembled, she snapped impatiently, "Oh, get back in your cage, Bupple," before turning back to continue her conversation with Auden.

Paul Bowles's measles finally lifted, only to be followed by the flu. Confined again to bed, Paul had time to observe his wife's growing enthusiasm for her novel and her sense that after more than two years of fruitless struggle, she was finally making progress. Sitting with Paul while he ate the delicious meals she brought up on a tray, Jane described the details of her characters' experience and the problems she was having in their development. Listening, Paul gradually found himself caught up in her enthusiasm, and even began to entertain thoughts of perhaps returning to writing fiction himself. Bowles had published poems before — in such

well-respected journals as *transition* in Paris — and had become a part of Gertrude Stein's circle for a brief period. But the previous summer, he had dropped the idea of continuing as a serious writer because, he claimed, the world was too complex and life too mysterious for him to ever communicate his view of it in a way that a reader might understand.

But Jane, it seemed, never worried about translating her worldview into a normal vernacular — she simply wrote down whatever ideas and images came into her head. Just as her sensibility tended toward a "natural" form of surrealism, in which the barrier between interior thought and exterior reality frequently ceased to exist, so her work habits seemed to echo the surrealist literary method of writing down words without thinking in order to bypass the strictures of the conscious mind. Paul's interest had always lain with the primitive mind — the private myths that lurked beneath the conscious thoughts and actions of everyday life but that directed them in profound ways. He could see possibilities in the idea of creating his own Kafkaesque story of a spiritual quest — a quest that would be in no way religious.

It would be years before Paul fully acted on his impulse. Now he confined himself to taking a proprietary interest in Jane's writing. The more deeply Jane fell under Auden's intellectual spell, the more resentful Paul became. Cool as he appeared to those who did not know him well, Paul was fiercely possessive of his wife. These feelings had established themselves in the first weeks of their marriage when, after what he considered an idyllic honeymoon in Panama, they had continued on to Paris. There, Jane had friends whom Paul disliked, and so she decided to go out with them alone — often not returning until three in the morning. "It was painful for me to go back to the hotel room at dinnertime and find that she had not yet come in," Paul wrote, "finally to have dinner alone and rush back to find the room still empty. And Jane was not one to change as a result of my suggestions." Jealous and angry, Paul finally left her alone in Paris and continued on to St.-Tropez. Once there, he regretted his action and sent for her, but the pattern reasserted itself elsewhere. The previous spring, Paul even struck her during an argument over a party she had held during his absence in their room at the Chelsea Hotel. Instantly horrified by his action, which reminded him of his abusive father, Paul begged Jane's forgiveness, and she was quick to forgive him. But, although their marriage continued with its former expressions of personal devotion, Jane was afraid to spend much time alone with Paul and refused to continue sexual relations with him.

Now, Jane appeared to be abandoning Paul, not physically or sexually, but in the realm of her creative imagination — sharing her ideas and experiencing her creative development with Auden instead. This felt to Paul even more threatening than a romantic affair. His resentment over Auden's perceived intellectual seduction of his wife mixed, as he lay brooding in bed, with residual anger over his banishment to the basement with his piano and with his characteristic resentment of the kinds of rules Auden had tried to impose on the household.

As soon as he was able to stagger downstairs for meals, Paul began to fight back against this authority figure who had interfered with his marriage, his work, and his personal life. Reenacting his adolescent rebellion against his father, he began baiting Auden at every opportunity — offering, for example, a Stalinist interpretation of every topic of conversation that was introduced in defiance of the rule against political discussion. Paul also objected loudly and frequently to Jane's increased drinking as well as to her new habit of taking Benzedrine tablets, like Auden, to increase her productivity. Auden and the others around the table soon learned the truth of Gertrude Stein's remark, made years earlier in Paris, that Paul Bowles was "delightful and sensible in summer but neither delightful nor sensible in winter." This pattern continued, particularly when he was sick and on a deadline, and feared losing his wife's allegiance.

All of these pressures — the approaching deadline for *Paul Bunyan,* the bleak war news and the criticism from England, the disturbing presence of the Dalís and the rest of the mixed group surrounding the Bowleses, and now the annoying, gadfly behavior of Paul — proved nearly too much for Auden that spring. Even the weather seemed designed to break his concentration as temperatures swung wildly between a bitter chill and the kind of sweltering heat that he happened to particularly loathe. Worst of all, it appears likely that Kallman chose this time to tell Auden of his affair with Jack Barker.

Kallman was never one to avoid an opportunity for drama when it presented itself. As Barker himself later wrote, "It was Chester's nature to create jealousy, misery, and rage in his lovers. He would cuckold them to their faces." Certainly, he made it difficult for Auden to continue to blind himself to his betrayals. And this last betrayal seemed, by all appearances, a final one. Chester Kallman, a Brooklyn student who had al-

ways privately considered his affair with the famous poet "utterly fantas-
tic," had chosen to end the fantasy and begin his real life.

But to Auden the relationship was more than a fantasy — more than
a love affair. It was the basis on which he had begun to build a new
way of thinking and an entirely new direction in his creative work. This
new direction, in turn, was his justification for not having returned to
serve in England and his private defense against the barrage of criticism
from both enemies and friends. For the past few months, "marriage" to
Kallman had become, Auden believed, the only path through which he
could ever hope to achieve spiritual salvation — a belief bolstered and in-
formed by his deepening friendship with Reinhold Niebuhr.

Auden simply could not imagine losing Kallman, and his lover's be-
trayal threatened to destroy him. As the time leading up to the premiere
of *Paul Bunyan* turned from weeks into days and the rush to compose
songs, complete the score, and make other last-minute adjustments grew
more frantic, Auden lashed out at the person in the house he considered
the most expendable.

Coming across Paul Bowles in an upstairs corridor one evening, Au-
den paused and announced casually, "I shall be requiring your room over
the weekend." Paul, taken aback, replied that he was still weak from the
measles and flu and had intended to stay in bed that weekend. As though
he hadn't heard, Auden insisted, "I have a friend coming from Michigan
and he will go into your room."

As Auden continued down the stairs, Bowles, incensed, remained
where he was. Of course, Auden knew he had kept his studio around the
corner from Middagh Street, but it was unheated, and the composer was
too ill to stay there. This unwarranted eviction, coming from nowhere,
Bowles felt, was just like the attacks from his father that he had sworn he
would never experience again. Running down the stairs, he confronted
Auden and said he had no intention of leaving the house — he was not
giving up his room for anyone, for any reason. At this, Auden went very
white, hesitated, then turned on his heel and stormed out of the house,
slamming the door violently behind him.

As promised, Bowles did not leave the house for a moment that week-
end. He remained defiant, challenging Auden's authority whenever the
opportunity arose. The feud between the two men continued for some
days, to the extreme discomfort of the rest of the household. George
Davis backed Auden's decision, however, and in the end Paul and Jane

Bowles had no choice but to move out. The rupture was as complete as it was unnecessary. Closely as Paul Bowles and W. H. Auden would circle each other in cultural arenas for the rest of their lives, they did not speak again for twenty years.

"Many people have the experience of feeling physically soiled and humiliated by life," Auden had written in his review of Roethke's *Open House* that winter: "some quickly put it out of their mind, others float narcissistically on its unimportant details; but both to remember and to transform the humiliation into something beautiful . . . is rare."

For more than a decade, Auden had tried to transform his own daily "humiliations" into something worthwhile — to evoke and analyze his sometimes amusing, sometimes difficult, but always human development in poetry and prose. But now, for the first time since he had begun writing poetry at the age of fifteen, he was unsure how to proceed.

In the final days before the opening of *Paul Bunyan,* Auden added some lines to the end of Act I — a good-night speech for the mythical giant to deliver to his people. "For the saint must descend into Hell," Bunyan intoned, "that his order may be tested by its disorder." And he added, as the people of America drifted off to sleep:

> Dear Children, trust the night and have faith in tomorrow,
> That these hours of ambiguity and indecision may be also
> the hours of healing.

Then Auden found he had nothing more to say. For three months — April, May, and June of 1941 — the poet who claimed that "unless I write something, anything, good, indifferent, or trashy, every day, I feel ill," failed to complete a single poem.

9

Joseph, Mary, pray for those
Misled by moonlight and the rose . . .

— W. H. Auden, "For the Time Being," 1941–42

One day in April, seventy-five thousand tea bags drifted down from the sky onto the fields and cities of occupied Holland. Dropped by Britain's RAF forces, they carried the message "Holland will arise. Keep your courage up."

In the cool, breezy days of a Brooklyn Heights spring, it seemed possible to hope for an upturn in one's personal fortunes as well. Neighborhood children, cooped up all winter, exploded out onto the sidewalks and into the blooming gardens and parks. Their shrieks and laughter, carried on the sea air past Benjamin Britten as he hurried from Middagh Street to the subway station, may have spurred memories of his own happy childhood in the seaside fishing village of Lowestoft, in Suffolk.

Britten always felt most homesick for England in the spring, but this year he had little time for nostalgia. The premiere of his *Sinfonia da Requiem* at Carnegie Hall had gone well, with an appreciative audience and a national radio broadcast, although it received scant critical attention. A brief reference in the *New York Herald Tribune* called the symphony "promising and frequently eloquent"; the *New York Times* merely mentioned that the performance had occurred.

Britten, however, continued to believe that the symphony was his best work yet. He had been further encouraged to learn that an April performance of his *Violin Concerto* by the London Philharmonic — the first British presentation of his new work in nearly a year — had enjoyed even greater success. The praise he received for a concerto composed in Amer-

ica might surely serve as a good omen for *Paul Bunyan*'s future. Privately, Britten had to acknowledge that the opera needed all the good omens it could get. With opening night just days away, he had only recently completed the music for the Narrator's between-scene ballads — by inviting the actor over to 7 Middagh Street and knocking out a lead sheet for him on the spot. Even now, each rehearsal brought forth a deluge of suggestions — for new cuts, additions, or improvisations — as cast and crew struggled to complete their work in a short time.

Somehow, despite the chaos, a poster had been designed, a program printed, and Auden had even submitted an essay, "Opera on an American Legend," describing the challenges of portraying the Paul Bunyan story onstage, to the *New York Times* for its May 4 Sunday edition.

"Everything in this country is valued by publicity. God, how I hate it all," Britten had written to a friend the year before. "I always make a resolution never to attend any more first performances — it is terrifying, & I make everyone all round me uncomfortable, by feeling sick, having diarrhoea, & sweating like a pig!" But on the night of the preview, he joined the sizable audience at Brander Matthews Hall along with Auden, Pears, the Mayers, and an assortment of other friends. The audience seemed eager to hear what Britain's most famous young poet and one of its most promising new composers had to say about their country. The first notes of Britten's magnificent Prologue made a promising beginning as the curtain rose on the Chorus of Old Trees:

> Since the birth
> Of the earth
> Time has gone
> On and on:
> Rivers saunter,
> Rivers run,
> Till they enter
> The enormous level sea
> Where they prefer to be.

From this hymnlike beginning, the opera carried its audience on America's mythical journey, from the appearance of the Blue Moon that signaled Paul Bunyan's arrival to the importation of ambitious lumberjacks from Europe's hinterlands, to the tilling of the land and the creation of cities, corporations, and government organizations that typified modern American civilization. To Britten's and Auden's relief, the audi-

ence seemed to appreciate the opera's exuberant style, laughing frequently at Auden's silly jokes and satirical jabs and applauding Britten's solo compositions. Despite the occasional bungling of the underrehearsed cast and the awkwardness of the university stage, the overall performance managed to convey both the creators' fascination with America and their concerns for its future. Britten could already see that some cuts needed to be made even before the next day's premiere, but if the audience's response was any indication, there seemed reason to hope that *Paul Bunyan* would survive its initiation. Britten and Auden received congratulations after the show and awaited the critical response.

The critics were not kind. Olin Downes, the much-feared music reviewer for the *New York Times,* acknowledged in his review on May 6 that the opera was burdened with amateur singers and insufficient time for rehearsals. Nevertheless, he wrote, while Britten was "a very clever young man, who can provide something in any style or taste," his work in this case was disappointingly shallow and inconsistent. "As for Mr. Auden, we had expected better of him," Downes continued. While one may not expect an English poet to inject a very American tone into the Paul Bunyan legend, "we had a right to hope for something from him that would have a consistently developed purpose. Whereas his libretto, like the music, seems to wander from one to another idea, without conviction or cohesion . . . It seems a rather poor sort of a bid for success, and possibly the beguilement of Americans."

The comments of Virgil Thomson, Paul Bowles's friend at the *New York Herald Tribune,* were even more negative. In a review headlined "Music-Theatrical Flop," he wrote that "'Paul Bunyan' has, as dramatic literature, no shape and very little substance . . . it exists, if at all, by style alone. How much the Auden style is worth on paper is a question this reviewer leaves willingly to the literary world. On the stage it has always been a flop. It is flaccid and spineless and without energy." Britten's work was "sort of witty at its best," Thomson wrote. "Otherwise it is undistinguished." But, he added acidly, "What any composer thinks he can do with a text like 'Paul Bunyan' is beyond me. It offers no characters and no plot. It is presumably, therefore, an allegory or a morality; and as either it is, I assure you, utterly obscure and tenuous . . . I never did figure out the theme."

Certainly, the opera needed work, but the critics' negative judgments, Thomson's in particular, appeared out of proportion to the production. Perhaps the reviewers were unaware of *Paul Bunyan*'s lengthy, circuitous

development from school production to Broadway extravaganza to ama-
teur college production — and so were insulted by its ingenuous, some-
times even adolescent "American" tone. Whatever the reason behind the
attacks, they effectively killed Britten's and Auden's hopes for a Broadway
production. There was some talk of refashioning the opera for a perfor-
mance at the Berkshire Music Festival at Tanglewood that summer, but
these plans, too, came to nothing.

Most disappointing for Britten was that this initial, headfirst dive into
the American musical theater — a genre he had long admired and to
which he had hoped to contribute — had been interpreted as derivative, a
shallow mimicry of such composers as Blitzstein, Copland, and Weill.
Again, he was being censured for his adaptability at the expense of a
strong individual style. It was the very type of comment he had hoped to
leave behind in England.

George Davis, who had recently taken a new assignment as theater
critic for *Decision,* may have been seeking revenge for this insult to his
housemates when he attacked two new plays for which Paul Bowles had
composed the music, even though both plays had already closed. *Liberty
Jones* was a "lisping, whimsical stinker of a play that should have been
booed and booted out of a miserable, peaked existence on its opening
night," he wrote, and the *Twelfth Night* revival was "almost deliberately
inept." Bowles had also provided the music for Lillian Hellman's new
Watch on the Rhine, which received rave reviews, but George wrote,
"There were panicky moments for me . . . when I might have found no
word for the horror and cruelty of life, when my soul might have paused
agonized and silent; but in the nick of time there were words aplenty, oh
yes . . . No, I'll stick to my guns; I'll see no masterpiece in 'Watch on the
Rhine.' As theatre, it passes, as they say, the time."

If these were intended as personal attacks, they missed their mark.
Paul and Jane Bowles were long gone, having landed on their feet with a
$2,500 Guggenheim grant awarded to Paul for composing a first opera.
Virgil Thomson had also offered Paul a job as the assistant music critic
on the *New York Herald Tribune* — a position he would soon accept. But
for now, with *Pastorela* finished and a bank account filled with grant
money and theater income, he was preparing to return to Mexico with
Jane. Although she would revise her novel considerably before it was fin-
ished, her time at 7 Middagh Street had given her the confidence she
needed to proceed with the work. Meanwhile, Paul continued to develop
his own reawakened ideas regarding fiction. Over the next five years, he

published a series of experimental short stories, usually featuring characters in a state of psychological disintegration, before finishing his first novel, *The Sheltering Sky*.

Regarding *Paul Bunyan*'s critics, Elizabeth Mayer advised Britten from Long Island, "Let them stew in their own juice, and go on working." The young composer did his best to comply, discussing with Auden ways to strengthen the opera's dramatic line in case of a second production. But these discussions soon petered out; Auden seemed distracted — dogmatic in the extreme, as one observer remarked, and "full of ideas about moral character and what-not" — and Britten was utterly exhausted. *Paul Bunyan* had required more time and energy than he had ever anticipated, and the negative response had sapped his remaining strength. As an artist who was always highly sensitive to criticism, he felt publicly shamed by these bad reviews in a country not his own — nearly as "physically soiled and humiliated by life" in his own way, perhaps, as Auden had felt the month before.

Britten continued to go through the motions — performing a two-piano recital with Colin McPhee and traveling to Long Island to conduct a series of concerts by his amateur orchestra. But it was clear that he had reached his emotional limit the evening he stepped onto the stage of the Suffolk County concert hall to find a nearly empty room — the audience significantly smaller than the orchestra they had come to hear. Britten's host, David Rothman, later recalled that Britten's eyes filled with tears at this show of American apathy to Europe's musical culture. A moment later, however, he turned his back on the room, faced his enthusiastic little orchestra, and raised his baton.

As was often the case during Britten's stay in America, Peter Pears provided the consolation and hope that he needed to go on. In May, Britten conducted *Les Illuminations*, his settings of Rimbaud's poems, for broadcast over CBS Radio. It was a particularly important event for both musicians, serving as the American premiere of the song cycle as a whole and as Pears's first public performance of the work after a winter of preparation. A surviving recording demonstrates that by now Pears had begun to develop the unique sound and vocal technique that eventually made him one of Britain's best-known singers. These qualities, springing forth naturally from his personality, particularly suited Britten's emerging style.

Despite the disappointment of the Long Island concerts, Britten still relished the opportunities to spend time with the Rothmans and, as the weather turned warmer, to join them on weekend outings to the beach.

The windy coastline near Montauk, at the tip of Long Island, reminded Britten of Aldeburgh, Suffolk, an old fishing village not far from his childhood home. Like Montauk, Aldeburgh was dominated by shrieking seagulls and roaring waves, and its traditions were rooted in many generations of fishermen's culture. Shortly before leaving England, Britten had bought and restored an old mill house in Snape, a quaint old village down the road from Aldeburgh, and set up a studio in its small tower. He had loved the peace and isolation of his country home and enjoyed his long walks through the surrounding marshlands, but his heart lay with the fishing boats and rattling shale beaches of Aldeburgh.

Now, walking along the beach as the Long Island fishing boats returned to shore, Britten reviewed the events of the previous hard winter. In retrospect and with Pears's sympathetic agreement, he could now admit to himself that the sort of wild ride on which Auden had taken him was not his style. As sincerely as he admired Auden's intellect, awed as he was by his enormous talent, Britten simply did not want to create operas by racing to catch up with a manic librettist and then jamming bits of music and lyrics together at the last minute to try to build a coherent story. Nor did he want to presume to interpret the history of a country he hardly knew, much less understood. Most certainly, he was no longer prepared to live in the state of ridiculous squalor into which 7 Middagh Street had fallen. Pears, who had worked double shifts through the winter, copying out parts for the opera in addition to his own musical activities, reinforced Britten's growing sense that it was time to find a new direction.

Change presented itself in the form of an invitation from Rae Robertson and Ethel Bartlett, the pair of British pianists who had performed some of Britten's work that year, to spend the summer with them in their cottage in Escondido, California. The couple, whom Britten and Pears privately called "the little Owls" for their comically small stature, seemed amiable enough and certainly unlikely to impose their personal foibles on Britten and Pears, as the residents of 7 Middagh Street had done. Pears, knowing that Britten had hoped to compose for Hollywood films when he arrived in America, pressed for the visit, and Britten soon agreed that it seemed a good idea. After all, Isherwood — another pacifist — seemed to have created a stable life for himself on the West Coast, with a studio contract to boot, as had Aldous Huxley. Even Thomas Mann had left Princeton and joined the western expatriate colony that spring, accompanied by his brother Heinrich and other members of his large fam-

ily. When Britten received a commission from a California patron to compose a string quartet for performance in Los Angeles in September, the visit to California seemed preordained.

At the end of May, as President Roosevelt delivered another Fireside Chat in which he continued to vacillate on the issue of war, and as U-boats continued to sink ships in the Atlantic and bombs continued to fall on England, Britten and Pears said good-bye to the bedbugs of 7 Middagh Street — and a friendly good-bye to a dispirited Auden — and set out for California in an old Ford V8. Perhaps they would find the fulfilling work they had hoped for out west. After all, as became increasingly clear on their cross-country trek through Virginia, Tennessee, Oklahoma, and the Mojave Desert, this was America, and anything could happen.

"We meant to tell you to take the bottle of Château La Tour which was sitting in the clothes closet at Middagh Street," Pears wrote to Elizabeth Mayer from the road. "Perhaps Wystan will have found it. If not, drink it together when you are next with him." Mayer, bereft at having lost her surrogate sons to Hollywood — along with her real son, Michael, to the draft — was eager for any excuse to spend time with Auden. But she was distressed to find, when she stopped by to collect the clothes, papers, and other belongings that "her boys" had carelessly left behind, that the house that had been bursting with activity a few months before now appeared virtually abandoned as summer approached, almost as dilapidated as when George Davis first discovered it. Auden was, as always, glad to see Elizabeth and willing to discuss his latest projects — including, this month, a review of de Rougemont's *Love in the Western World*. But while to new acquaintances, such as the *New Yorker* poetry critic Louise Bogan, Auden could still provide "a grand evening crammed with Insights and Autopsies and Great Simple Thoughts and Deep Intuitions," Mayer knew the poet well enough to worry over his new air of weariness and distraction. That month, he had delivered a lecture at the University of Michigan, "The Loneliness of the Individual," standing before the packed auditorium in his wrinkled white linen suit, his accent so thick that the students couldn't understand a word. And for once he offered no new poems and no amusing asides for his audience to repeat and savor.

George's mood seemed to echo Auden's as the weather in Brooklyn turned warm. "I do become terribly depressed, especially in the spring,"

he had once written to his parents. "Oh, you understand, when everything seems new, and accomplishment is far below ambition." By June, he had given up any remaining expectation, or desire, to return to a full-time position at *Harper's Bazaar*. Even his freelance commitments brought him into frequent conflict with the day-to-day demands of magazine production, and though George and Carmel Snow continued to respect each other's talents, George had become convinced, as he wrote to Gypsy, that "she wants me . . . only if I crawl back, and take my drudgery henceforth and like it." As that was not a situation Davis would accept, Mary Louise Aswell's name appeared as fiction editor in the magazine's June issue. George intended to look for a job elsewhere in a few months. Now, however, a new influx of old friends was expected from Europe — including the writer Kay Boyle, the heiress and editor Nancy Cunard, and the artists Marc Chagall, Jacques Lipchitz, and Max Ernst — and George was busy with plans to entertain these new refugees on Middagh Street. He was also tending to Carson McCullers, now back in New York but preparing to depart for a summer at Yaddo, the artists' colony in Saratoga Springs, New York.

Carson had returned to the city with Reeves in April, her health still precarious and her nerves on edge. At first, she had tried to live again as Reeves's wife in the apartment on West Eleventh Street. Both partners hoped that, now that Reeves had found a job and Carson's work was going well, they could reestablish a good relationship. But it did not take long for them to return to the habits of the previous summer. Reeves was still drinking heavily, and Carson had begun treating her cough with cough syrup containing codeine — even as she continued to sip sherry throughout the day and indulge a new taste for bourbon in the evenings. As a result, their arguments began again, punctuated with cruel taunts and occasional outbursts of violence. By May, they had retreated to separate beds, and Carson had announced that she would no longer have sexual relations with her husband on the grounds of ill health. At the same time, she frequently went out alone at night, sometimes failing to return until the next day. Reeves began going out as well, cruising the bars for new partners.

In the midst of this turmoil, Carson was introduced by her friend Muriel Rukeyser to the composer David Diamond. Carson, in awe of all composers, was drawn to Diamond as she had been to Britten — but in this case a personal chemistry manifested itself and the two initiated a friendship that quickly intensified. Carson was pleased when Diamond,

sensitive, romantic, and only twenty-five, gave her the ring that he happened to be wearing the first night they met. She was less pleased when he appeared to be attracted to Reeves as well.

This pattern had already established itself with Annemarie Clarac-Schwarzenbach the summer before: Carson sought relief from her marriage in an intense infatuation with another artist — and was once again overcome with jealousy as the object of her love also formed a friendship with Reeves. With a new prize to fight over, Carson and Reeves's battles grew more vicious, leaving the gentle Diamond to wonder what he had stepped into as he struggled to make peace between them. Janet Flanner, a friend of the composer's as well as Carson's, advised Diamond to avoid them during this period of mutual destructiveness. But Diamond seemed irresistibly drawn to the triangular friendship, even as his new friends' alcoholic life encroached on his own productivity.

As before, Carson fled to George Davis for comfort. Despite the subdued atmosphere at Middagh Street that May, it was refreshing to spend time again with the group whose work was now appearing, almost as a unit, in the pages of *Harper's Bazaar* and *Decision*. If the "we of me" sense of communion that Carson craved was difficult to maintain with Diamond and Reeves, she could always experience it by sharing a cocktail and a cigarette with George Davis, Auden, and Klaus Mann at the table in the overgrown rear garden at Middagh Street. It was comforting to listen to George affectionately prod Colin McPhee to stop worrying about his block against writing music and instead to write a book about the amazing life he had experienced on the island of Bali. George had already noted McPhee's stylish and perceptive writing in the many pieces of music criticism that the composer had written for the American journal *Modern Music*. George believed that his account of having built and lived in a traditional house in an idyllic Balinese village would attract a respectable readership and might even increase interest in McPhee's real obsession, Balinese music. The composer "huffed and puffed" when George pushed him on the issue, but the encouragement persuaded McPhee to apply for and win a place at Yaddo that summer along with Carson.

Carson was pleased, too, to learn that Klaus Mann had reviewed her novella *Reflections in a Golden Eye* in the same May issue of *Decision* in which Gertrude Stein's *Ida* and Auden's *Double Man* were discussed. Klaus had in fact created for his review a delightful imaginary dialogue between young Carson, "capering about like a nervous imp," and the

"well-preserved aunt" Gertrude Stein, carried on as they strolled together through the "amazing scenery of their capricious imaginations." In this fictional exchange, Carson, "wavering and intense, oversensitive, savage, charming and corruptible," paused during their walk and whispered, "The air is full of sordid mysteries" — at which Stein advised her to stop trying to appear sophisticated and to stick to writing "about savage things. New things. Sad things . . . American things. Not this nineteenth century stuff. With the garden shears! Many things happened to [my] Ida. Dear Ida. But nothing *that* ridiculous. Naturally not." Klaus made sure that his fictional Stein concluded with the advice: "You'd better be careful, or you will go astray . . . You are a poet, Carson McCullers. So if you destroy yourself, you destroy a poet. You deprive the twentieth century of a bit of poetry — if you destroy yourself."

Many of Carson's friends had begun to worry a great deal, particularly after her stroke, about her continued heavy drinking and irregular habits. But her only hope of escaping such self-destructive behavior lay in writing, and at 7 Middagh Street she could at least find the creative encouragement that was missing in her Manhattan home. That late spring and early summer, Carson drew much closer to Oliver Smith, her Brooklyn "younger brother" — climbing the stairs to the light-filled attic studio he had created when not preparing for an exhibition of his paintings in the city. At one end of the small rectangular room with its steeply pitched ceiling, Smith had installed a large semicircular desk, bequeathed to him by a distant ancestor, Henry James; the area at the other end near the window was dedicated to his watercolors and set designs.

Already, it was possible for the twenty-four-year-old Carson, who had experienced a first burst of fame, a marital separation, a scandalous second publication, and a major stroke all in the past year, to look on the poor but ambitious Oliver Smith with a certain fond nostalgia. While she admired the white china dishes on which the young artist mixed his paints and the watercolor designs he was creating for every play currently on Broadway, he entertained her with stories of his childhood and his early years in New York. Smith had spent his youth obsessively poring over floor plans and creating improved layouts for famous houses, hotels, and theaters. He remembered a time when he was twelve, accompanying his mother as she drove his nineteen-year-old cousin, Paul Bowles, to Yaddo for a stay arranged by Aaron Copland. Oliver had taken one look at the beautiful, turreted, gray stone Victorian mansion and cried, "Oh, Mother! I wish I were Paul." Outraged, his mother dragged him off

immediately. But now, in Brooklyn, no one minded if Oliver designed his own miniature palace at the top of the house — and he did not have to wait to be hired before realizing his vision.

Carson adored his stories and also appreciated Oliver Smith's knack for giving her the kind of attention she craved. The two talked at length that spring about *The Bride and Her Brother,* which Carson felt had reached a critical point in its development. His influence proved critical to her ability to progress with the story once she had settled in at Yaddo. Smith had extended the same kindness to Jane Bowles, suggesting that with her gift for dialogue she had great potential as a dramatist. "Someday I'll give you money to start writing a play," he had told her — and two years later he kept his promise, coproducing her play *In the Summer House.*

Smith's enthusiasm for art, theater, literature, music, and ballet, and his talent for acting as "an island of calm in the sea of temperament," allowed him to serve as a lively cross-pollinator among the other artists at 7 Middagh Street. That spring, he initiated or maintained friendships with the painters Eugène Berman, Pavel Tchelitchew, and Salvador Dalí at the Brooklyn house, became a favorite of the circle of dancers surrounding Lincoln Kirstein, and with the help of George Davis began doing illustrations for *Mademoiselle.* "When you're starting out, you have a wonderful time," he later remarked about this period. "It's like a series of great restaurants. You try a little bit and have fun with this period or that architect. Like a child in a cafeteria, you eat everything in sight."

Since Smith happened to have taken his exam for the set designer's union in Hollywood with only one other applicant — Salvador Dalí — he may have especially enjoyed attending Dalí's exhibition that May. Billed as Dalí's "last scandal," the beginning of his classical period, the exhibition fooled no one. As reviews in *Decision* and elsewhere pointed out, Dalí had merely presented his usual quasi-surrealist work in antique frames, although the exhibition did serve as effective advertising for the artist's upcoming autobiography. The catalogue reproduced a page of the manuscript, along with the Daliesque teasers: "Can one remember one's prenatal life? Explained in the book. Why are these horrible cats' tails grafted upon breasts? Explained in the book . . ."

Certainly, Smith enjoyed — along with everyone else — George's accounts of Gypsy Rose Lee's progress with *The G-String Murders.* Throughout the spring, she had worked to complete the revisions while starring in several shows a day at Todd's Theatre Café. Gypsy's editor, Lee

Wright, had taken over where George had left off, commenting on the manuscript as Gypsy wrote it. "I loved your notes," she wrote from her dressing room that May. "I was reading along and saying to myself, 'I like this chapter fine,' and at the end I'd come across, 'What happened to Jake?' in your hand-writing. Hurt me ego . . . that's wot."

A hitch in Gypsy's plan had occurred when the Mafia moved in on the Theatre Café in late spring, offering Todd a "partnership." Rather than get involved with the mobsters, he sold them the club for a dollar and took his and Gypsy's names off the marquee. Gypsy then lent Todd the money to take their elaborate *Gay New Orleans Review* on the road — staging three shows a day, six days a week, in Milwaukee, Toledo, San Francisco, Detroit, Atlantic City, and other cities across the country. Even while touring, Gypsy never stopped writing, and by June she had completed the manuscript. Within days, *Variety* reported that Metro-Goldwyn-Mayer had bid for the movie rights to the book. A Broadway production was also being discussed, but Gypsy claimed that if it were staged, she would not play the lead role. "Why should I?" she asked reporters. "I'd be a dope to play for $350 a week the part of a Chicago strip-teaser when I can *be* the Chicago stripper for $2000."

"Does this sound good for a dust jacket: a picture full length of a stripper?" she wrote to her editor. "Semi nude. The G String actually silver flitter. (Very inexpensive, that flitter business.) And a separate piece of paper pasted on as a skirt, like birthday cards, you know? The customers can lift the skirt, and there's the G-string sparkling gaily. It is strictly gag business but it might cause talk." Now that *The G-String Murders* was complete, Gypsy began to think about a sequel. Within the month, she started writing *Mother Finds a Body,* finding, thanks largely to George's tutelage, the second novel much easier going than the first. For the rest of her life, in fact, Gypsy relied on writing as a fulfilling outlet for her creativity, second only to her work as a performer.

Glad as Carson was to spend time with her friends, she was due at Yaddo by mid-June. As the summer heat intensified, the Brooklyn house emptied of many other visitors and lodgers as well. Colin McPhee had left for Saratoga Springs at the same time as Carson. Lincoln Kirstein — who had recently surprised everyone by marrying, despite his homosexuality, the sister of the artist Paul Cadmus, Fidelma — left with his new American Ballet Caravan on a South American tour. Paul and Jane Bowles had returned to Taxco, Mexico, to be joined by Oliver Smith, who was eager

to turn his back on "that long, hard winter working at awful jobs." George Davis departed on one of his periodic cross-country jaunts in which he was liable to turn up unexpectedly on a friend's or relative's doorstep with a stray cat, dog, or human companion in tow.

Klaus Mann returned to his room at the Bedford Hotel in Manhattan, tied to his work for *Decision*. The past few issues, he felt, had been among the best, and his hopes were rising that the journal would not only help new refugees but would lead to real change in the world as cultural leaders and government officials responded to the challenges in its pages. To his frustration, however, at the same time that he saw such positive results, the funding for the journal had begun to run out. Several major backers did not come through, and the income from subscriptions was not sufficient to cover the operating costs. Klaus had always paid his writers according to need rather than a set standard, but by April he was forced to renegotiate lower payments even to those writers who had no other income. The budget for the May issue did not even allow Klaus to pay himself a living wage, and he found himself, at thirty-four, having to write to his mother at her new home in California: "The other drop of bitterness is that I — it really can't be helped, it is very distressing to me — must ask for some money: two hundred dollars, I can't manage with less."

Asking his parents for money was especially depressing, for Klaus Mann had hoped to finally overcome his reputation as the privileged son, the moody dilettante, the invisible younger sibling of the dynamic Erika Mann. For the past year, he had worked feverishly to facilitate the safe transplantation of European culture to the fertile new soil of America. Yet the people he now approached for financial help seemed to believe that *Decision* had made its promising start more in spite of Klaus than because of him. More than one potential investor implied that Klaus was unable to manage *Decision* on his own — Klaus, who had conceived the idea of a journal for émigré artists, who had single-handedly raised the funds, and who had worked night and day for the past eight months to turn it into a tool for merging two disparate democratic cultures. Max Ascoli, the esteemed Italian émigré journalist now teaching at the New School, offered to help raise more money and contribute funds himself if Klaus would create a formal business plan and meet with investors in a conference room rather than at "social gatherings" such as those at Middagh Street. Others insisted that Klaus's father participate more actively as collaborator and adviser, that Klaus take on an editorial partner,

or that *Decision* be merged with their own political organizations or refugee aid societies.

Klaus might have been less resentful of such slights if he had not now been entering his eighth year of exile, still living and writing in a foreign language and struggling each day against America's apathy toward his and other refugees' concerns. Nearly a decade of drifting from country to country, from hotel to hotel, had left him with a sense of living in "a social and spiritual vacuum; striving for a true community but never finding it; disconnected, restless, wandering; haunted by those solemn abstractions in which nobody else believes — civilization, progress, liberty." Every day constituted another struggle to make himself heard, to connect with others, but it was the constant small cuts that made life unbearable.

Previously, Klaus had managed to survive emotionally by drawing from Erika's phenomenal energy, but Erika had been gone for nearly four months. The only person Klaus saw now in New York was Muriel Rukeyser, whom he had recently appointed associate editor of *Decision*. Without her editorial help and emotional support, he admitted, he could not have gone on. But even she escaped to the country three days each week while Klaus remained, "paralyzed, as it were, by the demon of this fierce and relentless summer. At times I actually fear suffocation in the stifling hole that's my room."

It seemed to Klaus that summer as though he and all of the other weary exiles from Hitler's regime had reached the end of their productive lives, and that, cut off from the culture that had sustained them, nothing more lay ahead but hardship and isolation. It was not surprising, somehow, that two of the three greatest innovators from that earlier age — James Joyce and Virginia Woolf — had perished since the year began. And recently, Sherwood Anderson, one of *Decision's* staunchest American supporters, had died in Panama. Numbly going through the motions, Klaus published a remembrance of Woolf by Christopher Isherwood in *Decision's* May issue, along with one of her early short stories. Reflecting on her death, he realized that he had lost more friends through suicide than through disease, crime, or accident. There had been several waves — the first one before the establishment of the Third Reich, the second after the invasion of Poland, and now a third wave as America teetered on the edge of war.

Klaus, too, was deeply attracted to the idea of suicide. "I've never understood why anyone should be afraid of death," he wrote in his diary,

"when it's only life that's so terrible." In earlier years, he had stifled the wish to end his life through the use of morphine, to which he remained intermittently addicted until his death. "My case is not pathological," he once told a doctor friend when discussing his dependence. "No doctor can cure me of the different things that weigh on me." Now he looked to world events for some reason — any reason — to find comfort. In mid-May, news had arrived that Rudolf Hess, Hitler's deputy, had parachuted out of his Messerchmitt 110 and landed in the village of Eaglesham in Scotland. When captured, he demanded to negotiate a peace plan with the British leaders, but Hitler repudiated the "deserter" and announced that Hess was suffering from a mental disorder. Was this desertion of one of the "Devil's stooges" just another symptom of the world's insanity, Klaus wondered, or could the flight of Hitler's "dearest friend [with his] red-painted toenails, the pockets of his uniform full of narcotics and photos," be a first sign that the Third Reich was crumbling?

Then, at four o'clock on the morning of June 22, Hitler invaded the Soviet Union in a blatant grab for the Soviet oil needed to fuel Germany's expansion. The attack came without warning and in spite of a non-aggression pact signed by both Germany and the USSR. The Russian population succumbed to mass panic even as Molotov shouted over the airwaves, "This incredible attack on our country is an act of treachery unequalled in the history of civilized nations."

Like the events of the previous summer, disasters followed one upon the other in numbing succession. As Italy, Romania, Slovakia, Finland, Hungary, and Albania joined forces against Russia, parts of Byelorussia, Lithuania, and the western Ukraine were lost. Japan, meanwhile, called up more than a million men for military service and ordered all its merchant ships in the Atlantic back home.

In California, Christopher Isherwood wrote in his diary, "Try to avoid negative emotion." But he had had a nightmare of returning to London. "The houses were smashed, but only the top floors . . . so many ruins you could see a hill in the distance . . . In the newspaper, an advertisement in fake Elizabethan language for seats in a fighter plane to take part in an air raid. Woke with enormous relief that I'm still here."

Klaus Mann, too, listened to the news with the strange sense that it was all a dream. "Hitler's attack on Russia is an event of such staggering implications that I don't dare to gauge them," he wrote that week. Yet "my spontaneous reaction is one of relief, rather than of dismay or apprehension. The air has become purer. The story of a colossal lie has finally

reached its end." It was now clear to everyone, at last, that Hitler would never keep a promise to any nation, that no country on earth could feel confident of remaining untouched by his greed. As Churchill acknowledged over the airwaves, "It is not too much to say here this summer evening that the lives and happiness of a thousand million additional human beings are now menaced with brutal Nazi violence."

At the same time, it was conceivable that Hitler's grasp had, in this case, exceeded his reach. It was a military truism, wasn't it, never to attack Russia? Churchill warned against the probability that, with the Soviets in hand, Hitler would launch a full-scale invasion of Britain before winter. For this reason, despite his government's "revulsion" against communism, Britain would come to Russia's aid. And if the USSR managed to resist long enough, Hitler could find himself pinched between these two great powers until the United States took advantage of the opportunity to step in and administer the fatal blow. Yes, it was a crisis, Klaus believed, but perhaps it was also the beginning of this terrible war's end.

This thought alone was almost enough to pull Klaus out of his despair. Even on the summer nights when New York had become "a parched and dusty inferno," with heat "so dazing that one can hardly breathe," he began to feel again the impulse to transform his experience into art. Wandering alone through the streets of Manhattan, he found that once more he enjoyed being "all alone in the midst of a sweating, easy-going, weary, and sensual crowd." He wrote, "I relish those sultry evenings when the vast masses of towered stones seem to exhale the accumulated glow of the day like tremendous stoves. I do not long for lush meadows, cool mountain valleys, and the salty breezes from the sea. It gives me a grim sort of pleasure to loiter around Times Square on a torrid August night. I do not seek company."

The return of his creative impulse was a godsend for Klaus, but he did not feel ready, in that time of flux, to attempt a work of fiction. "Can a novel be completely serious, completely sincere?" he wrote. "Perhaps. But I do not want to write one; not now, not at this hour. I am tired of all literary clichés and tricks. I am tired of all masks, all hypocrisy. Is it art itself that I am tired of? I don't want to play any more. I want to confess."

To confess — thereby ending one part of his life and beginning another. Klaus decided to write the story of his life as a young man in exile, to "tell the truth, the whole truth, and nothing but the truth . . . To tell my own story, not despite the crisis, but because of it." His account of the

life of a dislocated outsider, he believed, would be "at once unique and representative. Limited in its scope and molded by specific conditions; and yet full of infinite suggestions, transcending the range of its own problems and objectives, pointing to potentialities far beyond its empirical margin." And he would call his story *The Turning Point*, because

> it is from the turning point that we should examine the path we have covered. In measuring its serpentine curves and paradoxical zigzags, we may learn something as to the next step to take. For one thing is certain at least, in the midst of so many staggering uncertainties: the next step will carry us into new land with landscapes and conditions as they have never been seen before. Nobody can foretell whether things will be worse or better in this transformed world to come. The horizons which, from now on, will surround our lives may be brighter or darker than the skies we knew. But surely the light will alter.

Auden, too, had remained in the city that summer, despite the kind of heat that prompted him to remark of America some time later that "Nature never intended human beings to live here." He could be grateful, nevertheless, to be at home at all that summer: he had been ordered to report for American military duty on July 1, but at the last moment his appointment was postponed.

In the wake of Chester Kallman's betrayal and the disaster of the *Paul Bunyan* premiere — a failure that he regretted much more for Britten's sake than his own — Auden had to struggle to maintain his balance that summer. The absence of new poems had become a source of concern, as evidenced by his clipped response to a sympathetic inquiry from his benefactor Caroline Newton:

> Caroline dear, You oversimplify. Writing poems is not just a technical craft like making shoes, where the optimum conditions can be stated at once as light, tools, and unlimited leather. If I tried to live by the question 'what will help me most to write poetry?', I should never be able to write a line. All one has, are hunches about one's life as a whole. If the hunches are right, then it doesn't matter if one writes or not; if they are wrong, the most beautiful poem in the world will be no excuse. Love, Wystan.

The question that had infiltrated Auden's thinking that summer was whether the conclusions he had drawn from the past six months' activity were, in fact, wrong. The opportunity to review de Rougemont's *Love in the Western World* allowed him to reconsider his thinking about love as

one path to spiritual redemption, as de Rougemont analyzed the modern Western myth of passion as the misguided assumption that "only perfection is worthy to be loved." This erroneous idea sprang from a belief that matter was the creation of the Evil One, therefore all human institutions, including marriage, were corrupt. Only in death could humans escape matter and find perfection in the noncorporeal, according to this belief. And from it a reverse image was born of the Don Juan who believed that the material present was all and the immaterial afterlife a distant nothing.

Both versions, Auden pointed out, lacked any concept of the love object as a person, and both were essentially anathema to the Christian doctrine of agape, which dealt with the incarnation in the material world of the spiritual Word. It is in agape, this experience of God's love on earth, Auden wrote, that "we are delivered from the woe of being alive" and can achieve salvation. One way to arrive at a state of agape is through eros, that is, through the physical and spiritual love of a fellow human. Christian love leads to "an immediate reassertion, not of course of the old life, and not of an ideal life, but of our present life now repossessed by the Spirit."

The task, then, of human love, is "to actualize the possible," or to love in a way that opens one to a state of grace. This form of spiritual love can only be achieved "if the right decision is taken," Auden wrote, and "if any of the wrong decisions are taken, the result will be self-negation." To avoid this risk, many try to deny either the spiritual or the physical aspects of love, he added. Such crises of faith are inevitable. But there is a way to survive these crises intact — by following the rules of a Christian marriage, "which may not be either as absurdly straitlaced or as coarse as they once appeared."

It was how Auden worked through any emotional experience, no matter how painful or complex: through the saving mechanism of his intellect. As he pointed out himself so frequently, he was a Thinking and Intuition type, weaker in the areas of Feeling and Sensation, and so he learned from emotional experiences with more difficulty than most. His analysis of de Rougemont's book served as a necessary means through which he could begin trying to understand the disastrous turn in his relationship with Kallman. Surely, anyone could see that some bad "decisions" had been made in their marriage and that the result had clearly been his own "self-negation," in one sense, and Kallman's in another.

Kallman, however, had no intention of following any rules of mar-

riage, Christian or otherwise. Through the spring and summer months, he had continued to spend time at the house on Middagh Street, bringing along "friends," drinking through the night, and otherwise making clear his refusal to play along anymore with Auden's fantasy of spiritual and physical communion. It would have been difficult to find a less likely partner for a sacred marriage vow, in fact, as Chester refused to have sexual relations with his former lover, dropped all pretense of remaining emotionally faithful to him, and planned to depart in a few months for an independent life in Ann Arbor.

Still, wasn't that the basis of the myth that de Rougemont explored in his book, that "only perfection is worthy to be loved"? It was Kallman's bewitching imperfection that had attracted Auden in the first place — the mix of transcendence and devilry that epitomized the human condition. To love a young man like Kallman was to love humanity, and to accept him in all his inconstancy, ambition, cruelty, and anger was to "love one's neighbor as oneself."

Six months earlier, after Kallman's betrayal with Jack Barker but before Auden learned of it, he had written, "To be saved is to have Faith, and to have Faith means to recognize something as the Necessary. Whether or not the faith of an individual is misplaced does not matter: indeed, in an absolute sense, it always is." Back then, all of his talk of saints and salvation had been little more than a kind of playing at Christianity. His arbitrary choice of Chester Kallman as his path toward redemption had seemed easy and pleasant. Now, however, Auden had come up against a test of his commitment to moral action, set at the highest price he could imagine. Could he fully love Chester Kallman even as his lover turned away? Could he love him if they never touched, never spoke again? If the answer was yes, would his ability to do so lead to a higher consciousness — not only in this relationship, but in his relations with the world? And if the answer was no, then what other answer could he find?

One of the reasons Auden had moved to Middagh Street was his search for a place in which to work through just these kinds of questions. In rooms economical enough to allow him to focus on his best work, in a house filled with others in pursuit of the same goal, perhaps he could increase his chance of finding a solution to the question of how to choose the correct, moral action in a chaotic, immoral world. Seeking such answers required sacrifice. In the coming years, Auden would describe the artist's mission in his prose poem *The Sea and the Mirror,* a commentary on Shakespeare's *Tempest:*

And from this nightmare of public solitude, this everlasting Not Yet, what relief have you but in an ever giddier collective gallop, with bison eye and bevel course, toward the grey horizon of the bleaker vision . . . what goal but the Black Stone on which the bones are cracked, for only there in its cry of agony can your existence find at last an unequivocal meaning and your refusal to be yourself become a serious despair, the love nothing, the fear all?

Auden had sought the black stone, and at 7 Middagh Street he had found it — the moment of existential despair that came from too many drinks, too many accusations, too much squalor, and too much heat. Alone in the house in the dead of night that July, the poet and his lover succumbed to an exchange of shouted recriminations that ended only when Kallman reiterated his vow to end his relations with Auden and stumbled upstairs to collapse on the poet's bed and fall instantly asleep.

Auden remained downstairs alone, struggling with a desire to find Jack Barker and kill him. But Barker was at sea, while Auden sat smoking in the parlor and Kallman slept contentedly upstairs.

> Caught in the jealous trap
> Of an empty house I hear
> As I sit alone in the dark,
> Everything, everything,
> The drip of the bathroom tap,
> The creak of the sofa spring,
> The wind in the air-shaft, all
> Making the same remark
> Stupidly, stupidly,
> Over and over again.
> Father, what have I done?
> Answer me, Father, how
> Can I answer the tactless wall
> Or the pompous furniture now?

Louise Bogan recalled telling Auden that month about a man who broke into tears in a taxi, confessing to his traveling companion that he had a vestigial tail. "I shouldn't have minded a vestigial tail," Bogan said playfully to her friend. "No," Auden had replied, "one can always stand what other people have."

Auden had weathered George's managerial inefficiency, Carson's drinking and her marital woes, Gypsy's literary inexperience and remarkable restlessness, the Bowleses' irritating habits, and the critical lambasting of his friend, Benjamin Britten. But this last insult from

Kallman was too much. From childhood, Auden had determined to become a great poet. And only through the love of an individual, he had decided, could that transformation occur. The only person he had ever found whom he could love sufficiently was Chester Kallman. He did not expect Chester to be perfect, but he desperately needed him to remain present and involved, to allow himself to be used as a vehicle for transcendence.

Auden himself did not know what prompted him to leave the parlor after about an hour and climb the stairs to his room at the top of the house. Standing by the bed, looking down at Chester, Auden was overcome by a violent impulse. If he could not murder Jack Barker, he could kill Chester, or perhaps eventually both. While his lover slept, Auden put his thick fingers around Chester's throat and tried to strangle him to death.

What happened next was lost in the confusion of the moment. Chester awoke, realized what was happening, and either pushed Auden away with all his strength or ran away or laughed, rolled over, and went back to sleep. The attack was hardly frightening to a young man who courted violence in his sexual affairs. But for Auden, this intent to murder, even if it was not carried out, became a life-altering experience.

For the first time, after all his years of looking on the violence of the world and thinking through ways in which it might be defeated, he himself had experienced "what it is like to feel oneself the prey of demonic powers, in both the Greek and Christian sense, stripped of self-control and self-respect, behaving like a ham actor in a Strindberg play." No longer could he pretend to be appalled by, or not to understand, the urge toward violence behind the behavior of Gestapo jailers, book burners, or those who took pleasure in the humiliation and defeat of others. Later, still shaken but trying to come to terms with the experience, he remarked to a friend, "It's frightening how easy it is to commit murder in America. Just a drink too much — I can see myself doing it. In England one feels all the social restraints held one back. But here anything can happen." He had come to the land of infinite choice, and this was where it had led him.

During the next few days, Auden continued to move through the traditional stages of grief, from denial to anger and toward negotiation. Histrionic arguments gave way to pleading and bargaining for a place in Chester's life. But both men knew that he was now speaking from a com-

promised position. Auden blamed himself, not Chester, for their failed relationship. If he had not tried to impose his own aims and desires on his lover, if he had not bullied him intellectually and neglected him emotionally, if he had treated him less as an object and more as an individual with his own needs and destiny, none of this would have happened. Perhaps it was not too late to save the relationship. He could be Chester's friend if not his lover. All he asked was that Chester never leave him; that was the one thing he could not bear.

In mid-July, having traveled to Olivet College for a week's lecturing, Auden felt more depressed and lonely than ever before. "If I stay here any longer," he wrote to a friend, "I shall either take to the mysticism that Reinhold so disapproves of or buy a library of pornographic books." Conditions improved only marginally when he joined Chester for a visit to Caroline Newton's house near Jamestown, Rhode Island. Isherwood, whose contract with M-G-M had recently expired, traveled east to join them. If Auden was relieved to greet his closest friend, appearing as always fresh-faced and elegant after nearly a year in California, Isherwood was less pleased with the scene he found when he arrived.

"Caroline was a silly, snobbish, well-read woman with very little taste," Isherwood wrote in his journal, "often pathetic and kind-hearted. She was in love with Auden. The atmosphere was in the highest degree embarrassing." Most uncomfortable was the extreme tension between Auden and Kallman, which broke out periodically in loud arguments and passionate pleas that were impossible not to hear through the thin walls of their bedroom. "I had to keep going on walks, alternately, with the three others, to discuss the latest developments," he wrote. Kallman remained adamant about ending the relationship and was in fact scribbling desperate, longing notes to Jack Barker in his poetry notebook. Auden, for his part, "was in a difficult, strained, provocative mood, and kept attacking [Christopher's pacifist friend] Gerald [Heard] and talking theology."

Then a second disaster befell Auden. A telegram was delivered to the house by telephone — taken by Caroline Newton — that Auden's seventy-two-year-old mother had died in her sleep. Kallman was deputized to break the news to Auden. Despite the friction between them, he had the grace to deliver it with kindness. Finding Auden in their bedroom, preparing to go out with the others to dinner, Chester told him, "We're not going to King's." "Goody, goody," Auden said with relief. "The reason is," Chester continued gently, "your mother has died."

Auden had known his mother was ill. For some days, he had "raised heaven and earth" to speak with her by telephone, but it had proved impossible in wartime and he was never put through. Now all he could say to Chester was, "How like her that her last act on earth should be to get me out of a social engagement I didn't want," before he burst into tears.

Before Isherwood returned to California, he accompanied Auden to Middagh Street to take a look at the now-famous house that his friend had once shared with Gypsy Rose Lee. He found the house "an attractive, insanely untidy place where, owing to some freak of plumbing, the water in the toilet was nearly boiling. The weather was overpoweringly hot and sticky." It seemed a lonely place in midsummer in which to leave Auden and Kallman, especially when they were so at odds with each other. Isherwood wrote in his diary that "poor Wystan cried when I left for Los Angeles." Isherwood himself, having resolved to live and work as a pacifist at a Quaker settlement, was experiencing the euphoria of having finally reached a solution to his own dilemma of how to respond to the war. It was distressing to see his closest friend so low. But Auden had been determined to throw himself against the black stone of experience. And, in that summer, it seemed there was nothing left.

10

It has taken us long, too long, to come to terms
with our inward selves . . . We have had to face a
moral crisis for which we were scantily equipped.
But at last we have reached our conclusions and
are ready to act. We have come through.

— Carson McCullers, 1941

The passage of the Lend-Lease Bill by Congress led to a $7 billion appropriation for armaments manufacture for the Allies, and the effects of this enormous increase in production soon became visible in Brooklyn. In September 1941, the city's newspapers announced that the Brooklyn Navy Yard, now operating around the clock, would begin hiring female mechanics to replace men who had been drafted or had enlisted. Soon, the bars and luncheonettes of Sands Street filled with female as well as male shipfitters, apprentice welders, and acetylene torch burners who were putting in five-and-a-half-day, fifty-eight-hour weeks.

Such an increase in production demanded a similar increase in the supply of raw materials. Anticipating a shortage of metal, the government warned of lowered numbers of new automobiles, refrigerators, and washing machines in the year ahead, as well as oil and gas shortages. An Aluminum Collection Week was billed as most citizens' first chance to participate directly in America's defense. Gypsy Rose Lee helped publicize the event by posing nude, except for her signature high heels and an assortment of strategically placed aluminum pots, pans, and cooking spoons, for *Life* magazine.

For many, if by no means all Americans, it was gratifying to be asked to do something about the war in Europe after years of standing by and hearing the news. Reports in the newspapers that autumn told of the in-

stitution of the death penalty in Poland for Jews found outside the ghettos, of the deaths in Leningrad from freezing or starvation as the city lost electricity and heat, of a two-hour raid on Berlin delivered by RAF bombers on the anniversary of the first mass air attack on London, and of the massive Allied bombing of Naples and other parts of Italy. At the offices of *Decision,* Klaus Mann was surprised to see the change in the attitude toward engagement of his secretary's soldier-boyfriend, Johnny. Over the course of one month, he had evolved from an unhappy draftee considering going AWOL ("Let that guy Hitler conquer as much as he wants to") to a bloodthirsty warrior eager to "beat the hell out of them Japs."

President Roosevelt announced in his Fireside Chat of September 11 that because of a number of recent skirmishes between American ships and German submarines in the North Atlantic, he had authorized military escorts for the ships transporting supplies across the ocean. "From now on, if German or Italian vessels of war enter the waters, the protection of which is necessary for American defense, they do so at their own peril," he said. "The sole responsibility rests upon Germany. There will be no shooting unless Germany continues to seek it." Fifteen days later, the U.S. naval command ordered the sinking, when possible, of every Italian and German ship found in U.S. "defensive" waters. Meanwhile, Americans met in Moscow with representatives of Britain and the Soviet Union to work out a plan of urgent assistance to the Russians. Hitler, undeterred, launched an attack on Moscow on October 2, announcing that Russia "has already been broken and will never rise again." It would be an autumn of fierce fighting and thousands more deaths.

By this time, George Davis had returned to Middagh Street and set to work rearranging its tenancy. Many changes had taken place over the summer, for George as well as the other residents. The previous winter, he had written to Gypsy that he would be doing some hard thinking in the months ahead. "I figure that after that I'll be all right for a while," he had added. By fall, the period of anxiety over his failed attempt to write a second novel, the social experimentation through which he had gained release, and the gloom that followed had ended. George once again began telephoning friends, meeting colleagues for lunch in the city, securing work for himself and his housemates, and finding new artists to nurture and support. This year, in order to free the entire parlor floor of the house for socializing, George moved into Carson's third-floor suite, claiming the cardboard cutout of Gypsy for himself and installing it near

the window. He then furnished Gypsy's former rooms, complete with grand piano, for Carson when she was in New York.

Carson would use her space for a few days, a week, or even a month or two at a time in the coming years, but her health no longer permitted her to live permanently in the city. Still, during her summer at Yaddo, she had been able to capitalize on the moments of illumination she had experienced in the house in Brooklyn.

Yaddo's restful environment, with its carefully tended grounds and reliable routine, helped Carson concentrate, and the mix of American artists and European refugees proved stimulating, even if Carson's recent emotional strain caused her to behave in strange ways at times. In one of these episodes, Carson developed an infatuation for Katherine Anne Porter, the slim, sophisticated writer from Texas who had come to Yaddo for the summer and who counted George Davis, Glenway Wescott, James Stern, David Diamond, and Wystan Auden among her friends. Unaware that Porter had long ago read *The Heart Is a Lonely Hunter* and decided that she disliked it, Carson resolved to make herself the newest member of her illustrious social circle. She began following the writer around the grounds, declaring her love and begging to spend time with her, to no avail. Finally one evening, having pounded on Porter's door for quite a while without gaining entry, Carson lay down across the threshold so that when Porter left to go downstairs for dinner, she would be forced to acknowledge her. When Porter opened the door she looked down at Carson, paused, and simply stepped over her and continued down the hall without a word. Soon afterward, she moved into a separate house on the grounds expressly to avoid Carson — and thus ended their relationship.

There was no doubt that Carson's continued drinking — beginning with a beer at her writing table immediately after breakfast, continuing with sherry throughout the day, and ending with evening cocktails with the group of writers she had joined — complicated her relations with others at the colony. But she seemed unable to write without it. If her health must be sacrificed in the service of writing, it was a sacrifice she was willing to make.

Reporting to her desk by nine-thirty each morning, Carson made great progress, finishing *The Ballad of the Sad Café* and moving briskly forward with her problem novel, *The Bride and Her Brother*. Inspired by a new friendship with the *New Yorker* short story writer Edward Newhouse, she wrote a story of her own in two days and sold it to the magazine for a satisfying $400. She immediately began another story as well as

a poem, "The Twisted Trinity," for *Decision*. She also frequently visited Colin McPhee, who was writing about his years in Bali in a picturesque stone tower beside one of Yaddo's lakes.

His presence gave Carson an irresistible opportunity to play mentor to a fellow writer, and both she and the composer found that they benefited enormously from this relationship, though McPhee was nearly twice Carson's age. The younger writer was able to tease her friend out of his morose moods, and her playful techniques to maximize his production — once promising him a party when he finished a chapter — proved surprisingly effective. As the weeks passed, McPhee began to realize that in many ways he enjoyed writing about Bali even more than he liked creating music. "It has gone very well," he wrote, "18000 words in three weeks, and I am really happy in doing it . . . I write so much better than I compose that I wish a miracle might happen, even at this late date, and that I could express that something that I feel within, that has never found satisfactory utterance."

It meant a great deal to Carson to be able to give to someone else the attention and creative nurturing that George Davis had given her. The process of mentoring Colin McPhee, combined with the success of her writing projects, gave her a new level of self-confidence. By the middle of July, however, Carson felt herself pulled down again by the familiar ache for her group of Brooklyn friends. Reading the July issue of *Decision*, in which a poem of Muriel Rukeyser's appeared, Carson wrote to her that "the poem in *Decision* made me weep real wet tears, as I could remember your voice as you had said it and was suddenly homesick."

Carson also wrote to her husband, Reeves, and was disturbed not to receive a reply. She could not ask David Diamond whether he had any news of him, since the composer had left Yaddo early to deliver some lectures in New York. Carson had not seen as much of Diamond as she had expected to that summer; he had shared Katherine Anne Porter's two-story cottage, and Carson remained unwelcome there. After he left, she wrote to him of her longing to be with him, and Diamond responded with an offer of marriage, which surprised and disturbed Carson. Marriage to Diamond wasn't what she had in mind. She already had a husband, and that relationship was disastrous. Carson longed for communion — a platonic love that would nourish her creativity and Diamond's while leaving room for others as well. She continued to see more promise in triangular relationships, in which she was loved by one person while loving another. In *The Ballad of the Sad Café*, the hunchbacked Cousin

Lyman Willis found himself in this enviable position as he basked in Miss Amelia's adoration while yearning for her no-good husband. And in *The Bride and Her Brother,* she would write of Frankie, her brother, and his bride: "The three of them would go into the world and they would always be together. And finally, after the scared spring and the crazy summer, she was no more afraid."

It came as a shock, then, to find later that summer that she had been left out of the equation. Near the end of July, Carson learned that Reeves had moved to Rochester, New York, near David Diamond's home, with the intention of setting up housekeeping with the composer. Carson was equally stunned to discover that Reeves had financed his move by forging Carson's signature on her check from *The New Yorker* and on her royalty checks from Houghton Mifflin. In signing her name to the checks and pursuing the object of Carson's own infatuation, Reeves had in the most literal possible way reclaimed his name and taken back the life that he felt Carson had snatched from him, shutting her out completely.

If Carson had been experimenting with the idea of exile before — by interviewing Erika Mann and writing of a Jewish refugee traveling through the South — now she experienced for the first time the feeling of being abruptly cut off from family and home. Without ever having left America, she found herself exiled from the warm "we of me" form of communion, just as her fictional alter ego, Frankie Addams, had been forced to separate from her brother and his bride.

Carson McCullers, while physically frail, was unusually strong-willed. Reeves could hurt her deeply, but he would never be able to destroy her. Taking a leave of absence from Yaddo, Carson returned briefly to New York to replenish her overdrawn checking account and to talk with a lawyer about getting a divorce. A short time later, she contacted a psychiatrist, Elizabeth Mayer's husband, William, to discuss the possibility of entering therapy. Mayer specialized in treating artists — he had been working with McPhee for years — and could be counted on to respect the central importance to artists of their creative lives. Carson's relationship with him proved enormously helpful over time, and she eventually came to refer to him as her "protective angel."

Carson returned to Yaddo, crying most of the way back on the train. Once her residency ended in September, she returned to New York for another brief visit, meeting with Robert Linscott, her editor and by now her close friend, to discuss the publication of *The Ballad of the Sad Café.*

Then she took the train home to Georgia to begin the process of healing.

In New York, she had met with a number of her Middagh Street acquaintances in Manhattan but had resisted traveling out to Brooklyn to spend time there. She was not yet ready to explain her decision to divorce Reeves to such close friends as George and Auden, who would want to discuss it at length. No one on Middagh Street — or anywhere else, she realized — could save her. She would have to learn to take care of herself.

In earlier years, when returning south to recover from a stay in New York, Carson had had to fend off an inner voice suggesting that she left because she "couldn't take it" and calling her a quitter. Now, however, as the shocks of the previous year began to recede, she found that the voice had been silenced. She had, after all, made a great deal of progress in spite of a calamitous personal life. By the age of twenty-four, Carson had not only demonstrated an exceptional talent for fiction but had also established her skill at creating prescient, evocative essays, emotionally powerful short stories, informed literary criticism, and moving poetry. In the space of fifteen months, many of them under the influence of some of the most accomplished artists in America, Carson had moved from the creative experimentation of a talented novice to the full, creative life of a professional artist.

Bessie Breuer, a writer whom Carson visited briefly that fall, wrote to Klaus Mann that the young author now appeared to be in fine spirits — taking long walks in the woods, thinking about her novel, and talking excitedly about the new piano she had bought for her room at home. Part of this renewed energy derived from the accumulating evidence of the level of professional respect she had earned from other writers during the year in New York — often the very artists she had admired from afar such a short time before. She corresponded regularly with such friends as Muriel Rukeyser, Klaus Mann, and Gypsy Rose Lee. Even Annemarie Clarac-Schwarzenbach, now on a photojournalism assignment in the Belgian Congo, wrote fondly to Carson, and the two women soon established an epistolary friendship that they had been unable to achieve in person. Only Carson, Annemarie wrote, thought of the difficult tasks of writing in the same way she did. She expressed the hope that Carson would translate her book-in-progress, despite the southern writer's inability to speak or read German.

Janet Flanner, now forty-nine and at the top of her field, asked Carson

for literary help that autumn, requesting comments on "Goethe in Hollywood," her profile of Thomas Mann. Flanner had been tormented by the piece the entire previous year, partly because she had soon discovered that she preferred some of the younger Manns to their father, whom she had described as an author who "takes his symbolic eminence for granted." Nevertheless, Carson assured Flanner that she liked the profile — and then she burned the proofs without showing them to anyone, not even her mother, as the self-conscious Flanner had requested.

George kept up with these events through Carson's letters and through reports passed along by mutual friends. Events in Brooklyn, however, continued to preoccupy him. McPhee had agreed to move to Middagh Street after his stay at Yaddo ended, in part so that George could oversee the completion of his book, and he was overhauling the top floor for Colin's use. Oliver Smith was back in Brooklyn, too, returning from Mexico with the news that he had been given his first major job in set design. In Mexico with the Bowleses, Smith had learned that the Ballet Russe de Monte Carlo was passing through town. Dropping in to visit several acquaintances among the company's dancers, Smith heard that the scenic designer for Leonid Massine's upcoming ballet, a light comedy called *Saratoga,* had fallen ill. Smith pressed his friends to arrange an interview for him with Massine. Smith took to the meeting his portfolio of set designs created in his Middagh Street aerie, and later he recalled that as the choreographer paged through them, "he didn't say anything. He was very quiet. Then, he finally told me, 'Picasso you're not.'" But he liked Oliver's work enough to commission him to design the set.

When Smith described the project, George suggested that he mimic the style of his collection of hand-tinted, turn-of-the-century postcards that were once sold to tourists. Oliver found the images charming and began translating them into his own romantic-realist style. While the ballet itself proved unsuccessful when it opened at the Metropolitan Opera House in October, Smith was singled out by reviewers for his colorful, naturalistic scenery. It was sufficient recognition to guarantee future work.

The major event in George's life that fall, however, was the publication of Gypsy's novel, *The G-String Murders: The Story of a Burlesque Girl.* Born in the house on Middagh Street of their friendship, by autumn it had become perhaps the most eagerly anticipated mystery debut in the history of American publishing. Gypsy and George, no strangers to the publicity machine, had systematically amassed all the forces of book pro-

motion to ensure its success. George had spent months feeding members of the press with delicious rumors about the book's creation, about the true burlesque stories behind the fictional façade, and about Gypsy's background and literary aspirations. Janet Flanner had contributed some snappy flap copy that began: "Here is the living portrait of burlesque, with assorted deaths thrown in," and Marcel Vertès's sketch of Gypsy typing in her dressing room adorned the back cover with the caption "The Author at Work." On its September publication day, *The G-String Murders* appeared in New York's bookshop windows alongside Vertès's own new book of drawings, *The Stronger Sex*, with text by his Middagh Street friend Janet Flanner.

Gypsy's efforts to keep the newspaper ink flowing — with appearances at book signings, literary parties, author luncheons, and interviews, referring to herself as "America's leading literary figure," and tossing off such remarks as "These late hours are giving me the 'Yaddo' pallor" — paid off handsomely. Gypsy and her book were featured in *Life* magazine, her occasional writing appeared in *Harper's Bazaar* and *The New Yorker*, and respectable young women lined up around the block to buy an autographed copy of the novel. By winter, *The G-String Murders* had become the biggest-selling mystery since Dashiell Hammett's *Thin Man*. To George's delight, Gypsy's wit was even compared in print to Dorothy Parker's, and her preferences in modern art were solemnly disseminated for public consumption.

George would have enjoyed sharing this experience with Auden, who also appreciated the comedy of public life. It would have been helpful, too, to have Auden still present and managing the house as new tenants arrived and a new round of painting and redecorating was required. As George himself admitted to a friend, "I loathe the very word 'managing.'" And Oliver Smith was driving George to the brink of insanity over financial matters, arguing over the charges added to his weekly bill and always rounding his payments down to the nearest dollar, leaving the change unpaid.

Auden, however, was no longer serving as headmaster of 7 Middagh Street. The previous summer, he had received an offer to spend a year as a visiting lecturer at the University of Michigan in Ann Arbor — where Chester Kallman planned to be. In need of money and apparently unable to resist the temptation to follow Chester, Auden had accepted. At about the same time, however, Kallman postponed his own arrival at Ann Ar-

bor until the following semester and instead went to Los Angeles to search for a job. Auden, still in a state of emotional shock from the summer's events, thus found himself moving alone to the Midwest — just as his poem "Calypso," written during the exuberant early days of his affair with Kallman, appeared in the pages of *Harper's Bazaar*:

> Driver drive faster and make a good run
> Down the Springfield Line under the shining sun.
>
> Fly like an aeroplane, don't pull up short
> Till you brake for Grand Central Station, New York.
>
> For there in the middle of that waiting-hall
> Should be standing the one that I love best of all.

Auden moved into a small house in Ann Arbor and, rather than live alone, arranged for a graduate student in poetry, Charles Miller, to serve as live-in cook. Trying to keep a good face on his situation, in early October he wrote to Caroline Newton, "I had my first class last Thursday; some were pleased, others puzzled. The Middle West student is still a mystery to me, but I'm giving a party for them to-night and perhaps alcohol will reveal all." He remained mystified by this alien culture for a good while, however, as he witnessed Ann Arbor "in fiesta," with "85000 people here to see the football match of the year," then joined some students for dinner at a fraternity ("What an anthropological curiosity. I'd rather be dead than live in one").

Never in his life had Auden been so isolated and without close and accepting friends — not in Berlin, not in China, and certainly not in Brooklyn. For the first time, he was exposed to the general public's rude and hasty judgments without the insulating layer of like-minded companions. The fact of his homosexuality — which he had baldly announced at his initial interview, to the extreme embarrassment of his hosts — created a barrier between him and those with whom he hoped to connect, which he found quite irritating. He wrote to the Sterns that "every time I ask anyone in pants to the house, they are either hoping or dreading that I shall make a pass at them," and that recently a favorite student whom Auden had invited home for an evening of conversation "took my playing of a Marlene Dietrich record as a proposal and was promptly sick. I had to give him a long lecture on his lack of intellectual self-confidence and his excess of physical vanity before I could reassure him."

Over time, however, he found cause for amusement as well. He wrote

on one occasion of overhearing a professor remark, "I don't like to say anything malicious about another human being, but I hear Auden is a Platonist," and on another that "Ann Arbor is going to have a shock next week as Erika is coming to stay the night."

Essentially, at least for this first semester, Auden's exile to the Midwest served only to make him even more miserable then he had been before. "Happy I can't pretend to be," he wrote to Caroline Newton in early October. "I miss Chester; I miss New York . . . Il faut payer for the happiness of the last 2½ years; alright, but what is harder is that one must not only pay but like paying." To George he added, "I'm terribly homesick for Brooklyn. I have a lovely car, a lovely house, a student cook who is a perfect Jeeves, *but*, NO LOVE . . . If you can give me any introductions either here, or in Detroit, or Chicago, I should be *most* grateful. And if you could come for a visit, it would be lovely. Please give my love to everyone including the cats."

The letters from his friends often included harsh judgments of Kallman for his past year's mistreatment of Auden, so the poet frequently felt obliged to defend his absent lover. Tania Stern had advised him earlier not to hobble Kallman's independence by arranging for full payment of his tuition but to let him grow up by going out and getting a job. Now, Auden dutifully reported on Kallman's job search, and when Chester decided not to work but instead enroll in a secretarial school, Auden wrote to Tania, "Perhaps you will scold me for agreeing to pay for it, but even if it is wrong to do so, I don't see how I've the right to say so, seeing as I was kept by my parents till I was 22 He has, I think, so many wonderful qualities that it will be an awful shame if nothing comes of them, and I shall have much to answer for."

Yet, from Kallman himself the poet received a barrage of complaints that the many checks he sent arrived late or were insufficient. Making no secret of his continued infatuation with Jack Barker, Kallman also played up his new independence by reporting on his sexual activities in Los Angeles. "Sex has been spotty and silly," he wrote to Auden, "consisting of quick ones and morceaux de commerces who decide that I'm their dear one, — and have to be dropped discretely before the whole business, — the jealousy, the affection, the conversation, — becomes too violently tiresome — and God it's such a bore, bore, bore." The trouble, he explained, was that there were no real men in Hollywood. "Just the other night I picked up a 6 ft. 2½ in. merchant sailor from Brooklyn. Wildly attractive, young, strong, perfectly built, and large. I was all prepared for an

absolutely relentless fucking, — but — as it turned out in the end, that is what I had to provide him with."

Occasionally, however, a sudden, unexpected glimpse of affection appeared in these same letters , dashed off by Kallman as though in afterthought: "I know that, in whatever context it may be, or whatever interpretation it may be subjected to, I love you."

These rare comments were all that were necessary, it seemed, to keep Auden bound to Kallman. While he would write to Tania Stern a few years later that romance "is not my natural cup of tea at all for, as you know, what I like is humdrum certainty, the same person, the same times," Auden would also remark more than once on the benefit to the artist of unrequited love, which he can use to test and strengthen himself for his work. That autumn, Kallman wrote to Auden that others were quick to judge him because they could not really understand an ambivalent point of view. "Perhaps it's good for me that I can't be grasped at one word," he suggested; "it means more intensive thinking."

More intensive thinking, and feeling as well. Auden's suffering that summer in Brooklyn had proven to be as agonizing as any in his life — particularly as it coincided with his mother's death — yet at the same time he was aware that the pain he had experienced would stimulate him creatively. Auden had recently comforted his lonely cook with the words: "The person you really need will arrive at the proper moment to save you." For Auden, Kallman would always be that savior: he always propelled Auden forward in his growth — and thereby rescued him from what he called "frivolity."

The months of creative inactivity had ended. While the "social half" of Auden's version of Henry James's double man carried on with lectures and correspondence, the poet moved into his study and set to work. His new project was a Christmas oratorio that Benjamin Britten had agreed to set to music — the story of the birth of Jesus from Advent through the Flight into Egypt. As always, however, Auden used these events as a framework within which he could analyze the ideas and occurrences of his own life: his life served as a filter through which to better comprehend the parable. The Christmas story, describing a miraculous event — the merging of the spiritual with the material — served also as a perfect vehicle with which to recreate Auden's experience of his love affair as a means of seeking redemption.

Auden further intensified this double exposure by setting the reli-

gious tale in a modern environment, among bars and jukeboxes and newspaper editors and policemen. It was an old technique, routinely used in the past centuries to bring into focus the ultimate union of the profane and sacred, the erotic and religious, the body and soul — two aspects of human consciousness that had been divided only in recent times and whose separation Auden considered the greatest crisis of his time.

In "Advent," the first of the poem's nine episodes, Auden established the story's beginning in a period of faithlessness and confusion, when humankind had lost confidence in the ancient Greek gods and blindly groped for some new source of meaning. Such a state of uncertainty was necessary, Auden believed, to prepare the way for an entirely new vision — and it not coincidentally resembled his own state of uncertainty in the previous two years, when he had abandoned the "gods" of liberal relativism and sought a new way of deciding how one should live. Part II, "Annunciation," in which Mary exulted in the news of her coming child, echoed Auden's own relief and joy at the discovery of Chester Kallman. "The Temptation of St. Joseph," which followed, related in modern terms Joseph's attempts to ignore the gossip about his wife's pregnancy and to overcome his anger in the face of her claim that she had been inseminated by God. It mirrored Auden's own despair the previous summer as well; he wrote, in Joseph's words:

> All I ask is one
> Important and elegant proof
> That what my Love had done
> Was really at your will
> And that your will is Love.

And the angel Gabriel answered:

> No, you must believe;
> Be silent, and sit still.

For nine months, as Auden worked on the oratorio (later called *For the Time Being*), he drew together all of the elements of the previous year's spiritual, sexual, intellectual, and emotional crises and poured them into this vivid, exquisitely moving and accessible tale of spiritual salvation. Everything, it seemed, went into the soup: the Jungian Faculties of Intuition, Feeling, Sensation, and Thought with which Auden had catego-

rized himself and all his friends; the conviction that a secular, liberal outlook was largely responsible for the moral vacuum in which fascism had thrived; the use of conjugal love as a path for learning to love mankind; and the present widespread death and mayhem as a chronic backdrop to each day's events.

"Rummaging through [his] living for the images that hurt and connect," Auden scattered personal souvenirs throughout the oratorio: the Fifty-second Street dives featured in "September 1, 1939," now a place for Joseph to brood over Mary's religious claims; the homosexual slang of the Sands Street bars, echoed by Herod's soldiers as they prepared to slaughter the innocents; and even, it would seem, Eva Morcur, the beloved cook of Middagh Street, in the guise of "Eva, my coloured nurse," whom Herod thanked for the "regular habits" that helped make him a rational, liberal ruler. Samplings of the past year's poetry were tossed in as well: echoes of "Domesday Song" ("Deep among dock and dusty nettle lay"), "In Sickness and in Health" ("Domestic hatred can become / A habit-forming drug" and "Let even the young rejoice"), and the paradisiacal garden of "Kairos and Logos."

The final act, in which the poet and his readers dismantle the Christmas tree and pack away the decorations, recalled the celebratory Christmas feast created by Auden and Britten for *Paul Bunyan*. But here the mood was different: the celebrants prepared to resume their jobs and send the children back to school. Returning to the secular world, "the streets / Are much narrower than we remembered; we had forgotten / The office was as depressing as this." The fleeting moment of spiritual insight was over, with "The night of agony still to come." Now, "the time is noon," and one could only move forward, struggling toward faith and praying "that God's Will will be done, that . . . God will cheat no one, not even the world in its triumph."

Gone were both the previous year's groping uncertainty and its smug pronouncements. In their place, with the confidence and depth of a mature artist who had found his direction, Auden had distilled elements of the sacred and the profane into a new, stronger substance with which to address the eternal question of the arts: "How should we live?" Over the next few years, thrust still farther by the volatile explosion at Middagh Street, he would create two more long poems of extraordinary power and originality: *The Sea and the Mirror*, a poetic retelling of Shakespeare's *Tempest*, exploring the nature of creativity and the role of the

artist, and *The Age of Anxiety,* a meditation on and judgment of modern life set in a New York bar.

But even as Auden used his poetry to "*talk back* to God" in what was for him "a kind of prayer," he confessed to a friend that autumn that "I feel as if I were scattered into little pieces. And if the Devil were to offer [Kallman] back to me, on condition that I never wrote another line, I should unhesitatingly accept."

On November 11, Auden wrote to Britten, "I have sketched out the first movement of the Orations . . . Longing to see you. Much love to all." Britten and Pears, along with Elizabeth Mayer, had arranged to stop by Auden's house in Ann Arbor en route from Chicago and Grand Rapids, Michigan, to Ohio for a series of concerts of Britten's music. Auden was eager to discuss his new project with Britten and, if necessary, patch up any misunderstandings that lingered from the previous spring.

But it was an uncharacteristically cool and perfunctory Britten, just turned twenty-eight, who arrived at Auden's front door that afternoon. Like everyone else, he went through the motions of renewing old friendships, and he and Peter gave a rousing recital of their recent work in the living room. But Auden's housemate, Charles Miller, noted that while Britten smiled politely whenever anyone looked at him, "I don't remember hearing a note of laughter from that pale, patient face. As he sat in Wystan's blue upholstered chair, I was impressed with his melancholy, his generally passive attitude, even while Peter and Elizabeth rocked with laughter."

Certainly, the previous summer in California, to which Britten and Pears had fled with high hopes, had not worked out as planned. The musicians had enjoyed their westward drive, marveling at the scenery and at the number of young hitchhikers who freely wandered along the back roads of this enormous country. And, initially at least, California's mild weather and relaxed atmosphere had a palliative effect after the creative tension of the house in Brooklyn. "We live a very quiet existence in beautiful but strange country," Pears wrote to his mother; "40 years ago it was a desert, now it is full of orange & lemon trees. I go down to a house of an Englishwoman in the village and practise every morning from 9:30 until 12:45, and I'm doing a lot of good work." Pears also easily arranged a number of recitals in private homes, with Britten accompanying on the piano.

Even in sunny Escondido, however, their working conditions did not remain ideal for long. Britten soon realized that the amount of work he had scheduled for the summer would be virtually impossible to complete. Not only must his string quartet be ready for its September performance in Los Angeles, but he had planned to contribute a *Mazurka Elegiaca* for two pianos to a memorial volume for the composer I. J. Paderewski; a medley of traditional Scottish tunes for two pianos and orchestra, *Scottish Ballad,* for their hosts in lieu of rent; an arrangement of the Minuet from Mahler's *Symphony No. 3;* and *Seven Sonnets of Michelangelo,* a song cycle for Pears that he had wanted to finish for years. In addition, Britten needed to begin thinking about the music for Auden's "Ode to St. Cecilia"; the poem had already been completed and was due to be published soon in *Harper's Bazaar.*

War news was everywhere, just as on the East Coast, considerably raising the level of anxiety for the four British expatriates. As the threat from Japan appeared increasingly real, Britten wrote to William Mayer that "everyone out here . . . is terrified of the Japanese, and there is a terrific prejudice against the poor wretched Japs who have settled down and become perfectly respectable citizens . . . There are terrific goings-on in 'defense preparations' round here — but of course San Diego is the biggest naval-base on this coast." At the same time, more accusations of cowardice reached their ears from England, this time focusing on Britten himself.

The cause was Ernest Newman's enthusiastic review in the *Sunday Times* of Britten's *Violin Concerto,* performed by the London Philharmonic in April. Newman's reference to Britten as a "thoroughbred" of a composer sparked a flood of outraged letters, soon dubbed "the Battle of Britten," in which some writers remarked that "most of our musical 'thoroughbreds' are stabled in or near London and are directing all their endeavours towards winning the City and Suburban and the Victory Stakes," or claiming that as an expatriate, Britten could no longer claim the title of "British composer" and should be demoted to the status of "import." Others protested that by serving his art, Britten was serving his country, since "ultimately it is by its cultural achievements that a nation will be judged."

The controversy raged in England through the summer and into the fall, torturing the young composer, who loathed controversy and who preferred his native country to the one in which he now lived. By the end

of the summer Britten's stay in California had taken any bloom that remained off his enthusiasm for America. This was "a crazy country," he wrote to his sister:

> & I don't think I altogether like it. I know old England is a stuffy place, the BBC is horrible, & the plumbing is bad; but there are lots of things about this 'ere place that arn't [sic] so good, either. Their driving — their incessant radio — their fat and pampered children — their yearning for culture (to be absorbed in afternoon lectures, now that they can't "do" Europe) — and above all their blasted stomachs, with their vitamens [sic], their bowel movements (no one ever "goes" naturally here — only with a good deal of stimulus!), & their bogus medicines. Still they aren't blowing each other to bits so far, & perhaps that's something.

As for Los Angeles, Britten called it "the ugliest and most sprawling city on earth," now "swarming with refugees," with "every composer whose name is familiar" present and competing for a limited number of film jobs.

Britten could see that his Hollywood dream would go unfulfilled — though his disgust with Los Angeles kept him from becoming too despondent. Still, he needed to compose if he was to survive professionally, and the domestic situation at the Robertsons abruptly worsened when their two pianos arrived and the couple began practicing. Britten could not possibly concentrate under these conditions ("If anything is more disturbing than one piano it's two!" he wrote to his sister), and reacted to the intrusion of sound with no more grace than Paul Bowles had done in Brooklyn. Like Bowles, Britten found that he had no choice but to retreat — in his case, moving to the toolshed in the backyard, where he composed with an electric fan on to block the sound of the Robertsons' rehearsals.

As the weeks passed, he grew increasingly anxious and had a series of spats with his hosts. Some of the conflict centered on his working conditions, but much sprang from the couple's condescending attitude toward his relationship with Peter Pears. The Robertsons liked to insist that the "boys" would soon outgrow their homosexual phase and that Britten would then marry a nice young woman. This type of presumptive teasing enraged Britten, and Pears frequently had to act as peacekeeper.

It was in this mood — sick of California, only slightly more enthusias-

tic about New York, and tired of trying to cope with the "perpetual jig-saw puzzles" of personal relationships — that Britten picked up a copy of the *Listener,* a music journal that someone — perhaps Auden — had forwarded to him. It contained an article by E. M. Forster on George Crabbe, a turn-of-the-century poet from Aldeburgh. "To think of Crabbe is to think of England," Forster wrote; the poet, named after the national saint, had been a hard-working child of poverty on the British seaside, became a clergyman of the English Church, and spent his entire life in the villages of England.

Having grown up among the British poor, Crabbe was truly their poet, Forster wrote. Still, he had held no sentimental illusions about poverty's virtues. On the contrary, his understanding of life in England's grim fishing villages, and thus of England itself, had rested on an understanding of the weakness of the human race. "To all of them, and to their weaknesses, Crabbe extends a little pity, a little contempt, a little cynicism, and a much larger portion of reproof. The bitterness of his early experiences has eaten into his soul, and he does not love the human race, though he does not denounce it, and dares not despair of its ultimate redemption . . . Disapproval is all too common in the pulpit, but it is rare in poetry, and its presence gives his work a curious flavour, subtle yet tart, which will always attract connoisseurs."

Britten was taken by this description of the cantankerous poet's character but even more entranced by Forster's evocation of the landscape around Aldeburgh. Having himself grown up in a house directly facing the North Sea, with its fierce storms and salty air, Britten well knew the sound of "the wallop the sea makes as it pounds at the shingle." On his walks to Aldeburgh from his mill house in Snape, he, too, had grown to love the area's flat, melancholy scenery and the cries of the marsh birds. These images, brought forth by Forster, called to Britten with all the power of home. Forster wrote that no matter how far Crabbe wandered, he was never able to expunge the spirit of Aldeburgh and its people from his writing; Crabbe was a provincial, and the term was meant as high praise. Reading these words on the West Coast of America, Britten realized that they described him, too.

Soon afterward, on one of their trips into the city, Pears stopped in at a rare book shop and serendipitously came across a copy of *The Poetical Works of the Rev. George Crabbe,* published in 1851. He gave the book to Britten, who quickly became captivated by the evocative language in Crabbe's long poem "The Borough":

Our busy streets and sylvan-walks between,
Fen, marshes, bog and heath all intervene;
Here pits of crag, with spongy, plashy base,
To some enrich th'uncultivated space:
For there are blossoms rare and curious rush,
The gale's rich balm, and sun-dew's crimson blush,
Whose velvet leaf with radiant beauty dress'd,
Forms a gay pillow for the plover's breast.

Set in the early 1800s, the poem told the story of a fisherman named Peter Grimes whose young apprentice died by drowning. Although the death was officially deemed accidental, the town judged Grimes — a gruff, sometimes violent misfit — to be responsible. Forced to confront an unforgiving society, not wholly innocent yet not fully guilty, Grimes was tormented to his own ultimate demise in the rough waters of the North Sea.

Again, Britten identified fully with the themes running through Crabbe's story — the suffering of a weak person at odds with his community and the nature of innocence and its corruption. Reading the poem, Britten would recall, "I suddenly realized where I belonged and what I lacked." What he lacked — what had caused critics to repeatedly call his work derivative — had been the courage to do what Auden had done, to take on such personal and powerful themes in their darker and more gripping forms. And where he belonged was in England, where he could explore these ideas in terms of his own traditions. The fishing villages of England, the folk and religious heritage in all its destructive and inspirational aspects these were the elements to which Britten wanted to dedicate his talents. The previous winter he had written an article, under Auden's influence, stating that the static nature of folk music made it useless as a basis for composing new music, since it tended "to obstruct thinking." The community has been destroyed by the machine age, Britten wrote — or, quite possibly, Auden wrote for him — and only those who turned their backs on the traditions of the past would carry on the human heritage. Now, Britten realized that he disagreed absolutely with these pronouncements. Suddenly illuminated in the light of Crabbe's poetry, he saw his own path in music as springing directly from these cultural roots. He wanted to share with his own people the stories of their shared past in a way that would shed light on the present.

Peter Grimes's story could become an opera. Britten could hardly contain his excitement. The technique of choral presentations used to crys-

tallize a dramatic moment or emotion — an approach he had experimented with in *Paul Bunyan* — could quite effectively tell a story about a village of men and women whose livelihood depended on the sea. And the earthy, evocative language of Crabbe's poem begged for a vital musical setting. Britten began planning to return East immediately after the September 21 concert of his string quartet to begin work on *Peter Grimes*. In such a state of inspiration, he was loath to be distracted by the tiny Robertsons, yet they had something to tell him.

It seemed, they confided, that Ethel had fallen in love with Britten. There was nothing to be done about it — her passion must be satisfied. So, having discussed the matter, "the little Owls" had decided that Rae would offer his wife as a gift to the composer. He would be honored if Britten would accept.

Middagh Street might have been squalid and sometimes difficult, but at least in New York one had some connection with reality. Life in the Escondido cottage, far from providing the oasis of sanity Britten and Pears had desired, had become simply ridiculous. "Frankly, I'm a bit sick of California," Britten wrote to his sister. The day after his *String Quartet No. 1* was performed in Los Angeles, he and Pears packed their car and fled "like released prisoners."

By early October, they had arrived at the Mayers' home on Long Island, where they had chosen to stay for the brief period they expected to remain in America. Britten was filled with excitement over his idea for the new opera, and the two musicians had agreed during their trip that it was time to return home and face the ordeal of applying for conscientious objector status. Britten could hardly wait, as all of the pent-up anxiety and confusion of the previous year began to resolve itself within the framework of the story of *Peter Grimes*. The idea of working through these ideas at the mill house in Snape, with a regular timetable, long walks through the countryside after lunch, and only Pears for company, was enough to make him ache with anticipation. The musicians were blocked, however, by the extreme difficulty of obtaining passage to England when ships crossing the Atlantic risked attack and by the long list of commissions that Britten had yet to complete.

Emotionally strained but heady with ideas, Britten did his best to focus on the work at hand. He had now contracted to produce an overture for the Cleveland Orchestra. He worked so frantically to complete the piece, which he had renamed *An American Overture* with his imminent departure in mind, that years later he forgot he had ever composed it.

"My recollection of that time was of complete incapacity to work," he admitted. "I was in quite a psychological state then."

Increasingly, part of Britten's strain could be attributed to a growing awareness that it would not be easy to say good-bye to many of the people he had come to know in America. He was particularly bereft over the idea of leaving the Rothmans, the family who had welcomed him when he had traveled out to Long Island to conduct his orchestra. Immediately on his return from California, he had visited the family. As always, the entire group greeted him effusively — David Rothman, his wife, and their son, Bobby. Over the past year, Britten and Bobby Rothman had grown quite fond of each other, roughhousing, exploring the beaches around Montauk, and otherwise expending their youthful energy. Britten had written to David that his son was "a grand kid," that the Rothmans were "such a delightful family." That autumn, however, Britten understood that his simple affection for Bobby had changed: he had fallen in love with the boy, and he felt that he simply could not leave him and return to England permanently with his beloved but older partner, Peter.

For years, Britten had wrestled with his attraction to adolescent boys, courting a number of schoolboys but evidently resisting the urge to seduce in spite of Isherwood's and Auden's goading. Extremely sensitive to any form of public censure, and even more aware than most of the sanctity of childhood innocence, Britten believed he had found permanent relief from his tendencies in his relationship with Peter Pears. Bobby Rothman, however, was the first adolescent male with whom Britten had had close contact since his relationship with Peter had begun, and it now appeared that he had miserably failed his first test. For the next two weeks, while working nonstop, Britten silently struggled with his desire to throw away his future for the sake of a dark-eyed, trusting fourteen-year-old. Britten's hours at that time were brutal. "Unforgettable evening," Elizabeth Mayer wrote in her journal on October 16. "We three working in music room till 2:30 A.M. Peter reading aloud from Forster: A Room with a View — myself preparing score with ruler on piano."

On the twenty-second, Britten rushed to Boston for the first rehearsal of his *Sinfonia da Requiem* by the Boston Symphony Orchestra, conducted by Serge Koussevitsky. On his return, he began work on the score of *Scottish Ballad*. Once that was completed, he had to travel to Washington, D.C., with Peter and Elizabeth, to be presented with a medal for composition by his California patron, Elizabeth Coolidge, while the Kroll Quartet played his work. On November 4, he wrote to his sister that

perhaps he would stay in the United States after all. The pressure of try-
ing to come to terms with his growing obsession while maintaining his
career had led him to the brink of a nervous breakdown.

Back in Amityville, Elizabeth Mayer noted in her diary that Britten
was playing a great deal of Mahler. Preoccupied and gloomy, he spent a
few quiet days with his hosts, playing the piano and listening to the oth-
ers read aloud. On November 6, he left to spend two nights at the
Rothmans' house. For fun, David Rothman allowed Britten to help tend
his hardware store during the day, but he later confessed that he was
completely unprepared for the abrupt declaration that the composer
made on the second day. "He wanted to stop writing music," Rothman
recalled, "and wanted to work in my store . . . He had the feeling that he
would like to work in a store . . . which seemed to me most ridiculous. I
don't know whether he was serious or not, but I had the idea he might
have been." Stunned, Rothman said, "Look, you're only about twenty-six
years old; you've already done well . . . they did [your] violin concerto
with the New York Philharmonic. What do you want? Blood?"

Britten did not, of course, divulge the reason behind his desire to
abandon Peter and his music and settle down with the Rothmans and
their hardware store. He took the rejection stoically and didn't mention
the idea again. When it was time to leave, he said good-bye as usual and
returned to Elizabeth's house, where he found Auden's letter announcing
the completion of the first movement of his oratorio. In mid-November,
just before departing with Peter and Elizabeth for Chicago, Britten wrote
to David Rothman, "You, especially, David, I feel a real source of inspira-
tion & encouragement, such as I have rarely met. I am very touched by
your urgings on a certain important decision — please don't be injured if
I seem to treat them lightly, that is only to cover how seriously I consider
them. In spite of my jocularity, I am a great believer in 'Fate' or 'God' or
what-you-will, and I am for the moment going on with the work in hand
(which is plenty, I can assure you!) and letting the future take care of it-
self . . . from a grateful Benjamin B."

Britten was at that time also preparing settings for a series of English
folk songs, dedicating each song to an American friend as a farewell gift.
One of them, intended for a young girl recently betrothed, he dedicated
to Bobby Rothman. Its private meaning was quite clear:

> O father, dearest father, you've done to me great wrong,
> You've tied me to a boy when you know he is too young . . .

All because he was a young boy and growing,
All because he was a young boy and growing.

Now, in Ann Arbor, Britten realized with a certainty he had never before experienced in his relationship with Auden that the poet's grand examination of the nativity, barely concealing his own personal tragedy, was not the story he wanted to set to music. Having watched Auden transform his life into art for years and with his experience with Bobby Rothman still fresh in his mind, Britten found the story of Peter Grimes taking on an emotional urgency.

After years of following others' instructions — first his mother's, then Auden's, and then, to some degree, Pears's — Britten knew the direction he needed to take for his own artistic growth. In his music, if not in his life, he could explore the conflicting desire and fear that had made his own adult life too complex. The story of Peter Grimes, who tries to overcome his weakness and, in doing so, is classified as a criminal and destroyed, unearthed years of Britten's own struggle to conform to the sexual strictures of his culture. Perhaps he could channel those feelings into his work and create something not derivative (as critics too often called his work) but powerful, original, and great.

The November visit with Auden was short, with a concert scheduled for Cincinnati the following day. Britten and Auden said good-bye, aware that they were unlikely to see each other for some time. Professionally, their parting was friendly but inconclusive. Britten still planned to set "St. Cecilia" to music, and he had not refused outright to consider the oratorio. But Auden must have sensed that he had been to some degree dismissed by his former protégé. In essence, this poet, for whom friends were more important than anything except his work, the talented friends most of all, was losing the prize of his collection. Charles Miller noted that before Britten and Pears left, Auden nodded in their direction and remarked to him, "Now there's a happily married couple."

If his sense of isolation had been painful before, it worsened after Britten's departure. Only now, having written extensively about America and created an entire libretto describing its development, did Auden feel that he finally understood the full tragic loneliness of the American Middle West.

"Charlie, it's *amazing* that no one has really written about the true America, the land of the lonely!" he said to his housemate. "The land of

eccentrics and outcast lonelies. 'The Lonelies' could be the title of a grand unwritten American novel. I've been told of a likely hero, the homosexual 'queen' of Niles, Michigan, you know? Each evening when the New York–Chicago train pauses there to put off a passenger or so, this lonely queen meets the train, hoping to encounter one of his own kind. By profession, he's an accountant, but actually he's a loner who solicits traveling salesmen. His stand-by source of sex is high school football players who are coached not to 'do anything with women.'"

Taking a sip of his coffee, Auden added, "Imagine it, Charlie. Imagine such a scene being repeated daily in hundreds of dismal little American towns!" He sighed heavily. "America *is* one of the loneliest places on this planet. And my friend George Davis ought to write a novel about it . . .'"

"Hasn't Sherwood Anderson written it already?" Miller asked.

"Perhaps, in his own way. But the novel needs to be written by one of us."

George Davis, who had long before fled small-town America, was now too busy to consider writing novels. Fed up with having too little money and not enough influence, he had decided to give up the freelance life and accept an editorial position at *Mademoiselle*. After all, Auden had left, and Britten and Pears, and Golo Mann and Gypsy — and these days Carson didn't use her room at all. Klaus Mann, who was nearly certain that the January issue of *Decision* would be the last due to lack of funds, hardly ever came by anymore. Other artists were moving in, but it wasn't the same. The year was up, and the "gamble with myself and others" was over, even if the results were not yet all in. When Anaïs Nin visited the famous house some time later, she would find it charmingly furnished with bright carpets, heavy antiques, framed watercolors and sketches, and Victorian bric-a-brac covering every flat surface. "A museum of Americana," she called it, having arrived too late to witness the living, breathing creative workshop that it had once been.

On December 7, 1941, the death knell that the residents of 7 Middagh Street had been expecting finally arrived, though no one could have foreseen its form. At 7:55 A.M., with no declaration of war, the Empire of Japan mounted a surprise attack on the Pearl Harbor air and naval base in Hawaii. Nearly three thousand people were killed and more than six hundred wounded. The backbone of the American Pacific fleet was eliminated before the United States had even begun to fight. Americans were

stunned by this evidence of such advanced military logistics and organization. But in Britain, those who heard the news got out the last of their champagne for a celebratory toast, and in Europe the prisoners being carted off to concentration camps embraced one another in the midst of their despair. They were convinced that now Hitler had no hope of victory. America was ready. And everything would change.

Epilogue

Each moment then is a turning point — not only
the fruit of an infinite past but also the bud, the
chance, indeed, the promise of an infinite future.

— Klaus Mann, 1941

Janet Flanner's former companion, Solita Solano, later described 1941 as
the year that everything changed "nearly down to the roots of life." It
was certainly true for her. Having lost Flanner to the younger Natalia
Murray, she would stop writing that year and move west with her own
new lover. But of course the sea change after Pearl Harbor was more a
global political and cultural phenomenon than the result of any single
personal event. December 7 came to symbolize not only, in Churchill's
words, the end of the beginning of the Second World War and the begin-
ning of the end, but the end of one era in America and the beginning of
another.

Private dramas continued to play themselves out, even if viewed some-
what differently in light of world events. It must have astounded even
Wystan Auden, for example, to read Chester Kallman's letter, written on
the day of the attack, complaining of its effect on his Hollywood sex life:
"It really isn't fair — I feel bitter, vindictive, half-immersed in 'circular
madness' . . . Is it asking so much to want to be fucked or even to indulge
in the simplest of childhood experiences with a more dangerous engine?
. . . it's all very depressing — and now War." Despite this further evidence
of "imperfection," Auden, having made his commitment to Kallman, re-
mained. Traveling to California that month, he took Kallman on rounds
of visits to friends in a position to help him find a job, continued to sup-
port him financially when opportunities fell through, and arranged for

the payment of Kallman's tuition when he arrived in Ann Arbor for the spring semester.

Understanding that Kallman remained enraptured by Jack Barker, Auden even agreed to drive him to New York so that the two could meet — though only after Barker agreed to an interview with Auden to ensure that his intentions were "honorable." (Trying to explain his actions to Caroline Newton, Auden wrote, "Promiscuity . . . fills one with jealousy and anxiety for his spiritual welfare, while a genuine love fills one with jealousy and respect.") Although Barker managed to reassure Auden that his interest in Kallman was at least somewhat spiritual as well as carnal, the lovers' reunion did not go well. While staying with Kallman as George Davis's guest at 7 Middagh Street, Barker was diagnosed with syphilis, and an outraged household ordered the two boys out at once. Kallman wrote bitterly to Auden that "they all found the unity they appallingly lacked in a hysterical fear of 'catching disease,'" and that George "had an opportunity for his own special theatre," telling everyone that "he couldn't, out of respect for you, have me in the house with Jack!"

George was not the only friend of Auden's to react negatively to The Crisis, as the culmination of "*l'affaire* C" would become known. When the couple visited the Mann family in California, the entire group expressed such hostility to Kallman that Auden ended his relations that year with all but the patriarch, Thomas. He broke off his friendship with Lincoln Kirstein's sister, Mina Kirstein Curtiss, as well, after she referred to Kallman as "just a Brooklyn kike" (though she herself was Jewish). Only those who managed to hold their tongues, no matter what their private opinions — Isherwood, the Mayers, James and Tania Stern — remained part of Auden's circle after 1941.

Auden had always believed that a commitment of friendship meant full acceptance of that friend's decisions. If he was willing to tolerate Kallman's promiscuity and the end of his sexual relations with him, his friends must accept it, too. He acknowledged that the crisis he experienced at Middagh Street that summer was the most devastating of his life. Yet even when he confessed that "there are days when the knowledge that . . . there will never be a person with whom I shall be one flesh, seems more than I can bear," Auden seems never to have regretted his decision to remain with Kallman. "I never really loved anyone before," he wrote to Tania Stern that winter, "and even when he got through the wall, he became so much part of my life that I keep forgetting that he is a sepa-

rate person . . . I have also discovered what I never knew before, the dread of being abandoned and left alone. I am happy about him, though." He would rephrase this sentiment more succinctly fifteen years later:

> If equal affection cannot be,
> Let the more loving one be me.

For Auden, as for all of the residents of 7 Middagh Street, the more loving partner was the more creative one. "He makes me suffer and commit follies," Auden wrote about Kallman that January, a few days after Chester's twenty-first birthday, "without which I should soon become like the later Tennyson."

There was no danger of that as Auden proceeded full force with "For the Time Being," churning through the moral and psychological implications of those dismaying times to produce works of art that would sustain generations of readers. Even as he turned the dross of private catastrophe into poetic treasure, his own words reflected back at him in a way that helped him learn to live with the life fate had given him. On Christmas Day, 1941, while at work on "For the Time Being," Auden thanked Kallman for giving him the shock he needed in order to continue growing:

Dearest Chester
 it is in you, a Jew, that I, a Gentile, inheriting an o-so-genteel anti-semitism, have found my happiness:
 As *this* morning I think of Bethlehem, I think of you.
Because it is you, from Brooklyn, who have taught me, from Oxford, how the most liberal young man can assume that his money and his education ought to be able to buy love;
 As this morning, I think of the inn stable, I think of you. Because, suffering on your account the torments of sexual jealousy, I have had a glimpse of the infinite rudeness of masculine conceit;
 As this morning, I think of Joseph, I think of you . . .
Because it is through you that God has chosen to show me my beatitude,
 As this morning I think of the Godhead, I think of you.
Because in the eyes of our bohemian friends our relationship is absurd;
 As this morning I think of the Paradox of the Incarnation, I think of you.
Because, although our love, beginning Hans Andersen, became Grimm, and there are probably even grimmer tests to come, nevertheless I believe that if only we have faith in God and in each other, we shall be permitted to realize all that love is intended to be;

As this morning I think of the Good Friday and the Easter Sunday already *implicit* in Christmas Day, I think of you."

Benjamin Britten and Peter Pears, meanwhile, had been haunting the offices of the Cunard steamship line trying to obtain tickets on any ship bound for England. The sense of urgency increased in February, when Boston's Serge Koussevitsky offered to commission Britten's *Peter Grimes*. "I have reached a definite turning point in my work," Britten wrote excitedly to his brother-in-law in England, "& what I most want is to be able to think & think & work & work, completely undistracted for a good period of time. If it were in normal times this would be completely possible — but, my problem is only that of probably about 40,000,000 . . . ambitious young men."

Like Chester Kallman, Britten had received a kind of summing-up letter from Auden that winter — one that he did not at all appreciate. Apparently written without any knowledge of the incident with the Rothmans, it reflected an astounding perceptiveness on Auden's part about the conflicts that the young Britten would have to face up to and resolve. Having expressed his sadness over Britten and Pears's departure from America and his love for them both, Auden quickly moved on to express his thoughts about Britten and his work during the past year:

> As you know I think you [are] the white hope of music; for this very reason I am more critical of you than of anybody else, and I think I know something about the dangers that beset you as a man and as an artist because they are my own.
>
> Goodness and Beauty are the results of a perfect balance between Order and Chaos, Bohemianism and Bourgeois Convention.
>
> Bohemian chaos alone ends in a mad jumble of beautiful scraps; Bourgeois convention alone ends in large unfeeling corpses.
>
> Every artist except the supreme masters has a bias one way or the other . . . For middle-class Englishmen like you and me, the danger is of course the second. Your attraction to thin-as-a-board-juveniles, i.e., to the sexless and innocent, is a symptom of this. And I am certain too that it is your denial and evasion of the . . . demands of disorder that is responsible for your attacks of ill-health, i.e. sickness is your substitute for the Bohemian.
>
> Wherever you go you are and probably always will be surrounded by people who adore you, nurse you, and praise everything you do . . . Up to a certain point this is fine for you, but beware. You see, Bengy dear, you are always tempted to make things too easy for yourself in this way, i.e. to build

yourself a warm nest of love (of course when you get it, you find it a little stifling) by playing the lovable talented little boy.

If you are really to develop to your full stature, you will have, I think, to suffer, and make others suffer, in ways which are totally strange to you at present, and against every conscious value that you have; i.e., you will have to be able to say what you never yet had had the right to say — God, I'm a shit.

This is all expressed very muddle-headedly, but try and not misunderstand it, and believe that it is only my love and admiration for you that makes me say it.

The letter could not have been more poorly timed. Having spent several months working through this very issue on his own, Britten was no longer prepared to take advice from Auden. Answering Auden's letter with the statement that his relationship with Pears was hardly of the schoolboy variety, he ignored the additional movements of the Christmas oratorio that Auden had sent (now including, in Britten's opinion, a ludicrously wordy Fugue that would be impossible to set to music), and instead wrote to Isherwood, asking if he would be interested in writing the libretto for *Peter Grimes*. Isherwood, helping to resettle refugees at the Quaker camp in Pennsylvania, turned down the offer in surprise, and Britten was left to search for another collaborator to take Auden's place.

For the moment, the composer was satisfied. "I feel much, much older &, well perhaps wiser," he had written to a friend some months before. And now, consciously or unconsciously echoing Auden's own words, he added to his brother-in-law, discussing the need for discipline and obedience in life, "in art, as you know, the bias is . . . that of anarchy and romantic 'freedom'. A carefully chosen discipline is the only possible course." The experience of being in America, able to look back on his homeland and on his past with increased objectivity, had allowed Britten to decide for himself what he needed. And what he needed was not the sloppy, scandalous, bohemian life of Auden and his friends at Middagh Street but the ordered, civilized environment represented by Peter Pears and all of England. He was ready for the next stage of his creative development, and it would not take place in America.

In March 1941, two places on a small Swedish cargo ship became available, and Britten and Pears were at last able to depart. On the journey home, Britten worked hard, despite the cramped quarters and the constant fear of attack, to wrap up the work of an "American" period that was already receding into his past. By their arrival, he had finished the

music for Auden's "Ode to St. Cecilia." It was the last work on which the pair would collaborate. Nor would the two artists' friendship fully survive the year they spent together in America.

Shortly after his arrival, Britten invited the poet and journalist Montagu Slater to write the libretto for *Peter Grimes*. The collaboration proved exceptionally fruitful, and in time the opera was hailed by critics as among the most original and groundbreaking works of the twentieth century. Expressing the dark undertow of Britten's personality to a degree that Auden could hardly have imagined, *Peter Grimes* opened the way for more than three decades of brilliant, strong, and original music. As his abilities blossomed, so did Pears's. Once in England, Pears put his vastly improved singing technique to work in winning the title role in the opera *Tales of Hoffman*. The acclaim with which his performance was greeted assured him a career as long and successful as Britten's

It was strange at first, being back in England after their transformative years abroad. While Britten was quick to exclaim that "Snape is just heaven, I couldn't have believed that a place could be so lovely," he also wrote, "The first impression of the country is a sort of drab shabiness [sic]. All the excitement of the 'blitz' (except for isolated spots) has died down, & people seem very, very tired. Musical life doesn't really exist . . . So far people have all been nice to me, and there has been no suggestion of vindictiveness. In one or two places, *over*-kindness, which makes one suspicious." To his great relief, he got through the review by tribunal of his claim to conscientious objector status and was granted an unconditional exemption from military duty. Despite the relative ease of this transition, however, he found that he missed the country he had just left. He wrote to Elizabeth Mayer that, even as he enjoyed the help and friendship of his fellow artists, including Stephen Spender and especially Louis MacNeice, and however much he loved England, "I feel that, come what may, half my life is now tied up with America." Despite his break with Auden, he begged Elizabeth for reports about him as well as Isherwood, McPhee, and Copland. "I am so keen to hear their news," he wrote, "& I hate to feel that they're forgetting me!"

Mayer was happy to comply, dropping in at 7 Middagh Street for occasional visits and passing on to Britten and Pears any news she picked up. By the spring of 1942, she was able to report that Carson McCullers, Wystan Auden, and Colin McPhee had each won a Guggenheim fellowship to complete *The Member of the Wedding*, *For the Time Being*, and *A House in Bali*, respectively. ("Our average income was $25 per week," Oli-

ver Smith later joked, "most of it from the Guggenheim Foundation.") Carson maintained a room at 7 Middagh for years, using it occasionally as she moved from Georgia to Yaddo and back again. The novelist Richard Wright, who was entranced by Carson when he finally met her, moved to 7 Middagh Street with his family in 1942. While their neighbors had appeared remarkably tolerant of the wild goings-on at the house in previous years, occupancy by a black man, his white wife, and their baby daughter was another matter. Stones were thrown at the windows, and the coal deliverer, himself African American, resigned rather than serve someone of his own race. Nevertheless, it was Wright who chose to leave the house after a year. He found it too painful, he said, to witness Carson's self-destruction through drinking and George's dangerous adventures among the bars and brothels of Sands Street.

Carson, however, continued to find her life in Brooklyn Heights uniquely nurturing. Throughout the war years, she treasured her visits with George, who was always ready to enjoy a drink with her in the parlor or to trudge through the snowdrifts for a meal at their favorite Chinese restaurant, a few blocks away. In 1943, when Reeves wrote to Carson after more than a year without contact, George served as go-between as the couple considered reuniting. In his letters to Carson, Reeves claimed to understand now what a consuming process it was to write a novel and to have shed his jealousy of her success. Carson was impressed by Reeves's courage as a member of the elite Rangers assault outfit during the Normandy invasion and on the front lines in Germany. They remarried in 1945, and though their marriage again proved destructive — ending with Reeves's suicide in Paris in 1953 — everyone agreed that their bond had in the end been impossible to sever and that they had simply been destined to experience life together. Carson survived her husband by only fourteen years, dying from a series of strokes and severe illnesses in her home in Nyack, New York.

Ironically, the fate of Jane Bowles, Carson's temporary replacement at Middagh Street, proved remarkably similar to her predecessor's. Shortly after the Pearl Harbor attack, Jane showed her finished novel to her husband. When he objected strenuously to its many grammatical and spelling errors — shouting, "You can't let anyone see such an abject manuscript!" — she replied calmly, "They don't publish a book because it has perfect spelling, Gloompot." While not a commercial success, *Two Serious Ladies* survives as an utterly original, uniquely feminine literary work. Jane went on to publish a short story collection and to see her play,

In the Summer House, produced by her cousin-in-law Oliver Smith; but as Paul's writing career took off with the publication of *The Sheltering Sky,* Jane's fell victim to alcoholism and neurosis. Jane died at fifty-six in Spain, blinded by strokes and institutionalized, while Paul survived into old age as a successful, if alienated, author, living an exile's life in Morocco.

Oliver Smith's future was a happier one. After his work on *Saratoga,* Pavel Tchelitchew recommended him as set designer for the Ballet Russe production of *Rodeo.* Choreographed by Agnes de Mille to Aaron Copland's score, the Western ballet became a smash hit and is still performed around the world. Next, Oliver worked with the brilliant young choreographer Jerome Robbins and the composer Leonard Bernstein on *Fancy Free,* a "ballet story" about a pair of naïve young sailors on shore leave in New York. *Fancy Free,* whose setting at a waterfront bar resembled the raucous Sands Street haunts in Brooklyn, proved enormously successful and was soon transformed into the musical play *On the Town;* it was subsequently made into a hit Hollywood film. In 1945, Carson wrote to Reeves in amusement: "Oliver Smith has *produced* a show called On The Town, which is the most successful comedy in many years. The critics agree that it is the best thing of its kind in ages, and now suddenly he is wallowing in wealth. Two weeks ago he couldn't pay George the rent."

Smith earned enough money from that play and film to buy a twenty-eight-room, yellow brick Brooklyn Heights mansion on Willow Street, which he had long admired. There, he recreated his Middagh Street attic studio, invited as houseguests such artists as Truman Capote, one of George Davis's discoveries who would write *Breakfast at Tiffany's* and *In Cold Blood* in Oliver's basement, and rested between such culturally defining design and production projects as *Brigadoon, Gentlemen Prefer Blondes, West Side Story, My Fair Lady, Flower Drum Song, Camelot, Hello, Dolly!, Oklahoma, Guys and Dolls,* and *The Sound of Music.* Years later, he remarked that *West Side Story* had been inspired by the walks he and Jerome Robbins used to take under the Brooklyn Bridge and down by the docks around Sands Street. Consequently, he confided to a reporter, the set for that show was really "more Brooklyn than Manhattan — but don't tell anyone."

Like Smith, Gypsy Rose Lee succumbed to a severe case of house-lust in the wake of her stay at Middagh Street. In 1942, after Mayor La Guardia's successful efforts to ban burlesque entertainment in New York

City, she invested in Mike Todd's idea to cash in on the free publicity by producing a Broadway show about burlesque, to be called *Star and Garter* and starring Gypsy herself. Todd wagered that the general public would pay Broadway rates to see a sanitized version of forbidden entertainment, and his bet paid off enormously. Gypsy's thirty-nine and five-twelfths interest in the production — along with the royalties from *The G-String Murders* and its well-reviewed but financially less successful sequel, *Mother Finds a Body* — brought in enough cash to buy a fixer-upper mansion, also with twenty-eight rooms, on East Sixty-eighth Street in Manhattan.

Even better, Gypsy was able to wrap her great love, Mike Todd, tight in the apron strings of her bank account. Their correspondence during this period consisted of a dizzying series of IOUs, promises to pay, promises to invest more, and promises to pay more back. Still, despite their close financial relationship, Gypsy was unable to get the married producer divorced and back to the altar. By the time they produced Gypsy's first play, *The Naked Genius,* on Broadway, Todd had become a widower. But he cast Joan Blondell instead of Gypsy in the starring role — and when the playwright was panned but the actress praised by Broadway critics, Todd married Blondell. Gypsy, knocked down again but certainly not out, consoled herself with a new movie career, an affair with Otto Preminger (with whom she had a son), and the successful publication of *Gypsy,* the autobiography that led to the successful Broadway play. Years later her son, Erik Lee Preminger, wrote that, though his mother would always be "an entertainer first and a writer second," she was never happier than when at her typewriter. Given her lack of formal education, he added, Gypsy never could have found this lifelong source of satisfaction without the help of George Davis.

At *Mademoiselle,* where George continued to nurture new talent, its editorial assistants watched in awe as Gypsy Rose Lee, Christopher Isherwood, Wystan Auden, Carson McCullers, and an occasional French sailor dropped in to take George out to lunch or for drinks at the Russian Tea Room. George continued to fascinate the fashion magazine set, with his dark, gloomy office crammed to overflowing with musty antique furniture, his sly, knowing stories, and his illustrious roster of friends. At *Mademoiselle,* George soon found an assistant willing to cash his paychecks for him, to cover for his frequent absences, and to manage the waiting room outside his office, where his appointments "multiplied like planes stacked up over La Guardia" — and even to make editorial house calls to

his home, now shared with "a parrot with the usual bad disposition, a small, unraveled dog upstaged by half a dozen feline thugs," and a giant Austrian houseman whom George allowed to steal from him because he brought him orange juice in bed.

Eventually, this eccentric behavior would get George into trouble at *Mademoiselle* as it had at *Harper's Bazaar*. He left the magazine to help his friend Fleur Cowles, the wife of the publisher of *Look* magazine, launch *Flair*, a no-expenses-barred, modernist magazine. Yet again, after publishing the works of Tennessee Williams, Jean Cocteau, Gypsy Rose Lee, and Salvador Dalí, George was dismissed from *Flair* for his refusal, or inability, to conform to office procedures. But the cycle was finally broken when, in 1951, a year after the death of Kurt Weill, George married the composer's widow, Lotte Lenya. While the marriage may have initially been based on Lenya's need for company and George's for room and board, they soon found a new purpose in their shared effort to preserve Weill's place in the American musical canon, beginning with the wildly successful 1954 revival of *The Threepenny Opera* and continuing with Lenya's classic recordings of that opera as well as Weill's *Seven Deadly Sins* and *Mahagonny*. If George Davis had contributed nothing to American culture other than the Weill renaissance, for which he was wholly responsible, he deserved to die as contented as he did in 1957, of heart failure in Berlin, while helping Lenya, his last protégée, realize her artistic dream.

In the years between the attack on Pearl Harbor and George's death, the 7 Middagh Street alumni regularly reunited in various combinations to create new works. In 1946, Oliver Smith collaborated on a Tanglewood Music Festival production of Britten's *Peter Grimes*, now acknowledged as the first true British musical masterpiece of his generation. In 1952, he coproduced the successful revival of *Pal Joey*, the Broadway musical that had made Gypsy's sister, June Havoc, an overnight star. Colin McPhee dedicated his memoir, *A House in Bali*, to George, who had not only provided Colin with a place to live for many years but tirelessly bullied him into sticking with the book through its 1944 publication. Meanwhile, McPhee's musical transcriptions were performed alongside Britten's work and included on numerous occasions in the annual Aldeburgh Festival of Music and the Arts, founded by Britten in his beloved seaside village.

In 1943, Paul Bowles and Salvador Dalí collaborated on a ballet (a di-

saster in Bowles's opinion, a triumph in Dalí's), and three years later, Smith coproduced Paul's adaptation of Jean-Paul Sartre's *Huis Clos*, renamed *No Exit*. In 1946 and 1947, Janet Flanner and Natalia Murray introduced Carson to literary society in Paris and Rome. And in 1953 Kay Boyle, George Davis's old friend from 1920s Paris and by then one of Carson's closest confidantes, dedicated a poem to her two friends from Middagh Street, Carson and Reeves.

In a sense, then, creative life would go on as it had before Pearl Harbor, but in many ways, Carson and George had been right when they sensed the urgent need to focus on their work as long as they could because things would never be the same. With the American entry into the war, nearly all of the residents of Middagh Street were forced to put down their work, at least temporarily, and take a stand of some kind. Isherwood, Britten, and Pears successfully defended their claims as conscientious objectors, serving their countries in productive ways without ever holding a weapon. Auden, desperately working at his Christmas oratorio in hopes of completing it before being drafted, was in the end rejected by the military as psychologically unfit — that is, for being homosexual. Angry over his treatment by the "unpleasant and grotesquely ignorant" psychiatrist in charge, Auden finally managed an official assignment near the end of the war: accompanying James Stern on a mission to interview German citizens on the effect of Allied bombing raids on public morale. ("We got no answers that we didn't expect," Auden later remarked.) Meanwhile, Chester Kallman, who was not required to serve due to a slight curvature of the spine, took the only employment of any length he would ever hold — reviewing the correspondence of prisoners of war for the U.S. Censorship Office.

One frequenter of Middagh Street who responded to the crisis in a way no one could have predicted was Klaus Mann, now freed up by the demise of *Decision* and, by the end of 1942, having completed his autobiography along with a biographical study of his former mentor, André Gide. After several attempts to be accepted into the U.S. Army, he finally succeeded in December 1942. Still depressed nearly to the point of suicide, Klaus said that if his life were of no use to him, it might as well be put to use in the fight against Hitler.

To his own surprise, however, military life agreed with him. Inducted at Fort Dix, New Jersey, and transferred to a number of other training camps, the thirty-six-year-old writer was promoted from private first

class to staff sergeant within four months of enlisting. His obvious intelligence and fluency in German led to his assignment to the propaganda arm of the Psychological Warfare Branch of Military Intelligence, where he composed leaflets and appeared at the Italian front with a loudspeaker, urging German soldiers to surrender. Klaus endured enemy fire on numerous occasions and risked his life more than once. After the war, he chose to remain in uniform and work as a staff writer for *Stars and Stripes,* the American military journal.

While others among the 7 Middagh Street crowd — such as Lincoln Kirstein and Reeves McCullers — experienced great satisfaction through their military service, a few — including Paul Bowles and George Davis — were dismissed as homosexuals and forbidden to serve. Gypsy worked tirelessly for the war effort through a string of performances at military bases, the USO, and other organizations, while Carson wrote patriotic articles for American magazines and kept up an encouraging correspondence with Reeves. Even Brooklyn Heights did its part: its shops served more than seventy thousand employees of the Navy Yard at its peak, and many of its brownstones were requisitioned by the military as lodgings and jukebox canteens.

The house itself did not survive the war. In 1945 it was torn down to make room for the Brooklyn-Queens Expressway, encircling the two boroughs. George Davis, who had just renewed his lease for another five years, was forced to move to Manhattan, where he rented another brownstone until it, too, was demolished. After a brief and miserable time at the seedy midtown Hotel Columbia, he moved into Lotte Lenya's country house, bought with the proceeds of the 1941 production of *Lady in the Dark.* Now, nearly six decades later, all that remains of the unusual brownstone is a triangle of grass, a square of concrete sidewalk, and a sign: NO STANDING.

But life in Brooklyn is still slow and dreamy, and the streets are still filled with neatly dressed children and their nannies and rows and rows of maple trees. From where I sit at one of the rickety outdoor tables at the coffee shop on the corner of Middagh Street and Willow, I can see the spot where the house used to be. Sipping my coffee, I watch a tall, lanky girl in a man's blazer and a baseball cap cross the street, pause at the window of the rare book shop on the opposite corner, then continue down Middagh to the Brooklyn Promenade. Does she know, I wonder, how closely she resembles the fiercely ambitious young visionary who once

made a home here? When she paused at the bookstore, did she notice the word DRUGS detailed in the mosaic beneath her feet, the only reminder of the shy pharmacist, Mr. Parker? Does she have any idea that the bluff so crudely cut in half once supported an overgrown garden full of a poet's cats and apple trees whose fruit could go into a burlesque performer's strudel? Probably not, I decide, as she looks out across the harbor, takes a deep breath of salt air, and continues on. But some signs remain for those who know where to look.

There is, for example, a box of Gypsy's photographs of herself at the New York Public Library for the Performing Arts that contains one beautiful full-figure portrait of the twenty-three-year-old Carson McCullers in Central Park. In George's papers at the Weill-Lenya Center on West Twenty-eighth Street you will find the notebook in which Auden entered early drafts of "Anthem for St. Cecilia's Day," a tribute to Britten, and "The Quest," perhaps written partly in reference to Chester Kallman. Letters from Janet Flanner are in Carson's papers in Texas, and in Auden's archives in Manhattan is a handwritten, unfinished tribute to George. Still retained among Britten's belongings in his old house near Aldeburgh is a handwritten bill for rent and expenses, carefully enumerated on a scrap of lined notepaper in Auden's hand:

BENGY AND PETER

Food for two weeks	11.97
Service, laundry, coal etc. for two weeks	32.93
Putting in buzzer	4.50
Rent for Jan.	12.50
Total	61.90
Paid	<u>19.00</u>
Remaining	42.90

But perhaps the best place to look is the rare book shop itself. Its display windows and shelves are filled with the results of the 7 Middagh residents' and visitors' industry. These artists, all of them under thirty-five, did not accomplish everything that they had hoped before the war, but much of their best work was either created in the house or inspired during their stay. *For the Time Being, The Sea and the Mirror,* and *The Age of Anxiety* — in addition to such classic poems as "Leap Before You Look" and "In Sickness and in Health" — are considered by many critics to be Auden's most significant works. Carson's *Ballad of the Sad Café* and *The*

Member of the Wedding represented the high-water mark of her career. While Britten may not have achieved the worldly success he had hoped for in America, he made enormous emotional and artistic progress, composing his first symphony and opera and maturing in ways that made it possible for him to create his first dramatic masterpiece, *Peter Grimes*. Gypsy Rose Lee, of course, had finally added the title of "author" to her name, and Jane Bowles wrote the only novel she would publish in her life. Paul Bowles, despite his conflict with Auden, was sufficiently inspired to drop music in favor of literature. Louis MacNeice, Klaus Mann, Colin McPhee, and Salvador Dalí summarized their experiences in autobiographies or memoirs immediately after leaving the house. And, of course, George Davis would go on, for the rest of his life, nurturing the artists whose lives he happened across — even when, as was increasingly the case as time passed, he was unable to care for himself.

Auden and Britten's friendship, however, did not survive the Middagh Street experiment in any meaningful way. While Britten spent his remaining years with Peter Pears in England, Auden became an American citizen in 1946 and continued to live in New York in what he called a "cheerful unhygienic mess" almost until his death in 1973. After the war, he purchased a house in Austria and lived there half of each year with Chester Kallman, writing poetry in the morning and, in the afternoon, collaborating with the Brooklyn poet on the libretti for such operas as Stravinsky's *Rake's Progress*. The sexual component of the men's relationship never resumed — the moment Auden returned to New York each winter, Kallman escaped to a sybaritic life in Greece — but, for Auden, half a marriage was better than none. After his death from a heart attack (in his sleep, in a hotel room in Austria), Kallman suffered an emotional collapse and died himself sixteen months later.

All these years, Auden, who so treasured his friendships, remarked more than once that he had lost only one friend in his life — though he was too polite to name Britten. Whenever the subject of *Paul Bunyan* came up, he called it a failure and blamed his own inexperience and ignorance, as a result of which "some very lovely music of Britten's went down the drain." Britten ignored the opera completely, half-pretending it didn't exist even when Pears dug up the libretto and score decades later and suggested that they try it again.

In 1974, however, after heart surgery that left him too weak to continue composing, the sixty-year-old Britten reluctantly agreed to revive *Paul Bunyan* for a BBC radio broadcast and, later, a performance at the Alde-

burgh Festival. It was, recalled his biographer and close friend, Donald Mitchell, among the very last performances of his music in which he was able to be involved. When he listened to the recording in 1976, when it was first broadcast, Auden was already dead, and Britten himself would die within the year.

Now, listening to the recording, Mitchell later wrote, the aging composer "was deeply moved by the operetta he had created with his old friend all those years ago." The sheer exuberance of the music and words by these young artists in their prime could not help but bring back those years in America, when all had seemed possible and everything was at stake. Britten "was profoundly touched — sometimes to tears — by such lines as 'Once in a while the odd thing happens' — 'That was Peter,' he once confided about that particular chorus . . . and the great Litany at the end of Act Two . . . He turned to me on one occasion . . . and said, 'You know, Donald, I simply hadn't remembered that it was such a strong piece.'"

Perhaps, in the end, what was produced is not as important as the fact that these bold young artists, believing in and committed to the importance of their work, took action to pursue the truth as best they could before the events of history conspired to redirect their efforts. In coming together, they placed their faith in a creative energy that, at the very least, was bound to send them off on exciting new trajectories. And it was this journey that was the point of 7 Middagh Street, more even than the results. As Colin McPhee wrote in the sad, silent days after the house at 7 Middagh was torn down, "My few friends admire or love me, not for what I've accomplished, but for what they think I might have done. And ultimately, a work of art that does not exist is the most beautiful work of all — it's a rich blend of nostalgia, stoicism, and futility. Shake well, add fresh ginger, and pour through a fine sieve."

Author's Note
and Acknowledgments

The history of a year in the lives of a group of well-known artists necessarily depends on the scholarship accomplished by each individual's biographers. I would like to thank the following authors for their full-length portraits of the residents and guests of 7 Middagh Street or commentaries on their works. Katherine Bucknell, Gena Dagel Caponi, Humphrey Carpenter, Virginia Spencer Carr, Richard Davenport-Hines, Carlos Dews, Millicent Dillon, Irving Drutman, John Fuller, Ian Gibson, June Havoc, Peter Hoffer, Nicholas Jenkins, Edward Mendelson, Donald Mitchell and Philip Reed, Carol Oja, Erik Lee Preminger, Jerry Rosco, Josyane Savigneau, Donald Spoto, Jon Stallworthy, Nicholas Fox Weber, and Brenda Wineapple.

I relied as well on the knowledge and expert assistance of the curators and archivists Nicholas Clark at the Britten-Pears Library in Aldeburgh, England; Sue Hodson of the Huntington Library's Christopher Isherwood collection in San Marino, California; Ursula Hummel of the Münchner Stadtbibliothek, Monacensia Literature Archives, Collection Klaus Mann; Isaac Gewirtz, Philip Milito, and Wayne Furman of the New York Public Library's Henry W. and Albert A. Berg Collection; John Vallier of the UCLA Ethnomusicology Library; David Stein of the Kurt Weill Foundation for Music; and the staffs of the Goethe Institute in New York City, Harry Ransom Humanities Research Center in Austin, Texas, the New York Public Library for the Performing Arts, Yale University's Beinecke Library and its Sterling Memorial Library's Manuscripts and Archives Department, the Bodleian Library at Oxford, the Brooklyn Historical Society, the Brooklyn Public Library, Indiana University's Lilly

Library, the New York Public Library's Humanities and Social Science Library, and the Museum of Television and Radio in New York.

The literary executors Don Bachardy, Barbara Thompson Davis, Peter Davis, the estate of Dorothy Farnan, Floria V. Lasky, Edward Mendelson, and Erik Lee Preminger were more than generous with their time and assistance. Mark McCloud of the Curtis Brown Agency and Robert Lantz of the Lantz Office made every effort to facilitate the permissions process.

Peter Banki kindly translated research materials from German, and Dana Stevens, from French. Robert Nedelkoff, whom I have never met but who has become a true friend online, provided an impressive stack of interview leads and other information. Joel Block contributed valuable research documents. Aamin Cheema acted as consummate photography researcher. Susan Hamovitch provided a crucial collection of articles, including one by her mother, on the psychology of Paul Bowles. John Aielli magically produced just the right book on that same author at just the right time. Jan Van der Donk provided the portrait of Salvador and Gala Dalí. Janie W. Tippins demonstrated what a real librarian can do.

Many kind and enthusiastic people allowed themselves to be interviewed for this book. I would especially like to thank Kathryn Abbe, Don Bachardy, Peter Davis, Christine Evans, Gwen Franklin, Victor Guarneri, Erik Lee Preminger, and Dorothy Wheelock Edson for their valuable insights and information. Caroline Seebohm's and Elizabeth Moulton's essays about the British artists' American exile and about George Davis, respectively, proved invaluable. Kenneth Lisenbee of www.paulbowles.org extended both his knowledge and encouragement. The late Edward Jablonski, esteemed biographer of the Gershwins, took the time to describe what it was like to grow up in George Davis's Michigan and then to discover New York.

I would especially like to thank my agent, Gail Ross, and her staff at Gail Ross Literary Associates, who found the best possible home for my proposal in three breathtaking weeks. Leslie Breed contributed her own considerable talents in foreign rights. Deanne Urmy, my editor, has served as a passionate advocate for *February House* from the beginning, and her editorial comments were without exception both crucial to the book's development and wise. Melissa Grella accomplished a yeoman's task of organization. Luise Erdmann demonstrated her great sensitivity and care as manuscript editor. Walter Vatter, publicist, showed excep-

tional commitment to this project. And in England, Ben Ball's enthusiasm and informed understanding carried clearly across the Atlantic.

Early readers included the indispensable Eileen Keller, Prudence Tippins, and Janie W. Tippins. Joel Block, Marjorie Braman, John E. Elder, Joe Holley, Tara Holley, Carla Jablonski, Geeta Kothari, Rankin Tippins, Evelyne Worthington, and Mary Yznaga provided invaluable advice and encouragement. Vincent Polidoro and Sophia Nagornaya took the bus back to college so I could write. And without the loving companionship of Bob and Dash Mecoy there would be no point in writing anything.

Finally, I would like to thank Judy Willig and the staff of the Heights and Hill Community Center, which oversees the Brooklyn Heights Meals on Heels program, for introducing me to the wonderful people who first told me of the house on Middagh Street.

Notes

Abbreviations for frequently cited sources:

Berg The Henry W. and Albert A. Berg Collection of English and American Literature, The New York Public Library, Astor, Lenox and Tilden Foundations
BPL The Britten-Pears Library, Aldeburgh, England
BRC Billy Rose Theatre Collection, The New York Public Library for the Performing Arts
HL The Christopher Isherwood Collection, Huntington Library, San Marino, California
HRHRC Harry Ransom Humanities Research Center, The University of Texas at Austin
MAY Manuscripts and Archives, Yale University
MTR The Museum of Television and Radio, New York
PD Peter Davis archives (George Davis)
WLRC Weill-Lenya Research Center, The Kurt Weill Foundation for Music, New York

Part I. The House on the Hill

1 "All genuine poetry": Auden, Preface to *Oxford Poetry 1927,* in *Complete Works, Prose and Travel Books,* 4.

Chapter 1

3 "In the town": McCullers, *Heart Is a Lonely Hunter,* 3.
5 "sit-up-and-take-notice": Clifton Fadiman, "Books: Pretty Good for Twenty-two," *New Yorker,* June 8, 1940, 77.
"Maturity does not": Rose Feld, "A Remarkable First Novel of Lonely Lives," *New York Times Book Review,* June 16, 1940, 6.
6 "we had no": McCullers, *Illumination,* 19.
"we would just look": Ibid.
photographs of Carson's: Carr, *Lonely Hunter,* 97.
daughter was a genius: Ibid., 3.
7 "It was a shock": McCullers, *Illumination,* 16.

7 with a book: McCullers to Oliver Evans, July 20, 1963, HRHRC.
 freelance dog walker: Carr, *Lonely Hunter*, 45.
 "bizarre" changes: Ibid., 89.
 a year longer: McCullers to Hardwick Moseley, n.d., HRHRC (Series II, b24, f8).
 shunned by her neighbors: Carr, *Lonely Hunter*, 86.
8 "prominent and empty": Norman Mailer, in Caleb Crain, "Stormin' Norman," *New York Times Book Review*, December 19, 1999.
 "a power": Crain, ibid.
 written to a number: McCullers, *Illumination*, 20.
 "their faces shrill": McCullers, "The Cripple," HRHRC (Series II, b8, f5).
9 "A woman stood": Ibid.
 Davis's office had rejected: Geraldine Mavor to Carson McCullers, November 10, 1939, HRHRC (Series III, b25, f1).
10 babies delivered: G. Gordon Davis, "Funeral Stones," 2003.
 abandoned urchin: George Davis, "Dutchy Schmidt," *Harper's Magazine* (September 1935): 465.
 father had helped treat: Davis, "Funeral Stones."
 "coffee houses": George Davis, "A Letter in Passing: A Perverse Coloring of Greek-town Byplay," PD.
 "mysterious apparitions": Ibid.
 French sister-in-law: Peter Davis interview, August 23, 2003.
 Hôtel Saint-Germain-des-Prés: Wineapple, *Genêt*, 61–63.
11 "the whole comedy of the bar": George Davis, "Death of an Artist: A Memoir of Christian Bérard," WLRC (Series 37, b3, f33).
 "convoluted quiets": George Davis, "Memories of Christian Bérard in Paris," Spring 1949, WLRC (Series 37, b3, f31).
12 spent the night: Boyle and McAlmon, *Being Geniuses Together*, 359.
 "Like Brown's Cows": Flanner, *Paris Was Yesterday*, xviii.
 "Mere Oblivion": Harper & Brothers publishing contract, April 1, 1929, WLRC (Series 37, b4, f180).
 "The most important fact": Clifton Fadiman, "A Finished First Novel," *Nation*, 133 (October 14, 1931): 12.
 "might bring back": In "Noted Novelist Visiting Parental Home in City" (Ludington, Mich., 1931), PD.
 "They included me": Davis, "Memories of Christian Bérard in Paris."
13 "the early hurts": Ibid.
 read *My Life*: McCullers, *Illumination*, 54.
 adult acquaintance: Carr, *Lonely Hunter*, 71.
 photographs of carnival performers: Ibid., 127.
 pair of pinheads: Davis, "Notes," WLRC (Series 37, b3, f42).
14 "all life is theatre": Davis, "Memories of Christian Bérard in Paris."
 "magnificent kind of courtesy": Ibid.
 gestures and expressions: Peter Davis interview, August 23, 2003.
 burlesque dancers: Drutman, *Good Company*, 103.
 Bucket of Blood: Ibid., 104.
 "At least I have": Ibid., 92.
 "Shouldn't you have": Ibid., 100.

15 film star Marion Davies: Ibid.
hard-nosed, hard-drinking: Vreeland, *D.V.,* 15.
dancing at the St. Regis: Ibid., 88–89.
"violet velvet mittens": Vreeland, *Why Don't You?,* 36.
"an enormous white": Ibid., 35.
"the feelings and problems": "Meet the Magazine Editor," *Writer's Journal* (September 1947): 4.
16 more willing than: Clarke, *Capote,* 81–82.
"as pleasing as it was": Auden [Essays (6)], Berg.
"We ought": Isherwood, *Christopher and His Kind,* 313.
17 "We shot up": Isherwood, *Diaries,* 4.
performance staged especially: Isherwood, *Christopher and His Kind,* 313.
"All right": Ibid., 314.
"was a marvelous": Isherwood to Peter Davis, September 26, 1959, PD.
18 Bilious Margaret: brochure, George Davis Papers, WLRC (Series 37, b5, f308).
encounter with Greta Garbo: Carr, *Lonely Hunter,* 100.
"wearing out": Bertolt Brecht, "Yes, I Live in a Dark Age," *Decision* (October 1941): 75.
19 spent part of the $25 payment: McCullers, "Lecture," HRHRC (Series I, b9, f1).
listened to the news: McCullers to Emma DeLong Mills, 1939, Berg.
its own list: Marino, *Quiet American,* 45.
"warn an unaware": Mann, *Turning Point,* 271.
20 "very arresting": Ibid., 330.
"a strange mixture": Mann, June 26, 1941, in Savigneau, *Carson McCullers,* 67–68.
"She had a face": McCullers, *Illumination,* 21.
"like a boy": Carr, *Lonely Hunter,* 103.
spiritual twin: Carson McCullers to Reeves McCullers, September 21, 1951, HRHRC (Series II, b24, f9).
21 rather alarming: Savigneau, *Carson McCullers,* 74.
"It was going to be": McCullers, *Illumination,* 6.
"There is one thing": McCullers, "Sucker," *Mortgaged Heart,* 10.
Jewish refugee: Mann, *Turning Point,* 331.
22 their wedding night: McCullers to Emma DeLong Mills, September 29, 1937, Berg.
an entire novella: McCullers, broadcast interview of Carson McCullers and Tennessee Williams, 1945, HRHRC (Series 1, b2, f11).
"An army post": McCullers, *Reflections,* 3.
contract for $500: Carr, *Lonely Hunter,* 83.
23 "unslakable love of words": Moulton, "Remembering George Davis," 292.
"slick nuttiness": Drutman, *Good Company,* 107.
"indelibly entwined": Gwen Randolph Franklin interview, March 19, 2004.
named Frankie Abbe: Kathryn Abbe interview, March 16, 2004.
"How Young People Live": Moulton, "Remembering George Davis," 291.
"We all need a splash": Vreeland, *D.V.,* 122.
24 Edouard to America: Edouard de Bays to George Davis, January 30, 1939, WLRC (Series 37, b3, f99).
sailor in Montmartre: Clarke, *Capote,* 89.

24 mahogany fixtures: article on Georgia, McCullers, HRHRC (Series 1, b8, f5).

25 porcelain vases: Carr, *Lonely Hunter*, 126.
fun to gossip: Spoto, *Lenya*, 146.
"sipped their way": Ibid.
"energy of affection": Carr, *Lonely Hunter*, 123.
"face facts": Ibid., 171.

26 "astonishing humanity": Richard Wright, "Inner Landscape," *New Republic* (August 5, 1940): 195.
playing German *lieder:* Carr, *Lonely Hunter*, 114.
swiped Stegner's only bottle: Ibid., 113.

27 "Everything was weakening": Vreeland, *D.V.,* 95.
"larky" to depressed: Moulton, "Remembering George Davis," 287.
as the hot months: George Davis to Georgina Davis, n.d., PD.

28 cut it by half: Rosco, *Glenway Wescott Personally*, 94.
"Big Money magazines": Katherine Anne Porter to Glenway Wescott, January 23, 1941, in Porter, *Letters*, 188–89.
"Mrs. Cold Caramel": Phelps, *Continual Lessons,* 74.
cut the manuscript: Rosco, *Glenway Wescott Personally*, 94.

29 Carmel Snow's instruction: Dorothy Wheelock Edson interview, March 18, 2004.
even slapped Carson: McCullers, *Illumination*, 22.
Annemarie had met: Carr, *Lonely Hunter*, 107.
Carson lived: Savigneau, *Carson McCullers*, 74.
reading Louis Untermeyer's: Carr, *Lonely Hunter*, 115.
"It is our faith": Untermeyer, *From Another World*, 84.

30 if it was raining: Moulton, "Remembering George Davis," 286–87.

31 "The Call to Color": *Harper's Bazaar*, September 15, 1940.
"like ghosts shod": Edward R. Murrow, "A Reporter Remembers, Part 1," CBS Radio broadcast (February 24, 1946; original broadcast, August 24, 1940), R8510255, MTR.
"Like brother and sister": McCullers, *Illumination*, 23.

32 "All of us here": McCullers, *Heart Is a Lonely Hunter*, 193.

Chapter 2

33 "Summer was worse": Auden, "The Dark Years," *Collected Poems*, 283.
not the first time: E.A.W., "Treffpunkt Hamburg: George Davis" ("Meeting in Hamburg: George Davis"), newspaper interview of George Davis (October 1956), WLRC (Series 37, b4, f262).

34 George telephoned Carson: McCullers, *Illumination*, 23.

35 experiment with himself: Davis to Gypsy Rose Lee, December 26, 1940, BRC (Series I, Sub-series, b3, f2).
Carson's spirit: Reeves McCullers to Carson McCullers, September 14, 1944, HRHRC (Series III, b28, f3).

36 long-term lease: Lease renewal for 7 Middagh street, Brooklyn, 1946, WLRC (Series 37, b4, f220).

37 "just one word": Kirstein, "From an Early Diary," in Jenkins, *By With To & From*, 153.

37 Gulliver surrounded: Isherwood, *Diaries, Vol. I*, 12.
"Fuck! Stop that!": Norse, *Memoirs*, 65–66.
wrote a check: Paul Bowles to Peter Davis, August 25, 1959, PD.
38 wittiest person: Drutman, *Good Company*, 95.
39 might move in: Britten to Beth, Kit, and Sebastian Welford, September 18, 1940. In Britten, *Letters*, 862.
intrusive landlady: Auden to Mina Stein Kirstein Curtiss, September 18, 1940, Berg.
"largely dictated": Auden to Caroline Newton, February 2, 1942, Berg.
40 passenger liners: Frank Reil, "Brooklyn Waterfront," *Brooklyn Eagle* (November 4, 1940): 25.
hardly cracked: Auden, *"Yale Daily News* Banquet Address," March 6, 1941. In Auden, *Complete Works: Prose*, 2:119.
"Berlin meant Boys": Isherwood, *Christopher and His Kind*, 2.
"promised libido-land": In Seebohm, "Conscripts to an Age," 1.
"a city with no virgins": In Page, *Auden and Isherwood*, 8.
relax sexually: Isherwood, *Christopher and His Kind*, 3.
41 "complete freedom": In Carpenter, *W. H. Auden*, 86.
"You may throw": MacNeice, *Strings Are False*, 140.
"The attraction of buggery": Auden, journal, 1929, Berg.
"white slave traffic": Auden to Spender [1928]. In Davenport-Hines, *Auden*, 87.
"a middle-class rabbit": Ibid., 104.
42 "All this time": Auden, "1929, II," *Collected Poems*, 46.
"Before this loved one": Auden, "XV," *English Auden*, 31.
"Whispering neighbours": Auden, "XXVIII" (later "Autumn Song"), *English Auden*, 159.
"It is time": Auden, "1929, IV," *Collected Poems*, 49.
43 "this country": Auden, "The Orators," *English Auden*, 62.
"Lay your sleeping head": Auden, "Lullaby," *Collected Poems*, 157.
"The mortality": Jack Kroll, "W. H. Auden: Mapping the Twentieth Century," *Newsweek*, October 8, 1973, 117.
"O plunge your hands": Auden, "As I Walked Out One Evening," *Collected Poems*, 134.
"Young men": MacNeice, *Strings Are False*, 146.
too bourgeois by nature: Auden to Rupert Doone, 1932, Berg.
44 "I shall probably": Auden to E. R. Dodds. In Carpenter, *W. H. Auden*, 207.
"No one I know": Auden, "The Prolific and the Devourer," *Complete Works, Prose*, 2:411–58.
"P.S. — Congratulations": Dylan Thomas, "Twelve Comments on Auden," *New Verse*, nos. 26–27 (November 1937): 23–30. In Haffenden, *Auden*, 270.
45 "extremely embarrassing": In "Poet of Disenchantment," BBC Television, broadcast November 25, 1965, HL.
"a tourist's": Auden, *New Republic*, December 6, 1939, 208.
"dull, punching": Auden and Isherwood, *Journey to a War*, 71.
"War is bombing": Ibid., 202.
"The bottom": Ibid., 58.
"of course": Ibid., 58–59.

46 "clearly no national": Anthony Heibut, *Exiled in Paradise*. In Marino, *Quiet American*, 31.

"successful like": Auden, "In Time of War, XXIII," *English Auden*, 260.

"Behind each sociable": Auden, "In Time of War, XIV," *English Auden*, 257.

Daily Worker crowd: "Bubble Reputation," *Observer*, September 11, 1983.

a great poet: Davenport-Hines, *Auden*, 71.

"more aware": In Fenton, "Auden at Home," *New York Review of Books*, April 27, 2000, 12.

47 "That English life": "Poet of Disenchantment."

"I love my family": In Plimpton, *Poets at Work*, 288.

"dumb, chattering terror": MacNeice, *Strings Are False*, 174.

"sat in the Café Royal": Ibid.

"About suffering": Auden, "Musée des Beaux Arts," *Collected Poems*, 179.

48 "no past": Benjamin Appel, "Exiled Writers," *Saturday Review of Literature*, October 19, 1940, 5.

"penniless as before": Isherwood to George Davis, December 21, 1938, WLRC.

"a lonely": In MacNeice, *Horizon* 1/7 (July 1940).

49 "the leaders": *Harper's Bazaar*, October 1, 1938, 34.

"chemical life": Isherwood, *Diaries, Vol. I*, 10.

being subsidized: Carpenter, *W. H. Auden*, 372.

"The Americans": Isherwood to Kathleen Bradshaw-Isherwood, February 28, 1939, HL (CI 178).

50 college students: Farnan, *Auden in Love*, 18.

"Miss *Mess*": Norse, *Memoirs*, 62.

51 "It's the wrong blond!": Ibid., 64.

"I believed": Auden, "Heavy Date," *Collected Poems*, 262.

"I am mad with happiness": Auden to Britten, [ca. pre-June], 1939, Berg.

52 "wanted to get away": Isherwood, *Diaries, Vol. I*, 14.

"squat spruce body": Auden, "Poems 1931–1936," *English Auden*, 156.

scribbling poems: Farnan, *Auden in Love*, 23.

wore a wedding ring: Carpenter, *W. H. Auden*, 262.

53 accidentally walked off: Auden to Dr. Edward Kallman, July 5, 1939, Berg.

when Chester flirted: Norse, *Memoirs*, 75.

"unspeakable juke boxes": Auden, *Dyer's Hand*, 323.

"dotted with the houses": Auden to Mrs. E. R. Dodds, July 11, 1939. In Davenport-Hines, *W. H. Auden*, 196.

54 "The trouble": Auden, "The Prolific and the Devourer," *Complete Works, Prose*, 454.

"You keep evading": Ibid.

"For the first time": Auden to Margaret Mardiner, November 19, 1939, Berg.

55 "every hour or so": Auden to Mrs. E. R. Dodds, August 19, 1939. In Carpenter, *W. H. Auden*, 271.

"If you live": Edward R. Murrow, "A Reporter Remembers, Parts 1 & 2, 1941–1945," original broadcast August 31, 1939, R85:0256, MTR.

"I sit in": Auden, "September 1, 1939," Berg.

"The dive was": Norse, *Memoirs*, 79.

56 "I'm sure we are": Forster to Isherwood, October 31, 1939, HL.

57 false emotion: Plimpton, *Poets at Work*, 295. Interview by Michael Newman, 1973.

"infected with an incurable": In Mendelson, *Early Auden*, 201.

"every value": Auden to Nevill Coghill, January 19, [?1970], Berg. In Mendelson, *Later Auden*, 89.

"the brutal honesty:" [Spender], "The Dog Beneath the Gown," *New Statesman*, June 9, 1956, 656–57. In Mendelson, *Later Auden*, 89.

58 "While those whom": Auden, "Romantic or Free?" *Smith Alumnae Quarterly* (August 1940): 353–58. In Auden, *Complete Works, Prose*, 63.

"we must always hold": Ibid., 71.

"Terrifying powers work within us": In Fenton, "Auden at Home," 11.

"Hitler" in all of us: Ibid.

"I have tried": Adolf Hitler, in Salmaggi and Pallavisini, *2194 Days of War*, 73.

59 "ambitious young men": Cyril Connolly, "Comment," *Horizon* (February 1940): 68–69. In Carpenter, *W. H. Auden*, 290–91.

"four of our": In Carpenter, *W. H. Auden*, 291.

"Mr. Auden's brand": George Orwell, "Inside the Whale," March 1940. In Haffenden, *W. H. Auden*, 29.

Sir Jocelyn: Carpenter, *W. H. Auden*, 291.

very fair: Auden to Spender, [late April–early May?], Berg.

60 "pro-frog": Drutman, *Good Company*, 265.

a "serious" poet: In Foote, "Auden," *Time*, 113.

Chapter 3

62 "The house became": Davis to Gypsy Rose Lee, "Saturday Night" [ca. December 28, 1940], BRC (Series I, b3, f2).

63 "For concentration": Auden, "Letter to Lord Byron," *Collected Poems*, 106.

"At last": McCullers, *Illumination*, 23.

plywood partitions: Ibid., 20.

helped Carson pack: Carr, *Lonely Hunter*, 116.

64 Carson got to know: McCullers, "Brooklyn Is My Neighbourhood," *Vogue*, March 1, 1941. In McCullers, *Mortgaged Heart*, 216.

"always gives me": Ibid., 216–17

"The square of the hypotenuse": Ibid., 216.

65 "Isn't it wonderful": Webb, *Richard Wright*, 196.

"had the face": McCullers, "Brooklyn Is My Neighbourhood," 218.

66 "multiple bridal party": McCullers, *Illumination*, 23.

"lean, dark, and haggard": McCullers, "Brooklyn Is My Neighbourhood," 219.

Victor Guarneri: Victor Carl Guarneri interview, June 26, 2003.

Frankie Abbe: Kathryn Abbe interview, March 16, 2004.

67 "insane salads": Auden, *Dyer's Hand*, 323.

"a quarter of five": MacNeice, *Strings Are False*, 23.

on the sofa: Auden, [Essays (6)], Berg.

68 "sonnie boy": Carr, *Lonely Hunter*, 131.

68 canned green pea soup: Dr. Will Brantley, in "Exotic Birds of a Feather: Carson McCullers and Tennessee Williams," *Tennessee Williams Annual Review*, No. 3 (2000), www.tennesseewilliamsstudies.org.
idea that "'good' equals": Auden, "Mimesis and Allegory," *Complete Works, Prose*, 2:85.
69 "To set in order": Auden, "New Year Letter," *Collected Poems*, 200.
"one of those": Britten to Enid Slater, November 7, 1939, in Britten, *Letters*, 724.
writing table: Tony Palmer, director, "The South Bend Show: A Time There Was," BBC broadcast 1979, BPL.
70 the Devil himself: Fuller, *W. H. Auden*, 326.
"a crowd of lost beings": Auden, "The Reward of Patience," *Complete Works, Prose*, 2:154.
"George naked": Carpenter, *W. H. Auden*, 304.
"They're incredibly slow!": Pears to his mother, October 19, 1940, in Britten, *Letters*, 863–64.
71 beg the assistants: Moulton, "Remembering George Davis," 287.
"Uncle Wiz": Carpenter, *W. H. Auden*, 143.
"civilized meals": Isherwood, *Diaries*, 13.
nearby cafeteria: Benjamin Appel, "Exiled Writers," *Saturday Review of Literature*, October 19, 1940, 5.
"Dear Harry": Auden to Harry Brown, [ca. October 1940], Berg.
72 "getting on with the job": MacNeice, *Strings Are False*, 114.
dinner prepared for four: Victor Guarneri interview, June 26, 2003.
"I have the digestion": Auden to Chester Kallman, n.d., Berg.
"There are two things": In Carpenter, *W. H. Auden*, 305.
"a physician": In Nicholas Jenkins, "Auden Out Loud: 'A Tribute to W. H. Auden,'" *The W. H. Auden Society Newsletter*, 7 (October 1991): 13.
73 a word game: In Carpenter, *W. H. Auden*, 301.
"with inarticulates": Auden to Mina Kirstein Curtiss, n.d., Berg.
Emerson, Hawthorne: Appel, "Exiled Writers," 5.
he learned from: Auden to Spender, 1940, Berg.
Chester, on the other hand: Auden, "To Chester Kallman, b. Jan. 7, 1921," in Farnan, *Auden in Love*, 25–27.
74 insufficient weaning: Norse, *Memoirs*, 71.
bad breath: Farnan, *Auden in Love*, 36.
weakness lay: Norse, *Memoirs*, 63.
"I am *not*": Ibid., 70.
he fell in love: Farnan, *Auden in Love*, 45.
75 with his pinky: Jenkins, "Auden Out Loud," 13.
"Wystan is like": Kallman, notebook, ca. 1939–40, Berg.
76 Tania noted: Carpenter, *W. H. Auden*, 312.
"portrait of pure pride": Farnan, *Auden in Love*, 19.
"came away": MacNeice, *Strings Are False*, 114.
Mary Tucker: Carr, *Lonely Hunter*, 92–93.
77 sister, baby-child: McCullers [article on Georgia], n.d., HRHRC (Series 1, b1, f2).
"if I hadn't": Ibid.
"gobble and gossip": Drutman, *Good Company*, 261.

77 Naval officers: Christine Evans interview, April 25, 2001.
discreet assignations: Chauncey, *Gay New York*, 162.
Brooklyn's docks served: Frank Reil, "Brooklyn Waterfront," *Brooklyn Eagle* (November 4, 1940), 25.
78 Tony's Square Bar: Christine Evans interview.
"vivid old dowagers": McCullers, "Brooklyn Is My Neighbourhood," 219.
79 paid her $4,000: Laura Jacobs, "Taking It *All* Off," *Vanity Fair* (March 2003), 210.
"larger than Stalin's": Preminger, *Gypsy and Me*, 56.
"sepia Gypsy": Lee, *Gypsy*, 309.
"Gypsy Voga Lee": Nat Lefkowitz to I. Robert Mizzy, March 9, 1939, Gypsy Rose Lee Papers, BRC (Series III, b23, f4).
"Our Very Own": Lee, *Gypsy*, 309.
Billy Herrero: Unidentified newspaper clippings, Gypsy Rose Lee Papers, BRC.
"Gypsy Rose Flea": Drutman, *Good Company*, 78.
"Money in the bank": Havoc, *More Havoc*, 225.
Turkish cigarettes: Ibid., 228.
80 just after Gigolo: Lee, *Gypsy*, 91.
"almost alike": Ibid., 93.
81 "In the candle-lighted": Ibid., 94.
"These are poems": Ibid., 95.
"You don't dump": Ibid., 54.
82 freshly scrubbed and blooming: Drutman: *Good Company*, 120.
"Darlings, please": George Davis, "Gypsy Rose Lee: The Dark Young Pet of Burlesque," *Vanity Fair* 45/6 (February 1936): 51.
"Make 'em beg": In Jacobs, "Taking It *All* Off," 206.
83 "Like Eve I carry round this apple": Ibid., 207.
"Come on, Gyps": Drutman, *Good Company*, 120.
"need not know": Davis, "Gypsy Rose Lee," 51.
"Whither the New Negro?": Ibid., 52.
a new book "skintillating": Drutman, *Good Company*, 123.
"The great thing": Davis, "Gypsy Rose Lee."
84 "I wasn't naked": Havoc, *More Havoc*, 102.
"Experience not necessary": Jacobs, "Taking It *All* Off," 207.
"the undisputed queen": Davis, "Gypsy Rose Lee," 51.
four thousand letters of protest: Jacobs, "Taking It *All* Off."
Gypsy's mother, Rose: Havoc, *More Havoc*, 207.
Without her famous name: Preminger, *Gypsy and Me*, 40.
"I'm a Hollywood floppo": Havoc, *More Havoc*, 195.
85 "money at first sight": Ibid., 198.
"There's a no-talent broad": Ibid.
Schiaparelli sheath: Vreeland, *D.V.*, 95.
"Robert the Roué": Gypsy Rose Lee Papers, BRC (Series VII, Sub-series 3, b53, f20).
"I like my men": Lee to Charlotte Seitlin, July 7, 1941, BRC (Series VI, b45, f18).
86 "a classic paradox": Richard E. Lauterback, *Life*, December 4, 1942, 93.
three-inch fingernails: Havoc, *Pure Havoc*, 144.
fifteen-page description: Scrapbook, 1940, Gypsy Rose Lee Papers, BRC (Series X, vol. 1).

87 hardly finish reading: Ibid.

"strange, wonderful places": Lee, *Gypsy,* 93.

88 Two hundred dollars: Dorothy Wheelock Edson interview, March 16, 2004.

Chapter 4

89 "I wrote it": Lee, in Flanner, *G-String Murders,* flap copy.

"That's admirable": Janet Flanner interview, March 1, 1972, in Carr, *The Lonely Hunter,* 123.

persuaded him: Davis to Lee, "Saturday Night," [ca. December 28, 1940], BRC (Series I, b3, f2).

90 complete set of Balzac: Drutman, *Good Company,* 23.

Eva Morcur: Gypsy Rose Lee Papers, BRC (Series VI, Sub-series 1, b24, f1).

engaging a backstage lady's maid: Havoc, *More Havoc,* 143.

"You got your": Ibid.

flambé: Ibid., 101.

91 "Now, Victor": Donald Spoto, "Victor Carl Guarneri: An Oral History Interview," October 20, 1985, WLRC (Series 60).

lectures on Kierkegaard: McCullers, *Illumination,* 23.

Sophie and Boy: Davis to Lee, "Saturday night."

one square: Carpenter, *W. H. Auden,* 304.

"ever so Bohemian": MacNeice, *Strings Are False,* 35.

92 American draft number: "First Draft Number Is 158," *New York Times,* October 30, 1940, 1.

"conspiracy against our peace": Verne Marshall, "America Always," New York, WABC, January 1, 1941, MTR.

"the uproar": Mann, *Turning Point,* 337.

"Aren't we happy?": Ibid.

93 half-dressed strangers: Edward R. Murrow, "A Reporter Remembers, Part 1," CBS Radio broadcast (February 24, 1946; original broadcast, August 24, 1940), R85:0255, MTR.

harrowing mountain crossing: Marino, *Quiet American,* 167–69.

"like a great flag": Ibid., 168.

Mahler's music: Ibid., 164.

"flat-footed peace hyena": In Mann, *Turning Point,* 241.

"If they want": Ibid.

94 "the prince of the Manns": Carr, *Lonely Hunter,* 123.

"subordinate Klaus": Arthur Lubow, "Third Wheel," *New York Times Magazine,* December 28, 2003, 50.

Klaus's father: Reich-Ranicki, *Thomas Mann,* 166.

"Curiously, I can't": Mann, *Turning Point,* 338.

95 "after all, the [Fascist] dictators": Klaus Mann, "Two Confessions," *Decision* 1/1 (January 1941): 56.

"stimulating each other": Klaus Mann, "Issues at Stake: Decision," ibid., 8.

"Do you think": "Symposium," ibid., 45.

"intellectuals" separate from: Ibid., 44–45.

96 "as far as writers": Ibid., 45.
"very cagey": Isherwood, *Diaries, Vol. I,* 99.
press coverage: Seebohm, "Conscripts to an Age," 5–6, BPL.
97 "alarmist jealousy": Ibid., 5.
"*Poète,* why are you doing nothing?": MacNeice, *Strings Are False,* 27.
"Just a little statement": In Isherwood, *Diaries, Vol. I,* 99.
98 "black stone on which": Auden, "The Sea and the Mirror," *Collected Poems,* 441.
"Unless I am in love": Auden to Caroline Newton, April 13, 1942, Berg.
"the extraneous": In William Logan, "The Truth About Love," *New York Times Book Review,* May 23, 1999.
"rummaging into": Auden, "The Composer," *English Auden,* 239.
"Traditionally, poems are": "Poetry," *Time,* March 4, 1940, 72.
"Across East River": Auden, "New Year Letter," *Collected Poems,* 220.
99 "Where am I?": Auden, "The Maze," *Collected Poems,* 303.
"Airconditioning . . . Beauticians": Auden, notebook, Berg.
"What's freedom": Ibid.
first great admirer: Farnan, *Auden in Love,* 50.
clung to the hope: Ibid., 105.
100 open invitation: Auden to Caroline Newton, November 9 and 18, 1940, Berg. In Gopnick, "Double Man."
powerful tool: Auden, "Criticism in a Mass Society," *Complete Works, Prose,* 92–93.
"Time will say nothing": Auden, "If I Could Tell You," *Collected Poems,* 314.
"three stages": Carpenter, *W. H. Auden,* 286, quoting Louis Dupré, *Kierkegaard as Theologian.*
101 "abandon himself": Ibid.
slipping away: Golo Mann, "A Memoir," in Stephen Spender, ed., *W. H. Auden: A Tribute* (London: Faber & Faber, 1975), 102.
"at a special time, special tasks": In Mendelson, *Later Auden,* 151.
102 premiere of a new act: Davis to Lee, "Saturday Night," [ca. December 28, 1940], BRC.
103 early riser: Preminger, in Lee, *Gypsy,* 347.
cotton housecoat: Havoc, *More Havoc,* 224.
"get her ass pounded": Lee to Lee Wright, February 2, 1941, BRC (Series VI, b45, f18).
air of authority: Moulton, "Remembering George Davis."
104 would confess to George: Davis to Lee, "Saturday Night," [ca. December 28, 1940], BRC (Series I, b3, f2).
"For all your": Ibid.
"*la femme*": Flanner to Lee, 1955, BRC (Series I, b3, f3).
"Fiddle fiddle": Davis to Lee, December 26, 1940, BRC (Series I, b3, f3).
move out to her farmhouse: Ibid.
"to regard": Flanner to Lee, 1955, BRC (Series I, b3, f3).
105 "Miss *Bazaaar!*": Norse, *Memoirs,* 90.
"malice, callous": Kallman, notebook, ca. 1939–40, Berg.
"Upon the porch": Ibid.
surrounded by an admiring crowd: Farnan, *Auden in Love,* 48.

106 "is always right": Norse, *Memoirs of a Bastard Angel,* 67.

touring with Ziegfeld's: Lee, *Gypsy,* 32.

strip routines of Nudina: Ibid., 257.

Flossie, who covered: Ibid., 198.

appalled by the sight: McCullers, *Illumination,* 53.

Mrs. George Patton: Carr, *Lonely Hunter,* 91.

107 "the poetry of [her] own childhood": Broadcast interview of Carson McCullers and Tennessee Williams, 1945, HRHRC (Series I, b2, f11).

"flowering dream": McCullers, "The Flowering Dream: Notes on Writing," *Esquire,* December 1959, 162.

worn, if the night was chilly: Havoc, *More Havoc,* 224.

Hats on the bed: Preminger, *Gypsy and Me,* 11–12.

sit together: Reeves McCullers to Carson McCullers, October 16, 1943, HRHRC (Series III, b28, f2).

108 "I will make": McCullers, *Illumination,* 7.

"first love": Ibid., 6–7.

"somewhat limpet-like": Ibid., 53.

109 "My friend Carson": Rowley, *Richard Wright,* 135.

"I had bought": McCullers, *Illumination,* 32.

110 "thought truths out": In Davenport-Hines, *Auden,* 183–84.

gorgeous hunk of seafood: Norse, *Memoirs,* 90.

her favorite books: McCullers, "Books I Have Known," *Harper's Bazaar,* April 1941, 82.

experience of-a-lifetime: Britten, *Letters,* 900–901.

111 "The evening or rather morning": Britten to Antonio and Peggy Brosa, December 20, 1940. In Britten, *Letters,* 899.

"We ran for several blocks": Carson McCullers, "The Flowering Dream" (1959), typescript, August 28, 1958, HRHRC (Series I, b8, f14).

"I caught Gypsy's arm": Ibid.

112 a thin dusting of snow: *New York Times,* November 29, 1940, 1.

wolf collar coat: Stallworthy, *Louis MacNeice,* 286

"it is hard to risk": MacNeice, *Strings Are False,* 21.

"to a past": Ibid., 17.

"Beloved, we are always": Auden, "In Sickness and in Health," *Collected Poems,* 317.

Part II. The Bawdy House

113 "Here, I'm afraid": Britten to Enid Slater, June 27, 1939, in Britten, *Letters,* 2: 672.

Chapter 5

115 "Every day": Auden, *Paul Bunyan,* in Auden and Kallman, *Complete Works,* 46.

Snaggle-Tooth, a pimp: Drutman, *Good Company,* 105.

116 "like a whirlwind": MacNeice, *Strings Are False,* 35.

116 she was intelligent: Marcel Vertès to Gypsy Rose Lee, [ca. 1941], BRC (Series I, b3, f2).

117 "We would not think": Britten to Antonio and Peggy Brosa, December 20, 1940. In Britten, *Letters*, 899.

the sanitarium's superintendent: Seebohm, "Conscripts to an Age," 19.

118 "Gypsy did not strip": In Carr, *Lonely Hunter*, 119.

"Underneath an abject": Auden, "Twelve Songs, VII," *Collected Poems*, 140.

"I've got something": Auden to Britten, [ca. August] 1939, BPL.

"Dear Benjamin, Nothing": Auden to Britten, 1939, BPL.

119 Aaron Copland, who: Britten, *Letters*, 318.

120 "I am now definitely": Britten to Enid and Montagu Slater, December 29, 1938. In Britten, *Letters*, 603.

121 organize a new group: Britten, *Letters*, 907.

122 "Truth is always": Britten to Ralph Hawkes, September 8, 1940. In Britten, *Letters*, 858.

never be allowed back in England: Britten, *Letters*, 870.

"If people want": Britten to Ralph Hawkes, October 7, 1940. In Britten, *Letters*, 867.

123 haunted expressions: Marino, *Quiet American*, 90.

three hundred individuals: Ibid., 253.

"God, what a terrifying": Isherwood, *Christopher and His Kind*, 338.

124 "a diffuse but lusty": Mann, *Turning Point*, 272.

"focus the scattered energies": Ibid., 273.

"Paris is now": "Paris, Germany," in Drutman, *Janet Flanner's World*, 50.

125 "Have a good journey": Marino, *Quiet American*, 138.

"intellectual blitzkrieg": In Seebohm, "Conscripts to an Age," 10.

American Ph.D.'s: Ibid., 9.

"I like them": Ibid.

126 "The list of": Mann, *Turning Point*, 338.

"When this war began": Klaus Mann, "Issues at Stake: The City of Man," *Decision* 1/2 (February 1941): 6.

to define the moral, legal, and economic: Ibid.

127 "seen the bogus": Auden, "Tract for the Times," *Complete Works, Prose*, 109.

128 "I shan't feel": Auden to Isherwood, HL (CI 2991).

"Only your notes": Auden, "The Composer," *English Auden*, 239.

pompous and awkward: Mendelson, *Later Auden*, 162.

129 "always being out": Auden, "Tract for the Times," *Complete Works, Prose*, 109.

"A solitude": Auden, "Leap Before You Look," *Collected Poems*, 314.

"It happened": McCullers, *The Member of the Wedding, Collected Stories*, 257.

130 hospitalized in a psychiatric: Carr, *Lonely Hunter*, 133.

"pensive page": Mann, *Turning Point*, 187.

131 sexual affairs: Carr, *Lonely Hunter*, 172.

at the ballet: Ibid., 162.

"You're not to go": Ibid.

hard time understanding: McCullers, *Illumination*, 53.

132 Country Captain: McCullers, [article on Georgia], HRHRC (Series I, b1, f2).

"Here, precious": Carr, *Lonely Hunter*, 132–33.

132 her daughter's brilliance: Ibid., 132.

"The trouble": McCullers, "Loneliness . . . An American Malady," *Mortgaged Heart,* 260.

"On this night": McCullers, "Night Watch over Freedom," *Vogue* (January 1, 1941): 29.

133 "magnificent, incredible": In Mitchell, "Origins, Evolution and Metamorphoses," 130.

"It is a spring": Auden, *Paul Bunyan,* in Auden and Kallman, *Complete Works,* 10.

134 "Now that": Auden, "Opera on an American Legend," *New York Times,* May 4, 1941, Section 9, 7.

"America is what": Auden, *Paul Bunyan,* in Auden and Kallman, *Complete Works,* 46.

135 "the man of speculative": Auden, "Opera on an American Legend."

"It was out in the sticks": *Paul Bunyan,* in Auden and Kallman, *Complete Works,* 23.

"It isn't because": Ibid., 24.

136 "O but where": Ibid., 549.

repeatedly unzipping zippers: Havoc, *More Havoc,* 224.

"Anyway, now": Ibid., 227.

137 largest nightclub: Preminger, *Gypsy and Me,* 57.

"working-class Joes": Ibid.

"straight from 2500": Ibid., 58.

"Everything's going out": Drutman, *Good Company,* 105.

"like being all": Lee to Charlotte Seitlin, January 4, 1941, BRC (Series VI, b45, f18).

"if I have night lunch": Lee to Lee Wright, July 21, 1941, BRC (Series VI, b45, f18).

138 "Dammit, I love": Lee to Lee Wright, February 26, 1941, BRC (Series VI, b45, f18).

139 "got plastered": Davis to Lee, December 26, 1940, BRC (Series I, b3, f2).

"You have learned": Davis to Lee, "Saturday Night," [ca. December 28, 1940], BRC (Series I, b3, f2).

"The Victim": Davis, "The Victim," WLRC (Series 37, b3, f491).

"There's no use": Davis to Lee, December 26, 1940, BRC (Series I, b3, f2).

"That talk": Ibid.

140 "Dixie Darlings": Edward Jablonski interview, April 14, 2003.

periodic lynchings: Ibid.

she began longing: Virginia S. Carr, in "Exotic Birds of a Feather."

"Being home again": McCullers to Muriel Rukeyser, "Sunday Night," [ca. December 1940], Berg.

Carson sent George: Davis to Lee, December 26, 1940, BRC (Series I, b3, f2).

"fantastic old house": Ibid.

141 "Never before": Buhite and Levy, *FDR's Fireside Chats,* 165.

"I'm sitting here": Davis to Lee, "Saturday Night," BRC (Series I, b3, f2).

Chapter 6

142 "Ideas vibrate": McCullers, "The Flowering Dream" (1959), typescript, August 28, 1958, HRHRC (Series 1, b8, f14).

142 "common people": Verne Marshall, "America Always," New York, WABC, January 1, 1941, MTR.
Roosevelt made a detour: Buhite and Levy, *FDR's Fireside Chats*, 163–64.
"We must be": Ibid., 173.
143 "war gloom": "New Year's Revelry Downs War Gloom": *New York Times*, December 31, 1940, 1.
"This year is going": Isherwood, *Diaries, Vol. I,* 132.
return briefly to Brooklyn: Davis to Lee, January 15, 1941, BRC (Series I, b3, f2).
"All our reflections": Auden, "New Year Letter" (formerly "Letter to Elizabeth Mayer"), *Collected Poems,* 199.
wave of outrage: George W. Caldwell, "Ohio Mayor Bans Life picture, comments," *Life,* January 27, 1941, 2.
144 "One glance": "Decisions and Revisions," *Decision,* 1/3 (March 1941): 90.
"all culture": Saroyan, ibid.
"subscriptions and flattering comments": Mann, *Turning Point,* 341.
"oddly enough": Cyril Connolly, "Commentary," *Horizon,* January 1, 1941.
145 "a row among": Mann, "Issues at Stake: Horizon," *Decision,* 1/3 (March 1941): 8.
helped raise money: Auden to Mrs. Weschler, April 30, 1940, Berg.
146 "no use for mercy": Reich-Ranicki, *Thomas Mann,* 142.
"liked each other": Carpenter, *W. H. Auden,* 295-96.
emotional blackmail: Reich-Ranicki, *Thomas Mann,* 144.
"If I fear": Isherwood, *Diaries, Vol. I,* xiii.
drinking all the cream: Carr, *Lonely Hunter,* 123.
finally asked Auden: Carpenter, *W. H. Auden,* 297.
147 the theologian whose book: Mendelson, *Later Auden,* 173.
personal experience: Ibid., 174.
"quite suddenly": Auden, "The Protestant Mystics," *Forewords and Afterwords,* 69–70.
"I recalled with shame": Ibid.
148 "To be saved": Auden, "The Wandering Jew," *Complete Works,* 2:112.
sold a poem: "Drafts and Lists of Contributors' Fees," *Decision* papers, MAY (b1, f9).
grandmother, "Bobby": Farnan, *Auden in Love,* 24.
never to let Bobby: Ibid., 23.
cheerful, urbane: Norse, *Memoirs,* 25.
mixed sidecars: Farnan, *Auden in Love,* 25.
149 "There's wine": Auden, "To Chester Kallman, b. Jan. 7, 1921," in Farnan, *Auden in Love,* 25–27.
an almond-eyed: Mendelson, *Later Auden,* 177.
150 shot out of a cannon: In Farnan, *Auden in Love,* 54.
He didn't realize: Ibid., 56.
"We rarely": Norse, *Memoirs,* 73.
151 "When I do": Kallman to Norse, July 11, [?1940], Berg.
subway tearooms: Kirstein to Kallman, October 14, 1972, HRHRC.
George often talked about: Norse, *Memoirs,* 90–91.
believed he was: Ibid., 56.
"malicious dignity": Denis de Rougemont, in Savigneau, *Carson McCullers,* 76.

152 maternally fond: Murray, *Darlinghissimna*, 97.

representative of their age: Auden, "The Wandering Jew," 110.

hand over fist: Preminger, *Gypsy and Me*, 58.

planted a woman: J. P. McEvoy, "More Tease Than Strip," *Variety*, June 4, 1941, 55.

"I never try": Ibid.

soak off: Lee to Lee Wright, January 13, 1941, BRC (Series VI, b45, f18).

"If you kid": Davis to Lee, January 15, 1941, BRC (Series I, b3, f2).

"I'll do my specialty": Lee to Lee Wright, January 20, 1941, BRC.

153 "I thought the blue ribbon": Lee to Lee Wright, February 19, 1941, BRC (Series VI, b45, f18).

"Gypsy thinks June": In *Vanity Fair*, March 2003, 210.

"I'm delighted": Davis to Lee, January 15, 1941, BRC (Series I, b3, f2).

"I am aware": Davis to Lee, "Saturday Night," [ca. December 28, 1940], BRC (Series I, b3, f2).

154 leads' solos: Mitchell, "Origins, Evolution and Metamorphoses," 121–23.

stayed overnight: Seebohm, "Conscripts to an Age," 19.

"They are very": Britten, *Letters*, 721.

155 one of those things: Mitchell, "Origins, Evolution and Metamorphoses," 148.

156 "Young Trees": Auden, *Paul Bunyan*, in Auden and Kallman, *Complete Works*, 7, 544.

"Look at the moon!": Auden, *Paul Bunyan*, 17.

Bali-inspired tones: Mitchell, "Origins, Evolution and Metamorphoses," 100.

"But once in a while": Auden, *Paul Bunyan*, in Auden and Kallman, *Complete Works*, 7.

"petted by everyone": McCullers, "Brooklyn Is My Neighbourhood," *Mortgaged Heart*, 219.

157 struck with a vision: McCullers, "The Flowering Dream: Notes on Writing," *Esquire* (December 1959), 163.

"a dark, tall woman": Ibid., 198.

"Miss Amelia ate slowly": Ibid., 204.

"It is clean": Ibid., 203.

158 "a terrible character": Ibid., 198.

"There are the lover": Ibid., 216.

Chapter 7

159 "Living is quite": Britten to Antonio and Peggy Brosa, December 20, 1940. In Britten, *Letters*, 899.

"These Northern skies": Carson McCullers to Reeves McCullers, January 17, 1945, HRHRC (Series II, b24, f9).

Frankie Abbe: Kathryn Abbe interview, March 16, 2004.

Chinese boxes: Moulton, "Remembering George Davis," 289.

160 "Well, it takes": Ibid., 29.

several guests: Victor Guarneri interview, June 26, 2003.

a hundred or more: Robert James Lowry to Peter Davis, July 23, 1959, PD.

160 "all that was new": Denis de Rougemont, Preface, *Le Coeur est un Chasseur Soli-taire* (*The Heart Is a Lonely Hunter*), Paris: Club des Librairies de France, 1946. In Carr, *Lonely Hunter*, 123–24.

"open to the world": Jan Balet to Kathryne Abbe, June 2004. In Kathryne Abbe interview, June 18, 2004.

161 lunch at the Café: Bowles, *Without Stopping*, 110.

"I was considerably": Ibid., 220.

"meant to sound": Ibid., 230.

Kirstein heard: Bowles to Peter Davis, August 25, 1959, PD.

162 Tallulah's midget: Drutman, *Good Company*, 106.

first thing that popped: Dillon, *Little Original Sin*, 63.

a small strip of adhesive: Ibid., 86.

had escaped: Carr, *Lonely Hunter*, 137.

163 new relationship with God: Davenport-Hines, *Auden*, 215.

"the love of God": McCullers, "The Flowering Dream: Notes on Writing," *Esquire* (December 1959): 164.

father threw the book: Broadcast interview of Carson McCullers and Tennessee Williams, 1945, HRHRC (Series I, b2, f11).

telephone threat: McCullers, *Illumination*, 31.

164 "a more tightly bound tale": Rose Feld, *New York Herald Tribune*, February 16, 1941, 8.

"most compelling": Louis Untermeyer, *Reflections in a Golden Eye* (Boston: Houghton Mifflin, 1941), jacket copy.

"it is perfectly true": *Kansas City Star*, February 15, 1941.

"In its sphere": "Books: Masterpiece at 24," *Time*, February 17, 1941, 96.

rising and dressing: Margarita G. Smith, Introduction, *Mortgaged Heart*, xvii.

165 "We have broken": Winston Churchill, "Do Your Worst," February 7, 1941, MTR.

Pavel Tchelitchew decided: Carr, *Lonely Hunter*, 126.

166 "I'll get you for this": Dillon, *Little Original Sin*, 93.

"Dalí's Living Liquid Ladies": Schaffner, *Salvador Dalí's Dream of Venus*, 32.

167 "Surrealist babes": "Surrealist Babes," *New Yorker*, July 22, 1939, 13.

"Avida Dollars": Schaffner, *Salvador Dalí's Dream of Venus*, 60.

"It is man's right": In *The Collected Writings of Salvador Dalí*, ed. Haim Finkelstein (Cambridge: Cambridge University Press, 1998), 332.

"Come and See Gypsy": Schaffner, *Salvador Dalí's Dream of Venus*, 74.

168 "At the age": Dalí, *Secret Life*, 1.

"Very rich people": Ibid., 339.

"As a child": Ibid., 399–400.

"a new classicism": Gibson, *Shameful Life of Salvador Dalí*, 467.

"Fame was as intoxicating": In ibid., 422.

169 *"Je veux être"*: Bowles, *Without Stopping*, 220.

rarely smiled: Gibson, *Shameful Life of Salvador Dalí*, 454.

"the petrifying saliva": Dalí, *Secret Life*, 1.

Gala complained: Nin, *Diary*, 40.

"good feelings": Seebohm, "Conscripts to an Age," 26.

170 "just one hectic rush": Britten to Peggy Brosa, February 24, 1941. In Britten, *Letters*, 906.

170 "just staggering out": Britten to Beata Mayer, December 15[?], 1940. In Britten, *Letters*, 892.
attended the opera: Farnan, *Auden in Love*, 27.
"I am so anxious": Auden to Britten, June 8, 1939, Berg.
171 "our menagerie": In Carpenter, *W. H. Auden*, 304.
"Oh, Bubbles": In Dillon, *Little Original Sin*, 86.
"I have never met a surrealist": Auden, "Honest Doubt," submitted to Grigson's *New Verse*, n.d., HRHRC.
"Do you speak": Asako Kitaori, "Charles Henri Ford: Catalyst Among Poets," *Rain Taxi Review of Books* (Spring 2000).
172 they now met: Bowles, *Without Stopping*, 233–34.
washing dishes: Jack Anderson, "Oliver Smith, Set Designer, Dead at 75," *New York Times*, January 25, 1994, B9.
"slightly Dickensian": Jennifer Dunning, "Oliver Smith's Vision of Ballet Theatre," *New York Times*, April 22, 1991, C13.
173 "At that time": In Britten, *Letters*, 865.
"One might say": Ibid.
"less than friendly": Interview, Vivian Fine with Frances Harmeyer for Oral History, American Music, Yale, June 28, 1975, Bennington, Vt. In Copland and Perlis, *Copland*, 192.
"It might have been": Bowles to Peter Davis, August 25, 1959, PD.
174 "O ride till": Auden, *Paul Bunyan*, in Auden and Kallman, *Complete Works*, 22.
Pears brought him: Mitchell, "Origins, Evolution and Metamorphoses," 128.
"Chester . . . should": Auden to Isherwood, [ca. 1941], HL (CI 2991).
175 "For the youth": Auden, "*Yale Daily News* Banquet Address," March 6, 1941, *Complete Works, Prose*, 119.
176 "Each lover has": Auden, "Alone," *Collected Poems*, 312.
meet Chester in the office: Farnan, *Auden in Love*, 58.
few men were likely: Ibid.
wanted to be punished: Ibid., 61.
"O my love and punishment": Kallman, Notebook 4, August 20, 1941, HRHRC.
"Speak louder": Kallman, poem, Notebook 3, HRHRC.
177 Barker reacted: Farnan, *Auden in Love*, 56.

Part III. The House of Genius

179 "Once we could": Auden, "Domesday Song" ("Ten Songs, VII"), *Collected Poems*, 270.

Chapter 8

181 "Can we make wounds": Bowles, "Scene VIII," *Next to Nothing*, 59.
"We've got a roast": In Bowles, *Without Stopping*, 233.
182 "slow marching": Britten, program note. In Britten, *Letters*, 909.
"rather like": Britten to Peggy Brosa, [April 1941]. In Britten, *Letters*, 909.

182 completely tone-deaf: Ibid., 146.
"All but heroes": Auden, "Paul Bunyan," in Auden and Kallman, *Complete Works*, 45.
"Pressure Group": Ibid.
"entertainments neither true": Ibid.
"Paul, who are you?": Ibid., 46.
"Where the night": Ibid.
upbeat, patriotic finale: Mitchell, "Origins, Evolution and Metamorphoses," 107.
"I don't want": Ibid.
184 musical mentor: Britten, *Letters*, 923.
"one of those": In Drutman, *Good Company*, 273.
"I am definitely": Britten to Beth Welford, May 12, 1941. In Britten, *Letters*, 919–20.
"monstrous in his": Dillon, *Little Original Sin*, 54.
foot infection: Seebohm, "Conscripts to an Age," 26.
185 "Adelaide, *tenez-vous*": Dillon, *Little Original Sin*, 95.
last words: Auden, "Last Words," *Harper's Bazaar* (October 1941): 83, 118–119.
"There's Miss God": In Ibid.
"Je déteste": Bowles, *Without Stopping*, 234.
feathers up and down: Bowles to Peter Davis, August 25, 1959, PD.
suitcase that had been: Ibid.
"one of the plagues": Britten to Peggy Brosa, [April, 1941], in Britten, *Letters*, 908.
case of measles: Edmiston and Cirino, *Literary New York*, 352–53.
series of headaches: Carr, *Lonely Hunter*, 139.
186 stay with him: Ibid., 140.
friends one made: Kirstein, *Mosaic*, 186.
"You're not important": In Dillon, *Little Original Sin*, 95.
form of corruption: Davis to Lee, "Saturday Night," [ca. December 28, 1940], BRC (Series I, b3, f2).
"a work of art": Auden, "Review of *Open House* by Theodore Roethke," *Complete Works, Prose*, 125–27.
187 "on all fours": Auden, "New Year Letter," *Collected Poems*, 240–41.
debate with Klaus: W. H. Auden and Klaus Mann, "The Function of the Writer in the Political Crisis," *Forum*, WEVD, New York, radio broadcast, March 19, 1941, *Decision* archives, MAY.
188 with Annemarie: Carr, *Lonely Hunter*, 197.
"raging everywhere": Cyril Connelly to Klaus Mann, April 3, 1941, *Decision* archives, MAY.
no point: Carpenter, *W. H. Auden*, 292.
his "regret": Stephen Spender, "Letter to a Colleague in America," *New Statesman and Nation*, November 16, 1940, 490.
Lord of Death: MacNeice, *Strings Are False*, 128.
disgusted him: Spender, *World Within World*, 100.
"for the expatriate": Louis MacNeice, "Traveller's Return," *Horizon* 3/14 (February 1941). In Stallworthy, *Louis MacNeice*, 288.
189 "Dearest Stephen": Auden to Spender, March 13, 1941, Berg.
"The carriage will depart": In Carr, *Lonely Hunter*, 124.
190 descend in slippers: Carpenter, *W. H. Auden*, 304.

190 "George: 21.06": Auden, "Commonplace Book," n.d., Berg.

forbade personal arguments: Bowles, *Without Stopping*, 233.

"uh . . . uh . . .": Peter Pears, in Tony Palmer, director, *The South Bend Show*, "A Time There Was," BBC broadcast, 1979, BPL.

191 "nearer to becoming": Bowles, *Two Serious Ladies*, 201.

"gone to pieces,": Ibid., 197.

"Not very much": Ibid., 9.

physical model: Dillon, *Little Original Sin*, 104.

192 could no longer hide: Auden, "Wandering Jew," *Complete Works, Prose*, 2:113.

"hypnotized by the problem": Mann, *Turning Point*, 226.

"But that's nonsense": Dillon, *Little Original Sin*, 94.

"A neurosis is": Auden, "Wandering Jew," 113.

"Oh get back": In Dillon, *Little Original Sin*, 94.

193 world was too complex: Bowles, *Without Stopping*, 262.

"natural" form of surrealism: Dillon, *Little Original Sin*, 93.

"It was painful": Bowles, *Without Stopping*, 210.

primitive mind: Wayne Pounds, "The Subject of Paul Bowles," in Edward Butscher and Irving Malin, eds., *Twentieth Century Literature*, 307.

struck her: Dillon, *Little Original Sin*, 80.

afraid to spend: Bowles, *Without Stopping*, 223.

refused to continue: Dillon, *Little Original Sin*, 80.

194 Stalinist interpretation: Edmiston and Cirino, *Literary New York*, 352.

taking Benzedrine: Dillon, *Little Original Sin*, 97.

"delightful and sensible": Stein, *Autobiography*, 309. In Copland and Perlis, *Copland*, 187.

chose this time: Davenport-Hines, *Auden*, 213.

"It was Chester's": In Farnan, *Auden in Love*, 61.

195 "utterly fantastic". In Norse, *Memoirs*, 93.

"I shall be requiring": In Caponi, *Paul Bowles*, 89.

196 twenty years: Bowles, *Without Stopping*, 342.

"Many people have": Auden, "Review of *Open House* by Theodore Roethke," *Complete Works, Prose*, 125–27.

final days: Mendelson, *Later Auden*, 174.

"For the saint must": Auden, *Paul Bunyan*, in Auden and Kallman, *Complete Works*, 31.

"Dear Children": Ibid., 31–32.

"unless I write": Auden to Tania Stern, January 30, 1942, Berg.

failed to complete: Mendelson, *Later Auden*, 174.

Chapter 9

197 "Joseph, Mary, pray": Auden, "For the Time Being," *Collected Poems*, 366.

"Holland will arise": Salmaggi and Pallavisini, *2194 Days of War*, 109.

most homesick: Britten to Beth Welford, April 28, 1940. In Britten, *Letters*, 804.

"promising and frequently": R.L., "Philharmonic Repeats 'Sinfonia' by Britten," *New York Herald Tribune*, March 31, 1941, 8.

198 knocking out: Mitchell, "Origins, Evolution and Metamorphoses." 115.
submitted an essay: Auden, "Opera on an American Legend," *New York Times*, May 4, 1941.
"Everything in this": Britten to Enid Slater, April 7, 1940. In Britten, *Letters,* 799.
"Since the birth": Auden, "Paul Bunyan," in Auden and Kallman, *Complete Works,* 5.

199 laughing frequently: Mitchell, "Origins, Evolution and Metamorphoses," 93.
"a very clever": Olin Downes, "Official Opening for 'Paul Bunyan,'" *New York Times,* May 6, 1941, 25.
"Music-Theatrical Flop": Virgil Thomson, "Music-Theatrical Flop," *New York Herald Tribune,* May 6, 1941, 14.

200 "lisping, whimsical stinker": George Davis, "Theatre," *Decision* 1/5 (May 1941): 83.

201 "Let them stew": Elizabeth Mayer to Britten, May 6, 1941. In Britten, *Letters,* 913.
"full of ideas": In Davenport-Hines, *Auden,* 213.
filled with tears: Tony Palmer, director, *The South Bank Show,* "A Time There Was," London Weekend Television, April 6, 1980, BPL.

202 reminded Britten of Aldeburgh: Seebohm, "Conscripts to an Age," 19.
"the little Owls": Ibid., 157.

203 "We meant to tell": Pears to Elizabeth Mayer, [June 1941]. In Britten, *Letters,* 934.
"a grand evening": Louise Bogan to Morton D. Zabel, July 10, 1941. In Limmer, *What the Woman Lived,* 221.
delivered a lecture: Farnan, *Auden in Love,* 69.
"I do become": Davis to Georgina and Robert Davis, n.d., PD.

204 "she wants me": Davis to Lee, December 26, 1940, BRC (Series I, b3, f2).
cough syrup: Carr, *Lonely Hunter,* 143.
separate beds: Ibid., 150.

205 gave her the ring: Ibid., 147.
grew more vicious: Ibid., 151.
"huffed and puffed": Victor Guarneri interview, June 26, 2003.
"capering about": Klaus Mann, "Two Generations," *Decision* 1/5 (May 1941): 74.

206 bequeathed to him: Webb, *Richard Wright,* 195.
"Oh, Mother!": In Bowles, *Without Stopping,* 101.

207 influence proved critical: Jennifer Dunning, "Oliver Smith's Vision of Ballet Theatre," *New York Times,* April 22, 1991, C13.
"Someday I'll give": Dillon, *Little Original Sin,* 95.
"an island of calm": "Broadway, A Man for All Seasons," *Time,* March 19, 1965, 86.
illustrations for *Mademoiselle:* Fran Schumer, "Broadway Magic: The Lyrical Visions of Oliver Smith," *NYU Alumni News Magazine,* Fall 1990, 18.
"When you're starting": Patricia MacKay, "A Profile of Oliver Smith," *Theatre Crafts* (April 1982): 60.
"last scandal": In Gibson, *Shameful Life,* 464.
antique frames: Ibid., 465.
"Can one remember": In ibid., 467.

208 "I loved your notes": Lee to Lee Wright, May 15, 1941, BRC (Series VI, b45, f18).
Mafia moved in: Preminger, *Gypsy and Me,* 58.
"Why should I?": In J. P. McEvoy, "More Tease Than Strip," *Variety,* June 4, 1941, 2.

208 "Does this sound good": Lee to Lee Wright, February 26, 1941, BRC (Series VI, b45, f18).

209 "that long, hard": Dorothy Barret, "Man Behind the Scenes," *Dance* (March 1946): 23.

"The other drop": In Reich-Ranicki, *Thomas Mann*, 168.

"social gatherings": Max Ascoli to Klaus Mann, May 23, 1941, *Decision* papers, MAY.

210 merged with their own: Mann to Meyer Weisgal, March 5, 1941, *Decision* papers, MAY.

"a social and spiritual": Mann, *Turning Point*, 347.

"paralyzed, as it were": Ibid., 346.

deeply attracted: Hoffer, *Klaus Mann*, 113.

"I've never understood": In Reich-Ranicki, *Thomas Mann*, 173.

211 "My case is not": Ibid., 169.

Rudolf Hess: Salmaggi and Pallavisini, *2194 Days of War*, 122.

"Devil's stooges": Klaus Mann, "Issues at Stake: Blood, Sweat, and Tears," *Decision* 1/6 (June 1941): 3.

"Try to avoid": Isherwood, *Diaries, Vol. I*, 179.

"The houses were": Ibid., July 17, 1941, 175.

"Hitler's attack": Mann, *Turning Point*, 345.

212 "It is not too much": Winston Churchill, "Fourth Climacterics of the War," BBC broadcast, June 22, 1941, MTR.

"revulsion" against communism: Ibid.

"a parched and dusty": Mann, *Turning Point*, 346.

"so dazing": Ibid.

"all alone": Ibid.

"I relish": Ibid.

"Can a novel": In Hoffer, *Klaus Mann*, 112.

"tell the truth": Mann, *Turning Point*, 347.

213 "it is from": Ibid., 347–48.

"Nature never intended": Auden, *Dyer's Hand*, 317.

ordered to report: Britten, *Letters*, 976.

"Caroline dear": Auden to Caroline Newton, May 15, 1941, Berg.

214 "only perfection": Auden, "Eros and Agape," *Complete Works, Prose*, 2:138.

"we are delivered": Ibid., 139.

"to actualize": Ibid.

215 "To be saved": Auden, "Wandering Jew," *Complete Works, Prose*, 2:112.

216 "And from this": Auden, "Sea and the Mirror," *Collected Poems*, 441.

"Caught in the": Auden, "For the Time Being," *Collected Poems*, 363.

"I shouldn't have minded": Limmer, *What the Woman Lived*, 221.

217 "what it is like": Pike, *Modern Canterbury Pilgrims*, 41.

"It's frightening": In Carpenter, *W. H. Auden*, 312.

218 "If I stay": In Davenport-Hines, *Auden*, 214.

"Caroline was a silly": Isherwood, *Diaries, Vol. I*, 181.

"I had to keep going": Ibid.

ending the relationship: Mendelson, *Later Auden*, 178.

218 "We're not going": In Carpenter, *W. H. Auden*, 313.

219 "raised heaven and earth": Britten to Beth Welford, August 19, 1941. In Britten, *Letters*, 969.
"How like her": Mendelson, *Later Auden*, 178.
"an attractive": Isherwood, *Diaries, Vol. I*, 181.
"poor Wystan cried": Ibid.

Chapter 10

220 "It has taken": McCullers, "We Carried Our Banners — We Were Pacifists, Too," *Vogue*, July 1, 1941, 43.
hiring female mechanics: *New York Herald Tribune*, September 14, 1941, 1.
shipfitters, apprentice welders: Billie Cohen, "Torch Songs." In Robbins and Palitz, *Brooklyn*, 342.
citizens' first chance: "Shortages: Aluminum Drive Signals Start of Defense Raids on U.S. Kitchens," *Life*, August 4, 1941, 19.

221 "Let that guy": Mann, *Turning Point*, 353.
"beat the hell": Ibid., 355.
"From now on": In Buhite and Levy, *FDR's Fireside Chats*, 196.
"I figure that": Davis to Lee, December 26, 1940, BRC (Series I, b3, f2).

222 she disliked it: Katherine Anne Porter to Elizabeth Ames, May 29, 1943, in Porter, *Letters*, 268.
lay down across: Carr, *Lonely Hunter*, 156.
beer at her writing table: Ibid., 160.
$400: Ibid., 158.

223 picturesque stone tower: Ibid., 159.
"It has gone": Colin McPhee to Aaron Copland, July 20, [1941]. In Oja, *Colin McPhee*, 158.
"the poem in Decision": McCullers to Muriel Rukeyser, "Monday," n.d., Berg.
he had shared: Carr, *Lonely Hunter*, 157.

224 "The three of them": McCullers, *Member of the Wedding*, 295.
moved to Rochester: Carr, *Lonely Hunter*, 172.
returned briefly: Ibid., 175.
"protective angel": Ibid., 301.

225 "couldn't take it": McCullers, "Home Journey and the Green Arcade," n.d., HRHRC (Series I, b9, f13).
fine spirits: Bessie Breuer to Klaus Mann, November 3, 1941, *Decision* papers, MAY.
translate her book-in-progress: Carr, *Lonely Hunter*, 203.

226 preferred some of the younger: Wineapple, *Genêt*, 175.
"takes his symbolic eminence": Janet Flanner, "Goethe in Hollywood." In Flanner, *Janet Flanner's World*, 187.
Smith heard: Dorothy Barret, "Man Behind the Scenes," *Dance* (March 1946): 23.
"he didn't say": Fran Schumer, "Broadway Magic: The Lyrical Visions of Oliver Smith," *NYU Alumni News Magazine*, Fall 1990, 18.

227 "Here is the living portrait": Janet Flanner (flap copy). In Lee, *G-String Murders*.

227 "These late hours": Lee to Charlotte Seitlin, July 7, 1941, BRC (Series VI, b45, f18).
biggest-selling mystery: Richard E. Lauterbach, "Closeup: Gypsy Rose Lee," *Life*, December 14, 1942, 93.
"I loathe the": Davis to Robert Davis, September 22, 1949, PD.

228 "Driver drive faster": Auden, "Calypso" ("Ten Songs: II"), *Collected Poems*, 266.
"I had my first class": Auden to Caroline Newton, October 7, 1941, Berg.
"in fiesta": Auden to Caroline Newton, November 11, 1941, Berg.
"What an anthropological": Ibid.
"every time I ask": Auden to James and Tania Stern, [ca. October 10, 1941], Berg.
"took my playing": Ibid.

229 "I don't like": Auden to James and Tania Stern, December 18, 1941, Berg.
"Ann Arbor is going": Auden to James and Tania Stern, [ca. October 10, 1941], Berg.
"Happy I can't: Auden to Caroline Newton, October 7, 1941, Berg.
"I'm terribly homesick": Auden to Davis, November [1?], 1941, WLRC (Series 37, b3, f54).
"Perhaps you will": Auden to James and Tania Stern, [ca. October 10, 1941], Berg.
"Sex has been": Kallman to Auden, November 3, 1941, Berg.
"Just the other night": Kallman to Auden, November 10, 1941, Berg.

230 "I know that": Kallman to Auden, November 18, 1941, Berg.
"is not my natural": Auden to Tania Stern, December 31, 1944, Berg.
"Perhaps it's good": Kallman to Auden, November 3, 1941, Berg.
"The person you": Miller, *Auden*, 34.
Auden called "frivolity": Pike, *Modern Canterbury Pilgrims*, 41.

231 erotic and religious: Mendelson, *Later Auden*, 180.
"All I ask": Auden, "For the Time Being," *Collected Poems*, 363.
"No, you must": Ibid.

232 "Eva, my coloured nurse": Ibid., 390.
"Deep among dock": Ibid., 358.
"Domestic hatred": Ibid., 367.
"the streets": Ibid., 399.

233 "*talk back* to God": Limmer, *What the Woman Lived*, 317.
"I feel as if": Auden to Harold Norse, November 1, 1941, Indiana University Library.
"I have sketched": Auden to Britten, November 11, 1941, Berg.
"I don't remember": In Carpenter, *Benjamin Britten*, 163.
"We live a very": Pears to his mother, n.d. In Britten, *Letters*, 957.

234 "everyone out here": Britten to William and Elizabeth Mayer, July 29, 1941, BPL.
"thoroughbred" of a composer: Ernest Newman, *Sunday Times* of London, May 4, 1941. In Britten, *Letters*, 958.
"the Battle of Britten": Ernest Newman, *The Times*, June 8, 1941, in ibid.
"most of our musical": George Baker, *The Times*, June 15, 1941, in ibid., 959.
title of "British composer": E. R. Lewis, "English Composer Goes West," *Musical Times*, June 1941. In Britten, *Letters*, 870.
"ultimately it is by": Gerald Cockshott, *Musical Times*, 1941. In Britten, *Letters*, 871.

235 "a crazy country": Britten to Barbara Britten, [on or after September 7, 1941]. In Britten, *Letters*, 973–74.

235 "the ugliest and most sprawling" Britten to Beth Welford, August 19, 1941. In Britten, *Letters*, 968.

"swarming with refugees": Britten to Robert Britten, August 4, 1941. In Britten, *Letters*, 966.

"If anything is more": Benjamin Britten to Beth Welford, August 19, 1941. In Britten, *Letters*, 968.

236 "perpetual jig-saw puzzles": Britten to Elizabeth Mayer, September 6, 1941. In Britten, *Letters*, 972.

"To think of Crabbe": E. M. Forster, "George Crabbe: The Poet and the Man," Sadler Wells Opera Book about *Peter Grimes*, 1945, adapted from *The Listener*, May 29, 1941.

"To all of them": Ibid.

"the wallop": Ibid.

237 "Our busy streets": *The Poetical Works of the Rev. George Crabbe* (London: John Murray, 1851).

"I suddenly realized": Britten, "On Receiving the First Aspen Award" (1964). In Kildea, *Britten on Music*, 262.

static nature: Britten, "England and the Folk-Art Problem (1941)." In ibid., 32–35.

238 Ethel had fallen: Britten, *Letters*, 962.

"Frankly, I'm a bit": Britten to Beth Welford, August 19, 1941. In ibid., 969.

"like released prisoners": Britten to Peggy Brosa, November 4, 1941. In ibid., 991.

239 "My recollection": In ibid., 985.

"a grand kid": Britten to David Rothman, November 12, 1941. In ibid., 998.

fallen in love: Carpenter, *Benjamin Britten*, 161.

"Unforgettable evening": Elizabeth Mayer, diary. Reprinted in ibid., 885.

240 "He wanted to": Britten, *Letters*, 999.

"you, especially": Britten to David Rothman, November 12, 1941. In Britten, *Letters*, 998.

241 "Now there's": Miller, *Auden*, 57.

"Charlie, it's *amazing*": Ibid., 32–33

242 "gamble with himself": Davis to Lee, December 26, 1940, BRC (Series I, b3, f2).

"A museum": Nin, *Diary*, 270.

243 in Britain: Jane Isay interview, March 31, 2003.

the prisoners being: Ivan Klima, "What We Think of America," *Granta* 77 (Spring 2002): 50.

Epilogue

244 "Each moment then": Mann, *Turning Point*, 349.

"nearly down": In Wineapple, *Genêt*, 176.

"It really isn't fair": Kallman to Auden, December 7, 1941, Berg.

245 "Promiscuity . . . fills one": Auden to Caroline Newton, January 19, 1942, Berg.

"they all found": Kallman to Auden, January 19, 1942, Berg.

The Crisis: Mendelson, *Later Auden*, 176.

"just a Brooklyn": Auden to Mina Kirstein Curtiss, January 14, 1942, Berg.

"there are days": Auden to Elizabeth Mayer, February 20, 1943, Berg.

245 "I never really loved": Auden to Tania Stern, January 30, 1942, Berg.
246 "If equal affection": Auden, "The More Loving One," *Collected Poems*, 584.
 "He makes me": Auden to Caroline Newton, January 10, 1942, Berg.
 "Dearest Chester": Auden to Kallman, December 25, 1941, HRHRC.
247 "I have reached": Britten to Kit Welford, March 1, 1942, BPL.
 "As you know": Auden to Britten, "Saturday," [January 31, 1942]. In Britten, *Letters*, 1015.
248 "I feel much": Britten to Wulff Scherchen, September 9, 1941. In ibid., 977.
 "in art, as": Britten to Kit Welford, March 1, 1942, BPL.
249 "Snape is just": Britten to Elizabeth Mayer, May 17, 1942. In Britten, *Letters*, 1049.
 "The first impression": Britten to Elizabeth Mayer, May 4, 1942. In ibid., 1037.
 "I feel that": Britten to Elizabeth Mayer, June 5, 1942. In ibid., 1059.
 "Our average income": In Sally Hammond, "Closeup: Broadway Designer," February 1, 1966. In Oliver Smith, clippings file, New York Public Library for the Performing Arts.
250 Stones were thrown: Rowley, *Richard Wright*, 269.
 elite Rangers assault outfit: Carr, *Lonely Hunter*, 211.
 "You can't let": Bowles, *Without Stopping*, 240.
251 "Oliver Smith has *produced*": Carson McCullers to Reeves McCullers, January 6, 1945, HRHRC (Series II, b24, f9).
 "more Brooklyn than Manhattan": Dorothy Barret, "Man Behind the Scenes," *Dance* (March 1946): 23, 41.
252 thirty-nine and five-twelfths: Gypsy Rose Lee Papers, BRC (Series I, b6 f20).
 "an entertainer": Preminger, *Gypsy and Me*, 346.
 its editorial assistants: Grumbach, *Pleasure of Their Company*, 5.
 "multiplied like planes": Moulton, "Remembering George Davis," 287.
253 "a parrot with": Ibid., 289.
254 "unpleasant and grotesquely": Auden to Newton, September 2, 1942, Berg.
 "We got no answers": Carpenter, *W. H. Auden*, 357.
 reviewing the correspondence: Farnan, *Auden in Love*, 100.
 Inducted at Fort Dix: Hoffer, *Klaus Mann*, 19.
256 "Bengy and Peter": Auden (bill), BPL.
257 "cheerful unhygienic mess": Auden, "Last Words," *Harper's Bazaar*, October 1, 1941, 83.
258 "some very lovely": In Mitchell, "Origins, Evolution and Metamorphoses," 132.
 "was deeply moved": Ibid., 147.
 "was profoundly touched": Ibid.
 "My few friends": Colin McPhee to Sidney Cowell, "Wednesday," ["Aug. 3, 1949" added]. In Oja, *Colin McPhee*, 183.

Illustration Captions

"Davis was the one": In Plimpton, *Truman Capote*, 47.
"I am at the moment": Auden to Caroline Newton, October 2, 1940, Berg.
"I am mad with happiness": Auden to Britten, [before June], 1939, Berg.

"diffuse but lusty": Klaus Mann, *Turning Point,* 272.

"ever so Bohemian": MacNeice, *Strings Are False,* 35.

"Living is quite": Britten to Antonio and Peggy Brosa, December 20, 1940. *Letters,* 899.

"The house in Brooklyn": Davis to Lee, December 26, 1940, BRC.

"He wrote Music": In Dillon, *Little Original Sin,* 38.

"the petrifying saliva": In Prose, *Lives of the Muses,* 196.

Selected Bibliography

Ansen, Alan. *The Table Talk of W. H. Auden*. Edited by Nicholas Jenkins. London: Faber and Faber, 1991.

Auden, W. H. *Collected Poems*. Edited by Edward Mendelson. New York: Vintage International, 1991.

———. *The Collected Poetry of W. H. Auden*. New York: Random House, 1945.

———. *The Complete Works of W. H. Auden: Prose, Volume II, 1939–1948*. Edited by Edward Mendelson. Princeton, N.J.: Princeton University Press, 2002.

———. *The Complete Works of W. H. Auden: Prose and Travel Books in Prose and Verse, Volume I, 1926–1938*. Edited by Edward Mendelson. Princeton, N.J.: Princeton University Press, 1996.

———. *The Dyer's Hand and Other Essays*. New York: Random House, 1962.

———. *The English Auden: Poems, Essays and Dramatic Writings, 1927–1939*. Edited by Edward Mendelson. New York: Random House, 1977.

———. *Forewords and Afterwords*. Selected by Edward Mendelson. New York: Vintage International, 1989.

———. *Lectures on Shakespeare*. Reconstructed and edited by Arthur Kirsch. Princeton, N.J.: Princeton University Press, 2000.

———. *The Map of All My Youth: Early Works, Friends, and Influences*. Edited by Katherine Bucknell and Nicholas Jenkins. Oxford: Clarendon Press, 1990.

———. *Paul Bunyan: The Libretto of the Operetta by Benjamin Britten*. London: Faber and Faber, 1988.

———. *The Sea and the Mirror*. Edited by Arthur Kirsch. Princeton, N.J.: Princeton University Press, 2003.

Auden, W. H., and Christopher Isherwood. *Journey to a War*. New York: Paragon House, 1990.

Auden, W. H., and Chester Kallman. *The Complete Works of W. H. Auden and Chester Kallman: Libretti and Other Dramatic Writings, 1939–1973*. Edited by Edward Mendelson. Princeton, N.J.: Princeton University Press, 1993.

Auden Society Newsletter. London: W. H. Auden Society, www.audensociety.org.

Banks, Paul, ed. *The Making of Peter Grimes: Essays and Studies.* Suffolk, U.K.: St. Edmundsbury Press, Bury St. Edmunds, Suffolk, 1996.

Bloomfield, B. C., and Edward Mendelson. *W. H. Auden: A Bibliography 1924–1969.* 2nd ed. Charlottesville: University Press of Virginia, 1972.

Bogan, Louise. *What the Woman Lived: Selected Letters of Louise Bogan.* Edited by Ruth Limmer. New York: Harcourt Brace Jovanovich, 1973.

Bowles, Jane. *Feminine Wiles.* Santa Barbara, Calif.: Black Sparrow Press, 1976.

———. *Out In the World: Selected Letters of Jane Bowles, 1935–1970.* Edited by Millicent Dillon. Santa Rosa, Calif.: Black Sparrow Press, 1990.

———. *Two Serious Ladies.* New York: E. P. Dutton, 1984.

Bowles, Paul. *In Touch: The Letters of Paul Bowles.* Edited by Jeffrey Miller. New York: Flamingo, 1995.

———. *Next to Nothing: Collected Poems, 1926–1977.* Santa Rosa, Calif.: Black Sparrow Press, 1990.

———. *The Sheltering Sky, Let It Come Down, The Spider's House.* New York: Library of America, 2002.

———. *Without Stopping: An Autobiography.* Hopewell, N.J.: Ecco Press, 1972.

Boyle, Kay, and Robert McAlmon. *Being Geniuses Together.* New York: Doubleday, 1968.

Britten, Benjamin. *Britten on Music.* Edited by Paul Kildea. Oxford: Oxford University Press, 2003.

———. *Letters from a Life: Selected Letters and Diaries of Benjamin Britten.* Volume 1, 1923–39, and Volume 2, 1939–45. Edited by Donald Mitchell and Philip Reed. Berkeley: University of California Press, 1991.

Britten, Beth. *My Brother Benjamin.* Abbotsford, U.K.: Kensal Press, 1986.

Buhite, Russell D., and David W. Levy, eds. *FDR's Fireside Chats.* Norman: University of Oklahoma Press, 1992.

Caponi, Gena Dagel, ed. *Conversations with Paul Bowles.* Jackson: University Press of Mississippi, 1993.

———. *Paul Bowles: Romantic Savage.* Carbondale: Southern Illinois University Press, 1994.

Capote, Truman. *Brooklyn Heights: A Personal Memoir.* New York: Little Bookroom, 2002.

Carpenter, Humphrey. *Benjamin Britten: A Biography.* London: Faber and Faber, 1992.

———. *W. H. Auden: A Biography.* Boston: Houghton Mifflin, 1981.

Carr, Virginia Spencer. *The Lonely Hunter: A Biography of Carson McCullers.* New York: Carrol & Graf, 1975.

Chauncey, George. *Gay New York: Gender, Urban Culture, and the Making of the Gay Male World, 1890–1940.* New York: Basic Books, 1994.

Clark, Thekla. *Wystan and Chester: A Personal Memoir of W. H. Auden and Chester Kallman.* New York: Columbia University Press, 1995.

Clarke, Gerald. *Capote: A Biography.* New York: Simon and Schuster, 1988.

Copland, Aaron, and Vivian Perlis. *Copland: 1900 Through 1942.* New York: St. Martin's, 1984.

Dalí, Salvador. *The Secret Life of Salvador Dalí.* Translated by Haakon M. Chevalier. New York: Dover, 1993.

Davenport-Hines, Richard. *Auden.* New York: Vintage Books, 1995.

Davis, G. Gordon. "The Funeral Stones." 2003.

Davis, George. *The Opening of a Door.* New York: Harper & Brothers, 1931.

de Rougemont, Denis. *Love in the Western World.* Rev. ed. Translated by Montgomery Belgion. Princeton, N.J.: Princeton University Press, 1983.

Dillon, Millicent. *A Little Original Sin: The Life and Work of Jane Bowles.* New York: Holt, Rinehart and Winston, 1981.

———. *You Are Not I: A Portrait of Paul Bowles.* Berkeley: University of California Press, 1998.

Drutman, Irving. *Good Company: A Memoir, Mostly Theatrical.* Boston: Little, Brown, 1976.

Edmiston, Susan, and Linda D. Cirino. *Literary New York. A History and Guide.* Boston: Houghton Mifflin, 1976.

"Exotic Birds of a Feather: Carson McCullers and Tennessee Williams." *Tennessee Williams Annual Review.* No. 3 (2000).

Farnan, Dorothy J. *Auden in Love: The Intimate Story of a Lifelong Love Affair.* New York: Simon and Schuster, 1984.

Federal Writers Project. *The WPA Guide to New York City: The Federal Writers Project Guide to 1930s New York.* New York: New Press, 1939.

Fenton, James. "Auden at Home." *New York Review of Books,* April 27, 2000, 8–13.

———. "Auden's Enchantment." *New York Review of Books,* April 13, 2000, 62–66.

———. "Auden's Shakespeare." *New York Review of Books,* March 23, 2000, 24–28.

Finney, Brian. *Christopher Isherwood: A Critical Biography.* New York: Oxford University Press, 1979.

Fitch, Noel Riley. *Sylvia Beach and the Lost Generation: A History of Literary Paris in the Twenties and Thirties.* New York: W. W. Norton, 1983.

Flanner, Janet. *The Cubical City.* Carbondale: Southern Illinois University Press, 1926, 1974.

———. *Darlinghissima: Letters to a Friend.* Edited and with commentary by Natalia Danesi Murray. San Diego: Harcourt Brace Jovanovich, 1985.

———. *Janet Flanner's World: Uncollected Writings 1932–1975.* Edited by Irving Drutman. New York: Harcourt Brace Jovanovich, 1979.

———. *Paris Was Yesterday, 1925–1939.* Edited by Irving Drutman. New York: Viking Press, 1972.

Foote, Timothy. "Auden, The Sage of Anxiety." *Time,* October 8, 1973, 113–14.

Fryer, Jonathan. *Isherwood: A Biography.* Garden City, N.Y.: Doubleday, 1978.

Fuller, John. *W. H. Auden: A Commentary.* Princeton, N.J.: Princeton University Press, 1998.

Fussell, Paul. *Wartime: Understanding and Behavior in the Second World War.* New York: Oxford University Press, 1989.

Gibson, Ian. *The Shameful Life of Salvador Dalí*. New York: W. W. Norton, 1997.

Gopnik, Adam. "A Critic at Large: The Double Man." *New Yorker,* September 23, 2002, 86–91.

Grumbach, Doris. *The Pleasure of Their Company*. Boston: Beacon Press, 2000.

Haffenden, John, ed. *W. H. Auden: The Critical Heritage*. London: Routledge & Kegan Paul, 1983.

Havoc, June. *More Havoc*. New York: Harper & Row, 1980.

Heinsheimer, H. W. *Menagerie in F Sharp*. Garden City, N.Y.: Doubleday, 1947.

Hitchens, Christopher. *Unacknowledged Legislation: Writers in the Public Sphere*. London: Verso, 2000.

Hoffer, Peter T. *Klaus Mann*. Boston: Twayne Publishers, G. K. Hall, 1978.

Hynes, Samuel. *The Auden Generation: Literature and Politics in England in the 1930s*. New York: Viking Press, 1977.

Isherwood, Christopher. *The Berlin Stories*. New York: New Directions, 1963.

———. *Christopher and His Kind, 1929–1939*. New York: Farrar, Straus & Giroux, 1976.

———. *Diaries, Volume I, 1939–1960*. Edited by Katherine Bucknell. New York: HarperFlamingo, 1998.

James, Clive. "Auden's Achievement." *Commentary* 56, December 1973, 53–58.

Jenkins, Nicholas, ed. *By With To & From: A Lincoln Kirstein Reader*. New York: Farrar Straus & Giroux, 1991.

———. "Reflections: The Great Impresario." *New Yorker,* April 13, 1998, 48–64.

Kaiser, Charles. *The Gay Metropolis: The Landmark History of Gay Life in America Since World War II*. San Diego: Harcourt Brace, 1997.

Kerr, Gilbert A., ed. "Special Issue: W. H. Auden, 1907–1973." *Harvard Advocate,* vol. 108, nos. 2 and 3, 1975.

Kildea, Paul, ed. *Britten on Music*. Oxford: Oxford University Press, 2003.

Kirstein, Lincoln. *Mosaic*. New York: Farrar Straus & Giroux, 1994.

———. *Portrait of Mr. B: Photographs of George Balanchine with an Essay by Lincoln Kirstein*. New York: Viking Press, 1984.

Lancaster, Clay. *Old Brooklyn Heights: New York's First Suburb*. New York: Dover, 1979.

Leddick, David. *Intimate Companions: A Triography of George Platt Lynes, Paul Cadmus, Lincoln Kirstein, and Their Circle*. New York: St. Martin's Press, 2000.

Lee, Gypsy Rose. *The G-String Murders: The Story of a Burlesque Girl*. New York: Simon and Schuster, 1941.

———. *Gypsy: Memoirs of America's Most Celebrated Stripper*. Berkeley, Calif.: Frog, 1957.

Leggett, John. *A Daring Young Man: A Biography of William Saroyan*. New York: Knopf, 2002.

Lehmann, John. *Christopher Isherwood: A Personal Memoir*. New York: Henry Holt, 1987.

MacNeice, Louis. *Louis MacNeice: Poems Selected by Michael Longley (Poet to Poet)*. London: Faber and Faber, 2001.

———. *Poems, 1925–1940*. New York: Random House, 1941.

———. *The Strings Are False*. New York: Oxford University Press, 1966.

Mann, Klaus. *Mephisto*. Translated by Robin Smyth. New York: Penguin Books, 1995.

———. *The Turning Point*. London: Serpent's Tail, 1987.

Marino, Andy. *A Quiet American: The Secret War of Varian Fry*. New York: St. Martin's Press, 1999.

McCullers, Carson. *Collected Stories of Carson McCullers*. Boston: Mariner Books, 1998.

———. *The Heart Is a Lonely Hunter*. Boston: Mariner Books, 2000.

———. *Illumination & Night Glare: The Unfinished Autobiography of Carson McCullers*. Edited by Carlos Dews. Madison: University of Wisconsin Press, 1999.

———. *The Mortgaged Heart*. Edited by Marguerite G. Smith. Boston: Houghton Mifflin, 1971.

———. *Reflections in a Golden Eye*. Boston: Mariner Books, 2000.

McPhee, Colin. *A House in Bali*. Berkeley, Calif.: Periplus, 2000.

Mendelson, Edward. *Early Auden*. New York: Farrar, Straus & Giroux, 1981.

———. *Later Auden*. New York: Farrar, Straus & Giroux, 1999.

———. *W. H. Auden 1907–1973: An Exhibition from the Berg Collection*. New York: The New York Public Library Astor, Lenox and Tilden Foundations & Readex Books, 1976.

Merz, Charles, ed. *Days of Decision: Wartime Editorials from The New York Times*. Garden City, N.Y.: Doubleday, Doran, 1941.

Mikotowicz, Tom. *Oliver Smith: A Bio-Bibliography*. Westport, Conn.: Greenwood Press, 1993.

Miller, Charles. *Auden: An American Friendship*. New York: Paragon House, 1989.

Mitchell, Donald. "The Origins, Evolution and Metamorphoses of *Paul Bunyan*, Auden's and Britten's 'American' Opera." In W. H. Auden, *Paul Bunyan: The Libretto of the Operetta by Benjamin Britten*. London: Faber and Faber, 1988, 83–148.

Mitchell, Donald, and John Evans. *Benjamin Britten: Pictures from a Life, 1913–1976*. New York: Charles Scribner's Sons, 1978.

Moulton, Elizabeth. "Remembering George Davis." *Virginia Quarterly Review* 55, Spring 1979, 284–95.

Muldoon, Paul. *Meeting the British*. (Includes the poem "7, Middagh Street.") Winston-Salem, N.C.: Wake Forest University Press, 1987.

Nin, Anaïs. *The Diary of Anaïs Nin, Volume Three, 1939–1944*. Edited by Gunther Stuhlmann. New York: Harcourt Brace Jovanovich, 1969.

Norse, Harold. *Memoirs of a Bastard Angel: A Fifty-Year Literary and Erotic Odyssey*. New York: Thunder's Mouth Press, 1989.

Oja, Carol J. *Colin McPhee: Composer in Two Worlds*. Washington, D.C.: Smithsonian Institution Press, 1990.

Osborne, Charles. *W. H. Auden: The Life of a Poet*. London: Eyre Methuen, 1980.

Page, Norman. *Auden and Isherwood: The Berlin Years*. New York: St. Martin's Press, 2000.

Page, Tim. *Dawn Powell: A Biography*. New York: Henry Holt, 1998.

Palmer, Tony, director. "A Time There Was." *The South Bank Show*. London Weekend Television documentary, Broadcast April 6, 1980.

"Paul Bowles Issue." *Twentieth Century Literature: A Scholarly and Critical Journal* 32, no. 3/4, Fall/Winter 1986. Hempstead, N.Y.: Hofstra University, 1986.

Perkins, David. *A History of Modern Poetry: Modernism and After*. Cambridge, Mass.: Belknap Press, Harvard University Press, 1999.

Phelps, Robert, with Jerry Rosco. *Continual Lessons: The Journals of Glenway Wescott, 1937–1955*. New York: Farrar Straus & Giroux, 1990.

Pike, James A., ed. *Modern Canterbury Pilgrims and Why They Chose the Episcopal Church*. New York: Morehouse-Gorham, 1956.

Plimpton, George. *Truman Capote: In Which Various Friends, Enemies, Acquaintances, and Detractors Recall His Turbulent Career*. New York: Doubleday, 1997.

———, ed. *Poets at Work: The Paris Review Interviews*. New York: Penguin Books, 1989.

Porter, Katherine Anne. *Letters of Katherine Anne Porter*. Edited by Isabel Bayley. New York: Atlantic Monthly Press, 1990.

Powell, Dawn. *Selected Letters of Dawn Powell, 1913–1965*. Edited by Tim Page. New York: Henry Holt, 1999.

Preminger, Erik Lee. *Gypsy and Me: At Home and on the Road with Gypsy Rose Lee*. Boston: Little, Brown, 1984.

Prose, Francine. *The Lives of the Muses: Nine Women and the Artists They Inspired*. New York: HarperCollins, 2002.

Reich-Ranicki, Marcel. *Thomas Mann and His Family*. Translated by Ralph Manheim. London: Fontana Press, 1990.

Rilke, Rainer Maria. *Wartime Letters of Rainer Maria Rilke, 1914–1921*. Translated by M. D. Herter Norton. New York: W. W. Norton, 1940.

Robbins, Michael W., and Wendy Palitz: *Brooklyn: A State of Mind*. New York: Workman, 2001.

Rosco, Jerry. *Glenway Wescott Personally: A Biography*. Madison: University of Wisconsin Press, 2002.

Rowley, Hazel. *Richard Wright: The Life and Times*. New York: Henry Holt, 2001.

Salmaggi, Cesare, and Alfredo Pallavisini, eds. *2194 Days of War*. New York: Gallery Books, W. H. Smith, 1977.

Savigneau, Josyane. *Carson McCullers: A Life*. Translated by Joan E. Howard. Boston: Houghton Mifflin, 2001.

Schaffner, Ingrid. *Salvador Dalí's Dream of Venus: The Surrealist Funhouse from the 1939 World's Fair*. New York: Princeton Architectural Press, 2002.

Schauer, John, ed. "A Knight at the Opera: An Interview with Sir Peter Pears," *The Advocate*, July 29, 1979, 35–39.

Seebohm, Caroline. "Conscripts to an Age" (essay). Britten-Pears Library, Aldeburgh.

Sexton, Andrea Wyatt, and Alice Leccese Powers. *The Brooklyn Reader*. New York: Harmony Books, 1994.

Sifton, Elisabeth. *The Serenity Prayer: Faith and Politics in Times of Peace and War*. New York: W. W. Norton, 2003.

Snyder-Greenier, Ellen M. *Brooklyn: An Illustrated History*. Philadelphia: Temple University Press, 1996.

Spanier, Sandra Whipple. *Kay Boyle: Artist and Activist*. Carbondale: Southern Illinois University Press, 1986.

Spender, Stephen. *Letters to Christopher*. Edited by Lee Bartlett. Santa Barbara, Calif.: Black Sparrow Press, 1980.

———. *World Within World*. New York: Modern Library, 2001.

———, ed. *W. H. Auden: A Tribute*. New York: Macmillan, 1974.

Spoto, Donald. *Lenya: A Life*. Boston: Little, Brown, 1989.

Stallworthy, Jon. *Louis MacNeice: A Biography*. New York: W. W. Norton, 1995.

Stein, Gertrude. *The Autobiography of Alice B. Toklas*. New York: Vintage Books, 1998.

Stuart, Lawrence D. *Paul Bowles: The Illumination of North Africa*. Carbondale: Southern Illinois University Press, 1974.

Summers, Claude J. *The Gay and Lesbian Literary Heritage: A Reader's Companion to the Writers and Their Works, from Antiquity to the Present*. New York: Henry Holt, 1995.

Tebbel, John. *The American Magazine: A Compact History*. New York: Hawthorn Books, 1969.

Untermeyer, Louis. *From Another World*. New York: Harcourt Brace, 1939.

Vreeland, Diana. *D.V.* Cambridge, Mass.: Da Capo Press, 1984.

———. *Why Don't You?: Bazaar Years*. New York: Universe, 2001.

Webb, Constance. *Richard Wright: The Biography of a Major Figure in American Literature*. New York: G. P. Putnam, 1968.

Weber, Nicholas Fox. *Patron Saints: Five Rebels Who Opened America to a New Art, 1928–1943*. New Haven, Conn.: Yale University Press, 1992.

Weill, Kurt, and Lotte Lenya. *Speak Low (When You Speak Love): The Letters of Kurt Weill and Lotte Lenya*. Edited and translated by Lys Symonette and Kim H. Kowalke. Berkeley: University of California Press, 1996.

Wescott, Glenway. *The Pilgrim Hawk: A Love Story*. New York: New York Review of Books, 2001.

Wineapple, Brenda. *Genêt: A Biography of Janet Flanner*. Lincoln: University of Nebraska Press, 1992.

Wright, Richard. *Early Works: Lawd Today!/Uncle Tom's Children/Native Son*. New York: Library of America, 1991.

Credits

For quotations from the correspondence of Katherine Anne Porter: the Literary Estate of Katherine Anne Porter. Copyright by the Literary Estate of Katherine Anne Porter.

For quotations from the unpublished essay "Conscripts to an Age," by Caroline Seebohm: Caroline Seebohm, copyright by Caroline Seebohm.

The author also thanks the Henry W. and Albert A. Berg Collection of English and American Literature, The New York Public Library Astor, Lenox and Tilden Foundations, for permission to print quotations from W. H. Auden's letter to Rupert Doone on Oct. 19, 1932; to Benjamin Britten on [no date, ca. pre-June, 1939], on June 8, 1939, and on Nov. 11, 1941; to James Stern [no date]; to James and Tania Stern on [no date, ca. Oct. 10, 1941], and on Dec. 18, 1941; to Tania Stern on Jan. 30, 1942, and Dec. 31, 1944; to Harry Brown on [no date, ca. Oct. 1940]; to Stephen Spender in 1940 and on March 13, 1941; to Caroline Newton on Nov. 9, 1940, May 15, 1941, Oct. 7, 1941, Nov. 11, 1941, Jan. 10, 1942, and Jan. 19, 1942; and to Elizabeth Mayer on Feb. 23, 1943, as well as from W. H. Auden's Journal, April 1929, his bound notebook [Essays (6), undated], his notebook [undated, 3 v.] containing parts of "New Year Letter," and the typescript drafts of his poems "September: 1939" and "Love Letter." All items are Copyright by the Estate of W. H. Auden.

The author thanks the Berg Collection of English and American Literature, The New York Public Library Astor, Lenox and Tilden Foundations, for permission to print quotations from Chester Kallman's letter to Harold Norse, July 11 [?1940], and to W. H. Auden, Nov. 3, 1941, Nov. 10, 1941, Nov. 18, 1941, Dec. 7, 1941, and Jan. 19, 1941, and from Chester Kallman's Holograph Notebook, unsigned and undated [dated by Edward Mendelson as 1939/1940]. All items are copyright by the Estate of Chester Kallman.

The author also thanks the Berg Collection of English and American Literature, The New York Public Library Astor, Lenox and Tilden Foundations, too, for permission to print quotations from Carson McCullers's letter to Muriel Rukeyser, Sunday night [no date], and to Muriel Rukeyser, Monday [no date]. Both items copyright © the Estate of Carson McCullers.

Thanks are due to the Harry Ransom Humanities Research Center, The University of Texas at Austin, for permission to quote from the typescript of W. H. Auden's article "Honest Doubt," W. H. Auden's letter to Chester Kallman, Dec. 25, 1941, W. H. Auden's typescript poem, "To Chester Kallman, b. Jan. 7, 1921," Chester Kallman's Notebook 3 and Notebook 4, Carson McCullers's "The Cripple" (unpublished story, Series 1, Box 8, folder 5), Carson McCullers's "Home Journey and the Green Arcade" (Series 1, Box 9, folder 13), Carson McCullers's untitled article on Georgia (unpublished, Series 1, Box 1, folder 2), the typescript draft of her 1959 article "The Flowering Dream" (Aug. 28, 1958, Series 1, Box 8, folder 14), and her letters to Reeves McCullers of Jan. 6, 1945, Jan. 17, 1945, and Jan. 18, 1945 (Series II, Box 24, folder 9).

Quotations from E. M. Forster's letter to Christopher Isherwood, Oct. 31, 1939 (CI 822), Christopher Isherwood's letter to Kathleen Bradshaw-Isherwood, 1939 (CI 1278), and W. H. Auden's letter to Christopher Isherwood [1941?] (CI 2991): All items reproduced by permission of The Huntington Library, San Marino, California.

For permission to quote from W. H. Auden's letter to Harold Norse, Nov. 1, 1941, the author thanks the Lilly Library, Indiana University, Bloomington, Indiana.

Excerpts from Christopher Isherwood's letter to George Davis of Dec. 21, 1938, W. H. Auden's letter to George Davis, Nov. [1?], 1941, George Davis's unpublished works including "The Victim," "Death of an Artist: A Memoir of Christian Bérard," and "Death of an Artist" (folder 33), George Davis's publishing contract with Harper & Brothers for "Mere Oblivion," Apr. 1, 1929 (folder 4/180), and Donald Spoto's "Victor Carl Guarneri: An Oral History Interview (unpublished), Oct. 20, 1985, are reprinted with the permission of the Kurt Weill Foundation for Music, New York. All rights reserved.

For permission to reproduce illustrative material, acknowledgments are due to the following: the Henry W. and Albert A. Berg Collection of English and American Literature, The New York Public Library, Astor, Lenox and Tilden Foundations, for the photographs of W. H. Auden with Chester Kallman and of W. H. Auden with Erika Mann; Karl Bissinger and Catherine Johnson Art, Inc., for the Karl Bissinger portrait of Jane Bowles © Karl Bissinger; to the Bodleian Library, University of Oxford, for the photograph of Louis MacNeice (Stallworthy Dep. 30N, polyfoto of Louis MacNeice); to the Britten-Pears Library, Aldeburgh, England, for the photographs of W. H. Auden and Benjamin Britten, New York, c. 1941, and of Peter Pears and Benjamin Britten, New York, c. 1941, The Elizabeth Mayer Collection; to the Brooklyn Historical Society for the photograph of the view of New York Harbor from Brooklyn Heights; to the Louise Dahl-Wolfe Archive, Center for Creative Photography, University of Arizona, for the portrait of Carson McCullers, © 1989 Center for Creative Photography, Arizona Board of Regents; to Peter Davis for the three photographs of George Davis; to the Estate of Eric Schaal / Artists Rights Society (ARS), New York, for the Eric Schaal "Portrait of Salvador and Gala Dalí," © 2004 Estate of Eric Schaal / Artists Rights Society (ARS), New York; to the Münchner Stadtmuseum and Münchner Stadtbibliothek, Monacensia Literature Archives, Collection Klaus Mann, for the photograph of Klaus Mann; to the Museum of the City of New York, Theatre Collections, for the Marcus Blechman photograph of Oliver Smith; to the New York City Municipal Archives for the photograph of the house at 7 Middagh Street, Brooklyn; to Erik Lee Preminger for the portrait of Gypsy Rose Lee as stage performer; to Time Life Pictures/Getty Images for the Eliot Elisofon photograph of Gypsy Rose Lee at her typewriter; to the Van Vechten Trust and to the Yale Collection of American Literature, Beinecke Rare Book and Manuscript Library, for the Carl Van Vechten photograph of Paul Bowles; to the Weill-Lenya Research Center, Kurt Weill Foundation for Music, New York, for the portrait of Lotte Lenya (Ser. 70/0244) and for the photograph of W. H. Auden on moving day in Brooklyn (Ser. 37/288); and to the Yale Collection of American Literature, Beinecke Rare Book and Manuscript Library, for the photograph of Richard and Ellen Wright.

The author and publishers have made every effort to trace the owners of copyright material. They apologize if any person or source has been overlooked in these acknowledgments, and they would be grateful to be informed of any oversights.

Index

Molotov, Vyacheslav Mikhaylovich, 211
Montauk, Long Island, 202, 239
Monteverdi, Claudio, 170
Morcur, Eva, 88, 90, 109, 115, 139, 185, 232
Morocco, 251
Mother Finds a Body (Lee), 208, 252
Munich Accord, 48, 50
Murray, Natalia, 152, 244, 254
Murrow, Edward R., 31, 55
Museum of Modern Art, 15, 36, 92, 166
My Fair Lady, 251
My Life (Duncan), 13

Nabokov, Vladimir, 40
Naked Genius, The (Lee), 252
Nanking Massacre, 45
Nantucket, Massachusetts, 26, 29
Nation, The, 12, 49, 72, 127
National Socialist Party. *See* Nazism
Native Son (Wright), 4, 26
Nazism (National Socialist Party)
 democratic countries' program
 against, 126–27
 denunciation of, 146
 efforts to rescue intellectuals from,
 19, 93–94, 96–97, 109, 163
 films about, 57
 refugees from, xii, 93 97, 123–27, 138
 rise of, 40–42
 satirization of, 18
 in World War II, xiii, 3–5, 45–46, 50,
 141, 211–12
 See also Evil; Fascism; Hitler, Adolf
New English Singers, 121
Newhouse, Edward, 222
Newman, Ernest, 234
New Mexico, 52
New Orleans, Louisiana, 52
New Republic, The, 26, 49, 57, 150
New School for Social Research, 49, 85,
 209
Newton, Caroline, 99–100, 175, 213, 218,
 228, 229, 245
New Verse, 44
"New Year Letter" (Auden), 39, 57, 68–
 70, 143, 187
New York City
 Auden in, 16–18, 29, 33, 35, 38, 39, 48,
 55–61, 119, 160, 257

Barker's experience of, 149–50
Davis in, 14–15
émigré artists in, 18–20
German immigrants in, 57, 127
heat waves in, 25–26, 212
Isherwood and Auden in, 16–17, 48–
 50
McCullers in, 3–9, 12, 17–30
McCullers's apartment in, 35, 186,
 204–7
New Year's Eve 1940 in, 143
Oliver Smith in, 172
Star Spangled Ball in, 143
See also Bowery; Brooklyn Heights;
 Coney Island; Harlem; New York
 World's Fair; *specific places and
 institutions in*
New Yorker, The, 9, 72, 167, 186
 Auden's publication in, 49
 Bogan as writer for, 203
 Harper's Bazaar contrasted with, 16
 on *Heart Is a Lonely Hunter*, 5, 12
 Janet Flanner as writer for, 10, 25, 94,
 124–25
 Lee as writer for, 227
 McCullers's short story in, 222, 224
New York Harbor, 36, 60
New York Herald Tribune, 12, 161, 197,
 199, 200
New York Philharmonic Orchestra, 240
New York Public Library for the Per-
 forming Arts, 256
New York Times, 5, 12, 122, 143, 197–99
New York Times Book Review, 12
New York University, 6
New York World's Fair, 79, 85, 86, 136,
 137, 166–67
Nicolson, Harold, 59
Niebuhr, Reinhold, 126–27, 147, 148, 163,
 195, 218
Niebuhr, Ursula, 147
"Night Watch over Freedom"
 (McCullers), 132–33, 143
Nin, Anaïs, xiii, 164, 169, 242
No Exit (Sartre), 254
No-Foreign-Wars Committee, 142
Norse, Harold, 50, 55–56, 74, 150–51
North American Review, 9
Norway, 3, 57